# Painting
# outside the Lines

# Painting outside the Lines

## Patterns of Creativity in Modern Art

DAVID W. GALENSON

HARVARD UNIVERSITY PRESS
CAMBRIDGE, MASSACHUSETTS  LONDON, ENGLAND  2001

Copyright © 2001 by the President and Fellows of Harvard College
All rights reserved
Printed in the United States of America

*Library of Congress Cataloging-in-Publication Data*

Galenson, David W.
Painting outside the lines : patterns of creativity in modern art / David W. Galenson.
p.   cm.
Includes bibliographical references and index.
ISBN 0-674-00612-7 (alk. paper)
1. Painting, American—20th century.   2. Painting, French—19th century.
3. Painting, French—20th century.   4. Creation (Literary, artistic, etc.)—History.
5. Painters—Psychology.   I. Title.

ND212 .G25 2001
750'.1'9—dc21
2001024755

To the memory of my father

# CONTENTS

# ILLUSTRATIONS

# TABLES

# PREFACE

During my senior year in college I wrote an honors thesis on the economic history of the postbellum Texas cattle drives. The work was fascinating, as I learned firsthand how the application of economic theory and quantitative methods to historical evidence could produce powerful and unexpected conclusions. But it was also time-consuming: for months I spent afternoons in the library reading microfilms of newspapers from the Kansas cattle towns, while devoting my evenings to the memoirs of drovers and cowboys. To allow more time for my thesis I followed the tradition, time-honored among seniors, of filling out my schedule with enjoyable courses that were known not to make heavy demands. So in the spring of 1973 I signed up for what my friends called "Spots and Dots," the history of modern art.

The course was wonderful. With eloquent descriptions of the problems each generation of painters confronted, and precise explanations of the solutions they devised, the professor vividly brought to life the narrative of modern art. Even now, almost thirty years later, I remember not only the course's central themes but its analysis of the contributions of many specific artists, and even of individual paintings. The coverage came up to the present, and one thing that struck me in the last few weeks of the semester was the youth of some of the most recent artists: we studied paintings Jasper Johns, Frank Stella, and others had made in the 1950s and 1960s when they were barely out of college themselves.

Writing my senior thesis had convinced me that I wanted to become an economic historian. I studied economics in graduate school, and got a job as an academic economist. Over the next twenty years I investigated the operation of labor markets at a number of stages in American history. For each research project I used micro-level evidence, creating an appropriate data set with large numbers of observations on the characteristics and behavior of individuals in order to document and explain particular market outcomes in the past. In every study I eventually devoted considerable attention to measuring, and understanding, the role of age in the problem at hand—as a determinant of the activities and productivity of indentured servants in colonial America,

for example, or of the composition of slave cargoes in the transatlantic trade to the colonies, or of the wealth of immigrants and the education of their children in the nineteenth-century United States.

Since my college course I had remained interested in modern art. In the spring of 1997, in talking with several art dealers, I was intrigued to learn that the value of a particular contemporary artist's work had declined over the course of his career. Wondering how common this was, I realized that I could find out systematically, in much the same way I had measured age effects in my earlier work: I could use market transactions—the results of recent auctions—to estimate the relationship between the value of an artist's paintings and the artist's age at the time of their execution. During the following summer I collected the appropriate data and made these estimates for the most prominent American painters of two generations, the Abstract Expressionists and their successors.

The results were startling. The most valuable work of Jackson Pollock, Mark Rothko, and the other Abstract Expressionists was almost invariably done late in their careers, but just the opposite was true for Jasper Johns, Robert Rauschenberg, and the other major painters of the next generation. The emphasis of my college course on the importance of the early work of Johns and Stella had therefore not been an accident, for the leading artists of their generation almost all produced their most valuable work at early ages.

Curious whether these results were unique to New York in the 1950s and 1960s, I then made a similar study of the careers of the great French painters who dominated the first century of modern art. To my surprise, I again found evidence of a shift over time. Modern painters in France born before 1850, including Manet and Cézanne, normally produced their most valuable work late in their careers, but the leading artists in the generations that followed, from Gauguin and van Gogh through Picasso and Braque, typically did their best work when they were much younger.

This book presents the results of these two studies of the relationship between age and productivity, together with my interpretation of the causes of those results and consideration of some of their consequences. In doing this research, I found the same excitement in identifying and explaining systematic patterns in the history of art that I have always found in doing similar work on problems in economic and social history. I was amazed how often the results of quantitative analysis, whether of auction prices or textbook illustrations, could lead to accurate predictions about how individual painters conceived of

their enterprise as artists, and even about how they went about planning and executing their work. But I was also disappointed to discover how completely art historians have neglected quantitative approaches to their discipline. Such work can offer new insights into the history of modern art, and in so doing adds another dimension to existing work based on traditional approaches.

Since the 1960s, economic and social historians have used quantitative evidence, often accompanied by economic theory, to explore a wide range of issues involving attitudes and perceptions that earlier might have seemed immune to quantitative analysis. Examples abound. Such studies have not only measured the changing relative costs that led to the substitution of African slaves for English indentured servants in the tobacco fields of the seventeenth-century Chesapeake Bay colonies, but have also provided evidence on planters' feelings toward the two types of worker.[1] Quantitative analysis has not only established the profitability of slavery in the mid-nineteenth-century South, but has also revealed the expectations of southern planters about how long slavery would exist.[2] Quantitative studies have not only documented the social and economic mobility of the working class in the nineteenth century, but have also allowed inferences about those workers' attitudes toward the American ideology of social opportunity.[3] Quantitative studies have not only measured the school attendance of immigrants' children in the nineteenth-century United States, but have also yielded evidence about Irish immigrants' attitudes toward formal education.[4] In these and many other cases, quantitative methods have been used to carry out systematic analyses of past societies that have helped us learn not only about prices and quantities, but also about attitudes and perceptions.

Yet although quantitative methods have now been profitably applied to a host of topics in social and economic history, the history of modern art has remained virtually untouched by quantification.[5] Art historians may claim that their discipline is not amenable to quantification. Yet like the blanket dismissals of quantification that were made by some social historians in the 1960s, which are now looked back on with amusement, these protests carry little weight when they are made in ignorance of the power and subtlety of social scientific methods. Among the most basic lessons that emerge from the experience of the past four decades in social and economic history is that it is of little value to debate the utility of quantification in general; the only question of interest is how much we learn from its use in any particular case.[6] The present study provides an example of how quantification can make a contribution to

our understanding of the history of modern art. I hope that this book will encourage others to use social scientific methods to study art history, both to discover for themselves the unique pleasure that can be derived from using a combination of quantitative and qualitative evidence to study the past, and to provide to the discipline of art history the substantial intellectual rewards that this combination can yield.

I am grateful to a number of people for their interest in this research. Tom and Carolyn Sargent initially encouraged me to begin the project, and later Anne and Andy Abel, Orley Ashenfelter, Gary Becker, Judith Bernstock, Martin Bruegel, Lance Davis, Bruno Frey, Victor Ginsburgh, Richard Hellie, John James, Emmet Larkin, Gracie Mansion, Peter McClelland, Pierre-Michel Menger, John Michael Montias, Raymonde Moulin, Nancy Mozur, Magda Salvesen, Lester Telser, and Bob Topel read and commented on drafts of papers that led to this book. I also thank participants in seminars at the California Institute of Technology, the University of Chicago, Cornell University, Universidad Torcuato di Tella (Buenos Aires), the Ecole des Hautes Etudes en Sciences Sociales (Paris), and the Institut National de la Recherche Agronomique (Paris) for their comments. Michael Edelstein, Stanley Engerman, Clayne Pope, and Bruce Weinberg generously read and discussed with me a draft of the entire manuscript, as did Robert Jensen, who has also helped me to improve my understanding of the history of modern art in a series of enjoyable conversations. Elizabeth Gilbert judiciously edited the manuscript, after Michael Aronson and an anonymous referee made helpful suggestions for revisions. Sean Buckley, Allison Gamble, Britt Salvesen, and Tom Walker provided excellent research assistance, and Shirley Ogrodowski cheerfully and efficiently prepared the manuscript.

# Painting
# outside the Lines

# 1

## The Problem

I have made some progress. Why so late and with such difficulty? Is art really a priesthood that demands the pure in heart who must belong to it entirely?
    PAUL CÉZANNE, 1903[1]

Will I ever attain the end for which I have striven so much and so long? . . . I am always studying after nature and it seems to me that I make slow progress . . . But I am old, ill, and I have sworn to myself to die painting.
    PAUL CÉZANNE, SEPTEMBER 21, 1906[2]

In my opinion to search means nothing in painting. To find, is the thing . . . The several manners I have used in my art must not be considered as an evolution, or as steps toward an unknown ideal of painting . . . I have never made trials nor experiments. Whenever I had something to say, I have said it in the manner in which I have felt it ought to be said.
    PABLO PICASSO, 1923[3]

ON OCTOBER 22, 1906, Paul Cézanne died in Aix-en-Provence, at the age of sixty-seven. Severely ill with diabetes, he had collapsed after being caught in a violent thunderstorm while painting in the hills above his studio, was carried home after being exposed to the rain for several hours, and died seven days later. In time Cézanne would come to be widely regarded as the most influential painter who had worked in the nineteenth century. In 1914, for example, the English critic Clive Bell would declare that "in so far as one man can be said to inspire a whole age, Cézanne inspires the contemporary movement," and nearly four decades later, in 1951, the American critic Clement Greenberg would write that "Cézanne, as is generally enough recognized, is the most copious source of what we know as modern art."[4] It is also generally recognized that Cézanne produced his most important work late in his life. Thus the historian Theodore Reff concluded that "If . . . one period in Cézanne's long development has been of special importance, it is surely the last one, comprehending the extraordinary changes that occurred in his work after 1895, and especially after 1900," echoing Meyer Schapiro's earlier judgment of Cézanne that "the years from 1890 to his death in 1906 are a period of

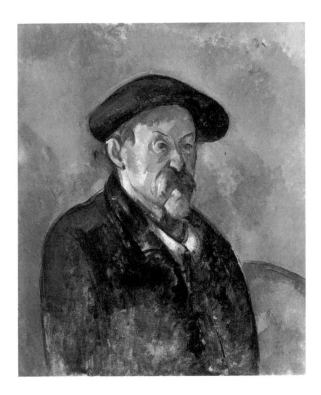

1. Paul Cézanne, *Portrait of the Artist with a Beret,* 1898–
1900. Painted while he was living in virtual seclusion in Aix,
one of Cézanne's last self-portraits suggests both his loneli-
ness and his resignation to it. Museum of Fine Arts, Boston.

magnificent growth"; for the historian George Heard Hamilton, it was during
the years from 1880 to 1906 "when Cézanne was most distinctively himself."[5]
Cézanne's single most celebrated work, the last of three large compositions ti-
tled *Les Grandes Baigneuses,* was begun early in 1906 and remained unfinished
at the time of his death in October.[6]

In the spring of 1907—less than a year after Cézanne's death—twenty-
five-year-old Pablo Picasso began to invite a few friends to his Paris studio to
see his new work in progress, a large painting that would later be given the title
*Les Demoiselles d'Avignon.*[7] In 1974 the critic John Russell declared that "in the
art of this century one painting has a place apart . . . [T]here is no doubt that
the *Demoiselles* is the white whale of modern art: the legendary giant with
which we have to come to terms sooner or later."[8] The privileged position of

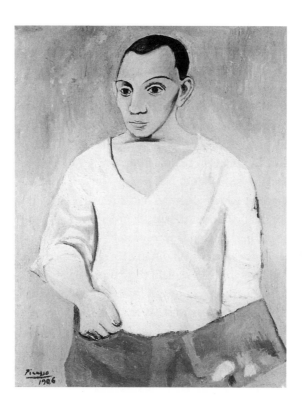

2. Pablo Picasso, *Self-Portrait with a Palette,* 1906. With simplified features that echo Cézanne's late style, the ambitious young Picasso painted himself in an aggressive pose. Philadelphia Museum of Art.

the painting is a consequence of its role as the forerunner of Cubism, which Picasso and his friend Georges Braque would create during the next few years, and which the historian John Golding describes as "perhaps the most important and certainly the most complete and radical artistic revolution since the Renaissance."[9] Picasso would go on to paint for another sixty-six years, until his death in 1973 at the age of ninety-two. During his long and enormously productive career, Picasso would become by far the most celebrated artist of the twentieth century. Yet he would never again produce a painting as important as the *Demoiselles,* or create another body of work as significant as that which he executed in the years between 1907 and the outbreak of World War I.

Cézanne was born in 1839, Picasso in 1881. In spite of the difference of more than forty years in their ages, both made their most important contributions to modern art within a single decade, the first of the twentieth century. Even more remarkably, both painted their most celebrated individual works within the span of barely more than a year, as Cézanne began *Les Grandes Baigneuses* sometime after January 1906, and Picasso first began inviting friends to see his *Demoiselles* early in the spring of 1907.[10] This contrast—between the ailing Cézanne, producing his greatest work only at the end of decades of painstaking study, and the young Picasso, producing his at just twenty-five, an age at which Cézanne had still been attending art school in Aix—raises in dramatic fashion the question of how such important painters could have careers that differed so profoundly.[11] Was it by chance that their greatest achievements came at such different stages of their careers, or is there some general principle that can explain the dissimilarity?

Answering this question requires an understanding of whether the careers of these two important painters were typical. At what stage of their lives have modern painters normally done their best work? This question has never been addressed systematically by art historians. Yet art historians have devoted enormous amounts of attention to biographies and detailed monographic studies of the careers, or portions of the careers, of individual modern painters. Even a casual survey of this extensive literature quickly suggests that there has been considerable variation in the ages at which important modern artists have executed their best work. In the absence of systematic comparative study, however, the nature of this variation remains unknown. The same question posed for Cézanne and Picasso can therefore be extended to modern painters in general: is it merely by chance that some have made their greatest contributions early in their careers, and others late in theirs, or is there some general explanation that accounts for the variation? Answering this question is the goal of this book.

## Scope of the Study

There is a theory I have heard you profess, that to paint it is absolutely necessary to live in Paris, so as to keep up with ideas.
PAUL GAUGUIN TO CAMILLE PISSARRO, 1881[12]

The art of the world has come out of the capitals of the world, because it is only in the capitals of the world, at certain favoured periods, that the best minds

among the older men and the ready minds of the younger enthusiasts have min-
gled and have taken fire from one another.

    EZRA POUND, 1913[13]

It is undeniable that, during the last fifty years, every artistic effort of impor-
tance has been made in Paris. Elsewhere, artists are content to follow where oth-
ers have led, but in Paris there is the enterprise and the courage necessary to all
creative work which has made this city an artistic centre.

    HENRI MATISSE, 1935[14]

One has the impression—but only the impression—that the immediate future
of Western art, if it is to have any immediate future, depends on what is done in
this country. As dark as the situation still is for us, American painting in its most
advanced aspects—that is, American abstract painting—has in the last several
years shown here and there a capacity for fresh content that does not seem to be
matched either in France or Great Britain.

    CLEMENT GREENBERG, 1948[15]

We wanted to communicate what the sources tell us about the character and
conduct of artists. In order to judge and assess this material, a knowledge of the
*ambiance* of the artists, of beliefs and convictions current at a given time, of
philosophical thought and literary conventions is necessary.

    RUDOLF AND MARGOT WITTKOWER, 1963[16]

In this book I focus on two groups: fifty painters born from 1796 through
1900 who lived and worked in France, and seventy-five American painters
born from 1870 through 1940.[17] These painters are listed, in order of birth-
date, in Tables 1.1 and 1.2. These painters were chosen to include all the artists
whom art historians consider to have been the most important figures in two
key periods in the history of modern art.[18] The first group includes the leading
artists who created modern painting in France during the mid-nineteenth
century, and carried it well into the twentieth; the second group includes the
American painters who dominated modern painting for two generations after
World War II, and who for the first time established the United States as the
source of the major developments in modern art. In both cases, some imme-
diate predecessors of the artists who were central to these periods are also in-
cluded to provide additional historical perspective.

Although these two periods are of obvious importance, the decision to
concentrate on them results in the omission of many important modern
painters. This decision stems from the belief that the loss in coverage is more
than compensated for by the gain in coherence, and consequently in explana-
tory power. For the goal here is not only to establish when artists produced

*Table 1.1*   French painters included in this study, in order of birthdate

| Artist | Country of birth | Year of birth | Year of death |
|---|---|---|---|
| Corot, Jean Baptiste Camille | France | 1796 | 1875 |
| Delacroix, Eugène | France | 1799 | 1863 |
| Daumier, Honoré | France | 1808 | 1879 |
| Rousseau, Théodore | France | 1812 | 1867 |
| Millet, Jean François | France | 1814 | 1875 |
| Daubigny, Charles François | France | 1817 | 1878 |
| Courbet, Gustave | France | 1819 | 1877 |
| Jongkind, Johann | Holland | 1819 | 1891 |
| Boudin, Eugène | France | 1825 | 1898 |
| Pissarro, Camille | St. Thomas | 1830 | 1903 |
| Manet, Edouard | France | 1832 | 1883 |
| Degas, Edgar | France | 1834 | 1917 |
| Whistler, James Abbott McNeill | U.S. | 1834 | 1903 |
| Cézanne, Paul | France | 1839 | 1906 |
| Sisley, Alfred | France | 1839 | 1899 |
| Monet, Claude | France | 1840 | 1926 |
| Redon, Odilon | France | 1840 | 1916 |
| Guillaumin, Armand | France | 1841 | 1927 |
| Morisot, Berthe | France | 1841 | 1895 |
| Renoir, Pierre Auguste | France | 1841 | 1919 |
| Rousseau, Henri | France | 1844 | 1910 |
| Cassatt, Mary | U.S. | 1845 | 1926 |
| Caillebotte, Gustave | France | 1848 | 1894 |
| Gauguin, Paul | France | 1848 | 1903 |
| van Gogh, Vincent | Holland | 1853 | 1890 |
| Seurat, Georges | France | 1859 | 1891 |
| Toulouse-Lautrec, Henri de | France | 1864 | 1901 |
| Bonnard, Pierre | France | 1867 | 1947 |

Table 1.1　(continued)

| Artist | Country of birth | Year of birth | Year of death |
|---|---|---|---|
| Vuillard, Edouard | France | 1868 | 1940 |
| Matisse, Henri | France | 1869 | 1954 |
| Rouault, Georges | France | 1871 | 1958 |
| Vlaminck, Maurice de | France | 1876 | 1958 |
| Dufy, Raoul | France | 1877 | 1953 |
| Picabia, Francis | France | 1879 | 1953 |
| Derain, André | France | 1880 | 1954 |
| Léger, Fernand | France | 1881 | 1955 |
| Picasso, Pablo | Spain | 1881 | 1973 |
| Braque, Georges | France | 1882 | 1963 |
| Herbin, Auguste | France | 1882 | 1960 |
| Modigliani, Amedeo | Italy | 1884 | 1920 |
| Delaunay, Robert | France | 1885 | 1941 |
| Arp, Jean | France | 1886 | 1966 |
| Duchamp, Marcel | France | 1887 | 1968 |
| Chagall, Marc | Russia | 1887 | 1985 |
| Gris, Juan | Spain | 1887 | 1927 |
| Bissière, Roger | France | 1888 | 1964 |
| Soutine, Chaim | Lithuania | 1893 | 1943 |
| Miró, Joan | Spain | 1893 | 1983 |
| Masson, André | France | 1896 | 1987 |
| Tanguy, Yves | France | 1900 | 1955 |

*Table 1.2*  American painters included in this study, in order of birthdate

| Artist | Country of birth | Year of birth | Year of death |
|---|---|---|---|
| Marin, John | U.S. | 1870 | 1953 |
| Feininger, Lyonel | U.S. | 1871 | 1956 |
| Sloan, John | U.S. | 1871 | 1951 |
| Hartley, Marsden | U.S. | 1877 | 1943 |
| Stella, Joseph | Italy | 1877 | 1946 |
| Bruce, Patrick Henry | U.S. | 1880 | 1937 |
| Dove, Arthur | U.S. | 1880 | 1946 |
| Hofmann, Hans | Germany | 1880 | 1966 |
| Weber, Max | Russia | 1881 | 1961 |
| Hopper, Edward | U.S. | 1882 | 1967 |
| Demuth, Charles | U.S. | 1883 | 1935 |
| Sheeler, Charles | U.S. | 1883 | 1965 |
| O'Keeffe, Georgia | U.S. | 1887 | 1986 |
| Albers, Josef | Germany | 1888 | 1976 |
| Macdonald-Wright, Stanton | U.S. | 1890 | 1973 |
| Tobey, Mark | U.S. | 1890 | 1976 |
| Davis, Stuart | U.S. | 1892 | 1964 |
| Wood, Grant | U.S. | 1892 | 1942 |
| Burchfield, Charles | U.S. | 1893 | 1967 |
| Shahn, Ben | U.S. | 1898 | 1969 |
| Tomlin, Bradley Walker | U.S. | 1899 | 1953 |
| Neel, Alice | U.S. | 1900 | 1984 |
| Gottlieb, Adolph | U.S. | 1903 | 1974 |
| Jensen, Alfred | Guatemala | 1903 | 1981 |
| Rothko, Mark | Russia | 1903 | 1970 |
| Gorky, Arshile | Armenia | 1904 | 1948 |
| de Kooning, Willem | Holland | 1904 | 1997 |
| Still, Clyfford | U.S. | 1904 | 1980 |

*Table 1.2*    *(continued)*

| Artist | Country of birth | Year of birth | Year of death |
|---|---|---|---|
| Newman, Barnett | U.S. | 1905 | 1970 |
| Porter, Fairfield | U.S. | 1907 | 1975 |
| Kline, Franz | U.S. | 1910 | 1962 |
| Baziotes, William | U.S. | 1912 | 1963 |
| Louis, Morris | U.S. | 1912 | 1962 |
| Martin, Agnes | Canada | 1912 | |
| Pollock, Jackson | U.S. | 1912 | 1956 |
| Guston, Philip | Canada | 1913 | 1980 |
| Reinhardt, Ad | U.S. | 1913 | 1967 |
| Motherwell, Robert | U.S. | 1915 | 1991 |
| Thiebaud, Wayne | U.S. | 1920 | |
| Diebenkorn, Richard | U.S. | 1922 | 1993 |
| Olitski, Jules | Russia | 1922 | |
| Francis, Sam | U.S. | 1923 | 1994 |
| Kelly, Ellsworth | U.S. | 1923 | |
| Lichtenstein, Roy | U.S. | 1923 | 1997 |
| Rivers, Larry | U.S. | 1923 | |
| Noland, Kenneth | U.S. | 1924 | |
| Pearlstein, Philip | U.S. | 1924 | |
| Rauschenberg, Robert | U.S. | 1925 | |
| Mitchell, Joan | U.S. | 1926 | 1992 |
| Youngerman, Jack | U.S. | 1926 | |
| Frankenthaler, Helen | U.S. | 1928 | |
| Indiana, Robert | U.S. | 1928 | |
| LeWitt, Sol | U.S. | 1928 | |
| Twombly, Cy | U.S. | 1928 | |
| Warhol, Andy | U.S. | 1928 | 1987 |
| Anuszkiewicz, Richard | U.S. | 1930 | |

*Table 1.2    (continued)*

| Artist | Country of birth | Year of birth | Year of death |
|---|---|---|---|
| Johns, Jasper | U.S. | 1930 | |
| Ryman, Robert | U.S. | 1930 | |
| Flack, Audrey | U.S. | 1931 | |
| Morley, Malcolm | Great Britain | 1931 | |
| Wesselman, Tom | U.S. | 1931 | |
| Kitaj, Ronald | U.S. | 1932 | |
| Rosenquist, James | U.S. | 1933 | |
| Rockburne, Dorothea | Canada | 1934 | |
| Dine, Jim | U.S. | 1935 | |
| Moskowitz, Robert | U.S. | 1935 | |
| Estes, Richard | U.S. | 1936 | |
| Stella, Frank | U.S. | 1936 | |
| Hockney, David | Great Britain | 1937 | |
| Mangold, Robert | U.S. | 1937 | |
| Poons, Larry | Japan | 1937 | |
| Ruscha, Ed | U.S. | 1937 | |
| Marden, Brice | U.S. | 1938 | |
| Close, Chuck | U.S. | 1940 | |
| Murray, Elizabeth | U.S. | 1940 | |

their best work, but to identify patterns over time among groups of artists, and to explain this timing for large numbers of individuals. Providing convincing explanations requires an understanding of the market forces that influenced these artists. It is important to emphasize immediately that the relevant markets are not only the economic markets for paintings, but also the intellectual markets for ideas. As will be seen, the competition for prestige and influence through the formulation of new theories and techniques—among critics as well as among painters—has often played a much larger role in influencing modern painters' attitudes toward their profession, and consequently their

conception and execution of their work, than competition for economic success. But whatever the primary motivations driving modern artists—economic, intellectual, or otherwise—understanding the ambiance of the artists is critical to understanding their careers. This dictates the restriction of this study by time and place.

Modern artists' primary markets, both intellectual and economic, have been highly centralized. In both Paris and New York in the periods considered here, the art world depended heavily on face-to-face contacts. Artists often painted together in their studios or in the countryside, they gathered in cafés and bars to argue with one another and with critics, they went to museums to study the work of their predecessors, they went to galleries both to see the work of their contemporaries and to discuss the state of the market with dealers, and they went to the homes of collectors to cultivate their patrons. This centralization was not an accident, or merely a convenience, for the most important advances in modern painting have been the result of collaboration, in which groups of artists worked together on technical problems of common interest. The innovations these groups produced then diffused outward geographically from the centers where they had been created. Artists who did not live in these centers of activity, or did not visit them regularly, would not see the latest innovations or hear the latest theories. But those who lived in Paris in the 1870s, or New York in the 1950s, could hear artists and critics argue about those innovations and theories any evening at the Café Guerbois or the Cedar Street Tavern, or see the work that embodied those innovations any day at the galleries of Paul Durand-Ruel or Sidney Janis. Although the concentration here on Paris and New York will not result in a complete account of modern painting, focusing on groups of artists who lived in the same place at the same time, and thereby allowing precise identification of the milieu in which they worked, permits the use of new methods to improve our understanding of two key periods in that history.

# 2

## Artists, Ages, and Prices

At the age of ten, twenty, a hundred, very young, a little older, and very old, an artist is always an artist. Isn't he better at some times, some moments, than at others? Never impeccable, since he is a living, human being?

PAUL GAUGUIN, 1903[1]

Attorney-General: "The labour of two days, then, is that for which you ask two hundred guineas!"

Mr. Whistler: "No, I ask it for the knowledge of a lifetime."

JAMES A. M. WHISTLER V. JOHN RUSKIN, COURT OF EXCHEQUER, NOVEMBER 15, 1878[2]

I began to *understand my sensations,* to know what I wanted to achieve around the age of 40—but indistinctly—at 50, in 1880, I formulated the idea of unity, without being able to render it, at 60 I begin to see the possibility of achieving it.

CAMILLE PISSARRO, 1890[3]

I am trying not to lose my skill. It is the absolute truth, however, that it is difficult to acquire a certain facility in production, and by ceasing to work, I shall lose it more quickly and more easily than the pains it has cost to acquire it.

VINCENT VAN GOGH, 1890[4]

For two months I have been filled with one mortal fear: that I am not the Gauguin I used to be.

PAUL GAUGUIN, 1902[5]

I feel very strongly the tie between my earlier and my recent works. But I do not think exactly the way I thought yesterday. Or rather, my basic thought has not changed, but it has evolved, and my means of expression have followed. I do not repudiate any of my paintings, but there is not one of them I would not redo differently, if I had it to redo.

HENRI MATISSE, 1908[6]

Art can only progress with increasing understanding, with the inner growth of the artist. It is the incredible folly of our times to pretend that any artist who is young, i.e. 20 to 30 years old, is ipso facto an accomplished artist. In no art has

mere youth produced its main works compared to the work of more mature years.

LYONEL FEININGER, 1916[7]

He was always asking how old Picasso had been when he had painted a certain picture. When he was told he always said, I am not as old as that yet. I will do as much when I am that age.

GERTRUDE STEIN, ABOUT ROBERT DELAUNAY, 1933[8]

Why do you think I date everything I make? Because it is not enough to know an artist's works. One must also know when he made them, why, how, under what circumstances. No doubt there will some day be a science, called "the science of man," perhaps, which will seek above all to get a deeper understanding of man via man-the-creator. I often think of that science, and I want the documentation I leave to posterity to be as complete as possible. That's why I date everything I make.

PABLO PICASSO, 1943[9]

MANY MODERN ARTISTS have reflected on the relationship between an artist's age and the quality of his work. Most often they have considered this in the context of their own careers, in looking back on the improvement over time of their skills or judgment, or in worrying about the deterioration of their abilities or creativity. Yet although these artists' awareness of the relationship underscores its importance, their assessment of it has not generally been intended to be comprehensive. How, and why, does the quality of artists' work vary with age?

The measurement of the relationship between the quality of an artist's work and the artist's age at the time of its execution may begin with an econometric analysis of data from auctions. This is done using multiple regression analysis, a statistical technique that allows estimation of the relationship between a designated dependent variable and a specified set of independent or explanatory variables. This analysis is based on the proposition that variation in values of the dependent variable—in the present case, differences in the sale prices of all paintings by a particular artist that were sold at auction during 1970–1997—can be explained in part by reference to the associated values of several other variables—here the artist's age when each painting was executed, the work's support (whether it was done on paper or canvas), the work's size, and the date of its sale at auction.[10] The evidence for the analysis was drawn from annual editions of *Le Guide Mayer*, which compiles the results of all fine

art auctions held throughout the world. For the 125 painters considered by this study, the 28 annual editions of *Mayer* for 1970–1997 yielded a total of more than 26,000 sales of individual works, or an average of more than 200 paintings per artist.

The estimates obtained for the regression equation for a given artist allow us to isolate the effect of that artist's age at the time of the execution of a painting on the sale price of that painting, separating this effect from the impact on that price of the work's support, size, and date of sale. The estimates can consequently be used to draw the relationship between age and price for an artist as illustrated in Figures 2.1 and 2.2, which show the estimated age-price profiles for Cézanne and Picasso, respectively, that emerge from the data for auctions held during 1970–1997. Each of these figures traces out the hypothetical auction values of a series of paintings, of identical size, support, and sale date, done in each year of the artist's career.[11] Thus Figure 2.1 shows that the market's valuation of Cézanne's paintings rises steadily from the work of his twenties through that of his mid-forties, declines slightly to the work of his mid-fifties, then rises thereafter to an overall peak for work done at the end of his life.[12] In contrast, Figure 2.2 shows that what would become Picasso's most valuable work was done early; after rising to a peak at age twenty-six—in 1907, the year he painted *Les Demoiselles d'Avignon*—his age-price profile declines steadily thereafter.[13]

Overall, the econometric analysis reveals that age had a statistically significant impact on the value of an artist's work for forty-two of the fifty French artists, and fifty-seven of the seventy-five Americans.[14] For these ninety-nine, Tables 2.1 and 2.2 show the estimated age at which the value of each artist's work reached a peak.[15] Thus the entry for Cézanne in Table 2.1 is sixty-seven, and that for Picasso is twenty-six.

These two tables both display a striking—and similar—pattern. Specifically, in both tables there is a pronounced decline over time in the typical age at which artists produced what the auction market would later consider their most valuable work. One way to see this is simply to divide both sets of artists into two groups, according to their date of birth. In Table 2.1, if we divide the French artists into those born before and after 1850, the median age at which they produced their most valuable work falls from forty-four years for the eighteen artists in the earlier group to thirty-five years for the twenty-four artists in the later one. In Table 2.2, if we divide the American artists into those born through 1920 and those born thereafter, the median age at peak value

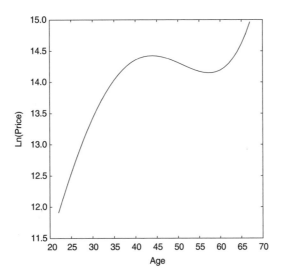

Figure 2.1    Estimated age-price profile for
Paul Cézanne (1839–1906)

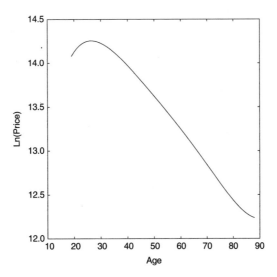

Figure 2.2    Estimated age-price profile for
Pablo Picasso (1881–1973)

*Table 2.1*    Estimated age at peak value, French artists

| Artist | Year of birth | N | Peak age | Artist | Year of birth | N | Peak age |
|---|---|---|---|---|---|---|---|
| Delacroix | 1799 | 97 | 58 | Bonnard | 1867 | 656 | 77 |
| Daumier | 1808 | 49 | 51 | Vuillard | 1868 | 568 | 26 |
| Millet | 1814 | 59 | 42 | Matisse | 1869 | 269 | 66 |
| Daubigny | 1817 | 136 | 60 | Rouault | 1871 | 520 | 81 |
| Jongkind | 1819 | 385 | 43 | Vlaminck | 1876 | 590 | 29 |
| Boudin | 1825 | 1,070 | 44 | Dufy | 1877 | 1,128 | 59 |
| Pissarro | 1830 | 698 | 45 | Picabia | 1879 | 423 | 39 |
| Manet | 1832 | 83 | 50 | Derain | 1880 | 354 | 24 |
| Degas | 1834 | 409 | 46 | Léger | 1881 | 1,084 | 33 |
| Cézanne | 1839 | 278 | 67 | Picasso | 1881 | 1,170 | 26 |
| Sisley | 1839 | 287 | 35 | Braque | 1882 | 392 | 28 |
| Monet | 1840 | 539 | 29 | Herbin | 1882 | 511 | 73 |
| Redon | 1840 | 136 | 59 | Modigliani | 1884 | 149 | 35 |
| Guillaumin | 1841 | 651 | 35 | Arp | 1886 | 87 | 35 |
| Morisot | 1841 | 140 | 33 | Chagall | 1887 | 976 | 29 |
| Renoir | 1841 | 1,079 | 35 | Gris | 1887 | 175 | 28 |
| Cassatt | 1845 | 146 | 40 | Bissière | 1888 | 140 | 70 |
| Gauguin | 1848 | 195 | 44 | Soutine | 1893 | 208 | 37 |
| van Gogh | 1853 | 140 | 36 | Miró | 1893 | 620 | 46 |
| Seurat | 1859 | 24 | 29 | Masson | 1896 | 512 | 34 |
| Toulouse-Lautrec | 1864 | 188 | 26 | Tanguy | 1900 | 156 | 35 |

*Source:* See text.

*Note:* In both Tables 2.1 and 2.2, *N* indicates the number of sales of works by the artist in the sample. Peak age is the estimated age at peak value; see text for the method of estimation.

*Table 2.2*   Estimated age at peak value, American artists

| Artist | Year of birth | N | Peak age | Artist | Year of birth | N | Peak age |
|---|---|---|---|---|---|---|---|
| Marin | 1870 | 157 | 54 | Reinhardt | 1913 | 72 | 43 |
| Feininger | 1871 | 423 | 40 | Motherwell | 1915 | 206 | 71 |
| Sloan | 1871 | 48 | 42 | Thiebaud | 1920 | 49 | 66 |
| Hartley | 1877 | 68 | 32 | Olitski | 1922 | 134 | 41 |
| J. Stella | 1877 | 96 | 41 | Francis | 1923 | 479 | 31 |
| Dove | 1880 | 60 | 36 | Kelly | 1923 | 75 | 47 |
| Hofmann | 1880 | 262 | 84 | Lichtenstein | 1923 | 163 | 35 |
| Weber | 1881 | 96 | 27 | Rivers | 1923 | 35 | 38 |
| Demuth | 1883 | 78 | 41 | Noland | 1924 | 236 | 35 |
| Sheeler | 1883 | 40 | 45 | Pearlstein | 1924 | 48 | 69 |
| O'Keeffe | 1887 | 70 | 48 | Rauschenberg | 1925 | 140 | 31 |
| Macdonald-Wright | 1890 | 48 | 43 | Frankenthaler | 1928 | 132 | 33 |
| Tobey | 1890 | 276 | 61 | Indiana | 1928 | 168 | 42 |
| Davis | 1892 | 64 | 68 | LeWitt | 1928 | 104 | 32 |
| Shahn | 1898 | 46 | 41 | Twombly | 1928 | 164 | 24 |
| Tomlin | 1899 | 19 | 52 | Warhol | 1928 | 569 | 33 |
| Jensen | 1903 | 70 | 58 | Anuszkiewicz | 1930 | 49 | 57 |
| Rothko | 1903 | 117 | 54 | Johns | 1930 | 44 | 27 |
| Gorky | 1904 | 68 | 41 | Morley | 1931 | 82 | 58 |
| de Kooning | 1904 | 217 | 43 | Wesselman | 1931 | 227 | 28 |
| Newman | 1905 | 19 | 40 | Rosenquist | 1933 | 116 | 29 |
| Porter | 1907 | 48 | 68 | Dine | 1935 | 150 | 42 |
| Kline | 1910 | 151 | 51 | Moskowitz | 1935 | 16 | 48 |
| Baziotes | 1912 | 66 | 44 | Estes | 1936 | 53 | 54 |
| Louis | 1912 | 101 | 50 | F. Stella | 1936 | 207 | 24 |
| Martin | 1912 | 61 | 52 | Hockney | 1937 | 107 | 30 |
| Pollock | 1912 | 65 | 38 | Mangold | 1937 | 65 | 50 |
| Guston | 1913 | 73 | 36 | Poons | 1937 | 85 | 27 |
|  |  |  |  | Ruscha | 1937 | 139 | 24 |

falls from forty-four years for the thirty-one artists in the earlier group to thirty-four years for the twenty-six artists in the later one.[16]

In both periods the probability that an artist would execute his most valuable work early in his career increased considerably over time. The probability that an artist would do his most valuable work before the age of forty more than doubled, from 28 percent to 71 percent, for the French artists born before and after 1850, and this probability increased by a factor of almost four, from 16 percent to 62 percent, for the Americans born before and after 1920.[17] The probability that an artist would produce his most valuable work while still in his twenties increased over six times, from 6 percent to 38 percent, across the two groups of French artists, and by a factor of nine, from 3 percent to 27 percent, across the two groups of Americans.[18] Thus the typical age at which an artist produced his most valuable work fell from the mid-forties to the mid-thirties over time in both Paris and New York, and the chances that the artist would produce that work before reaching the age of thirty increased from less than one in sixteen to more than one in four in both places.

The shifts demonstrated by Table 2.1 and 2.2 are substantial in magnitude. They pose intriguing puzzles. Why would the age at which artists produce their most valuable work change substantially across birth cohorts? Furthermore, why would this age shift twice in the same direction—from older to younger peaks—within the era of modern art?

Explaining these shifts will be the principal task of the remainder of this study. It is important, however, to consider the historical significance of the results obtained here. Does statistical evidence on the market valuation of artists' work tell us something meaningful about the quality of that work, or does it merely reflect the casual or uneducated expenditures of wealthy art collectors? The next chapter will examine this question

## Aesthetics and Econometrics:
## Proxies and Omitted Variables

Before we proceed, it is useful briefly to consider several common misunderstandings about the econometric methods used to obtain the quantitative results presented earlier in this chapter. These misunderstandings follow from the observation that the estimating equations used here are incomplete. Any art scholar will immediately recognize that the price of a painting depends on

many more variables than just those analyzed in this study—the painter's age when the work was executed, the work's support, its size, and its sale date. The sale price of a given painting by a particular artist at a specific time obviously depends on a much larger vector of attributes of the work and its history: these can include its style, its subject matter, its condition, its provenance, its exhibition history, and recent auction outcomes for other paintings by the same artist, to name just a few.[19] The variables I analyze as determinants of the value of a painting are all those reported in the auction records that are relevant to price determination; the additional variables just mentioned are not reported in the auction data. A common misunderstanding of the procedure followed here—using a set of explanatory variables that is not complete—is the belief that the results obtained in this way are invalidated by the incompleteness of the information, and that absence of evidence on many variables that belong in the more complete vector of relevant attributes nullifies the usefulness of the relationships actually estimated between price and the observed characteristics.[20]

The first important point in this regard is that the variables included in the estimating equation serve as proxies for some of the most important missing variables.[21] The style of a painting by a given artist is obviously central to its value. Cézanne's greatest contribution, for example, lay in the style he developed from Impressionist beginnings. Paintings that use his famous constructive brushstroke, that use color rather than traditional perspective to create depth, and that employ multiple vantage points embody this style, and are generally considerably more valuable than the darker, romantic paintings, with dramatic narrative content, that he often painted with a palette knife. Although the style of Cézanne's paintings is not recorded in the auction data, that style is highly correlated with the date of the paintings' execution. The romantic paintings were products of his early years. He abandoned their dark colors after beginning to work with Pissarro in Pontoise in 1872, and from then until the end of his life he progressively developed the distinctive stylistic devices that have had such a great impact on later generations. In general, the later the works within his mature period, the more advanced the development of these devices.[22] To know the date of a Cézanne painting is therefore to know a great deal about its style and importance. The same is true for the work of many other artists.[23]

Other variables can also serve as proxies for omitted variables. An exam-

ple is size. As the American Abstract Expressionists developed their trademark mature styles, many of them began to work on larger canvases. For most of these artists, these larger paintings tend to be their most important. The auction data reveal that there was a positive correlation between painting size and the artist's age for works sold by Hofmann, Rothko, Gorky, Kline, Baziotes, Pollock, Guston, and Motherwell.[24] The size of the paintings, in addition to the artist's age, thus tends to signal the style of the works for these artists.

Yet not all unobserved variables will be proxied by measured variables. Factors such as a work's current condition or its provenance may not be related systematically to the artist's age when the works were produced. A second important point pertains here: if unobserved variables are not systematically related to those included in the estimating equation, their effects on price obviously will not be captured, but their omission will have no effect on the accuracy of the measurement of the relationships between price and each of the observed variables.[25] The current condition of paintings by Cézanne will vary, of course, and a canvas in excellent condition will be worth more than a work, alike in other respects, in poor condition. But as long as Cézanne's late works are not systematically in better or worse condition than early ones, variation in the condition of the paintings auctioned will not affect the measurement of the relationship between price and the artist's age. The age-price relationship thus need not be biased by the omission of a number of potentially significant determinants of price.

The quantitative analysis of prices used here can therefore be valuable in spite of the fact that its explanations are incomplete. And this should not be surprising, for the same is true of qualitative analysis. The study of key relationships, in which analysis of just one or two factors can produce important general conclusions, is a common feature of research in all disciplines. Notable examples can readily be found in art history. In an important article published in 1979, the Yale historian Robert Herbert challenged the widespread view that Claude Monet's art was one of improvisation. Herbert described his own method of inquiry:

> My point of departure will be a close study of Monet's actual technique in several representative paintings. I am not going to discuss every aspect of his technique, but I will document a few of his most important devices, enough to prove that he was an artful contriver whose technique, only in appearance improvisatory, was as complicated as Cézanne's, and usually involved as many separate stages as those which lay behind a Renaissance landscape.[26]

Herbert's principal evidence for his thesis was a close inspection of the brush-strokes in just six paintings.[27] In his judgment, even a conclusion as broad as the proposition that "Monet's art was not spontaneous," but rather "involved a long process 'in a calculated and intentional effort'"—a conclusion that he contended would do no less than bring "the whole edifice of Impressionist criticism . . . tumbling down"—could be based on consideration of what he considered a single key aspect of Monet's technique, as witnessed in just a half dozen works.[28] Herbert's neglect of many other aspects of Monet's technique implicitly communicated his belief that a careful consideration of these would not invalidate or reverse the conclusions he drew from the study of the one he selected, and thus that the brushstroke either proxied for these neglected aspects or stood independent of them.

Another interesting example appears in a 1989 article by the English art historian Charles Harrison. In the course of an analysis of the importance of the material surface of paintings, Harrison examined Camille Pissarro's 1873 landscape, *Hoarfrost—The Old Road to Ennery.* Harrison observed that the figure of a peasant "palpably breaks the plane of the picture, and in so doing disrupts the decorative integrity that is the very hallmark of the canonical impressionist landscape."[29] The dissonance of the peasant's figure on the surface of this painting led Harrison to a broad generalization:

> What the painting narrates is the divergence of two trajectories: on the one hand those discourses within which rural labour and the identity of the peasantry were possibly realistic topics; on the other hand the developing discourses of Modernism, with their emphasis on the autonomy of expression and of pictorial form. Pissarro no doubt wished and intended to bring these discourses together and to articulate them both within one practice. The vivid testimony of the painting is that in 1873 this could not be done.[30]

Thus consideration of what Harrison regards as one key technical variable in a single painting leads him to no less sweeping a conclusion than that social concerns and modernist painting could not be combined: "the historical impossibility of reconciliation between an actual political and an actual cultural world is worked out and narrated on the surface of [Pissarro's] picture." Even more generally, the "evidence of the surface" alone is sufficient "to remind us that we can't make the world better with art."[31]

Examples could be multiplied, but these instances drawn from the work of two distinguished scholars may suffice to demonstrate how heavily art his-

torians implicitly rely on the approach described above, in which a focus on a single key relationship, as evidenced in a very limited sample of works, leads to conclusions broader than might initially have seemed likely. This method can be used well or badly, and the criteria for judging any particular instance follow from the general considerations stated at the outset of this section. Specifically, the appropriateness of the evidence of any particular independent variable for a stated conclusion will depend on the substantive importance of the behavior it captures, whether directly or by proxy, and on the likely impact on the measured relationship of omitted variables. Whenever possible, the most convincing way of assessing the usefulness of the particular relationship studied is to compare the results it produces with evidence on the same phenomenon obtained by other methods. To test the value of the age-price relationship in illuminating the connection between the stages of an artist's career and the quality of his work, we now proceed to just such an assessment.

# 3

## Market Values and Critical Evaluation

In the history of art, as in more materialistic matters, money talks vividly. Let us not be ashamed to listen.

ALFRED H. BARR, JR., 1929[1]

Quality in art can be neither ascertained nor proved by logic or discourse. Experience alone rules in this area . . . Yet, quality in art is not just a matter of private experience. There is a *consensus* of taste. The best taste is that of the people who, in each generation, spend the most time and trouble on art, and this best taste has always turned out to be unanimous, within certain limits.

CLEMENT GREENBERG, 1961[2]

The modern professional humanist is an academic person who pretends to despise measurement because of its "scientific" nature. He regards his mandate as the explanation of human expressions in the language of normal discourse. Yet to explain something and to measure it are similar operations. Both are translations.

GEORGE KUBLER, 1962[3]

This distinction points to another major element in the value of a picture, its art-historical importance . . . A painting is of particular importance if it has influenced others, or demonstrates an influence itself.

GERALDINE KEEN, 1971[4]

The determination of price on the art market has more to do with fashion, rarity, prestige, investment, and ostentation than with that quality which determines artistic reception.

ARNOLD HAUSER, 1974[5]

Each stylistic portion of an artist's total time span constitutes a separate sum of artifacts, and this is recognized by the art market in the values it places upon certain "periods" of an artist's work in contrast to others.

HAROLD ROSENBERG, 1974[6]

The price of a work of art is an index of pure, irrational desire.

ROBERT HUGHES, 1978[7]

The often stated claim that the prices of works of modern art are completely un-related to their artistic value is thus not borne out by our research. If anything, the contrary tends to be true.
    BRUNO FREY AND WERNER POMMEREHNE, 1989[8]

I immediately distrust anybody trying to detect patterns of that sort in art, espe-cially in terms of economics.
    ROBERT ROSENBLUM, 1998[9]

THE ART MARKET is often dismissed by art historians as having little relevance to true art appreciation, with the assertion that prices are determined by wealthy collectors—or perhaps unscrupulous dealers—whose purchases are of no scholarly interest. This attitude has been particularly common with re-gard to the market for contemporary art: in 1962 one critic complained that the new art was attracting a new clientele, and that art galleries were being in-vaded by "gum chewers, bobby soxers, and worse, delinquents."[10] An impor-tant question is therefore whether the auction sales on which the econometric results presented in Chapter 2 are based represent the outcomes of decisions that reflect educated judgments.

Perhaps the most obvious way to answer this question is to make a sys-tematic comparison between the statistical results of Chapter 2 and the evalu-ations of experts. Yet many experts would deny that this is possible. Scholars' explicit evaluations of when artists did their best work are often elusive. For many artists this issue has not been addressed directly, and even when it has, scholars' statements can be qualified or ambiguous. Scholars can also disagree, making it difficult to determine a consensus when only a few stated opinions are available.

But although the use of explicit statements is therefore problematic, clear implicit evidence of scholars' judgments of when an artist's best work was done is available in abundance. Two different sources will be examined here.

One source of implicit evidence is published surveys of art history. Whether monographs or textbooks, these books contain photographs of the work of leading artists, chosen to illustrate each artist's most important contribution or contributions. No single book can be considered definitive, but examining a number of books can effectively provide a survey of critical opinion.

I found a total of thirty-three books providing illustrated surveys of mod-ern painting that had been published in English from 1968 on. Texts and monographs on art history are chosen as a source of evidence in order to draw

on the judgment of art scholars. The dozens of authors and coauthors represented by the books used here include many distinguished art historians, critics, and curators of the recent past and present. But regardless of the distinction of the authors, all are likely to be among those of their generations who, in Clement Greenberg's words, "spend the most time and trouble on art," for they have been willing to make the considerable effort necessary to communicate their views on the history of modern art in a systematic way. Their work thus allows us to survey the views of experts on the composition of the core of modern art. Although the expertise of the authors varies, the number of books consulted is sufficiently large that no important result depends on the opinions of any one author or any one book.

This investigation is carried out in the spirit of a citation study, in which the importance of a scholarly book or article is judged by the number of citations it receives in some set of relevant books or journals. Yet using illustrations of paintings as the unit of analysis, rather than alternatives such as the number of times a painter or his work is mentioned, has the advantage that illustrations are substantially more costly than written references. In addition to the greater space taken up by the illustration and the greater cost of printing, the author must obtain permission to reproduce each painting, and must pay for the use of a suitable photograph. This cost in time and money implies that authors may be more selective in their use of illustrations, and that illustrations consequently provide a more accurate indication than written references of what an author believes to be genuinely important.

The objection might be raised that the paintings reproduced in textbooks are not necessarily the most important, but instead the most easily accessible to the authors, or those that require the lowest permission fees. Authors would deny this—Marilyn Stokstad, for example, declares that her book covers "the world's most significant paintings"—but such claims might be considered disingenuous.[11] Yet for major artists, whose work has had decades to make its way into public museums by purchase and bequest, the constraint posed by difficulty of access is not likely to bind tightly. Scores of museums own the work of the artists considered by this study, in quantities generally far greater than the requirements of the textbooks. Even if we restrict our view to a small number of the greatest museums, the numbers of works they own by these artists are substantial. Thirty-five different works by Picasso just from the collection of New York's Museum of Modern Art appear in the thirty-three textbooks; nineteen different illustrated Monets are drawn just from the collec-

tions of the Musée d'Orsay, as are nineteen works of Degas, and eleven of Manet.[12] And these museums typically hold many more works than are displayed or reproduced: Chicago's Art Institute, for example, owns forty-nine paintings by Monet, thirty-one by Manet, twenty-seven by Picasso, and eighteen by Matisse.[13] The works owned by museums also tend to be important ones, because curators—particularly at major museums—generally have little interest in acquiring unimportant works. Thus it seems clear that authors can usually choose among large numbers of important works in selecting the paintings to illustrate their textbooks. The interest here is in which they choose.[14]

Table 3.1 demonstrates how this evidence can be used. For Cézanne and Picasso, it shows the distribution of all the illustrations of their work, tabulated by the artist's age at the date of the work's execution, contained in the books surveyed. The contrast in the attention paid to the stages of the two artists' careers is striking: more than 80 percent of Cézanne's illustrations are of paintings he did after the age of forty, whereas 65 percent of Picasso's illustrations are of works he did before that age.[15] For both artists, the greatest concentration of illustrations is in the same decade as their estimated peak in value shown in Table 2.1: for Cézanne, more than one-third of all the illustrations are of works done just in his sixties, and for Picasso nearly two-fifths are of paintings done in his twenties. And for both artists the single year represented by the largest number of illustrations is the same as the year estimated in Table 2.1 of the artist's peak in value—age sixty-seven for Cézanne, and twenty-six for Picasso.[16]

Appendix A presents a detailed comparison of the statistical results obtained from the auction market data and the textbook evidence for all the modern French artists considered by this study. This comparison shows that although the two sources do not always agree as closely as they do for Cézanne and Picasso, they rarely disagree sharply, and for most artists they agree quite strongly.

In contrast to textbook illustrations, which are generally chosen to represent the author's judgment of the artist's most important work, systematic critical evaluations of the relative quality of artists' work over the course of their entire career are implicit in the composition of retrospective exhibitions. Museum curators who organize retrospectives reveal their judgments of the importance of an artist's work at different ages through their decisions on how many paintings to include from each phase of an artist's career. Some exhibi-

*Table 3.1*    Textbook illustrations by age, Cézanne and Picasso

| Age | Cézanne | | Picasso | |
|---|---|---|---|---|
| | *n* | % | *n* | % |
| 10–19 | 0 | 0 | 3 | 1 |
| 20–29 | 3 | 2 | 127 | 38 |
| 30–39 | 21 | 16 | 85 | 25 |
| 40–49 | 30 | 22 | 64 | 19 |
| 50–59 | 33 | 24 | 46 | 14 |
| 60–67 | 49 | 36 | | |
| 60–69 | | | 5 | 2 |
| 70–79 | | | 3 | 1 |
| 80–89 | | | 0 | 0 |
| 90–92 | | | 0 | 0 |
| Total | 136 | 100 | 333 | 100 |
| Estimated age at peak value | 67 | | 26 | |

*Source:* See text and Appendix A. Age at peak value is taken from Table 2.1.

tions might not precisely reflect an organizer's wishes, because inability to locate some works, or to persuade owners to lend valuable works, can prevent the inclusion of paintings the organizer would have preferred to show. Yet this effect is likely to be minor for retrospectives produced by important museums, for these institutions devote substantial resources to finding and obtaining the works they consider significant, and the prestige and value of the imprimatur conferred on paintings included in these shows increase the likelihood that owners will agree to lend their paintings. In addition, although retrospectives are typically organized by a single museum, after they have been shown at that site most tour to one or more other museums. The curators who organize these exhibitions can therefore usually draw on the efforts and influence of their counterparts at several other important museums in assembling their shows. A variety of considerations thus suggests that retrospectives are likely to reflect quite closely the judgments of the curator.

Because retrospectives are usually organized by an individual curator,

however, a different objection might be raised, that their composition may reflect only the judgment of a single person, and would therefore be subject both to the whim of the curator and to his possible lack of expertise. This objection is not relevant in most cases, however. Organizers of retrospectives are often specialists in the study of the artist who is the subject of the exhibition. Whether this is the case or not, organizers frequently seek advice from experts outside their own museums, and normally work with a staff of art historians within their own institutions. The composition of a completed retrospective therefore typically represents the collective judgment of a group of art historians, and is offered to the public as the presentation not just of a single curator, but of an institution. In general, the larger the museum arranging the retrospective, the greater the number of art historians who work on assembling and analyzing it.[17] Retrospectives arranged by major museums may consequently be least subject to this criticism. The importance of the American artists considered by this study is such that most have been given retrospectives by major museums within the past four decades.[18]

Table 3.2 shows the distribution, by the artist's age, of paintings included in five recent retrospectives for four of the leading American artists examined in this book. Four of these shows were organized by the Museum of Modern Art in New York (MoMA)—the leading American museum devoted exclusively to modern art—while the fifth was organized by the National Gallery in Washington, D.C., and was also shown at the Tate Gallery in London. In each case, the period of the artist's career most highly valued by the auction market corresponds closely to that most heavily emphasized by the retrospective: the curators at MoMA agreed with the market that Jasper Johns's most important work was done in his late twenties and Andy Warhol's in his early thirties, and their colleagues at the National Gallery located Willem de Kooning's peak in his late forties, not far from the market's estimated peak of forty-three. The table also shows that the curators at MoMA in 1967 agreed with the market that Jackson Pollock's peak occurred in his late thirties, and their successors did precisely the same more than thirty years later in 1998, impressive testimony to the stability of the critical assessment of Pollock's work over time.[19]

Appendix B presents a detailed examination of the retrospectives for all of the American artists considered by this study for whom catalogues of such exhibitions during the past four decades are available. Although the retrospectives do not always agree as closely with the auction market as the five examined here, the agreement between the two is generally impressive.

*Table 3.2*　Distribution of paintings included in retrospective exhibitions, by age of artist (mean number of paintings per year)

| Age | Jackson Pollock | | Willem de Kooning | Jasper Johns | Andy Warhol |
| | (1) | (2) | | | |
| --- | --- | --- | --- | --- | --- |
| 20–24 | 1.4 | 0.6 | 0.0 | 0.4 | 0.4 |
| 25–29 | 5.6 | 7.2 | 0.0 | 6.6 | 9.8 |
| 30–34 | 8.4 | 10.2 | 0.2 | 6.2 | 26.0 |
| 35–39 | 14.0 | 16.0 | 0.6 | 1.4 | 18.8 |
| 40–44 | 3.6 | 3.0 | 2.2 | 1.2 | 1.8 |
| 45–49 | | | 3.4 | 1.4 | 3.6 |
| 50–54 | | | 2.8 | 3.6 | 6.4 |
| 55–59 | | | 1.2 | 2.0 | 11.2 |
| 60–64 | | | 1.2 | 2.4 | |
| 65–69 | | | 1.2 | 1.0 | |
| 70–74 | | | 2.0 | | |
| 75–79 | | | 1.2 | | |
| 80–84 | | | 0.8 | | |
| Estimated age at peak value | | 38 | 43 | 27 | 33 |

*Source:* (1) Francis V. O'Connor, *Jackson Pollock* (New York: Museum of Modern Art, 1967); (2) Kirk Varnedoe, *Jackson Pollock* (New York: Museum of Modern Art, 1998); Marla Prather, *Willem de Kooning* (New Haven: Yale University Press, 1994); Kirk Varnedoe, *Jasper Johns: A Retrospective* (New York: Museum of Modern Art, 1996); Kynaston McShine, *Andy Warhol: A Retrospective* (New York: Museum of Modern Art, 1989).

*Note:* See Appendix B for methods of analysis. Estimated age at peak value is taken from Table 2.2.

## Auction Outcomes and Collector Motivations: A Theoretical Note

Paintings are perhaps the most costly man-made objects in the world. The enormous importance given to a work of art as a precious object which is advertised and known in connection with its price is bound to affect the consciousness of our culture.

MEYER SCHAPIRO, 1957[20]

I must admit that the artistic judgment of current big bucks is better than the average among, say, critics. (Like the prospect of being hanged, shelling out millions may concentrate the mind wonderfully.)

PETER SCHJELDAHL, 1989[21]

The close correspondence between the outcomes of art auctions and the opinions of art experts might be taken necessarily to imply that collectors are knowledgeable about art history, and that their purchases demonstrate their enjoyment of quality in modern art. Yet although this motivation is consistent with the observed market outcomes, it is not warranted to infer that it is necessarily the case, because other motives are also consistent with these patterns.

One of these was famously identified in 1899 by Thorstein Veblen: "Conspicuous consumption of valuable goods is a means of reputability to the gentleman of leisure."[22] There can be little doubt that this remains true today, and in fact public fascination with the escalating auction prices of paintings may have increased since Veblen's time. Yet it seems clear that the greatest benefits in "reputability" are normally gained not merely by the expenditure of large sums, but by spending these sums on works of recognized excellence: conspicuous consumers usually want to be known for their discerning taste as well as for their wealth.[23] The safest way to ensure this is to purchase objects already widely regarded as excellent by experts. Some wealthy collectors may take the trouble to study the judgments of art historians, while others may prefer to rely on the advice of hired experts, but in either case their purchases will most often follow the prevailing consensus of art historians and critics.

Another motive for buying art is investment. Collectors may buy paintings just as they buy other assets, not for aesthetic pleasure or to impress others, but in the hope of making a profit when the paintings rise in value. For these collectors, their own taste in art may be irrelevant, for the future price of a painting will depend on the taste of other collectors. Although collector-investors may devote considerable effort to spotting trends in taste, the safest investments will generally appear to be in works already held in high regard in the art world. Consequently the more cautious the investor, the more strongly he will be led to buy what art experts judge to be the best work of important artists.

These motives are not mutually exclusive: collectors who love art may increase their purchases of it both because of the fame it brings them and because of the possibility of capital gains.[24] Veblen himself recognized that "very many if not most of the most highly prized works of fine art are intrinsically

beautiful," and that consequently "their exclusive enjoyment gratifies the possessor's sense of pecuniary superiority at the same time that their contemplation gratifies his sense of beauty."[25] Nor is it necessarily the case that any of these motives will lead collectors to follow the consensus of art experts: the taste of a particular sophisticated collector may diverge from that consensus, some collectors may seek to gain reputations as mavericks, and some collectors may enjoy making risky investments in works currently considered unimportant, in the hope of future shifts in taste. Yet it seems likely that any of these motives, individually or in combination, will lead most collectors to value most highly those paintings most valued by art experts. In view of this, the close correspondence observed here between auction prices and the judgments of art experts is hardly surprising.

## Conclusion

Robert Storr, a curator at the Museum of Modern Art, expressed an opinion probably widely shared by his fellow art historians when he declared in 1998 that an artist's success "is completely unquantifiable."[26] The prevalence of this attitude among art historians makes it all the more interesting that the evidence presented in this chapter demonstrates that Storr is wrong. Systematic evidence of scholarly evaluations, drawn from quantitative analysis of both art history textbooks and retrospective exhibitions, points to strong agreement between the opinions of art experts and the outcomes of art auctions on the question of when particular modern painters produced their best work.[27] This support for the proposition that an artist's most valuable work is usually also that which experts consider his most important obviously heightens the interest in explaining the patterns revealed earlier by the age-price profiles.

# 4

## Importance in Modern Art

There is indeed no painter of consequence who during the last few years has not adopted or pondered over some one of the theories advanced by the Impressionists, and notably that of the open air, which influences all modern artistic thought.

STÉPHANE MALLARMÉ, 1876[1]

The masters, truth to tell, are judged as much by their influence as by their works . . . It would be necessary to write a history of our school of painting over the last twenty years to show the all-powerful role that Manet has played therein . . . Today whether they admit it or not, all our young painters who are in the vanguard have submitted to Manet's influence.

EMILE ZOLA, 1884[2]

Shall the painter then . . . decide upon painting? Shall *he* be the critic and sole authority? Aggressive as is this supposition, I fear that, in the length of time, his assertion alone has established what even the gentlemen of the quill accept as the canons of art, and recognize as the masterpieces of work.

JAMES MCNEILL WHISTLER, 1892[3]

To my mind one does not put oneself in place of the past, one only adds a new link.

PAUL CÉZANNE, 1905[4]

As if I don't know Cézanne! He was my one and only master! Don't you think I've looked at his paintings? I spent years studying them. Cézanne! He was like the father of us all. He was the one who protected us.

PABLO PICASSO, 1943[5]

If he drips, I drip.

ARSHILE GORKY ON PICASSO'S RECENT PAINTINGS, 1937[6]

Perhaps we have been inclined to consider the art-dealer, the fashionable "socialite" and . . . the "art expert," too much . . . [I]t is painters and only painters who, in the end, are the *valuers* of painting. There would be no two-hundred-thousand dollar Rembrandts and Michelangelos today without the recognition and consent of the painters, generation after generation; and for musical valuations we depend ultimately on the musician—as much as all that we know of Newton or Einstein we know thanks to the physicist and the mathematician.

WYNDHAM LEWIS, 1940[7]

I accept the fact that the important painting of the last hundred years was done in France . . . Thus the fact that good European moderns are now here is very important, for they bring with them an understanding of the problems of modern painting.

JACKSON POLLOCK, 1944[8]

Every consequential contribution to *l'art moderne* has been made by revolutionary minds.

ROBERT MOTHERWELL, 1944[9]

Our notion of quality derives primarily from artists . . . [W]e determine what is good art by the fact that other artists imitate it.

MICHAEL COMPTON, KEEPER OF EXHIBITIONS AND EDUCATION,
TATE GALLERY, 1975[10]

I believe in the importance of tradition and one school of the highest quality spawning the next.

HELEN FRANKENTHALER, 1998[11]

THE ECONOMETRIC RESULTS presented in Chapter 2 provide evidence of two dramatic shifts: in both Paris during the late nineteenth century and New York in the mid-twentieth, there was a tendency over time for artists to produce their most valuable work—and the work that art historians have judged their most important—at progressively younger ages. Explaining why these shifts occurred is possible only after answering two basic questions. First, what makes the work of a modern artist important? And second, why have some important modern artists produced their best work late in their careers, while others have done their best work early in theirs? Answering these questions, in this chapter and the next, will provide the basis for presenting a consistent explanation for the two shifts.

The answer to the first question is surprisingly simple. For modern artists, importance is primarily a function of innovation—producing a change in existing practice that becomes widely adopted by other artists. This has been generally recognized by art historians and critics. The historian Meyer Schapiro remarked in 1952, for example, on "the unique intensity of the growth of styles in painting since the 1830s," and observed that "every great painter in that period (and many a lesser one) is an innovator in the structure of painting."[12] The critic Clement Greenberg commented in 1968 that "until the middle of the last century innovation in Western art had not had to be startling or upsetting; since then it has had to be that."[13] The historian Alan Bowness agreed in 1972 that the recent stress on innovation is not new: "We

are always persuaded that there has never been a more revolutionary period, never an age when art was more experimental. This remark, however, has been made about contemporary art for a great many years now—certainly since Manet exhibited at the Salon des Refusés [in 1863]."[14] The sociologist Raymonde Moulin observed that "artists since the impressionists have been in the business of challenging established values and perpetually renovating the house of art. The history of modern art has been one of new tendencies establishing themselves in opposition to the old, only to be quickly challenged by still newer ones."[15] The historian Leo Steinberg similarly noted that "every moment during the past hundred years has had an outrageous art of its own, so that every generation, from Courbet down, has had a crack at the discomfort to be had from modern art," and generalized: "Modern art always projects itself into a twilight zone where no values are fixed."[16] The critic Michael Fried described the history of modern art as one of "perpetual revolution," arguing that "the best model for the evolution of modernist painting is that of the dialectic understood as an unceasing process of perpetual radical self-criticism."[17] The sociologist Pierre Bourdieu similarly described modern painting as "a field which has reached a high degree of autonomy and is inhabited by a tradition of permanent rupture with aesthetic tradition."[18] And in a celebrated essay of 1952, the critic Harold Rosenberg stated that "the only thing that counts for Modern Art is that a work shall be NEW."[19]

Since the birth of modern painting in the mid-nineteenth century, artists have made innovations in many areas, including subject matter, composition, scale, materials, and technique. But whatever the nature of an artist's innovation, its importance has ultimately been determined by the extent of its influence on other artists.[20] The more widespread the adoption of an innovation, the more important its creator. The importance of individual works similarly depends on the extent of their influence. The most important individual works are those that announce the appearance of important innovations.

## Artistic Success:
## Short Run and Long Run

Now there is in your canvases a vigor; . . . they will undoubtedly be appreciated someday. When we see that the Pissarros, the Gauguins, the Renoirs, the Guillaumins do not sell, one ought to be almost glad of not having the public's

favor, seeing that those who have it now will not have it forever, and it is quite possible that times will change very shortly.

THEO VAN GOGH TO VINCENT, 1889[21]

You wouldn't believe how difficult it is for me to make certain collectors, who are friends of the impressionists, understand how precious Cézanne's qualities are. I suppose centuries will pass before these are appreciated. Degas and Renoir are enthusiastic about Cézanne's works.

CAMILLE PISSARRO TO HIS SON LUCIEN, 1895[22]

I can say with truth that I have had in my shop many of his pictures which are the most sought after today, but for which the artist, at that time, could not obtain the price of a stretcher. I can also tell a story of the artist's Cubist period, at a time when not only the man in the street, but amateurs, art critics and even painters still refused to admit that nature might consist of an assemblage of geometrical forms.

AMBROISE VOLLARD ON PICASSO, 1936[23]

Picasso later told me, very correctly, "In order for paintings to be sold at high prices, they must first have been sold very cheaply." Well, I sold Picasso's pictures very cheaply, like the rest, and I bought them very cheaply too.

DANIEL-HENRY KAHNWEILER, 1961[24]

It should be emphasized that the success at issue here is not the short-run interest that gains an artist critical or commercial success during his own career, but the long-run importance that eventually places his work on the walls of major museums and makes his contribution the subject of study by scholars of art.[25] Within the era of modern art these two types of success have sometimes coincided, but often have not. Thus famous cautionary tales from this era include not only those of painters neglected in their own time, like van Gogh and Gauguin, whose work became greatly celebrated after their deaths, but also those of artists like William Adolphe Bouguereau (1825–1905) and Ernest Meissonier (1815–1891), whose paintings attracted both critical acclaim and the enthusiasm of wealthy collectors during their own lifetimes, but whose reputations declined to much more modest levels in the decades after their deaths.[26] It is not surprising that this correlation between short-run and long-run success is imperfect, for evaluation of what constitutes significant innovation may require a considerably longer period of time than judgment of many other attributes, including novelty or technical virtuosity, that can gain an artist early recognition. In part this delay follows from the fact that successful innovation depends not only on the favorable reception of an artist's work

by other artists but on others' adoption of the innovation in their own work. Although it has generally been true that artists are the first to recognize talent in their peers, the adoption of new approaches or methods may involve considerable lags in time.[27] And because it is young artists who are most likely to be receptive to innovation, judging the impact of an artist's work on other practitioners often requires waiting for the maturation of a new generation of artists.[28]

## The Role of Critics and Dealers

> Vollard is a genius in his line[;] he seems to be able to sell *anything.*
> MARY CASSATT TO LOUISINE HAVEMEYER, 1913[29]

> The business of selling paintings, like any other business, is concerned with making money. In order for a business to exist, it must have a merchandise that sells. It is true that nowadays, in certain fields, industry and business have succeeded in creating needs. In painting I don't think this is the case. I think that besides myself, there have really only been two art dealers, Durand-Ruel and Vollard, who bought paintings that did not sell or sold poorly. To the extent that I know my colleagues, I am convinced that almost all of them buy merchandise that sells.
> DANIEL-HENRY KAHNWEILER, 1961[30]

The central place of innovation in determining an artist's importance has not always been recognized. Throughout the history of modern art, there has been a recurring suspicion that success can be manufactured by powerful critics or dealers. Insofar as the success in question is that of the long run, this suspicion appears unfounded. In the short run, there is little doubt that some critics and dealers can gain attention for an artist. It seems clear, however, that unless this attention subsequently translates into influence on other artists, it does not succeed in gaining that artist a place in art history, as witnessed by the sustained attention of scholars and museums.

One of the most striking demonstrations of this proposition in the history of modern art occurred at the very outset. Perhaps the single most important critical statement in the history of modern art, often considered the first declaration of the modern revolution, was made in a series of articles published in Paris in 1863 by Charles Baudelaire. Baudelaire was a leading figure in intellectual circles, recognized not only as an art critic but also as an important poet, and in "The Painter of Modern Life" he presented a revolu-

tionary theory of the relationship between art and society that influenced major modern painters from the Impressionists to the Cubists.[31] The essay was cast in the form of a description of the work of a single artist who, although identified only by his initials, was clearly recognizable as the painter Constantin Guys. In spite of the privileged position of Baudelaire's essay in the history of modern art, the critical opinion of Guys today as a minor artist is little different from that which prevailed before Baudelaire praised him as a "master" and a "genius." The editor of a recent edition of Baudelaire's essay, for example, who considers the essay itself a "prose masterpiece" that remains "a landmark in the development of our understanding of the arts," dismisses Guys as a "delightfully gifted but essentially minor artist."[32]

The critic who has perhaps most often been described as a kingmaker in modern art is the American Clement Greenberg. Both his admirers and his detractors have acknowledged Greenberg's central role in gaining early public attention for the Abstract Expressionists, as in articles written during the late 1940s and early 1950s Greenberg boldly championed a small group of little-known American painters as the most important artists of their time.[33] Later decades would witness a growing consensus that this claim was true and that, as Greenberg had also been the first to argue publicly, the greatest among these artists was Jackson Pollock. Yet that this consensus was ultimately a result of the vast influence of the Abstract Expressionists on other artists rather than of Greenberg's powers of persuasion, as many skeptics claimed, is demonstrated by Greenberg's inability to repeat his success. Thus despite Greenberg's assertions during the 1960s that Kenneth Noland and Jules Olitski were the best painters of the next generation, these two artists' reputations were decisively eclipsed by those of a number of their contemporaries, including Robert Rauschenberg, Jasper Johns, and Andy Warhol, whose art was belittled by Greenberg but nonetheless had a much greater impact on other artists.[34]

Distrust of the commercial motives of art dealers has also sometimes given rise to the suspicion that their promotional efforts have been a greater source of the success of modern artists than any qualities of their work. This distrust has been present from the earliest stages of modern art. By the mid-nineteenth century the state-run Salon, to which entry was controlled by a jury usually dominated by members of the Academy of Fine Arts, was firmly established as the source of respectability and legitimacy for artists' work. The traditional belief this had fostered in the greater validity of large-scale group shows prompted the Impressionists' decision to create a joint-stock company

to present their work in the group exhibitions they began in 1874, instead of relying on exhibits by private dealers.[35] As late as 1883, Camille Pissarro reported to his son that Claude Monet's new show at Paul Durand-Ruel's gallery, "which is marvelous, has not made a penny." Pissarro blamed the lack of publicity—"the newspapers, knowing that a dealer is behind it, do not breathe a word"—and concluded that it was "a poor idea to have one-man shows."[36]

The general lack of commercial success of modern art in nineteenth-century Paris prevented any widespread belief that dealers were manipulating the public, but the same was not true of the more lucrative market that emerged in New York after World War II. Peggy Guggenheim was the first dealer to exhibit the work of many of the Abstract Expressionists; during the 1940s she gave their first one-man shows to important members of the group such as Jackson Pollock, William Baziotes, Hans Hofmann, Robert Motherwell, and Clyfford Still. But a show at Guggenheim's gallery was hardly a guarantee of success, as during the same period she also gave exhibitions to a number of artists who never gained comparable reputations, including Charles Seliger, Lee Hersch, Ted Bradley, and Virginia Admiral.[37] After Guggenheim left New York to return to Europe in 1947, among the most important of her successors was Leo Castelli, who became the leading dealer for artists of the generation that followed the Abstract Expressionists. Castelli presented the first one-man shows of Jasper Johns and Frank Stella, and also represented Robert Rauschenberg, Cy Twombly, and Roy Lichtenstein. Castelli was considered by many a master salesman who could manipulate the market and create reputations almost at will. An often-quoted comment was that of Willem de Kooning: "Give Leo Castelli two beer cans and he could sell them." Yet Castelli's power too appears to have been exaggerated, for he also represented Paul Brach, Norman Bluhm, Jon Schueler, Horia Damian, and many other artists who never gained substantial popular or critical success.[38]

Critics and dealers obviously play a role in allowing artists a chance to become successful. Favorable reviews help painters gain an audience, and gallery shows have become necessary for financial success as a modern artist. But although some critics and dealers can offer artists a forum that affords them an opportunity to gain success, in the history of modern art critical enthusiasm has no more guaranteed eventual artistic importance than critical rejection has ensured obscurity, and the support of a powerful dealer has no more guaranteed an artist's ultimate importance than the lack of this support has ensured the opposite. This was the conclusion of the critic Harold Rosenberg,

Greenberg's chief rival during the 1950s, who wrote in 1965: "The sum of it is that no dealer, curator, buyer, or critic, or any existing combination of these, can be depended on to produce a reputation that is more than a momentary flurry."[39] The real source of importance in modern art is influence on other artists. Consequently, as in academic disciplines, practitioners are the ultimate judges of significance. Again, in Rosenberg's words: "The single most potent force in the art world is still, in the last analysis, the artist . . . A painter with prestige among painters is bound to be discovered sooner or later by the tastes of those who determine when an artist deserves to be bought, hired, or chosen as one of the four or fourteen Americans currently entitled to museum fanfare."[40]

## The Early Growth of the Demand for Innovation in Modern Painting

The modern movement in art was a revolt against the academy, with its shackles of a decaying tradition . . . It taught that art is an expression of thought, of important truths, not of a sentimental and artificial "beauty." It established the artist as a creator and a searcher rather than as a copyist or a maker of candy.
    BARNETT NEWMAN, 1944[41]

The critical interpreters of Impressionist painting filled three roles: that of publicist . . . ; that of ideologue for the new painter; and that of theorist . . . In the Academic system, painters themselves had been propounders and enforcers of formal theory. Now this role passed to the critics as the new system developed.
    HARRISON AND CYNTHIA WHITE, 1965[42]

In many ways, the Paris art world of the 1880s was like the New York art world of the 1980s—competitive, aggressive, swept by the demand that artists come up with something new or perish.
    ARTHUR DANTO, 1990[43]

What is painting? Everyone's still clinging to outdated ideas, obsolete definitions, as if the artist's role was not precisely to offer new ones.
    PABLO PICASSO, 1943[44]

The growing importance of innovation in Paris during the early phases of modern painting can most tellingly be chronicled through the language of contemporary art critics. This language not only reflects the growth in the demand for innovation, but was one of the most powerful forces creating that demand, as critics increasingly added to their older role of interpreting the

work of painters the newer one of challenging modern painters to produce new forms of art.

Baudelaire, a key figure in establishing this new role of criticism, proposed in 1863, in "The Painter of Modern Life," no less than a new "rational and historical theory of beauty," which would entail a radical departure from the prevailing criteria for excellence in painting. Specifically rejecting what he called "the academic theory of a unique and absolute beauty," which held beauty to be timeless and invariant, he scornfully criticized those in the Paris art world who were content with simply admiring the work of sixteenth-century masters such as Raphael and Titian. Although Baudelaire conceded that "beauty is made up of an eternal, invariable element," he insisted that it must also contain "a relative, circumstantial element," representing the contemporary, "the age, its fashions, its morals, its emotions." He challenged advocates of the reigning academic orthodoxy: "I defy anyone to point to a single scrap of beauty which does not contain these two elements."[45]

A central implication of Baudelaire's theory was that the ambitious artist must seek to represent "'modernity' [by which] I mean the ephemeral, the fugitive, the contingent, the half of art whose other half is the eternal and the immutable." This would require artists to redirect their efforts away from the approved slavish devotion to imitation and reproduction of historical subjects: "It is no doubt an excellent thing to study the old masters in order to learn how to paint; but it can be no more than a waste of labor if your aim is to understand the special nature of present-day beauty." And artists must be concerned not only to choose new contemporary subjects, but to execute them with new techniques appropriate to the task, for in the accelerated pace of modern life "there is a rapidity of movement which calls for an equal speed of execution from the artist."[46]

"The Painter of Modern Life" was published late in 1863. Earlier that year the Paris art world had been startled by the Salon des Refusés, presented by the government to mollify the large number of artists whose work had been rejected by the jury of the official Salon, and which included Manet's innovative *Déjeuner sur l'herbe*, Whistler's *White Girl*, and other controversial new works. The excitement generated by the Salon des Refusés may have served to make young artists even more receptive to the call to arms of Baudelaire's revolutionary manifesto. Whether their practice was a direct result of reading Baudelaire's article, or was affected indirectly through its impact on their peers, key members of a new generation of young artists began to depart from

accepted academic practice by rejecting historical subject matter in favor of contemporary motifs. And some of these young artists may have recognized the even greater liberating potential of Baudelaire's new criteria, in that his proposal called not simply for an innovative art for his time but for perpetual revolution in art: capturing the special nature of the present was to be an essential part of great art, and because every age would have its own distinctive features, the truly original painter of each age must develop new styles and techniques suited to these new features.

Other critics soon followed Baudelaire's lead in making artists' innovations in portraying modernity a central criterion for their assessment of quality. In 1867 the novelist and critic Emile Zola approvingly compared Manet's artistic approach to that of modern scientific innovation: "He is a child of our times. To me he is an analytical painter. Since science required a solid foundation and returned to the exact observation of facts, everything has been called in question. This movement has occurred not only in the scientific world. All fields of knowledge, all human undertakings look for constant and definite principles in reality. Our modern landscape painters have far surpassed our painters of history and genre because they have studied our countryside, content to set down the first edge of a wood they come to. Manet applied the same method in each of his works. While others rack their brains to invent a new *Death of Caesar* or a new *Socrates Drinking the Hemlock,* he calmly poses figures and objects in his studio and starts to paint." [47]

To a growing number of critics, Manet was the leader of an emerging group of innovative painters. In 1870 Théodore Duret wrote, "We can now relish Manet . . . for what in his work is excellent and novel . . . [H]e is an innovator, one of the rare beings who has his own view of nature."[48] In 1876 Edmond Duranty praised Manet for having "repeatedly produced the most daring innovations," embodied in "works of depth and originality standing apart from all others." Referring to the painters then exhibiting in the Impressionists' second group show, Duranty declared that "the battle really is between traditional art and the new art, between old painting and the new painting."[49] In the same year the poet Stéphane Mallarmé published an appreciation of the Impressionists. He singled out Manet as the leader of the group, and praised him for the originality of his technique and choice of subjects. Of Manet's *Olympia,* "that wan wasted courtesan, showing to the public, for the first time, the non-traditional, unconventional nude," Mallarmé observed that "rarely has any modern work been more applauded by some few, or more

deeply damned by the many, than was that of this innovator." Mallarmé concluded that "honor is due to those who have brought to the service of art an extraordinary . . . newness of vision," and declared that "Impressionism is the principal and real movement of contemporary painting."[50]

During the following years, praise for artists as innovators became commonplace, as critics competed for honor by putting forth their own candidates for the title of the leading advanced painter of the day, with appropriate justifications for their claims. In 1880 the novelist and critic J. K. Huysmans described Degas as "the greatest artist we possess today in France," and recalled his first sight of Degas' work: "A painter of modern life had been born, moreover, a painter who derived from and resembled no other, who brought with him a totally new artistic flavor, as well as totally new skills."[51] In 1887 Félix Fénéon criticized Impressionism for its haphazard technique, and declared that "since 1884–1885 Impressionism has come into possession of [a] rigorous technique. Georges Seurat was its instigator. The innovation of M. Seurat . . . is based on the scientific division of the tone."[52] And in 1892 a young Symbolist writer, Albert Aurier, announced that "Paul Gauguin seems to me to be the initiator of a new art."[53]

Artists clearly felt the pressure of the art world's increased demand for innovation and novelty. In 1887 a colleague reported that Georges Seurat was reluctant to exhibit his work for fear that others would steal his technique.[54] The following year Paul Signac, a member of the Neo-Impressionist group led by Seurat, was angered by a journalist's claim that Seurat "sees his paternity of the theory contested by misinformed critics and unscrupulous comrades." Seurat responded to Signac's indignation by disavowing responsibility for the published accusation, but he elaborated the fears he had expressed to the journalist: "I have told him nothing but what I have always thought: the more of us there are, the less originality we will have, and the day when everyone practices this technique, it will no longer have any value and people will look for something new as is already happening." The young master then added: "It is my right to think this and to say it, since I paint in this way only to find a new approach which is my own."[55]

The artists' reaction to the persistent demand for novelty appeared in the form of frustration as well as anxiety, as painters often objected to the exaggerated and simplistic claims of the critics. When the critic Aurier published an article in 1890 praising Vincent van Gogh as "the only painter who perceives the coloration of things with such intensity" and describing him as a Symbol-

ist who "considers this enchanting pigment only as a kind of marvelous language destined to express the Idea," the artist wrote to Aurier in embarrassment, avowing his debt to other painters and expressing his discomfort at what he considered critics' exaggerated differentiation among artists: "You see, it seems to me so difficult to make a distinction between impressionism and other things; I do not see the necessity for so much sectarian spirit as we have seen in these last years; *in fact I fear its absurdity.*"[56] Yet van Gogh gave Aurier's words serious consideration, not only sending the critic a painting in gratitude, but confiding to his brother that "I do not paint like that, but I do see in it how I ought to paint."[57] The thoughtful artist recognized the critic's real intention: "For the article is very right as far as indicating the gap to be filled, and I think that the writer really wrote it more to guide, not only me, but the other impressionists as well." In serving as the vehicle for Aurier's manifesto, Vincent recognized that he was actually "*posing* a bit for *the model*," a role he accepted as "a duty and a bit of one's job like any other."[58]

In 1895 Camille Pissarro, who had introduced Cézanne to Impressionism two decades earlier, complained to his son of the oversimplification of a critic's praise of Cézanne's originality: "He simply doesn't know that Cézanne was influenced like all the rest of us, which detracts nothing from his qualities. People forget that Cézanne was first influenced by Delacroix, Courbet, Manet, and even Legros, like all of us; he was influenced by me at Pontoise, and I by him." Pissarro was irritated by Zola and other critics who "imagined that artists are the sole inventors of their style and that to resemble someone else is to be unoriginal."[59] In an essay written in 1902, Paul Gauguin expressed similar frustration at the claims of critics: "At an exhibition in London, one sagacious critic wrote: 'Monsieur Degas seems a good pupil of Nittis!' Doesn't this reflect that mania which men of letters have for squabbling in court over who had a given idea first? And the mania spreads to painters who take great care of their originality."[60]

In an influential study, Harrison and Cynthia White argued that the growth of a new class of private Paris art galleries as early as the 1860s provided an additional incentive for young artists to innovate, by creating a potential alternative outlet for their work. Unlike the annual Salon run by the state Academy of Fine Arts, which showed the work of hundreds of artists, private dealers would invest in the paintings of individual artists and show them to best advantage. An artist who succeeded in differentiating his work might thereby attract a dealer who would publicize and exhibit his paintings,

and perhaps provide him with a steady income. The Whites argued that particularly favored painters might become the objects of competition among dealers, making the free market a reliable form of patronage for the artist.[61]

Yet the impact of the new system of private dealers on the careers of artists in the late nineteenth century does not appear to have been great.[62] The number of galleries that sold the work of living artists remained very small, so few working painters appear to have benefited from competition among dealers. The Whites argued that the Impressionists were "sustained by the new system," but as late as 1891, with the great discoveries of the Impressionists more than a decade in the past, Camille Pissarro's complaints to his son reveal his frustration at the lack of competition, because of the small number of dealers available as outlets for his work: "What I need is a good exhibition, but where? . . . At Boussod & Valadon's they soft-soap me and talk against Durand. If I go to Durand's they become furious, and if I go to Boussod's, Durand is no more furious; in short: neither will buy my work. If anyone else were available, I would unhesitatingly turn to him, but there is nobody."[63] Although Pissarro professed little faith in Paul Durand-Ruel, the Impressionists' principal dealer, he recognized that the underlying problem was not the dealer, but the lack of collectors who desired his work: "Since Durand is unable to support all the impressionists, it is entirely to his interest to let them fall by the wayside after he has obtained enough of their work, for he knows their pictures will not sell until much later. The lower the prices, the better for him—he can leave our canvases to his children. He behaves like a modern speculator for all his angelic soft-spokenness . . . If I could find some base of support, I would certainly frustrate his hyena-like calculations—but my work is not understood."[64]

The interest of private dealers in the work of advanced contemporary artists grew very slowly. Thus when Vincent van Gogh arrived in Paris in 1887, he reported to his brother: "Trade is slow here. The great dealers sell Millet, Delacroix, Corot, Daubigny, Dupré, a few other masters at exorbitant prices. They do little or nothing for young artists. The second class dealers contrariwise sell those at very low prices."[65] Three years later the situation had changed little. In 1890, distraught at Vincent's suicide, Theo van Gogh resigned from his job as director of a small branch of Boussod & Valadon, a major Paris gallery. The gallery's owner complained to Theo's successor that Theo had "accumulated appalling things by modern painters which had brought the firm to discredit." Theo's inventory included works by Pissarro, Degas, Monet, Redon,

Guillaumin, Gauguin, and Lautrec, among others, but Boussod claimed that of these only Monet's paintings could be sold.[66]

Monet may in fact have been the only modern painter who benefited significantly from competition among dealers prior to the 1890s. Paul Durand-Ruel began his pioneering efforts on behalf of the Impressionists during the 1870s, but his lack of commercial success was such that it was not until 1885 that he encountered competition from another dealer, as in that year Monet exhibited at the rival gallery of Georges Petit. Petit also showed the work of Renoir the following year, and that of Pissarro and Sisley in 1887, but collectors' demand for their paintings remained insufficient to create effective competition for their output. Monet was the first exception, as the demand for his paintings began to increase after Durand-Ruel's first New York show in 1886, and in 1888 Theo van Gogh, working for Boussod & Valadon, bid him away from Petit. But Monet's success was an isolated case among advanced artists of his generation, and it was only later that more galleries for advanced modern art were opened in Paris, and competition among dealers emerged for the work of other living artists.[67]

The small size of the market for the work of modern artists, and the caution of dealers in choosing artists to represent, thus meant that few artists were significantly affected by the new system of private galleries during the nineteenth century. Later this would change, as the growing number of galleries committed to the sale of contemporary art could provide even young artists with the opportunity to gain economic success. The first modern artist who would gain fame and fortune in Paris while showing almost exclusively at private galleries was Pablo Picasso, who had his first Paris gallery show in 1901, at the age of twenty.[68] Picasso's artistic genius was complemented by a shrewd business sense that led him to take advantage of competition among dealers throughout his career, and in his case artistic innovation may have been influenced by market outcomes.[69] Later in his life Picasso suggested that his radical departure into Cubism might have been affected by the earlier success of his gallery shows, which he called his "wall of protection": "The blue period, the rose period, they were screens that shielded me . . . It was from within the shelter of my success that I could do what I liked, anything I liked."[70] Picasso's first Paris show was at the gallery of Ambroise Vollard, the respected dealer of Cézanne and Gauguin, but Vollard did not make a large investment in Picasso's work until later. In the spring of 1906 Vollard bought twenty paintings from the young artist, and the money and prestige this pur-

chase carried with it may well have helped give Picasso the self-confidence to produce the *Demoiselles d'Avignon* during that year.[71] And later, in the years immediately before World War I, the financial security provided by the support of the dealer Daniel-Henry Kahnweiler may have allowed Picasso and his friend Georges Braque to pursue the development of the late forms of Cubism in spite of the lack of widespread public enthusiasm for that work.[72] But although the private gallery system would later become a powerful influence on artists' careers, its slow early development made its effect much smaller in the nineteenth than in the twentieth century.

## The Metaphor of Language

Painters who are obedient to the imagination seek in their dictionary the elements which suit with their conception; in adjusting those elements, however, with more or less of art, they confer upon them a totally new physiognomy. But those who have no imagination just copy the dictionary.

CHARLES BAUDELAIRE, 1863[73]

He spoke a stern but elegant language which shocked the public to a degree. I do not contend that this language was entirely new . . . But from certain bold and veracious metaphors it was easy to see that an artist had been born unto us. He spoke a language which he had made his own, and which henceforth belonged only to him.

EMILE ZOLA ON EDOUARD MANET, 1867[74]

Do you think that I do not care about technique, that I do not seek it? Most certainly I do . . . but I don't care a damn whether my language is in conformity with that of the grammarians.

VINCENT VAN GOGH, 1884[75]

The critic asks me: "So you are a Symbolist? I mean well and I would like to learn; why don't you explain Symbolism to me." . . . I answer . . . "Well . . . my paintings probably speak Hebrew, which you do not understand, so there is no point in continuing the conversation."

PAUL GAUGUIN, 1898[76]

The fact that for a long time cubism has not been understood and that even today there are people who cannot see anything in it, means nothing. I do not read English, an English book is a blank book to me. This does not mean that the English language does not exist, why should I blame anybody but myself if I cannot understand what I know nothing about?

PABLO PICASSO, 1923[77]

The importance of an artist is to be measured by the number of new signs he has introduced into the plastic language.
    Henri Matisse, 1942[78]

We must not forget something that is absolutely fundamental, in my opinion, to the comprehension of cubism and of what, for me, is truly modern art: the fact that *painting is a form of writing* . . . [S]tarting with the impressionists, the general public could no longer read the work of real painters . . . [S]o we must . . . learn to read this writing.
    Daniel-Henry Kahnweiler, 1961[79]

New needs need new techniques. And the modern artists have found new ways and new means of making their statements.
    Jackson Pollock, 1951[80]

It was as if I suddenly went to a foreign country but didn't know the language, but had read enough and had a passionate interest, and was eager to live there. I wanted to live in this land; I *had* to live there, and master the language.
    Helen Frankenthaler, on her initial reaction to Pollock's painting in 1951[81]

One interesting reflection of the centrality of innovation in modern art is the recurring use of the metaphor, by both critics and artists, of new art as analogous to new or unfamiliar language. In 1867 Emile Zola declared that "every society will produce its artists, who will bring with them their own points of view." He believed that the job of the critic was clear: "Our task then, as judges of art, is limited to establishing the language and energy they possess."[82] Since Zola's time, artists and sympathetic critics have repeatedly emphasized that the most important new art, like new language, could be understood and appreciated only by those who took the time and trouble to study it and to learn its structure and conventions. This marked a fundamental break with the past: the procession of new languages devised by modern artists would no longer be directly accessible to all interested spectators, but would instead require its audience either to undertake extensive study or to rely on professional critics to serve as translators.

    Recognizing the central importance of innovation in modern art has a number of benefits. One is to afford an immediate understanding of both the familiar alienation of the public from advanced art and the increased importance of professional critics in the modern era. Another, even more important for present purposes, is to provide a more precise focus for the central prob-

lem considered here. For the question of why different artists have done their most important work at different ages can now be restated as the question of why different artists have innovated at different ages. Answering this question leads to an investigation of how modern artists have produced their innovations. This is the next task for this study.

# 5

## Experimental and Conceptual Innovators

I tell myself that anyone who says he has finished a canvas is terribly arrogant. Finished means complete, perfect, and I toil away without making any progress, searching, fumbling around, without achieving anything much.

    CLAUDE MONET, 1893[1]

I have just about finished my large figure paintings. Finished? That is to say I am letting them lie around the studio until I find, at some moment, the final sensation that will give life to the whole. Alas! while I have not found this last moment I can't do anything further with them.

    CAMILLE PISSARRO, 1895[2]

I was interested in ideas—not merely in visual products. I wanted to put painting once again at the service of the mind.

    MARCEL DUCHAMP[3]

I start a canvas without a thought of what it might eventually become.

    JOAN MIRÓ, 1948[4]

I think of my pictures as dramas . . . Neither the action nor the actors can be anticipated, or described in advance. They begin as an unknown adventure in an unknown space.

    MARK ROTHKO, 1947[5]

The reason I'm painting this way is that I want to be a machine.

    ANDY WARHOL, 1963[6]

In conceptual art the idea or concept is the most important aspect of the work. When an artist uses a conceptual form of art, it means that all of the planning and decisions are made beforehand and the execution is a perfunctory affair.

    SOL LEWITT, 1967[7]

I HAVE ARGUED that all important modern artists have been innovators—indeed, that they are important because they are innovators. In view of this, it is not surprising that an artist's most important work is his most innovative work, that which introduces his most important contribution. Chapters 2 and 3 demonstrated that both art collectors and art historians judge that there has been a great deal of variation in the ages at which modern artists have produced their best work. Explaining this variation can now be seen to depend on

answering a single question: why have some artists innovated late in their careers, and others early?

The answer lies principally in the fact that there have been two very different types of innovation in the history of modern art. What distinguishes them is not their importance: instances of both rank among the major innovations in modern art. What distinguishes them is rather the method by which they are produced. Each of these methods results directly from a specific conception of the goals of modern painting, and each is associated with specific practices in creating art. Describing the methods consequently involves characterizing not only the procedures the artist uses to produce the work, but also the artist's motivation for undertaking the work and the criteria by which he judges it. One of these methods can be called aesthetically motivated experimentation, the other conceptual execution.[8]

Modern artists who have produced experimental innovations have been motivated by aesthetic considerations: their art has usually sought to present visual perceptions or sensations. These painters are art's empiricists, working inductively to draw new general principles from extended observation and experimentation. Their goals are imprecise, so their procedure has been tentative and incremental. Their goals also tend to be ambitious, and experimental artists' careers are consequently often dominated by the pursuit of a single objective. These artists repeat themselves, painting the same subject many times—sometimes even painting over a single work many times—but gradually changing its treatment in an experimental process of trial and error. Because each work leads to the next, experimental painters rarely make specific preparatory sketches or plans for a painting. They often describe the production of a painting as a process of searching. Their innovations appear gradually over extended periods: they are rarely declared in any single work, but rather appear piecemeal in a large body of work. Experimental artists build up skills over the course of their careers, learning and therefore improving their work gradually over long periods. Yet even though they are aware of this process, it rarely brings them great satisfaction. The imprecision of their goals typically leaves them troubled with doubts about the significance of their achievements, and they commonly believe that their experimentation produces no conclusive results. These artists are perfectionists, and even the greatest of them have been plagued by frustration at their inability to achieve their desired goals.

In contrast, modern artists who have produced conceptual innovations

have normally been motivated by criteria that are other than visual: their art has been intended to communicate emotions or ideas. These artists produce works that embody innovations derived by deduction from general principles. Their goals for a particular work can usually be stated precisely, in advance of its production; these goals may be stated either as a desired outcome or as a desired process for the work's production. Conceptual artists often make detailed preparatory sketches or plans for their paintings. Their work is consequently often systematic, with all major decisions made before they begin to paint: this may be either because they begin with a precise mental image of the finished work, or because they have formulated a set of rules that they then follow without deviation. In either case they often describe the execution of a painting as perfunctory. Conceptual innovations typically appear suddenly, as a new idea produces a result quite different not only from other artists' work but also from the artist's own previous work. One consequence of the suddenness of these innovations is that they are often embodied in individual breakthrough works.

Because their goals are precise, conceptual artists are often satisfied that they have produced one or more works that achieve a specific purpose. Unlike experimental artists, whose inability to achieve their goals often ties them to a single problem for a whole career, the conceptual artist's ability to be satisfied that a problem has been solved can free him to pursue new goals. The careers of some important conceptual artists have consequently been marked by a series of innovations, each very different from the others.

## Archetypes: Cézanne and Picasso

I progress very slowly, for nature reveals herself to me in very complex ways; and the progress needed is endless.
PAUL CÉZANNE, 1904[9]

Cézanne's anxiety is what interests us. That is his lesson.
PABLO PICASSO, 1935[10]

I paint objects as I think them, not as I see them.
PABLO PICASSO[11]

The two artists who were used to introduce the central problem of this study serve to illustrate the two types of innovator. In two letters written in September 1906, the month before his death, the sixty-seven-year-old Paul Cézanne

expresses nearly all the characteristics of the experimental innovator: the visual criteria, the view of his enterprise as research, the need for the accumulation of evidence, the incremental nature and slow pace of his progress, the repeated study of a single motif, the total absorption in the pursuit of an ambitious but vague and elusive goal, and the artist's frustration with his perceived lack of success in achieving the desired results. Thus on September 8 he wrote to his son:

> Finally I must tell you that as a painter I am becoming more clear-sighted before nature, but that with me the realization of my sensations is always painful. I cannot attain the intensity that is unfolded before my senses. I have not the magnificent richness of coloring that animates nature. Here on the bank of the river the motifs multiply, the same subject seen from a different angle offers subject for study of the most powerful interest and so varied that I think I could occupy myself for months without changing place, by turning now more to the right, now more to the left.

Two weeks later he wrote to a friend, the painter Emile Bernard:

> Now it seems to me that I see better and that I think more correctly about the direction of my studies. Will I ever attain the end for which I have striven so much and so long? I hope so, but as long as it is not attained a vague state of uneasiness persists which will not disappear until I have reached port, that is until I have realized something which develops better than in the past, and thereby can prove the theories—which in themselves are always easy; it is only giving proof of what one thinks that raises serious obstacles. So I continue to study.
>
> But I have just re-read your letter and I see that I always answer off the mark. Be good enough to forgive me; it is, as I told you, this constant preoccupation with the aim I want to reach, which is the cause of it.
>
> I am always studying after nature and it seems to me that I make slow progress. I should have liked you near me, for solitude always weighs me down a bit. But I am old, ill, and I have sworn to myself to die painting . . .
>
> You must forgive me for continually coming back to the same thing; but I believe in the logical development of everything we see and feel through the study of nature and turn my attention to technical questions later.[12]

The irony of these expressions of frustration stems not only from the fact that in time Cézanne would come to be generally recognized as the greatest painter of his generation, but as mentioned earlier, that it would be the work he did in the last few years of his life that would have the greatest impact on the subse-

quent course of modern art, and that would be considered his greatest contri-
bution.[13]

The incremental nature of Cézanne's approach was eloquently discussed
by the critic Roger Fry:

> For him, as I understand his work, the ultimate synthesis of a design was
> never revealed in a flash; rather he approached it with infinite precautions,
> stalking it, as it were, now from one point of view, now from another, and al-
> ways in fear lest a premature definition might deprive it of something of its
> total complexity. For him the synthesis was an asymptote toward which he
> was for ever approaching without ever quite reaching it; it was a reality, inca-
> pable of complete realization . . . But when one speaks thus of Cézanne it
> is necessary to explain that all this refers to Cézanne in the plenitude of
> his development, after many years of research, after the failure of many at-
> tempts in different directions—to Cézanne when he had discovered his own
> personality.[14]

Meyer Schapiro pointed to Cézanne's constant experimentation when he
wrote that "Cézanne's method was not a foreseen goal which, once reached,
permitted him to create masterpieces easily. His art is a model of steadfast
searching and growth."[15] Alan Bowness also stressed Cézanne's avoidance of
preconception: "His procedure is always empirical, not dogmatic—Cézanne is
not following a set of rules, but trying, with every new picture, to record his
sensations before nature."[16] Emile Bernard, who had spent a month in Aix
painting with Cézanne, concluded that "his way of working was actually like a
form of meditation, brush in hand."[17]

Cézanne's artistic maturity was dominated by a single goal, often referred
to in summary form by comments in which he expressed a desire to make of
Impressionism something as lasting as the art of the museums, and to redo
Poussin after nature.[18] The turning point in Cézanne's career occurred in the
early 1870s. In 1872, already thirty-three years old, he moved to Pontoise, a
village near Paris, to join Camille Pissarro, and he lived there and in nearby
Auvers for parts of the next two years. During this time, in Fry's words,
"Cézanne became in effect apprentice to Pissarro."[19] Under Pissarro's
influence Cézanne's art was transformed, as he adopted several of the key in-
novations of the Impressionists, including the small brushstrokes, the bright
palette, and the use of changes of color instead of shading to achieve the illu-
sion of depth.[20] Cézanne later acknowledged his debt to Pissarro, reflecting,
"We are perhaps all derived from Pissarro . . . 'Only paint with the three pri-

mary colors and their immediate derivatives,' he told me."[21] Yet although Cézanne would thereafter share the Impressionists' devotion to painting nature, he rejected their goal of portraying the momentary effects of light and atmosphere, and their progressive sacrifice of depth in pursuit of that goal. The distinctive devices of his mature art, including the graduated shades of color across the horizontal divisions of his landscapes, the use of multiple viewpoints within a single picture, and the constructive brushstroke that both creates a two-dimensional surface pattern and tilts back into three-dimensional space, were all intended to create an art more solid and timeless than the fleeting images of Impressionism. The development of this mature style would lead the artist Maurice Denis in 1907 to call Cézanne the "Poussin of impressionism" for his effort to "create the classicism of impressionism," and this development occupied him from the time of his studies with Pissarro in the early 1870s until his death more than thirty years later.[22]

In his letters Cézanne repeatedly stressed the visual character of his goal. In his opinion, his progress was slow because of the complexity of nature, the difficulty of training his eye to see it clearly, and the problems involved in developing a technique that would present his perceptions; thus he wrote to a friend in 1904 that the knowledge of how to express his feeling for nature "is only to be acquired through very long experience."[23] He steadfastly maintained that studying nature was essential to his pursuit of the elusive goal of realization in painting: "in order to make progress, there is only nature."[24] The strength of Cézanne's commitment to a visual goal is witnessed by his continued insistence on painting outdoors, in spite of the growing physical hardships this imposed on him in old age. Although he did not dramatize his suffering, it frustrated him. Two years before his death he wrote to Emile Bernard, "I believe I have in fact made some more progress, rather slow, in the last studies which you have seen at my house. It is, however, very painful to have to state that the improvement produced in the comprehension of nature from the point of view of the picture and the development of the means of expression is accompanied by old age and a weakening of the body."[25] In the same year he reflected, even more pointedly, "My age and health will never allow me to realize my dream of art that I have been pursuing all my life."[26]

Cézanne's procedures in painting were deliberate and painstaking in the extreme. His dealer and friend Vollard reported that "for one who has not seen him paint, it is difficult to imagine how slow and painful his progress was

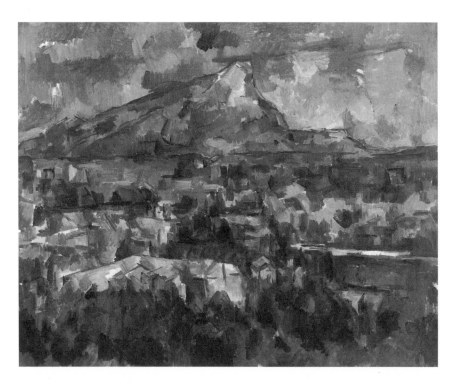

3. Paul Cézanne, *Mont Ste-Victoire,* 1904. A late view of Mont Ste-Victoire shows how Cézanne's brushstrokes serve both to create a complex surface pattern and to define planes that produce the illusion of a three-dimensional space. Philadelphia Museum of Art.

on certain days." Vollard had occasion to know, for when Cézanne agreed to paint his portrait, during Cézanne's visits to Paris the dealer would sit in the artist's studio each morning for three and a half hours. After 115 sittings over a period of three years, Cézanne left the painting to return to his home in Aix. Even then, however, he considered the portrait unfinished, insisting that Vollard leave in the studio the clothes in which he had posed, in anticipation of future sessions. Vollard understood that Cézanne almost invariably considered his work provisional: "When Cézanne laid a canvas aside, it was almost always with the intention of taking it up again, in the hope of bringing it to perfection."[27] The deliberateness of Cézanne's approach could even cause a change in a painting's subject. Referring to a snow scene of Auvers that Cézanne painted in the early 1870s, the artist's friend and patron Dr. Paul Gachet observed that "he came to the motif twice a day, in the morning and in

the evening, in gray weather and in clear; it so happened that he often slaved away at a painting from one season to another, from one year to another, so that in the end the spring of 1873 became the effect of snow, 1874."[28]

Cézanne's experimental approach appears to explain the disregard he often showed for his own works, an aspect of his behavior that has frequently been remarked on as a curious and unfortunate idiosyncrasy. Vollard recounted a number of examples: how Cézanne allowed the dealer Tanguy to cut pieces from his canvases for collectors who could not afford to buy larger paintings; Cézanne's amusement when his young son poked holes in his father's paintings; Cézanne's random destruction of paintings in his studio when he wished to vent his anger or frustration; and the understanding of Cézanne's servants that they were to destroy canvases that they found discarded in the garden of his house.[29] The historian Richard Shiff has disapprovingly described what he calls "the unprofessional character of Cézanne's enterprise—as a rule, he neither signed nor dated his paintings, left parts of them in varying states of finish, and often returned to repaint canvases with the result of placing one image over another incompatible one."[30] Yet rather than demonstrating his eccentricity or lack of respect for his craft, these accounts of apparent negligence appear to attest to Cézanne's view of his paintings as a series of experiments: once he had learned from the process of painting them, he no longer needed them. Clive Bell understood Cézanne's experimental procedure, and its source, and in 1914 he anticipated and responded to Shiff's criticism:

> Few great artists have depended more on the model. Every picture carried him a little further towards his goal—complete expression; and because it was not the making of pictures but the expression of his sense of the significance of form that he cared about, he lost interest in his work so soon as he had made it express as much as he had grasped. His own pictures were for Cézanne nothing but rungs in a ladder at the top of which would be complete expression. The whole of his later life was a climbing towards an ideal. For him every picture was a means, a step, a stick, a hold, a stepping-stone— something he was ready to discard as soon as it had served his purpose. He had no use for his own pictures. To him they were experiments. He tossed them into bushes, or left them in the open fields to be stumbling-blocks for a future race of luckless critics.[31]

Bell's contention that Cézanne considered many of his paintings to be experiments is supported by a painter who visited Cézanne in 1894, who recalled

that "he never ceased declaring that he was not making pictures, but that he was searching for a technique. Of that technique, each picture contained a portion successfully applied, like a correct phrase of a new language to be created."[32] Cézanne's letters reveal his view of his work as research, as in his admonition to Bernard that "painters must devote themselves entirely to the study of nature and try to produce pictures which will be an education."[33] He saw no need to save what he considered failed experiments: "When a picture isn't realized, you pitch it in the fire and start another one!"[34]

Picasso's conception of his art would appear more elusive, for he rarely wrote about his work and his quoted comments are often contradictory. Yet in an extended published statement made in 1923, recorded by a friend and approved by Picasso, he clearly presented the view that art should communicate conceptual discoveries, and expressed his disdain for the experimental approach:

I can hardly understand the importance given to the word *research* in connection with modern painting. In my opinion to search means nothing in painting. To find, is the thing. Nobody is interested in following a man who, with his eyes fixed on the ground, spends his life looking for the pocketbook that fortune should put in his path. The one who finds something no matter what it might be, even if his intention were not to search for it, at least arouses our curiosity, if not our admiration.

Among the several sins that I have been accused of committing, none is more false than the one that I have, as the principal objective in my work, the spirit of research. When I paint my object is to show what I have found and not what I am looking for. In art intentions are not sufficient . . . What one does is what counts and not what one had the intention of doing . . .

The idea of research has often made painting go astray, and made the artist lose himself in mental lucubrations. Perhaps this has been the principal fault of modern art. The spirit of research has poisoned those who have not fully understood all the positive and conclusive elements in modern art and has made them attempt to paint the invisible and, therefore, the unpaintable.

They speak of naturalism in opposition to modern painting. I would like to know if anyone has ever seen a natural work of art. Nature and art, being two different things cannot be the same thing. Through art we express our conception of what nature is not . . .

I also often hear the word evolution. Repeatedly I am asked to explain how my painting evolved. To me there is no past or future in art . . . [T]he ideas of people change and with them their mode of expression . . .

Variation does not mean evolution. If an artist varies his mode of ex-
pression this only means that he has changed his manner of thinking . . .

The several manners I have used in my art must not be considered as an
evolution, or as steps toward an unknown ideal of painting . . . If the subjects
I have wanted to express have suggested different ways of expression I have
never hesitated to adopt them. I have never made trials nor experiments.
Whenever I had something to say, I have said it in the manner in which I
have felt it ought to be said.[35]

Picasso's rejection of the description of his art as an evolution was not
merely posturing, but has been confirmed by generations of observers. As
early as 1920, with Picasso not yet forty years old, Bell described his career as
"a series of discoveries, each of which he has rapidly developed," and com-
mented on the abruptness and frequency of his stylistic changes, an observa-
tion that would later become a commonplace among Picasso's many biog-
raphers.[36] Thus Frank Elgar described his work as "ever-changing, ever
unforeseeable . . . so changing and so contradictory that hardly has he finished
a picture before he has begun another to deny it"; Mary Mathews Gedo ob-
served that "throughout his long lifetime, Picasso changed styles with bewil-
dering rapidity"; Patrick O'Brian declared that "he repeatedly revolutionized
his own painting"; Roland Penrose considered "the rapid changes from one
style to another" to be "the signature of his personality"; and John Berger re-
marked that "in the life work of no other artist is each group of works so inde-
pendent of those which have just gone before, or so irrelevant to those which
are to follow."[37] Yet another biographer, Pierre Cabanne, made this point using
the same contrast with Cézanne emphasized here: "No painter had ever so
varied his styles. There was not one Picasso, but ten, twenty, always different,
unpredictably changing, and in this he was the opposite of a Cézanne."[38] Pi-
casso's protean changes of style stemmed directly from his conceptual ap-
proach. He did not work slowly and incrementally toward a single distant
goal, but rather changed frequently and abruptly, as new ideas generated new
styles, each motivated by—and each the solution to—a different problem.
When asked by an interviewer in 1945 why he painted in a way that was so
difficult for viewers to understand, Picasso responded: "I paint this way be-
cause it's a result of my thought."[39] One consequence of this was Picasso's fa-
mous self-confidence: as the historian Lionello Venturi observed, "everything
he does he affirms with unshaken assurance, with terrific authority."[40]

Although in a statement recorded by a friend in 1935 Picasso denied that

his paintings were "thought out and settled beforehand," he nonetheless remarked in that statement that his finished works corresponded with his initial vision for them:

> It would be very interesting to preserve photographically, not the stages, but the metamorphoses of a picture. Possibly one might then discover the path followed by the brain in materializing a dream. But there is one very odd thing—to notice that basically a picture doesn't change, that the first "vision" remains almost intact, in spite of appearances. I often ponder on a light and a dark when I have put them into a picture; I try hard to break them up by interpolating a color that will create a different effect. When the work is photographed, I note that what I put in to correct my first vision has disappeared, and that, after all, the photographic image corresponds with my first vision before the transformation I insisted on.[41]

On several occasions Picasso specifically remarked that his works were preconceived. In 1932 he told a critic, "The whole interest of art is in the start. Once started, it's already over."[42] Françoise Gilot, Picasso's companion during the late 1940s, reported his account of the origins of *L'Homme au mouton*, a large sculpture of a man holding a sheep in his arms. After showing her a series of drawings of a group of figures, Picasso explained:

> When I begin a series of drawings like that, I don't know whether they're going to remain just drawings, or become an etching or a lithograph, or even a sculpture. But when I had finally isolated that figure of the man carrying the sheep . . . I knew it couldn't be a painting; it *had* to be a sculpture. At that moment I had such a clear picture of it, it came forth just like Athena, fully armed from the brow of Zeus. The conception was a year or two in taking shape, but when I went to work, the sculpture was done almost immediately.[43]

Late in his life Picasso made a similar comment to a biographer: " 'The key to everything that happens is here,' he said one day, pointing to his forehead. 'Before it comes out of the pen or brush, the key is to have it at one's fingertips, entirely without losing any of it.' "[44]

Picasso's attitude toward his own completed works contrasted sharply with Cézanne's casual disregard. Although he sometimes claimed to have no interest in his finished works, his behavior indicated otherwise, for he became furious if he saw that any of his paintings had been varnished or cleaned, and he hated for anyone to handle his unframed drawings, for fear they would get

wrinkled or soiled.[45] He always signed his works, and he often dated them not only with the customary year but also with the month and day—and occasionally even the time of day—of their execution.[46] Far from considering his work as merely the residue of past experiments, Picasso's actions indicate that he regarded each piece as a significant individual work that would someday be of historical interest. Consistent with this attitude, Picasso was delighted when Christian Zervos set out in 1932 to produce a complete catalogue of his works, and Picasso took an active interest in the project's progress. Picasso gave Zervos several paintings as tokens of his gratitude, and he actually corrected proofs of the catalogue himself.[47] Unlike Cézanne, who would often destroy works he considered unsuccessful, Picasso wanted to leave all his works to posterity: "I paint the way some people write their autobiography. The paintings, finished or not, are the pages of my journal, and as such they are valid. The future will choose the pages it prefers. It's not up to me to make the choice."[48]

Françoise Gilot told a story that reveals an interesting feature of Picasso's conceptual attitude toward his work. One evening in 1948, Picasso was working on a large painting of the kitchen of their Paris apartment. Having reached a certain point in making the painting, he said to her, "Now I see two possible directions for this canvas. I want another one just like it, to start from. You make a second version up to this point and I'll work on it from there. I want it tomorrow." Gilot was herself a painter, but because of the little time available she asked Picasso's nephew, Javier Vilato, who was also a painter, to help her. Together they made the replica Picasso had ordered. Gilot recalled:

> From time to time Pablo gave me the job of painting a copy like that; painting it up to a certain point, that is. It was generally, as in the case of *La Cuisine,* because he had followed one course of action to its logical conclusion and after the picture was completed he was haunted by the thought of what it might have been if, at the fork in the road, so to speak, he had branched off onto the other path. To avoid having to do over again everything he had done to reach that point, he would have me do an exact copy of it . . . That gave him a chance to get to the main point quickly and work over it longer. That winter I did three or four other jobs like that one.

Gilot concluded by observing that "for Pablo my collaboration was a practical demonstration of one of his favorite aphorisms: 'If I telegraph one of my canvases to New York,' he said, 'any house-painter should be able to do it properly.

A painting is a sign—just like the sign that indicates a one-way street.' "[49] Picasso's willingness to incorporate the work of others into his paintings indicates a greater concern for the idea of the work than for the importance of his own touch. And even if suggested in jest, the notion of having his paintings executed by others anticipated what would become a deliberate policy of a number of conceptual painters during the 1960s and beyond.

Picasso's conceptual approach can also be seen in his extensive preparations for his two most celebrated works. During the winter of 1906–1907, he filled one sketchbook after another with preparatory drawings for *Les Demoiselles d'Avignon*. He is known to have made nineteen drawings of the full composition, and scores of sketches of each of the five individual female figures that appeared in the final painting, as well as of the two male figures that appeared in early plans but were omitted from the final version.[50] William Rubin calculated "that there are at least some four to five hundred studies in all mediums *associated* in one way or another with the genesis and execution of the *Demoiselles*," and concluded that this constituted "a quantity of preparatory work . . . without parallel, for a single picture, in the entire history of art."[51]

The *Demoiselles* has been described as "one of those rare individual works of art that have changed the course of visual history," for announcing the Cubist revolution, while *Guernica* has been recognized as a demonstration that the new forms of modern art that the *Demoiselles* had ushered in could be used not only for private expression but also for the large-scale humane and public statements that had been central to Western painting before the advent of modern art.[52] Picasso had been asked in January 1937 to paint a mural for the Spanish pavilion at the approaching Paris World's Fair, but he decided on his contribution only after the bombing in late April of the Basque town of Guernica, by German planes acting for the Spanish fascists. On May 1 he began making sketches for his painting. During the next few weeks Picasso made more than fifty preparatory sketches for the work, which he then painted over a period of a month. Picasso dated and numbered each of the sketches, allowing the historian Herschel Chipp to observe:

> By the end of the first day of work, Picasso had performed a most remarkable feat: in a few hours he had formulated the basic conception of *Guernica*. The sixth and last sketch of May 1 brought together all the elements developed so far . . . This image of the first day persisted throughout all the succeeding stages and became essentially the concept of the final painting more than five weeks later.[53]

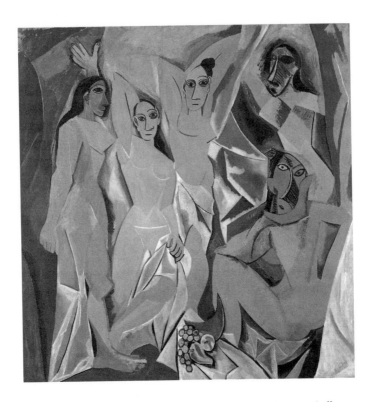

4. Pablo Picasso, *Les Demoiselles d'Avignon*, 1907. In the *Demoiselles*, Picasso combined influences as diverse as pre-Roman Iberian sculpture, African carvings, and the late styles of Cézanne and Gauguin to create new forms that led to the invention of Cubism. Museum of Modern Art, New York.

Thus although Picasso's preparations for *Guernica* were made more quickly than those for the *Demoiselles*, both works were carefully planned before the actual paintings were begun. In this his practice differed diametrically from that of Cézanne, who "hardly ever did preliminary sketches, since his canvases are . . . the result of direct observation which did not allow such preparations."[54]

In a review of an exhibition of Picasso's paintings in Barcelona in 1912, a critic observed: "Picasso does not paint the image reflected in his own eyes. He is not interested in representing objects more or less—as he says—*photographically*, but rather in representing the idea of those objects his imagination has formed."[55] Decades later, the historian John Golding echoed this critical observation as he underscored the conceptual nature of Picasso's great early

innovation: "The Cubism of Picasso and Braque was to be essentially conceptual. Even in the initial stages of the movement, when the painters still relied to a large extent on visual models, their paintings are not so much records of the sensory appearance of their subjects, as expressions in pictorial terms of their idea or knowledge of them."[56] Picasso intended Cubism to be a reaction against the visual basis of earlier modern painting, and Golding emphasized his success:

> Cubism was, if not necessarily the most important, at least the most complete and radical artistic revolution since the Renaissance . . . [Nothing] has so altered the principles, so shaken the foundations of Western painting as did Cubism. Indeed, from a visual point of view it is easier to bridge the three hundred and fifty years separating Impressionism from the High Renaissance than it is to bridge the fifty years that lie between Impressionism and Cubism . . . [A] portrait by Renoir will seem closer to a portrait by Raphael than it does to a Cubist portrait by Picasso.[57]

## Planning, Working, and Stopping

For any given artist, what does his work signify? . . . According to their natures, some will pass easily from one work to another, tear up or sell, and go on to something quite different; others, on the contrary, become obsessed, involved in endless revision, cannot give up the game.
PAUL VALÉRY, 1936[58]

One might say that the School of New York tries to find out what art is precisely through the process of making art. That is to say, one discovers, so to speak, rather than imposes a picture. What constitutes the discovery is the discovery of one's own feeling, which none of us would dare to propose before the act of painting itself.
ROBERT MOTHERWELL, 1950[59]

In Action painting the pressing issue for artists was: When is a painting finished? Answer: At exactly the end of the artist's lifetime.
HAROLD ROSENBERG, 1970[60]

Does creation reside in the idea or in the action?
ALAN BOWNESS, 1972[61]

There are several ways of constructing a work of art. One is by making decisions at each step, another by inventing a system to make decisions.
SOL LEWITT, 1983[62]

The distinction between experimental and conceptual artists can be summarized, and perhaps made more precise, by modifying a scheme suggested by the philosopher Richard Wollheim. Wollheim proposed that

> the production of an art object consists, first of all, in a phase that might be called, perhaps oversimply, "work" *tout court*: that is to say, the putting of paint on canvas, the hacking of stone, the welding of metal elements . . . But the second phase in artistic productivity consists in decision, which . . . is that without which work would be meaningless: namely, the decision that the work has gone far enough.[63]

This scheme becomes more useful for present purposes if to Wollheim's two stages we add another, which occurs prior to his two. This consists of all of the artist's preparations before starting to put paint on canvas. Making a painting then involves three stages—planning, working, and stopping.

For the experimental artist, the planning of a painting is of little or no importance. The motif selected need have no symbolic significance, but might be simply a convenient object of study; in many cases the artist returns to work on a subject he has used in the past, often that which he used in his most recent previous painting. The experimental painter rarely makes detailed plans or sketches in advance of beginning any particular painting. Once a painting is begun, the working stage is open-ended, and involves a series of decisions. The artist proceeds during this working stage on the basis of visual inspection of the developing painting, evaluating whether what he sees on the canvas corresponds with his view of a model, or to a desired mental image. He changes things on the canvas when he isn't satisfied with them because, in a phrase that often recurs among experimental artists, they don't look right. The decision to stop is also based on inspection and judgment of the work: the painter stops when he decides he is satisfied with the appearance of the work, or abandons it as an incomplete or failed effort. In either case, however, the decision is based on the appearance of the object. The decision to stop is typically a difficult one, because the imprecision of his goal rarely allows the artist to be completely satisfied with what he accomplishes in any individual work. And because the decision to stop is often provisional, experimental artists are more likely to return to work on a painting that they earlier abandoned or considered finished, even after long intervals.

In contrast, the work of the conceptual artist is preconceived. For the conceptual artist, planning is consequently the most important stage, as the artist

either mentally envisages the completed work or specifies a set of procedures that will produce the finished work. Conceptual artists often make detailed preparatory drawings or studies before beginning a painting. The working stage is devoted to executing the plan—either producing the preconceived image or carrying out the prescribed procedures. The decision to stop is based on predetermined criteria, as the artist stops either when he has produced the image he had originally conceived or when he has fully carried out the process he planned.

This scheme highlights the difference in how and when the most important decisions are made in creating a painting. For the conceptual artist they are made chiefly in the planning stage; for the experimentalist they are made on visual grounds, during the subsequent stages of working and stopping.

## Age and Artistic Innovation

When a situation requires a new way of looking at things, the acquisition of new techniques or even new vocabularies, the old seem stereotyped and rigid . . . But when a situation requires a store of past knowledge then the old find their advantage over the young.
  HARVEY LEHMAN, 1953[64]

Innovations in art usually come from young men.
  ALAN BOWNESS, 1972[65]

Any complete explanation of the age function for creative productivity must provide for the fact that the age curve alters systematically from one discipline to another. In the current model, this accommodation is accomplished by recognizing that the information-processing requirements for one field may be quite different from those for another field.
  DEAN KEITH SIMONTON, 1988[66]

Recognizing the difference between experimental and conceptual innovations provides the basis for a more systematic understanding of the relationship between age and artistic innovation. The long periods of trial and error often required for important experimental innovations mean that they frequently occur late in an artist's career. Conceptual innovations, which result from a new idea, are made more quickly, and can occur at any age. Radical conceptual innovations are in fact most often made by young artists, who have not yet become accustomed to existing conventions and traditional methods and are

consequently more likely to be able to formulate and appreciate more extreme deviations from these accepted techniques.[67]

Conceptual innovators are also more likely than experimental innovators to produce more than one significant innovation in a career. The elusiveness of the goals of experimental innovators makes them more prone to devoting an entire career to a single problem. But because the purpose of conceptual innovations can be formulated precisely, the artist—and his audience—can often be satisfied that a conceptual innovation has achieved its goal, leaving the artist free to move on to other problems.

It is valuable to recognize that the relationships just outlined have a parallel in the research of psychologists on when practitioners of a variety of academic disciplines and arts have produced their major contributions. Psychologists have found that chemists, mathematicians, theoretical physicists, and poets typically do their best work at younger ages than do astronomers, biologists, geologists, and novelists.[68] One proposed explanation for these differences argues that they are a function of the rates at which creative ideations can be produced and elaborated: it may be possible both to conceive new ideas and to develop them into finished products more rapidly in disciplines that deal with more abstract conceptual entities than in those in which the central ideas are more complex and concrete.[69] In more heavily empirical disciplines it may take longer both to assimilate the existing knowledge necessary to generate a new hypothesis, and to produce the evidence needed to demonstrate the value of the new hypothesis.

The inductive methods followed by experimental innovators in painting makes their enterprise resemble that of the more concrete and empirical disciplines considered by the psychologists, while the deductive approach of the conceptual innovators makes theirs resemble that of the more abstract and theoretical disciplines. Cézanne did not even formulate the central problem of his career, of making Impressionism a more timeless and solid art, until he was in his mid-thirties. He then worked at developing his solution to that problem for more than three decades, and arrived at his most important contribution at the end of his life. In contrast, Picasso conceived his most important idea while in his mid-twenties, when he painted the *Demoiselles,* and he developed that idea into the several forms of Cubism, his single most important contribution, before he reached the age of thirty-five. In 1914 Picasso had completed the work that would revolutionize Western art. He was then thirty-three, the same age at which Cézanne had traveled to Pontoise to learn from

Pissarro the techniques of Impressionism, which would cause him to begin the research that would culminate in his greatest achievement more than thirty years later. In these cases, the slower production and elaboration of new creative ideas that were associated with Cézanne's experimental approach led to a very late peak in the quality of his work, whereas the rapid production and elaboration of new ideas that were associated with Picasso's conceptual method led to a very early peak in the quality of his work.

Psychologists' research on scientific innovation has produced an interesting result that leads to a qualification of a statement made earlier, that extreme conceptual innovations are typically made by the young. Chronological age and career experience tend to be highly correlated, but individuals who begin a scientific career late generally have the stages of their careers delayed accordingly.[70] Thus what matters for conceptual innovation is apparently less chronological age than experience, the duration of an individual's career: as the individual's exposure to a discipline accumulates, existing thought patterns become reinforced, and it becomes more difficult to perceive alternative conceptual approaches. A more accurate generalization may consequently be that radical conceptual innovations are likely to be made early in an artist's career.

One further qualification of the above analysis concerns experimental innovators. Although important experimental innovations typically require long periods of development, this need not always be true. Apprenticeship or collaboration with an older, experienced practitioner may sometimes effectively afford a young worker access to the benefits of a large body of knowledge relatively quickly, and allow him to formulate a new experiment earlier than would otherwise have been the case. In such cases important experimental innovations can sometimes be made by the young. Yet this possibility does not destroy the validity of the distinction drawn here between the two types of artistic innovation, because careful observation can still reveal whether a young artist's innovation is conceptual or experimental. In conceptual innovations, the new idea itself is the innovation, and the breakthrough is therefore coincident with the adoption of the new approach. In contrast, few experiments produce innovations immediately. The time needed to carry out an experiment may be extensive, as may be the time needed to assimilate its results. The changes in methods and procedures that constitute the experimental artist's attempt to produce a new visual effect will consequently occur sometime before the innovation is fully achieved in his finished work.

## Masters and Masterpieces

These are stark problems, white numbers on a blackboard. This is the first ap-
pearance of the painting-equation.
ANDRÉ SALMON ON *Les Demoiselles d'Avignon,* 1912[71]

The value of the distinction suggested here between the two types of artistic
innovation can be illustrated through the use of a body of data described ear-
lier. Tables 5.1 and 5.2 are constructed from the listing, described in Chapter 3,
of the textbook illustrations of the works of the French artists from the period
under consideration. Table 5.1 lists the fifteen artists with the most total illus-
trations in the thirty-three texts analyzed; Table 5.2 ranks the top ten (actually
eleven, because of a tie) individual paintings by the same measure.[72] Neither
list appears surprising in itself. The artists in Table 5.1 are the greatest masters
of modern French painting: Picasso, Matisse, and Braque were clearly the ma-
jor figures of the twentieth century, as were Cézanne, Manet, and Monet those
of the nineteenth. And the paintings in Table 5.2 are all classic works, their im-
ages immediately familiar to students of modern art.

Yet obvious puzzles appear when the two tables are compared. Two of the
five artists ranked highest in total illustrations—Cézanne and Monet—have
no works among the eleven highest-ranked paintings. And some of the high-
est-ranking paintings in Table 5.2—including *Sunday Afternoon on the Island
of the Grande Jatte,* the single most frequently illustrated painting executed
in the nineteenth century—are by artists who fail to appear near the top of
Table 5.1.

First, why did some of the most important artists not produce the most
important individual works? Both Cézanne and Monet were experimental in-
novators, who produced bodies of work that presented their innovations
incrementally, rather than in individual breakthrough works. As noted above,
experimental innovators typically repeat the same motif. Cézanne's late views
of Mont Sainte-Victoire are among the most celebrated images in modern art,
famed for their demonstration of his attempt to create depth without the use
of Renaissance perspective and without sacrificing the colors of the Impres-
sionists. Had he produced just one of these, it would likely rival the *Demoi-
selles d'Avignon* in importance. But instead he made dozens; thirteen different
views of the mountain done in just his last two decades are illustrated in the
books surveyed here, and in total they appear thirty times.[73] Cézanne's single
most illustrated painting, reproduced in fourteen of the thirty-three books, is

Table 5.1    Ranking of fifteen leading French artists, by total illustrations

| Rank | Artist | Total illustrations |
|------|--------|---------------------|
| 1 | Picasso | 335 |
| 2 | Matisse | 169 |
| 3 | Cézanne | 136 |
| 4 | Manet | 130 |
| 5 | Monet | 125 |
| 6(t) | Braque | 116 |
| 6(t) | van Gogh | 116 |
| 8 | Gauguin | 97 |
| 9 | Degas | 81 |
| 10 | Renoir | 74 |
| 11 | Duchamp | 72 |
| 12 | Courbet | 68 |
| 13 | Miró | 64 |
| 14 | Seurat | 60 |
| 15 | Léger | 51 |

*Note:* Total illustrations is the total number of reproductions of each artist's paintings contained in the thirty-three textbooks surveyed. See Appendix A, note 1, for a list of these books. This table is restricted to painters listed in Table 1.1 who were born during 1819–1900. (t) signifies a tie for the specified rank.

*Les Grandes Baigneuses* now in Philadelphia, completed in 1906. If it were his only treatment of the subject, it would surely rank among the paintings listed in Table 5.2. But it is in fact one of more than seventy-five studies Cézanne executed of bathers; five different versions are reproduced in the textbooks surveyed, in a total of twenty-four illustrations.[74]

Monet's experimental use of the serial approach is even more celebrated than that of Cézanne, as he made repeated studies of a number of motifs— including grainstacks, poplars, Rouen Cathedral, the cliffs of Normandy, the Seine, and the Thames—in his effort to capture variation in the instantaneous effects of light and atmosphere. His concern with showing the effects of even the slightest change in conditions led him to work on groups of canvases instead of executing them sequentially. In 1886 Guy de Maupassant wrote of

*Table 5.2*    Ranking of leading French paintings, by total illustrations

| Rank | Number of illustrations | Artist and painting | Age when completed | Date | Current location |
|------|-----|-----|-----|-----|-----|
| 1 | 30 | Picasso, *Les Demoiselles d'Avignon* | 26 | 1907 | New York |
| 2 | 25 | Picasso, *Guernica* | 56 | 1937 | Madrid |
| 3 | 24 | Seurat, *Sunday Afternoon on the Island of the Grande Jatte* | 27 | 1886 | Chicago |
| 4(t) | 21 | Duchamp, *Nude Descending a Staircase, No. 2* | 25 | 1912 | Philadelphia |
| 4(t) | 21 | Manet, *Le Déjeuner sur l'herbe* | 31 | 1863 | Paris |
| 6 | 20 | Manet, *Bar at the Folies-Bergère* | 50 | 1882 | London |
| 7 | 16 | Duchamp, *The Bride Stripped Bare by Her Bachelors, Even* | 36 | 1923 | Philadelphia |
| 8(t) | 15 | Courbet, *L'Atelier* | 36 | 1855 | Paris |
| 8(t) | 15 | Gauguin, *The Vision after the Sermon* | 40 | 1888 | Edinburgh |
| 8(t) | 15 | Manet, *Olympia* | 31 | 1863 | Paris |
| 8(t) | 15 | Matisse, *The Joy of Life* | 36 | 1906 | Merion, Pa. |

*Note:* The paintings are ranked by the total number of different books in which each is illustrated. See Appendix A, note 1, for a list of the thirty-three books surveyed. (t) signifies a tie for the specified rank.

seeing Monet work at the seashore: "Off he went, followed by children carrying his canvases, five or six canvases representing the same subject at different times of day and with different light effects. He picked them up and put them down, according to the changing weather."[75] In London in 1900, painting views of the Thames from his room in the Savoy Hotel, Monet wrote to his wife, "I've never seen such changeable conditions and I had over 15 canvases under way, going from one to the other and back again."[76] Although collectively important, no single work emerges from these famous series as having greater significance than the others. Fourteen different paintings of Rouen Cathedral, for example, all done during 1893–94, are illustrated in the textbooks surveyed, but no one of them appears in more than three of the books. The scores of paintings of water lilies Monet did at his home in Giverny between 1899 and his death in 1926 constitute perhaps the most monumental single

example of serial painting in the history of modern art. Their collective importance is clear: seventeen different paintings of the water lilies appear in the texts surveyed, illustrated a total of twenty-two times. Yet the water-lily paintings are almost invariably discussed as a group, and no single canvas has emerged as a canonical image.

The cases of Cézanne and Monet thus demonstrate that important experimental innovators produce important bodies of work rather than important individual works. These examples could be multiplied, for this is true not only for Cézanne and Monet but also for other great experimental painters, including Degas, Miró, and Pissarro: naming each brings to mind famous motifs, but not famous individual paintings. This is a direct result of their incremental approach to innovation, for their greatest contributions did not appear suddenly in a single work, or even typically in a single short span of time, but instead were usually arrived at gradually, and were consequently embodied in large numbers of works, each only marginally different from the others produced in the same period.

Turning to the second question raised above, why were some of the most important individual paintings produced by painters who do not rank among the most important artists? For example, neither Seurat nor Duchamp ranks even among the leading ten French painters in Table 5.1, based on artists' total illustrations. Yet Seurat's painting of the *Grande Jatte* ranks above any other painting executed in the nineteenth century in Table 5.2, and two of Duchamp's works rank among the highest seven paintings in that table, both above any single painting by masters such as Cézanne, Degas, Monet, or Renoir.

The explanation for this apparent anomaly again appears to lie in these innovators' methods. Both Seurat and Duchamp were conceptual innovators. Their innovations were discretely embodied in individual breakthrough works, which were consequently of much greater importance than any later works that repeated the same innovations. At the age of just twenty-five Seurat set out to produce a masterpiece—a painting more than sixty square feet in size—as a definitive illustration of the systematic use of scientific color theory in painting. Seurat's painting of the *Grande Jatte* proved extremely influential; while some contemporaries praised it for what they considered its scientific improvements on Impressionism, others were inspired by what they perceived as a major Symbolist statement in its deformation of objective nature.[77] Later, also extremely influential would be the twenty-five-year-old Duchamp's

painting of the *Nude Descending a Staircase*, which produced a static image of movement and introduced the idea of reducing humans to mechanical forms, and the thirty-six-year-old Duchamp's *The Bride Stripped Bare by Her Bachelors, Even*, which used mechanical elements to represent biological functions.[78] The clear embodiment of the two artists' ideas in these striking individual paintings has made these works stand out prominently among bodies of work that, for both Seurat and Duchamp, were very limited in total volume—in Seurat's case because of his premature death, and in Duchamp's because of his early retirement from painting.

The evidence of Table 5.2 also bears in several other ways on the analysis presented earlier in this chapter. Three painters appear more than once—Picasso and Duchamp twice each, and Manet three times. The ages at which their listed works were executed range up to thirty-six for Duchamp, fifty for Manet, and fifty-six for Picasso. Yet all three artists had made major innovations earlier: Picasso's highest-ranked painting in Table 5.2 was done at age twenty-six, Duchamp's at twenty-five, and Manet's at thirty-one. And the paintings in Table 5.2 that these artists produced at these early ages are unquestionably among a handful of the most important individual conceptual works in the history of modern art: each abruptly announced a major artistic breakthrough, each aroused great controversy, and each had a profound influence on many of the advanced artists of their own and later generations. All three artists therefore fit the model of important conceptual innovators who made a major innovation early in their careers, then moved on to make other innovations later by working on different problems.

The only other painting in Table 5.2 executed by a painter beyond his thirties is Gauguin's *Vision after the Sermon*, the work that established Gauguin as the leader of the Symbolist painters centered in Pont-Aven during the 1880s. Gauguin's intent in the painting was avowedly conceptual: he wrote to Vincent van Gogh of his belief that "in my figures I have achieved a great simplicity, which is both rustic and superstitious . . . [I]n this picture the landscape and the struggle [between Jacob and the angel] exist only in the imagination of the people whom the sermon has moved to prayer. That's why there is a contrast between the people, depicted naturally, and the struggle in its unnatural and disproportioned landscape."[79] But despite the fact that Gauguin made this conceptual innovation at the relatively late age of forty, it came just five years after he resigned his job in the stock exchange to become a full-time artist. Interestingly, also, Gauguin produced *Vision after the Sermon* just two

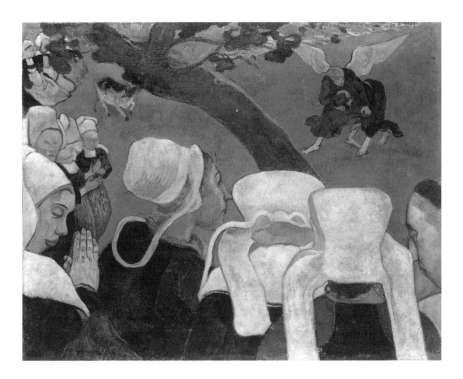

5. Paul Gauguin, *The Vision after the Sermon*, 1888. In a pioneering Symbolist work,
Gauguin produces a visual representation of faith: the pattern formed by the horns and
legs of a cow causes a group of Breton women to imagine they are seeing an enactment of
the sermon their priest has just delivered, on the struggle between Jacob and the angel.
National Gallery of Scotland, Edinburgh.

years after the eighth and final Impressionist group exhibition. Gauguin had
displayed nineteen paintings in that show, but they attracted little interest.[80]
Among the most controversial works in that show was Seurat's *Grande Jatte*,
and Gauguin may have been impressed with that painting's impact on the
Paris art community. A biographer has suggested that the lesson Gauguin
took from Seurat's painting was that he would have to produce a powerful and
bold work in order to have a comparable impact, and that *The Vision after the
Sermon* was the consequence of that lesson.[81] *The Vision* was Gauguin's first
completely Symbolist painting, and it can be seen as joining the *Grande Jatte*
in marking decisively the departure of a new generation of artists from the
naturalism of earlier nineteenth-century French painting.[82] In this case an im-
portant conceptual innovation occurred early in an artist's career, and per-

haps in response to a specific challenge, but at a relatively old age because of the artist's delayed entry into his career.

The explanatory apparatus to be used in this study is now complete. Using the understanding gained to this point of what has made modern artists important, and why artists with different approaches have made important contributions at very different ages, what remains to be done is to examine the chronology of each of the two periods considered here. The purpose is to explain the causes of the shifts identified earlier, in which in each case a generation or more of painters who innovated late in their careers was followed by a generation of those who innovated early.

# 6

## Paris from Manet to Miró

I think I shall much regret no longer having one foot in Paris. This was very useful for me, since it enabled me to keep up with everything that concerns painting.

CAMILLE PISSARRO, 1883[1]

There is but one Paris . . . What is to be gained is *progress* and what the deuce that is, it is to be found here.

VINCENT VAN GOGH, 1887[2]

If the Impressionists reduced things to the artist's sensations, their successors reduced them further to projections or constructions of his feelings and moods, or to "essences" grasped in a tense intuition.

MEYER SCHAPIRO, 1937[3]

Paris was the unrivaled center of art in the 150 years before 1950. If you weren't in Paris or in touch with Paris you were condemned to be a more or less provincial or minor artist.

CLEMENT GREENBERG, 1969[4]

I HAVE OFFERED an explanation for why some modern artists have innovated late in their careers, and others early in theirs, and have begun to show how this explanation can account for a number of differences in the practices and goals of modern painters. What remains to be done is to examine the major artists, and the major schools of painting, that fall within the limits of time and place defined at the outset. This chapter will consider, in chronological order, the individuals and groups who dominated modern art in France from Manet and the Impressionists through the Cubists and Surrealists; the next chapter will do the same for New York from Marin and other major painters of the early twentieth century through the Abstract Expressionists to the Minimalists and beyond. In both of these surveys, the objective will be twofold: to understand how the major figures in these periods fit into the two categories proposed by this study, and to understand how the evolution of modern art is illuminated by this categorization. Ultimately the goal is to gain a deeper and more unified understanding of the nature of the contributions of key individ-

ual artists and of the changes in the goals and methods of modern painting that have occurred since its inception.

The growing emphasis on innovation as the prime determinant of the importance of new art in Paris after the middle of the nineteenth century gave rise to a changing conception of painting that allowed artists to make significant contributions at younger ages. Throughout the first half of the century the dominant method of training artists, in which students attended the official Ecole des Beaux-Arts where they were effectively apprenticed to masters who were members of the Academy of Fine Arts, reflected a conception of painting as essentially a skilled craft. In the words of Bourdieu, academic painting of this era was "above all an art of execution which, in so far as it implements an already established model of accomplishment based on the analysis of past masterpieces, can and must show its virtuosity only in terms of its technique and the historical culture that it can deploy." Academic training was not intended to inspire innovation: "Trained in the school of copying, instructed in the respect of present and past masters, convinced that art arises from obedience to canons, and especially to the rules which define legitimate topics of painting and legitimate ways of treating them, the academic painters . . . direct their research more towards literary content than towards purely pictorial invention."[5] The training process, which consisted of repetitious copying and execution of assigned canonical subjects, was based on the assumption that excellence in painting resulted from practice and imitation. The hierarchical organization of the Academy, which significantly affected the supply of new painters and paintings to the French market for fine art, equally demonstrated a belief in the value of experience to painters: members of the Academy were elected for life, with an average age of entry above fifty, and an average term of service of more than twenty years.[6]

Although few painters in the period under consideration here were born before 1830, the evidence for those is consistent with the Academy's implicit assumption that an artist's mature work was his best: the six artists in Table 2.1 born before 1830 all did their most valuable work after the age of forty. Eugène Delacroix, the greatest among them, produced his most valuable work in his late fifties. Delacroix was the leading French Romantic painter. His inspiration came from literature, and the subjects of his major paintings are taken from Dante, Shakespeare, Byron, and other poets. Delacroix revered the Old Masters of the seventeenth century, and studied their work throughout his life. In his journal, he noted approvingly that "Rubens, when past fifty

years of age, used the time he did not give to the business of his mission to the King of Spain in copying the superb Italian originals he found in Madrid." Delacroix's belief in the need for traditional skills in painting was firm: "Accuracy of the eye, sureness of hand, the art of carrying the picture on from the indications of the lay-in to the rounding out of the work, and so many other matters which are all of primary importance, demand application at every moment, and the practice of a lifetime."[7]

Edouard Manet was a conceptual innovator, perhaps the most important of the nineteenth century. Remarkably, Table 5.2 shows that three of his paintings rank among the six most illustrated modern French paintings of the century. Yet Table 2.1 shows that his most valuable work was done at fifty, at the end of his life. This is an anomaly in terms of the usual association described in Chapter 5, between the conceptual approach and innovation early in a career. It appears to be a result of the fact that Manet's genuinely revolutionary approach to painting was tempered by a deep commitment to both the traditions and the institutions of French painting.

Manet made major innovations at two different stages in his career. These innovations can be characterized by the major works that have come to represent them. For the earlier stage, the greatest of these were *Déjeuner sur l'herbe*, shown at the Salon des Refusés in 1863, and *Olympia*, also painted in 1863 and exhibited at the Salon of 1865. Painted when Manet was thirty-one, these paintings provoked public outrage for both their methods and their subjects. In each, Manet abandoned the traditional use of the graduated tones that produced shadow to create the illusion of three-dimensionality; many contemporaries condemned him for incompetent draftsmanship that in their view resulted in flat images and made his figures unconvincing representations of real people. He furthermore posed contemporary figures in classical settings; the nude female figures in both pictures shocked the public because they were not romanticized or mythical beings, but modern women who looked directly and immodestly at their viewers. These are often considered the first modern paintings, both for their recognition of the flatness of the medium and for their explicitly modern subject matter.[8]

Manet's painting continued to change over time. His work inspired the Impressionists in the 1860s, and in the 1870s he became generally recognized as the leader of the new painting they were creating. But during the latter decade Manet was in turn influenced by the Impressionists, as he developed a looser style, began to use a brighter palette, and increasingly drew his subjects

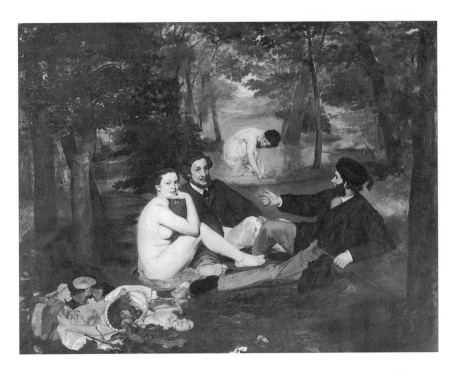

6. Edouard Manet, *Le Déjeuner sur l'herbe*, 1863. Manet's *Déjeuner* created a scandal at the 1863 Salon des Refusés and inspired young artists to experiment with new techniques and modern subjects. Musée d'Orsay, Paris.

from scenes of modern life.[9] In the *Bar at the Folies-Bergère,* shown at the Salon of 1882 the year before his death, Manet produced a final masterpiece which, like his earlier landmarks of 1863, has remained a subject of debate for both its motif and its techniques. In a radical technical innovation, Manet intentionally distorted the painting's representation of space in a way that has been identified as an inspiration to later artists to use space arbitrarily, thus initiating a process that eventually led to abstraction in painting.[10] The historian Jack Flam observed that in this work "Manet went out of his way to insist upon an ambiguous and contradictory reading of the image in the mirror. The *Bar* offers the most striking instance in Manet's art of the primacy of mental vision over actual sight."[11]

Manet's conceptual approach is reflected not only in the sudden and dramatic introduction of the innovations embodied in these famous paintings, but also in his selection of subjects; unlike his friends Cézanne and Monet,

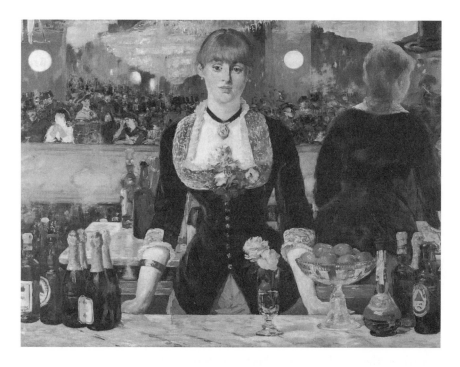

7. Edouard Manet, *Bar at the Folies-Bergère,* 1882. Set in a popular *café-concert*—a café with entertainment—Manet's last masterpiece presents a visual contradiction between the placement of the bar maid and the mirrored reflection of her encounter with a patron. Courtauld Institute, London.

whose experimental approach led them to return repeatedly to study the same subjects, Manet's conceptual approach led to variety. A friend, the critic Théodore Duret, wrote that Manet "had no circumscribed circle. He painted indifferently all that the eye can see—men and women under every aspect and all sorts of groupings, landscape, seascape, still life, flowers, animals, in the open air, and in the studio. His method was to have a constant change of subject, and never to stale a success by repetition."[12] Manet made preparatory studies for many of his paintings, including the *Déjeuner* and *Olympia.* Duret noted that "his favorite method was to use watercolor for the preliminary studies for his pictures, in order to establish the proper color scheme and composition."[13]

Although he produced radical innovations, and was widely recognized as the inspirational leader of the younger painters who began to gain attention

during the 1870s, Manet retained a traditional conception of the craft of painting and its institutions. Thus Duret declared that "no painter ever strove harder to acquire a mastery of his craft than Manet."[14] Manet declined to participate in the renegade group exhibitions organized by the Impressionists, and instead continued to submit his work to the official Salon. Despite numerous snubs of his work by the jury, including the Salon's famous rejection of the *Déjeuner sur l'herbe* in 1863, he held firmly to the position that "the Salon is the true field of battle—it is there that one must measure oneself."[15] He was finally awarded a prize at the Salon of 1881, when a bare majority of the thirty-three jurors voted him one of ten second-class medals given that year. Although many of his friends scorned the award as tardy and inadequate, Manet insisted on visiting each of the seventeen jurors who had supported him, to express his appreciation.[16] After Manet's death in 1883, Pissarro remarked sadly that "Manet, great painter that he was, had a petty side, he was crazy to be recognized by the constituted authorities, he believed in success, he longed for honors . . . He died without achieving his desire."[17]

The significance of Manet's work remains an active source of controversy today, as it was during his lifetime. The many ambiguities of his contributions may reflect the conflict between his revolutionary conceptual innovations and his traditional conception of painting. Major disagreements persist over the relative importance of the stages of his career: Michael Fried considers the years 1862–1865 his "anni mirabiles," during which he produced "a remarkable series of highly original works that quickly established [his] reputation as the leader of a new generation"; George Heard Hamilton argues that during the 1860s "Manet was working generally within the limits of mid-century realism," and that it was during the late period of 1871–1882 that "he made his enduring contribution to modern art, modern both in relation to the progressive painting of his day and in the sense of providing a body of work to which future painters would look for solutions to their own problems in discovering a truly modern expression."[18] The auction market valuation of his work agrees with the latter view, preferring the late works influenced by the discoveries of the Impressionists to the more realist works of his earlier years. It is clear that Manet's career was exceptional, not only for its enormous influence on the course of modern art but for the extraordinary importance of both of the periods of his major innovations.

Impressionism was the greatest artistic innovation of the nineteenth century. In addition to the profound changes it produced in the way modern art-

ists painted, it changed the way they presented their work to the public. The enterprise originated in 1864 when Charles Gleyre, a master at the Ecole des Beaux-Arts, closed his studio in Paris, leaving several dozen students without a teacher. Instead of enrolling in another studio, twenty-four-year-old Claude Monet persuaded several of his friends—Frédéric Bazille, Pierre-Auguste Renoir, and Alfred Sisley—to join him painting landscapes in the country. The Impressionists' first innovation was consequently their working relationship: according to Théodore Duret, who wrote one of the earliest histories of Impressionism, the small core group "shared the same ideas, and, keeping in close touch with one another, all contributed to the perfecting of their system, and to the discovery of the laws which were to be applied."[19] Working together was not a new custom for artists, but the Impressionists did not follow the Academy's apprenticeship system of master and pupils, or band together primarily for social purposes, like the earlier landscape painters of the Barbizon School.[20] As the American painter Barnett Newman would later observe, "Modern painting begins with the Impressionists precisely because for the first time in history a group of artists arose who, repudiating the role of the great personal message with its attendant doctrine of the immaculate conception, decided to devote themselves exclusively to solving a technical problem in painting."[21] With Monet as the informal leader, for a number of years the original members of the group often worked together, regularly joined by an older friend, Camille Pissarro, often by the two mentors Monet had met in his hometown of Le Havre, Eugène Boudin and Johann Jongkind, and occasionally by Gustave Courbet and James McNeill Whistler. Monet repeatedly stressed the value of the group as a source of learning. In 1864 he wrote to urge Bazille, for example, to rejoin the group: "All alone, there are some things that one cannot fathom." Later the same year Monet again scolded Bazille for his absence: "There are a lot of us at the moment in Honfleur . . . Boudin and Jongkind are here; we are getting on marvelously. I regret very much that you aren't here, because in such company there's a lot to be learned."[22] Working together much like participants in a modern scholarly research project, the Impressionists served as the model for the many later groups of artists that would become the principal source of innovation in modern painting.

One of the most celebrated practices of what became the core group of the Impressionists—Monet, Pissarro, Renoir, and Sisley—was their commitment to open-air painting. Painting outdoors was not original to the group: earlier in the nineteenth century the English painter John Constable and the

French painters Camille Corot and Gustave Courbet had done it occasionally, it was a common practice of the French Barbizon painters, and Monet himself was led to paint outdoors by Boudin and Jongkind. Yet these earlier painters typically made only small paintings or preliminary studies outdoors, then returned to their studios to produce larger, finished works. Monet's innovation was to make open-air painting his primary practice rather than just a stage in it or an occasional exercise. Later in his life he stressed this priority, recalling that in 1867, "I threw myself body and soul into the *plein air*. It was a dangerous innovation. Up to that time no one had indulged in it, not even Manet, who only attempted it later, after me. His paintings were still very classical, and I still recall the contempt he showed for my beginnings."[23] Monet's claim to have executed his paintings exclusively outdoors has been shown to be an exaggeration.[24] But the real significance of his rejection of studio work lay in the fact that the Impressionists' commitment to open-air painting was indicative of a new goal, of capturing the momentary effects of the atmosphere. In the words of Duret,

> The Impressionists came to obtain novel and unexpected effects. Stubbornly working in the open in all sorts of weather, they were able to seize and record those fugitive impressions of nature which painters working in their studios missed altogether. They observed the different aspects which the same countryside wears at different hours of the day, in rain and in mist, in bright sunshine and in dull grey weather; to others these differences were unimportant, but to them essential. They studied the changes in the appearance of the foliage according to the different seasons. The subtle hues which water derives from the reflection of the banks, from the angle at which the sun's rays fall upon it, from the mud which the stream carries along, were gradated on their canvases with an infinity of different tones.[25]

Despite the radical nature of their departure into painting outdoors, and their conscious intention to change the subject matter and techniques of modern painting, like others of their generation the Impressionists retained a traditional conception of art. They distrusted rapid change, and believed that valuable achievements could be made only slowly and incrementally, as a result of extended study and experimentation. Monet is of course celebrated for his commitment to working in front of his subject: as early as 1864, he told Bazille that progress would come only with "observation and reflection."[26] But throughout his career, his letters consistently reveal dissatisfaction with his inability to achieve his goals. In 1868 he wrote to Bazille, "The further I get, the

more I regret how little I know," and in 1884, warning his dealer Durand-Ruel of a delay in shipping his latest works, he explained, "I'm never satisfied when working from nature."[27] He always struggled with the decision to let a painting go. In 1884 he told a friend, "I'm never finished with my paintings; the further I get, the more I seek the impossible and the more powerless I feel."[28] In 1890 the fifty-year-old Monet complained to a friend, the critic Gustave Geffroy, that he was "profoundly disgusted with painting," which he found "a continual torture." Although Monet's goal differed from that of Cézanne, his attitude toward his work recalled that of his friend in its emphasis on both the difficulty of achieving the desired visual effects and the necessity of approaching his goal deliberately:

> I'm getting so slow at my work it makes me despair, but the further I get, the more I see that a lot of work has to be done in order to render what I'm looking for: "instantaneity," the "envelope" above all, the same light spread over everything, and more than ever I'm disgusted by things that come in one go . . . I'm increasingly obsessed by the need to render what I experience, and I'm praying that I'll have a few good years left to me because I think I may make some progress in that direction.[29]

In 1893, while in Rouen working on the series of views of the cathedral, he wrote to his wife, in despair, "What's the good of working when I don't get to the end of anything?" But he immediately reminded himself that "the essential thing is to avoid the urge to do it all too quickly, try, try again, and get it right."[30] As with Cézanne, Monet's frustration with and hope for his ambitious goals persisted late into his career. In 1912, at age seventy-two, he wrote to Durand-Ruel of his disappointment at his inability to eliminate the mistakes from his work, and reflected that "I still hold out some hope of doing better, but age and unhappiness have sapped my strength."[31]

Renoir left fewer descriptions of his methods and attitudes, but occasional comments give glimpses of his experimental approach. In 1881, while visiting Italy, he wrote to his dealer Durand-Ruel, "I still have the experiment disease. I'm not pleased, and I rub out, I rub out again. I hope this mania will end." Nonetheless, he reported, "I think I will have made some progress, which always happens after long experiments." While on the same trip he wrote to a friend that "up until now I've spent my time searching. I don't dare tell you that I've found anything, since for about 20 years I've kept believing that I've found art."[32] Renoir's doubts about his work were sufficiently strong that in

1886, at the age of 45, he destroyed all the paintings he had done during a stay of several months in Brittany.[33] Late in his life Renoir became a close friend of Ambroise Vollard, and painted the dealer's portrait three times. Vollard later recalled that Renoir worked directly on these occasions: "Renoir always attacked his canvas without the slightest apparent plan. Patches would appear first, then more patches, then, suddenly, a few strokes of the brush, and the subject 'came out.' "[34]

Pissarro's letters to his eldest son, which began when Lucien left home in 1883 and continued until the artist's death twenty years later, provide a detailed account of Pissarro's attitudes toward his work. Although he was proud of his part in the core Impressionist innovations of the late 1860s and the 1870s, and remained deeply committed to his art, Pissarro nonetheless suffered from persistent doubt over the quality of his work. In 1883, already past the age of fifty, in assessing a show of his work at Durand-Ruel's gallery he confessed, "I am much disturbed by my unpolished and rough execution; I should like to develop a smoother technique." Yet he vowed to persevere in spite of his uncertainty: "I will calmly tread the path I have taken, and try to do my best. At bottom, I have only a vague sense of its rightness or wrongness."[35] After spending several months in Rouen later the same year, his fears were even greater: "I have just concluded my series of paintings. I look at them constantly. I who made them often find them horrible. I understand them only at rare moments . . . Sometimes I am horribly afraid to turn round canvases which I have piled against the wall; I am constantly afraid of finding monsters where I believed there were precious gems!"[36]

Pissarro's letters reveal not only the doubt of an experimental painter but also the firm conviction that art must be based on vision and hard work. As Lucien became an aspiring artist, his father advised him of the value of practice: "It is only by drawing often, drawing everything, drawing incessantly, that one fine day you discover to your surprise that you have rendered something in its true character."[37] Progress would come only with effort: "So much the better if it is painful for you to take even the first step, the more toilsome the work the stronger you will emerge from it . . . I repeat, guard against facility."[38] A decade later, in 1894, he warned his son against fashion, and repeated his belief in looking and working: "Long hair, dandyism, noise, count for nothing; work, observation and sensation are the only real forces."[39] Pissarro equally stressed the empirical basis of his approach in his advice to another young painter in 1896: "Don't be afraid of putting on color, refine the work little by

little. Don't proceed according to rules and principles, but paint what you observe and feel . . . One must have only one master—nature; she is the one always to be consulted."[40]

Monet and his closest colleagues thus followed an experimental approach, and although the members of the core group of Impressionists achieved their major artistic breakthroughs relatively early in their careers, these nonetheless came several years after their initial decision to follow the novel practice of working entirely outdoors. Monet recognized this. In looking back on that decision, he recalled, "It was in 1867; my manner had shaped itself but, after all, it was not revolutionary in character. I was still far from having adopted the principle of the subdivision of colors that set so many against me, but I was beginning to try my hand at it partially, and I was experimenting with effects of light and color that shocked accepted customs."[41] The Impressionists' major breakthrough did not consist of the idea of open-air painting, but was rather a visual achievement in the execution of their painting that followed after several additional years of experimentation. During the summer of 1869, Monet and Renoir painted together at a riverside café near Paris. The historian Kenneth Clark called that café, La Grenouillère, the birthplace of Impressionism: the two artists' novel treatment of "the sparkle and reflection of light on water" produced a new technique so powerful "that it not only captivated sympathetic spirits like Sisley and Pissarro, but imposed itself on painters to whom it was quite alien," as painters as disparate as Manet, Cézanne, Gauguin, and van Gogh were lured into experiments with Impressionist methods.[42]

The 1870s became the triumphant decade of Impressionism, as Monet, Pissarro, Renoir, and Sisley produced innovations in both the composition and the execution of paintings. Perhaps their most famous experiments were with color. Influenced by the work of Delacroix and Manet, the group rejected the use of shadow to create the illusion of solid shapes. Using predominantly bright colors, they created form by juxtaposing contrasting pure colors rather than graduated lighter and darker shades of a single color.[43] In addition to this radical innovation, the Impressionists changed the conventional composition of landscapes. Eliminating the traditional emphasis on a central subject, usually human figures, the Impressionists progressively divided the focus of attention and eliminated narrative content.[44] They also experimented with new brushstrokes. Manet had created a controversy with the use of touches of paint that remained visible in his finished works, instead of blending into smooth surfaces. The Impressionists went further, developing brush-

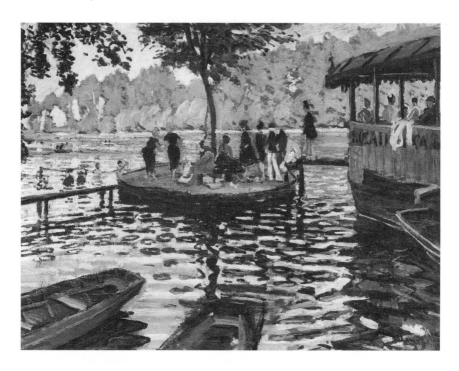

8. Claude Monet, *La Grenouillère,* 1869. Working together in the summer of 1869 at a café on the Seine, Monet and Renoir made key innovations that initiated Impressionism. These included the small, fragmented brushstrokes that juxtaposed pure colors, creating new representations of movement and the reflection of light. Metropolitan Museum, New York.

strokes in a variety of shapes that served to mimic natural textures within landscapes.[45]

The close collaboration of the core group made Impressionism a distinctive joint style: Mallarmé observed in 1876 that "the Impressionists themselves, those whom cosy studio chats and an amicable interchange of idea have enabled to push together towards new and unexpected horizons, and fresh-formed truths, such as MM Claude Monet, Sisley and Pizzaro [*sic*], paint wondrously alike."[46] The auction market identifies the timing of the early Impressionist breakthrough, as Table 2.1 shows that each of the four members of the core group produced what would become his most valuable work within a span of just eight years: Monet's work reached its peak value in 1869 (at age twenty-nine), Sisley's in 1874 (at thirty-five), Pissarro's in 1875 (at forty-five), and Renoir's in 1876 (at thirty-five).[47] The value of the work of two of the

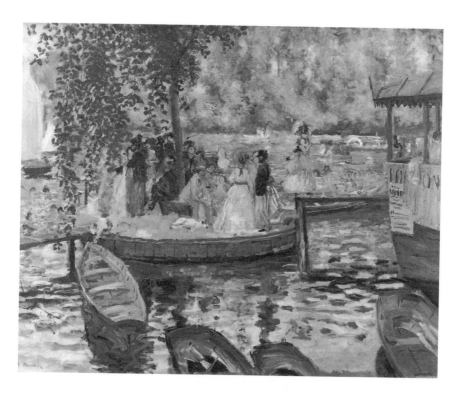

9. Pierre-Auguste Renoir, *La Grenouillère,* 1869. National Museum, Stockholm.

group's close followers also reached a peak in this same period—that of Berthe Morisot in 1874 (at thirty-three), and of Armand Guillaumin in 1876 (at thirty-five). Monet's leadership of the group, and his primary role in its artistic breakthrough, is neatly recognized by the fact that his peak in value occurred earliest, in 1869, the year Kenneth Clark identified as that of the seminal discovery. The auction market also clearly recognizes the enormous importance of the early Impressionist breakthrough, for although Monet would go on to paint for more than fifty years after 1869, producing important and beautiful landmarks such as the series paintings of the 1890s and the water lilies done at Giverny after 1900, the market identifies as his most valuable contribution that early work which had the greatest impact on the development of modern painting, and which resulted in Monet's being set apart in this study as the only artist born in the first half of the nineteenth century who produced his most valuable work before the age of thirty.

It is unusual for major experimental innovations to occur so early in a ca-

reer. But it is apparent that Monet's progress was greatly advanced by the lessons he learned from the older painters Boudin and Jongkind, who both devoted their careers to developing new methods for painting nature.[48] Monet himself acknowledged this. He later recalled that on first meeting Boudin in Le Havre in 1858, when Monet was still in his teens, he had ignored the older artist's advice to abandon drawing caricatures in favor of painting nature: "The exhortations of Boudin had no effect . . . [W]hen he offered to take me with him to sketch in the fields, I always found a pretext to decline politely." But even decades later Monet vividly remembered the revelation he received shortly thereafter: "Weary of resisting, I gave in at last, and Boudin, with untiring kindness, undertook my education. My eyes were finally opened and I really understood nature; I learned at the same time to love it."[49] Similarly, Monet recalled his first meeting with Boudin's friend Jongkind in 1862: "He asked to see my sketches, invited me to come and work with him, explained to me the why and the wherefore of his manner, and thereby completed the teachings that I had already received from Boudin. From that time on he was my real master, and it was to him that I owed the final education of my eye."[50] Thus Monet's early achievement of the innovation of Impressionism resulted in large part from his ability to incorporate the results of the earlier experiments of his informal teachers.

One of the last joint innovations of the Impressionists involved the public presentation of their work. In 1873 Monet revived a plan that he and Bazille had devised but had been unable to carry out in 1867, of holding a group exhibition at the artists' own expense. Frustrated by their frequent rejection by the jury of the Salon, and the poor treatment of their work when it was accepted, Monet, Renoir, Pissarro, and their friend Degas took the initiative in organizing an exhibition in 1874 that included the work of twenty-nine artists.[51] The show created a sensation, for it marked the first time that artists had joined together to present their work directly to the public without the authorization of the government or the approval of a jury. Critical reactions to the 1874 exhibition were predominantly negative, but it quickly established the Impressionists as leaders in the advanced art world. In total, eight group exhibitions were held between 1874 and 1886. Disagreements among the painters over matters both artistic and economic eventually caused defections, and the Impressionists' working relationship disintegrated during the late 1870s, so the shows' composition varied; Pissarro was the only artist who exhibited in all eight shows.[52] Yet although it took longer than they had hoped, the group

exhibitions did contribute significantly to the goal Monet and Bazille had originally conceived, of using the strength of the group to bring critical and financial success to the individual painters. The group shows also had the even more revolutionary result, far beyond the most ambitious plans of the two young artists in 1867, of hastening the demise of the Salon as the art world's most prestigious forum. In their career as the first group of modern artists to band together in the systematic pursuit of innovation, the Impressionists therefore changed not only the appearance of modern art but also the way it was presented to the public.[53]

Another important artist who consistently exhibited in the Impressionist group shows was Edgar Degas. Unlike Cézanne and Monet, Degas was not committed to open-air painting: he believed that "the study of nature is of no significance, for painting is a conventional art, and it is infinitely more worthwhile to learn to draw after Holbein."[54] Although he studied only briefly at the Ecole des Beaux-Arts, Degas did not share the other Impressionists' hostility toward academic technique and methods of instruction. Among living artists he most admired the dominant academic painter of the time, Jean-Auguste-Dominique Ingres, and he endorsed the Ecole's emphasis on imitation: to learn his craft a painter "must copy the masters and recopy them."[55] Degas agonized over his work. A friend, the poet Paul Valéry, emphasized Degas' doubt: "Severely self-critical, he would take a certain pleasure in repeating what a critic had said about him in a review of an exhibition: 'Continually uncertain about proportions.' Nothing, he claimed, could better describe his state of mind while he was toiling and struggling over a work."[56]

Degas' experimental approach was clearly expressed in his belief in repetition: "One must redo ten times, a hundred times the same subject."[57] This belief often led him to begin new drawings by tracing the outlines of earlier ones. The dealer Vollard noted that "because of the many tracings that Degas did of his drawings, the public accused him of repeating himself. But his passion for perfection was responsible for his continual research."[58] Valéry compared Degas to "a writer striving to attain the utmost precision of form, drafting and redrafting, canceling, advancing by endless recapitulation, never admitting that his work has reached its *final* stage: from sheet to sheet, copy to copy, he continually revises his drawing, deepening, tightening, closing it up."[59] Valéry observed: "I am convinced that [Degas] felt a work could never be called *finished*, and that he could not conceive how an artist could look at one of his pictures after a time and not feel the need to retouch it."[60]

An amusing account of Degas' reluctance to cease working on his paintings appears in a reminiscence by Ernest Rouart, the son of a close friend of Degas. Recalling that "Degas was very difficult to satisfy, and could rarely convince himself that a picture was finished," Rouart told of an incident involving a painting that his father had owned:

> Whenever [Degas] came upon some more or less early work of his own, he always wanted to get it back on the easel and rework it. Thus, after seeing again and again at our house a delightful pastel my father had bought and was very fond of, Degas was seized with his habitual and imperious urge to retouch it. He would not let the matter alone, and in the end my father, from sheer weariness, let him take it away. It was never seen again.
>
> Often my father would ask him about his beloved pastel; Degas would put him off in one way or another, but in the end he had to confess his crime: the work entrusted to him for a few retouches had been completely destroyed. Imagine my father's despair; he never forgave himself for being party to the destruction of something he was so fond of.
>
> It was then that Degas, to make up to him for his loss, sent him one day the famous *Danseuses à la barre*.
>
> The comic part of it was that for years and years afterward we would hear Degas, whenever he saw this picture, say to my father: "That watering can is definitely idiotic, I simply must take it out!"
>
> I believe he was right, and that the effect of the picture could only have been improved by the removal of that utensil. But having learned from experience, my father would never allow him another try.
>
> People have even said that the picture was secured to the wall with a padlock, so that Degas could not take it away—which is pure invention.[61]

Degas is famous for his studies of ballet dancers, in which he arrived at radical innovations in the use of pastel and other materials and the representation of space. But like the examples discussed earlier of Cézanne and Monet, Degas' dancers are a clear case of a large body of work in which the innovations appeared gradually. As a friend, the critic George Moore, observed, "He has done so many dancers and so often repeated himself that it is difficult to specify any particular one."[62] This is confirmed by art history textbooks: whereas twenty different individual paintings of dancers by Degas, executed over a period of more than thirty years, appear in the thirty-three textbooks surveyed by this study, and together these account for a total of twenty-nine illustrations, no one of them appears in more than four different books. Degas' experimental approach, attested to by his uncompromising belief in the value

of experience, is also reflected in market valuations, as his work rose sharply in value to a peak at age forty-six, and declined little from then until the end of his life nearly four decades later.

Cézanne, Monet, and their contemporaries had entered the world of art in Paris during the 1860s. As young artists they could see that world beginning to change, most dramatically in the paintings of Manet and the writings of Baudelaire, and they responded with a desire to innovate, to contribute to the process of change. Yet the art world they entered was still dominated by the standards of the Ecole des Beaux-Arts and the Salon, and although Monet and his friends consciously rejected some of those standards, they accepted others. So painters of their generation continued to believe that craftsmanship, acquired only with time and effort, was a critical element of quality in art, and consequently that valuable innovations could be made only slowly. The innovations of their generation were also driven by visual criteria: Monet's consistent belief in the need to observe nature and Cézanne's insistence on the need to study nature, clearly reveal their goals of using paint to capture visual sensations. The depth of their commitment to this goal is apparent in their insistence on painting outdoors in spite of the problems this caused them with the advance of age and illness.

The major artists of the next generation—including Paul Gauguin, Vincent van Gogh, Georges Seurat, and Henri de Toulouse-Lautrec—entered the Paris art world a decade or more later than the Impressionists, during the 1870s and 1880s. The impact of Manet and the Impressionists had already begun to change that world, and ambitious young artists could see that the Ecole and the Salon were no longer necessarily the best source of standards and practices. Some of the artists of this next generation believed that painting could be learned more quickly and informally, without the tedious exercises of the Ecole, through contact with the Impressionists. With the example of these innovators before them, the next generation could also see that success in the advanced art world was possible even early in a career. The critics' growing emphasis on innovation, discussed earlier, further served as a guide to how success could be achieved. The most important innovations of these younger artists would derive from a source very different from those of their immediate predecessors, for their approach would be neither visual nor experimental. Instead, these younger painters made breakthroughs that were conceptual in origin and motivation, as increasingly color and form were used to express ideas and emotions, to symbolize nature rather than to describe it. One conse-

quence of this was that innovations could be made more wittingly and more rapidly, as the uncertain and painstaking experimental approach that Monet and Cézanne followed in their search for visual goals was not deemed necessary for the expression of the painter's own ideas or emotions.

The Paris art world of the 1880s became a battleground, as warring factions of painters, and the critics who served as their spokesmen, contended for supremacy in the increasingly ideological atmosphere of the cafés and galleries. The prize was to succeed the Impressionists as the leading movement of advanced art. One of the contending groups was given the name of Neo-Impressionism by Félix Fénéon, the critic most closely identified with it, because its leader, Georges Seurat, specifically set out to replace the unsystematic approach of the Impressionists with scientific method. Seurat "wanted to make of painting a more logical art, more systematic, where less room would be left for accidental effect. Just as there are rules for techniques, he wanted them also for the conception, composition, and expression of subjects."[63] Seurat's paintings were presented by the artist as solutions to particular problems. A friend wrote of his approach that "not only did he never begin his paintings without knowing where he was going, but his concern went even beyond their success as individual works. They had no great meaning for him if they did not prove some rule, some truth of art, or some conquest of the unknown."[64]

As a student Seurat had begun to read scientific treatises on the visual perception of color, and had become fascinated with the proposition he read in a textbook by Charles Blanc, an art critic, that "color, which is controlled by fixed laws, can be taught like music."[65] Color was consequently the first element of painting he sought to systematize. Seurat studied research on color theory that had begun with the discovery by Michel-Eugène Chevreul, a chemist at the tapestry workshops of Les Gobelins, that the perceived intensity of a color did not depend so much on the pigmentation of the material used as it did on the color of the neighboring fabric, a finding that had subsequently been developed by others, including an American physicist, Ogden Rood, who published a treatise on chromatics in 1879.[66] The Impressionists had discovered the advantages of optical mixture—allowing the eye to mix adjacent colors rather than mixing them on the palette—but they had not approached it scientifically; Seurat would determine the placement of adjacent colors, placed on the canvas in the form of small dots, according to principles of the optical perception of color developed by Rood in laboratory experiments.[67]

Seurat's greatest work, *Sunday Afternoon on the Island of the Grande Jatte,* was first exhibited in 1886, and it quickly became a focal point for debate over the new challenge to Impressionism. The historian Robert Herbert has observed that public discussion of the painting soon made it "both the star turn of Neo-Impressionism and the most famous painting of the decade."[68] Painted on "a canvas made-to-measure exactly three by two metres," the *Grande Jatte* was carefully planned; in all, there are more than fifty surviving preparatory works for the painting, including drawings, painted wood panels, and canvases.[69] Seurat worked on the final version of the picture for more than a year. His methodical execution of it is described by the historian John Rewald in terms that suggest its conceptual basis:

> Standing on his ladder, he patiently covered his canvas with those tiny multicolored strokes which give it, from a distance, that intense life and luminosity which are the secret of his style. At his task, Seurat always concentrated on a single section of the canvas, having previously determined each stroke and color to be applied. Thus he was able to paint steadily without having to step back from the canvas in order to judge the effect obtained, which is all the more striking when we realize that he intended his pictures to be seen only from a certain distance. His extreme mental concentration also enabled him to keep on working late into the night, despite the treacherous character of artificial lighting. But the type of light in which he painted was unimportant, since his purpose was completely formulated before he took his brush and carefully ordered palette in hand. Nothing was left to chance, to some happily inspired brush stroke.[70]

When visitors to his studio praised his work, Seurat remarked to a friend: "They see poetry in what I have done. No, I apply my method and that is all there is to it."[71]

Seurat's followers included Paul Signac, who was to carry on the Neo-Impressionist crusade after Seurat's premature death, and for a time Camille Pissarro, who defected from his old Impressionist friends in the mid-1880s when he became convinced that Seurat's method constituted a more advanced form of Impressionism. Monet was stung by his old friend's betrayal, and belittled Pissarro's new "chemical" techniques; Pissarro responded by referring condescendingly to his old colleagues as the "romantic" Impressionists, in contrast to the new movement of "scientific" Impressionism.[72] Pissarro explicitly stressed the conceptual approach of his new Neo-Impressionist friends, in seeking "a modern synthesis of methods based on science," as he

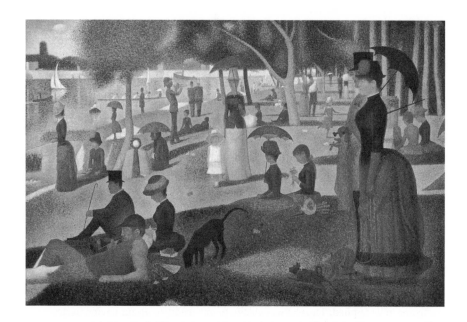

10. Georges Seurat, *Sunday Afternoon on the Island of the Grande Jatte,* 1886. The young Seurat set out to create a large painting that would demonstrate his new systematic approach to color, and the resulting work became one of the most famous paintings of the nineteenth century. Art Institute of Chicago.

emphasized the systematic nature of their work. In the terms suggested in Chapter 5, he recognized that Seurat's method privileged the planning stage over that of working. Thus in a letter to Durand-Ruel explaining the new approach, Pissarro observed, "As far as execution is concerned, we regard it as of little importance; art, as we see it, does not reside in the execution."[73] Rejecting "the snobbish judgments of 'romantic impressionists' to whose interest it is to combat new tendencies," in 1886 Pissarro expressed his confidence that "Seurat has something new to contribute . . . I am personally convinced of the progressive character of his art and certain that in time it will yield extraordinary results."[74] The following year he told his son that he believed the Neo-Impressionists were ready to become the new leaders in advanced art: "Once our paintings are hung somewhere they will have an effect like our early canvases had on official art."[75]

The case of Pissarro is of special interest for this study. From one vantage point, his decision to join the Neo-Impressionists was a brave venture by

an older artist—aged fifty-five in 1885—to enlist in a movement of much younger artists, at considerable personal cost in lost friendships and public ridicule, because he regarded their methods as an advance over those he had worked for more than a decade to develop. Yet it also represented an artist's attempt in mid-career to trade the experimental approach of Impressionism for the conceptual approach of Neo-Impressionism. As we have seen, the frustration and uncertainty of Pissarro's letters of the early 1880s plainly reveal him to be an experimentalist. In 1883, for example, a decade after his initial participation in the great Impressionist discoveries of the early 1870s, and already past the age of fifty, he wrote to his son of his dissatisfaction with his work: "I should like to develop a smoother technique which, while retaining the old fierceness, would be rid of those jarring notes."[76] It was precisely this dissatisfaction with his old technique that attracted Pissarro to Seurat's ideas, for Neo-Impressionism gave him the hope of replacing his unsystematic procedures with a rigorous and methodical approach based on scientific laws of color. Yet if Pissarro were able successfully to abandon his experimental approach for a conceptual one in his mid-fifties, it would substantially reduce the value of the distinction between the experimental and conceptual approaches for understanding an artist's career, for it would suggest that an artist's approach is a choice, subject to change at any time by a mere decision, rather than a more basic and immutable characteristic of his conception of his profession.

Pissarro discovered, however, that he could not make this change. After working for several years in the new style, and initially vigorously defending it against detractors, he began to find the new technique confining and limiting. Having confidently proclaimed the new gospel to Durand-Ruel and his old Impressionist colleagues in 1886, as early as 1888 he confessed to his son that "the dot is meager, lacking in body, diaphanous, more monotonous than simple, even in the Seurats, particularly in the Seurats"; in 1889 he complained to the critic Fénéon of his problems with a "technique which ties me down and prevents me from producing with spontaneity of sensation"; and by 1891, when Seurat died, Pissarro declared that the movement was finished.[77] In explaining his decision to a fellow artist several years later, with his customary honesty he revealed his awareness that an artist's use of an experimental or a conceptual approach was not subject to choice, but stemmed from basic traits of personality:

I believe that it is my duty to write you frankly and tell you how I now regard the attempt I made to be a systematic divisionist, following our friend Seurat. Having tried this theory for four years and having now abandoned it, not without painful and obstinate struggles to regain what I had lost and not to lose what I had learned, I can no longer consider myself one of the neo-impressionists who abandon movement and life for a diametrically opposed aesthetic which, perhaps, is the right thing for the man with the right temperament but is not right for me, anxious as I am to avoid all narrow, so-called scientific theories. Having found after many attempts (I speak for myself), having found that it was impossible to be true to my sensations and consequently to render life and movement, impossible to be faithful to the so random and so admirable effects of nature, impossible to give an individual character to my drawing, I had to give it up.[78]

In 1895 Pissarro expressed his distaste for the practices of the Neo-Impressionists even more vigorously in telling his son of a chance meeting with one of the group:

Met [Charles] Angrand at Durand's yesterday. Oh, what theories . . . boring and exasperating! I couldn't keep from telling him that it was simply idiotic, that their science was humbug, that the truth was they were not artists, that they had killed their instincts for the sake of a false science, that Seurat, who did indeed have talent and instinct, had destroyed his spontaneity with his cold and dull theory, that Monet achieved more luminosity than they did and that his pictures are much less rotten and boring.[79]

Thus Pissarro discovered that he could not adhere to the conceptual approach of the Neo-Impressionists, and renounced the style even though—true to his experimental nature—he did not yet know how to replace its techniques and was greatly troubled by the resulting uncertainty. In 1889 he wrote to Lucien that

I am at this moment looking for some substitute for the dot; so far I have not found what I want, the actual execution does not seem to me to be rapid enough and does not follow sensation with enough inevitability; but it would be best not to speak of this. The fact is I would be hard put to express my meaning clearly, although I am completely aware of what I lack.[80]

*Sunday Afternoon on the Island of the Grande Jatte* was Seurat's demonstration of the artistic use of color theory, and having completed it he turned to new conceptual problems. A friend reported his new program: "If I have

been able to find scientifically and through the experience of art the law of pictorial color, can I not discover an equally logical, scientific, and pictorial system which will permit me to coordinate the lines of the painting towards harmony as I am able to coordinate colors?"[81] Seurat believed he had found an answer in the research of Charles Henry, a young scholar he knew and admired, and he devoted the few years that remained in his life to applying to painting Henry's theories on the relationship between line and expression.[82]

Henri Matisse would later declare that Seurat had made "the great innovation of that day. This new technique made a great impression on me. Painting had at last been reduced to a scientific formula; it was the secession from the empiricism of the preceding eras."[83] That Seurat could make such a fundamental contribution in spite of the fact that his career lasted barely a decade, until his death at just thirty-one, was a consequence of the conceptual basis of his approach to painting. Roger Fry wrote of his procedure, "Nothing can be imagined more deliberate, more pre-ordained than this method, nothing less like that divine afflatus of inspiration with which artists are often credited."[84]

The belief that the ideas embodied in a painting were more important than representing visual perceptions of nature was also used during the 1880s to support the very different approach of what became known as Symbolism. Paul Gauguin was one of its leading figures. Gauguin had collected Impressionist paintings during a career in the stock exchange, and from the mid-1870s he studied with Pissarro to learn Impressionist techniques, initially spending vacations working with Pissarro in Pontoise, then in 1883 joining Pissarro in Rouen when he decided to become a full-time painter at the age of thirty-five. Although Gauguin was a gifted pupil, Pissarro was troubled by his eagerness to sell his work as he began his new career in 1883: "Gauguin disturbs me very much, he is so deeply commercial . . . I haven't the heart to point out to him how false and unpromising is his attitude; true, his needs are great, his family being used to luxury, just the same his attitude can only hurt him."[85] Gauguin did gain influence quickly in the art world, if never the commercial success he hoped for, but he did it by rejecting Impressionism for an art that would express emotions. In contrast to Pissarro's belief that dedicated effort might lead to slow progress, as early as 1885 Gauguin advised a fellow painter: "Work freely and madly; you will make progress . . . Above all, don't sweat over a painting; a great sentiment can be rendered immediately." Gauguin rejected not only the painstaking technique of Impressionism but also its artistic goal, as he further advised his friend, "Don't copy nature too closely. Art is an ab-

straction; as you dream amid nature, extrapolate art from it and concentrate on what you will create as a result."[86] This attitude grew even stronger in later years as he developed his own philosophy of art. In 1900 he wrote to his dealer, Ambroise Vollard, "I do not paint by copying nature. Everything I do springs from my wild imagination."[87]

In 1891 the critic Albert Aurier hailed Gauguin as the leading Symbolist painter. Aurier declared that "the normal and final goal of painting, as of all arts, cannot be the direct presentation of objects. Its ultimate goal is to express Ideas." Toward this end the artist had the right "to exaggerate, attenuate, and deform . . . according to the needs of the Idea to be expressed."[88] Gauguin's most valuable works were done around the time of Aurier's declaration, both in the Brittany town of Pont-Aven and in Tahiti, where he went in 1891 in search of a simpler and more basic way of life. Drawing on a wide variety of influences, including Japanese prints and medieval tapestries as well as imagery from a number of cultures he considered primitive, Gauguin developed a style that combined flattened forms, large areas of pure and unrealistic color, and exaggerations of form. His human figures, who often appear deep in thought, are placed in vividly colored landscapes. In keeping with his belief that "color being enigmatic in itself . . . then to be logical we cannot use it any other way than enigmatically," Gauguin's symbolism is often ambiguous and elusive.[89] He intended his art to create moods:

> I borrow some subject or other from life or from nature, and, using it as a pretext, I arrange lines and colors so as to obtain symphonies, harmonies that do not represent a thing that is real, in the vulgar sense of the word, and do not directly express any idea, but are supposed to make you think the way music is supposed to make you think, unaided by ideas or images, simply through the mysterious affinities that exist between our brains and such arrangements of colors and lines.[90]

Gauguin was perhaps the most influential initiator of the use of primitive themes and symbols in modern art, which would later play a major role in twentieth-century painting. This impulse began not in Tahiti but in Brittany, where Gauguin first went in 1886 in search of an inexpensive place to live and work. Gauguin wrote to a friend, "I love Brittany; I find wildness and primitiveness there. When my wooden shoes ring on this granite, I hear the muffled, dull, and powerful tone which I try to achieve in painting."[91] His later work in

Tahiti continued his interest in primitive art and culture, and gave freer rein to the bold use of color that was among his distinctive contributions.

One explicit account of Gauguin's work is contained in a letter he wrote to a friend from Tahiti in 1898. Already suffering from the syphilis that would later kill him, Gauguin had decided to commit suicide, "so before I died I wanted to paint a large canvas that I had worked out in my head, and all month long I worked day and night at fever pitch . . . [I]t's all done without a model." More than fifty square feet in size, the painting portrays human figures in a sequence by age, from a newborn child to an old woman near death. Gauguin titled the work *Where do we come from? What are we? Where are we going?* Although he expected critics to dismiss this painting as poorly executed, Gauguin declared, "I was so bent on putting all my energy in it before dying, such painful passion amid terrible circumstances, and such a clear vision without corrections that the hastiness of it disappears and life bursts from it. It does not stink of models, professionalism, and the so-called rules that I have always disregarded."[92] His emphasis on the value of a relatively brutal technique to achieve the purpose of examining the emotional lives of human beings puzzled many of his contemporaries, but Gauguin's art would have a great impact on painters of later generations for its rejection of naturalism, its imaginative use of symbolic distortions of form and color, and its adaptation of artistic devices from a wide variety of sources—including prehistoric art—into a recognizably French modern art. That he could achieve this in a career of less than twenty years is a direct consequence of his conceptual approach.

Vincent van Gogh's career as an artist lasted barely a decade, from his decision in 1880 to be a painter, after failed careers as an art dealer and pastor, to his suicide in 1890, at the age of only thirty-seven. He was a self-taught painter, and his greatest work was done after he left Holland for France, where he spent the last four years of his life. During his first two years in France he lived in Paris, where he saw the work of the Impressionists and their successors in modern French art for the first time and assimilated their innovations at an extraordinary rate. His work was transformed by the bright colors of Impressionism, but he was not comfortable with the constraints Impressionist techniques imposed on his ability to express his emotions. In Paris he was also influenced by the group of Symbolist painters, including Gauguin and Emile Bernard, who had begun to use form and color for purposes of expression

rather than description, and his relationships with these artists greatly affected his development.

After two years of intense work, in 1888 van Gogh left Paris for Arles, seeking a "place of retreat where one can recuperate and get one's tranquillity and poise back."[93] His most celebrated—and most valuable—work was done in the two years that remained in his life. The eloquent descriptions of his work in his letters to his brother express the goals of the personal form of Symbolism that he developed. Thus shortly after his arrival in Arles, he wrote, "I should not be surprised if the impressionists soon find fault with my way of working . . . Because instead of trying to reproduce exactly what I have before my eyes, I use color more arbitrarily, in order to express myself forcibly."[94] He wrote of his famous 1888 painting of the *Night Café* that "I have tried to express the terrible passions of humanity by means of red and green." He made the colors "clash and contrast" in the service of expression: "It is color not locally true from the point of view of the . . . realist, but color suggesting some emotion of an ardent temperament." His purpose was "to express the idea that the café is a place where one can ruin oneself, go mad, or commit a crime," and realistic description was inadequate to this goal: "If you make the color exact or the drawing exact, it won't give you sensations like that."[95]

In mid-1889 van Gogh entered an asylum in Provence, and during the year he spent there he often had to work indoors, from memory. Yet even before this his imagination had played a significant role in his work. The previous year, for example, he had written, "I have a terrible lucidity at moments, these days when nature is so beautiful, and the picture comes to me as in a dream."[96] Van Gogh told his brother that "as for landscapes, I begin to find that some done more rapidly than ever are the best of what I do." For each of these paintings "all the essential work was done in a single long sitting," but Vincent emphatically defended them in advance against criticisms of inadequate attention to their execution: "Understand that I am in the midst of a complicated calculation which results in a quick succession of canvases quickly executed but calculated long *beforehand*. So now, when anyone says that such and such is done too quickly, you can reply that they have looked at it too quickly."[97] Fry observed that van Gogh worked "with a feverish haste to get the image which obsesses him externalized in paint . . . Van Gogh had no time and no need for that slow process of gradually perfecting an idea and bringing out its possibilities."[98] The historian Roland Dorn has noted the consequence of van Gogh's conceptual approach for the development of his art:

"The conviction that occasionally made him thoroughly and quickly reorient his ideas or suddenly change the appearance and style of his work throughout the ten years of his career was his unshakable belief that creation is based on rational thought."[99] In 1888 van Gogh told his brother of the mental effort involved in his painting: "Sheer work and calculation, with one's mind strained to the utmost, like an actor on the stage in a difficult part, with a hundred things to think of at once in a single half hour."[100]

The intentional distortions of form and color, the use of mental images, and the preconception of his works are all characteristics of the conceptual basis of van Gogh's art. Yet they account only in part for the magnitude of the contribution he made to modern art in such a brief career. For van Gogh's personality became inseparable from his paintings in creating a new image for the modern artist. His hundreds of letters, most to his devoted brother Theo, provide a vivid record not only of an intense emotional life but of a remarkably active intelligence, as van Gogh created a detailed narrative of his life and art. Van Gogh's conceptual use of color and form had a great impact on artists of the next generation; his art, with that of his friend Gauguin, was to be a central influence on Fauvism and Expressionism, and on the early work of Picasso. But the powerful representation of emotion contained in his paintings, achieved at the cost of enormous suffering detailed in his letters, made his life an inspiration even for many later artists who did not follow his techniques. In 1884 he wrote to a fellow painter of his belief that "art is something greater and higher than our own adroitness or accomplishments or knowledge; that art is something which, although produced by human hands, is not created by these hands alone, but something which wells up from a deeper source in our souls."[101] Disheartened by the lack of recognition of his work, van Gogh consoled himself with the hope that his efforts might be better understood in the future: "Painters . . . dead and buried speak to the next generation or to several succeeding generations through their work . . . Perhaps death is not the hardest thing in a painter's life."[102] But his total commitment to his art persisted. Alone in Arles in 1888, he wrote to Theo, "I almost dare to swear to you that my painting will improve. Because I have nothing left but that."[103] The dramatic record of van Gogh's search for new forms of conceptual expression, created in both his painting and his letters, made his career a turning point in the history of modern art. As Picasso later remarked, "Beginning with van Gogh, however great we may be, we are all, in a measure, autodidacts—you might almost say primitive painters."[104]

The next major French painter, Henri Matisse, was of the subsequent generation. Matisse's most celebrated contribution was his leading role in Fauvism, the first concerted development in painting in the twentieth century. Other principal members of the group were André Derain and Maurice Vlaminck. Pursuing the implications of earlier Symbolist painting, the Fauves produced works distinguished by bright, antinaturalistic color, a flattened picture surface, and crude, visible brushwork. The style came into existence suddenly, it was practiced intensively only briefly, during 1904–1907, and then it was largely abandoned by most of those involved. Given these characteristics, it is not surprising that the art had conceptual origins. The writer André Gide recognized at first sight that Fauve paintings were "the demonstrations of theorems . . . Everything can be deduced, explained . . . Yes, this painting is reasonable, or rather it is itself reasoning."[105] Fauvism derived from thought rather than observation: as Derain later admitted, "We painted with theories, ideas."[106] Both Derain and Vlaminck produced their most valuable work during this brief period—Derain in 1907, at twenty-four, and Vlaminck in 1905, at twenty-nine.

Matisse's most valuable work dates not from the heyday of Fauvism, however, but rather from three decades later in 1935, when he was in his midsixties. His case is an interesting one. His approach to art was avowedly conceptual. In a famous article he wrote in 1908, he stated straightforwardly that "what I am after, above all, is expression . . . I am unable to distinguish between the feeling I have about life and my way of translating it." Characterizing Impressionism as representing a "succession of moments which constitutes the superficial existence of beings and things," Matisse declared that "one can search for a truer, more essential character, which the artist will seize so that he may give reality a more lasting interpretation." Matisse explained that he needed to define precisely in advance the character of the object he wished to paint: "For me, all is in the conception. It is thus necessary to have a clear vision of the whole right from the beginning."[107] Decades later, in an essay of 1935, he again emphasized the conceptual motivations that led to his conclusion that "the methods of the Impressionists were not for me. I wanted to see beyond their subtle gradations of tone and continual experiments. In short, I wanted to understand myself."[108] And in words that reflected the certainty that separated him from experimentalists like Cézanne and Monet, responding to an interviewer who asked when he considered a painting finished, Matisse re-

plied, "When it represents my emotion very precisely and when I feel that there is nothing more to be added."[109]

Matisse planned his works carefully. His preparations for one of his major early works, *Luxe, calme, et volupté*, occupied the whole winter of 1904–1905. Watercolor sketches he had made the previous summer of the bay of St. Tropez became the basis for oil studies. He added studio studies of nude figures, then produced a full-scale charcoal drawing of the whole composition. After his wife and daughter transferred this drawing to a large canvas using pouncing, a traditional technique, Matisse painted within the contours they had traced to produce the finished work. Even Matisse's celebrated ink line drawings were based on preparatory sketches. He explained in 1939 that they were "always preceded by studies made in a less rigorous medium than pure line, such as charcoal or stump drawing, which allow me to consider simultaneously the character of the model, her human expression, the quality of surrounding light, the atmosphere." These studies might require several sessions, until Matisse felt he was "drained by the work," and it was only then "that my mind is cleared and I have the confidence to give free rein to my pen. Then I distinctly feel that my emotion is expressed."[110]

Matisse was one of the dominant artists of the twentieth century, and his long and productive career had a number of celebrated phases. The question of the relative importance of his several contributions remains a contentious one. Although Fauvism is generally recognized as his most distinctive innovation, the movement was short-lived and does not stand out as far more influential than Matisse's other significant achievements, which include his enormous *Dance* of 1910, his reaction to Cubism during 1915–1917, his large figure paintings of the 1930s, and at the end of his life in the late 1940s and early 1950s, the paper constructions for *Jazz* and the design of the chapel at Vence. A recent study of Matisse's influence on the American Abstract Expressionists illustrates the variety of his lessons for younger artists. During the late 1920s, Arshile Gorky produced studies based on works Matisse had painted in 1906, 1916–1918, and 1927.[111] Mark Rothko spent hours studying Matisse's 1911 *Red Studio* at the Museum of Modern Art, and after Matisse's death in 1954 Rothko paid tribute to that work in *Homage to Matisse*.[112] Willem de Kooning told an interviewer that his celebrated series of paintings of women of the early 1950s was related to Matisse's 1940 *Woman in a Red Blouse*.[113] And Robert Motherwell's "Wall Paintings" of the 1950s contain references to

Matisse's paper cut-outs of the late 1940s, including *La Danseuse* of 1949, which Motherwell bought for his own collection.[114] Thus these artists drew different inspirations from different stages of Matisse's career.

Commenting on the sustained quality of Matisse's work, the historian Richard Shiff wrote that "at the time of his death in 1954, his practice . . . belonged as much to the avant-garde as ever before."[115] Earlier, Clement Greenberg had made a similar observation when he commented that Matisse's *Red Interior* of 1948 "can stand up to anything he did in the past."[116] And the philosopher David Carrier observes that whereas some artists fail to develop in interesting ways as they age, "Matisse was glorious in old age."[117] Matisse appears as an unusual case, a conceptual innovator who throughout his career made a series of contributions of great beauty, no one of which clearly dominates the others.

Throughout his career, Matisse's rival for preeminence in modern French painting was his friend Pablo Picasso. Picasso's career contrasts sharply with that of Matisse, for he was a great conceptual innovator whose career was dominated by the towering importance of one early and enormously influential achievement. Interestingly, the origins of this achievement may have been prompted in part by Picasso's envy of Matisse. The two painters were first introduced to each other by Gertrude Stein in 1906; she later wrote that the two "became friends but they were enemies."[118] Picasso was already jealous of the public furor that Matisse and his friends had created when they first exhibited their Fauve works at the 1905 Salon d'Automne, and his competitive instincts were aroused particularly by the fame of Matisse's *Le Bonheur de vivre*, the large painting that served as the Fauves' manifesto.[119] Matisse was the informal leader of Paris' advanced art world until Picasso produced his own large painting, in 1907, that gained him that position.

Cubism was primarily the result of a collaboration that began when Georges Braque visited Picasso's studio late in 1907. Braque was shocked by his first sight of *Les Demoiselles d'Avignon*—it prompted him to compare Picasso to the fairground fire-eaters who drank kerosene and spit flames—but on reflection Braque realized that although Picasso's approach was more radical than his, they were nonetheless "both headed in the same general direction."[120] The problems they were struggling with had been brought forcibly to the attention of the Paris art world by shows of Cézanne's late work at the Salon d'Automne in 1904–1907. Under the influence of Cézanne, both Picasso and Braque had been working independently on developing a new art that rejected

the linear perspective that had been the basis for Western art since the fifteenth century. Cézanne had created volume without the use of traditional perspective, and a central device in this achievement was his constructive brushstroke. Picasso and Braque both saw this as a point of departure: "in the months before they began working together, each understood and accepted the perspectival ambiguity implicit in Cézanne's colored planes, which they saw as acting simultaneously in two different positions: one an illusion, a colored equivalent for the position of the natural object in depth, the other actual, as an area of color on the surface of the picture."[121] Having discovered their common interest, Picasso and Braque joined forces to create a revolution.

The collaboration began gradually, but from 1909 until August 1914, when Braque joined the French army, the two artists worked together "like two mountaineers roped together."[122] Together the two produced a series of innovations that radically changed the course of modern art. They wished to represent the tangible nature of objects without the use of linear perspective, which they regarded as a mistaken convention. They discarded the single viewpoint of Renaissance perspective—Braque ridiculed it, saying, "It is as if someone spent his life drawing profiles and believed that man was one-eyed"—in favor of an approach that allowed them to represent their full knowledge of objects, as seen from many different positions.[123] They furthermore sought to do this without the Impressionists' use of color, for they wanted to show the durable reality of objects rather than simply their momentary and changing reflection of light. They did not replace these conventions with any single system, but over time developed a number of devices to substitute for them.

The most striking early development was adapted from Cézanne. Late in his career, Cézanne often used several vantage points within a single composition. Picasso and Braque extended this approach, and the (initially pejorative) name of Cubism was given to their work as a result of the faceting they used to portray each of a number of different elements of an object from a different point of view. In this early phase, their colors were restricted to a limited range dominated by shades of gray and brown. The search for a way to reintroduce a wider range of colors eventually led Picasso to produce the first collage in 1912, by attaching a piece of cloth to the canvas, and later the same year prompted Braque to produce the first papier collé. When the artists began to translate the effects of papier collé into paint, the result was a new flattened

construction of superimposed planes that existed within a much shallower space than the earlier heavily shaded facets of objects. The new phase after 1912, in which compositions were built up from larger, flattened elements, came to be known as Synthetic Cubism, in contrast to the earlier Analytic phase, in which objects were broken into many smaller fragments, many of which were shaded to create an illusion of solidity.[124]

The innovations of Picasso and Braque quickly attracted imitators among the young painters of Paris, but the two artists consciously separated themselves from other artists. The one exception was Picasso's inclusion of Juan Gris, a young Spanish painter, in their group in 1911.[125] The Cubists' dealer, Daniel Kahnweiler, later wrote that it is always necessary to understand "that setting which always to some extent determines a man's work," but that "in the case of the Cubist painters this is still more important. One must have lived those years between 1907 and 1914 with them in order to know the meaning of a collective effort by a number of great painters, in order to understand anything of the continual exchange of ideas."[126] World War I ended this collaboration. Picasso later told Kahnweiler, "On August 2, 1914, I took Braque and Derain to the Gare d'Avignon. I never saw them again."[127] The statement wasn't literally true, for Braque and Picasso maintained a relationship until Braque's death in 1963, but it expressed Picasso's regret at the ending of their intense and enormously productive collaboration.

Picasso, Braque, and Gris created an art that transformed the painting of the twentieth century. The historian Douglas Cooper aptly compared Cubism to the artistic revolution of the Renaissance: although stylistically opposite, both movements "were initiated by a few artists, spread quickly throughout the western world and became the starting-point of a new and more modern art."[128] This twentieth-century revolution was made not by established artists after years of study, but by young men still in their twenties. This was possible because of the nature of their innovation, for Cubism was a conceptual development, its paintings based on the desire to represent the artist's knowledge of objects rather than their appearance. The auction market not only reflects the importance of this period, but closely tracks its timing. The movement's leader, Picasso, produced the most valuable work of his long and extraordinarily productive career at the age of twenty-six in 1907, the year he painted the *Demoiselles*, the breakthrough painting that led to the new art. Braque followed, as his most valuable work dates from 1910, when he was just twenty-eight. The last entrant into the group, Gris, also produced his most valuable

work at age twenty-eight, in 1915. The influence of Cubism spread rapidly and deeply into Western art in the decades that followed, and scores of younger artists who were affected by it are not included in this study, for reasons of time and place.[129] Yet two other major painters who are included and were profoundly affected by Cubism both produced their most valuable work soon after their exposure to it, while they were very much under its influence. Thus Fernand Léger's age-price profile peaked in 1914, when he was thirty-three, and Francis Picabia's peaked in 1918, when he was thirty-nine.

The last artistic movement represented by a number of painters among the French artists considered here is Surrealism. This was a more diffuse movement than Cubism, as Surrealism involved larger numbers of painters, in several distinct periods, over a stretch of several decades. Yet four artists included in this study—Jean Arp, Joan Miró, André Masson, and Yves Tanguy—were among the most important painters associated with Surrealism.

All of the Surrealist painters were influenced by Cubism early in their careers, but Surrealism represented a reaction against Cubism. Instead of the guitars and other studio props that provided the Cubists' subject matter, the Surrealists wanted to deal with epic subjects—"birth, death, sex, war, and the unplumbed recesses of the mind."[130] Surrealist painters developed several distinct styles, but one approach taken by Masson and Miró to exploring the unconscious was called automatic drawing. The artist would begin a work by allowing his hand to wander freely. "Only after the drawing was well under way did Masson permit himself to 'step back' . . . to consider the results. In the tangle of lines, certain forms . . . would seem to have suggested themselves, and only then might Masson consciously add detailing to make these clear, just as he might add other markings to assure a consistent pictorial order for the image."[131]

As this description suggests, these Surrealists replaced the conceptual approach of the Cubists with an experimental method in which works could not be planned in advance. The writings of Miró, who emerged as the most important among the Surrealist painters, confirm this. From the beginning of his career, he firmly believed artistic progress could come only slowly, with great effort. At the age of twenty-six, he wrote to a friend: "What we have to do is learn to paint . . . We must . . . keep on always searching and digging deeply and preparing ourselves for the day we are mature enough to *start* doing *really interesting* things." In the same vein, he soon wrote again, declaring, "I have studied a lot this summer. My two paintings have been changed a thousand

times . . . Perhaps this summer's paintings will be a *struggle* more than a *result*—so much the better."[132] Some years later, at thirty-five, he told an interviewer that he never considered his completed works to be definitive: "When I've finished something I discover it's just a basis for what I've got to do next. It's never anything more than a point of departure . . . I'd paint it over again, right on top of it. Far from being a finished work, to me it's just a beginning, a hotbed for the idea that's just sprouted, just emerged."[133] Later still, at fifty-five, he told another interviewer: "I start a canvas without a thought of what it might eventually become . . . Forms take reality for me as I work. In other words, rather than setting out to paint something, I begin painting and as I paint the picture begins to assert itself, or suggest itself under my brush. The form becomes a sign for a woman or a bird as I work."[134] Three years later, he made the remarkable statement that he regarded all easel painting as provisional: "Easel painting is an experimental thing. Valuable in itself, of course, but only as a kind of laboratory research."[135]

Miró's descriptions of his attitude toward painting and his approach to his work patently mark him as an experimental innovator. In fact, in a letter written when he was twenty-four, he provided an extended description of the kind of artist he admired, which may constitute the most complete general description of the experimental artist made by any painter in this study. This artist "sees a different problem in every tree and in every bit of sky: this is the man who suffers, the man who is always moving and can never sit still, the man who will never do what people call a 'definitive' work. He is the man who always stumbles and gets to his feet again . . . [H]e is always saying *not yet, it is still not ready,* and when he is satisfied with his last canvas and starts another one, he destroys the earlier one. His work is always a new beginning, as though today he was just beginning to paint."[136] At twenty-five, Miró declared that "no man . . . will begin to know how to paint until he is 45," and his predictive accuracy is impressive, for Table 2.1 shows that his most valuable work was done at the age of forty-six.[137] The other Surrealists studied here all did their most valuable work after thirty—Arp at thirty-five, Masson at thirty-four, and Tanguy at thirty-five. Their work was important not only because it constituted perhaps the last in the remarkable succession of important French movements in modern painting that matured while Paris remained the dominant center of Western art, but also because it would have a considerable influence on the development of the most important American movement in modern art. Thus Masson and others who fled to New York before and during

World War II took with them the interest in automatism and the unconscious that would have a decisive impact on the emergence of Abstract Expressionism.[138]

Marcel Duchamp was another French painter whose work later had a great impact, of a very different kind, on the development of modern art in the United States. Duchamp produced few paintings; only twelve of his works appear in the nearly three decades of auction results analyzed here, so it is not possible to obtain a reliable econometric estimate of his age at peak value. There is no uncertainty involved in identifying him as a conceptual innovator who produced major works early in his career, however, for he largely gave up painting before the age of forty, having already produced two of the most celebrated paintings of the twentieth century. He made the first of these, *Nude Descending a Staircase, No. 2,* at the age of twenty-five, and the second, *The Bride Stripped Bare by Her Bachelors, Even,* at thirty-six.[139] Duchamp's avowed goal was to reverse what he considered a mistaken trend of modern painting, and to make art more conceptual. He argued that before the modern era "paint was always a means to an end, whether the end was religious, social, decorative, or romantic. Now it's become an end in itself."[140] He considered Impressionism "the beginning of a cult devoted to the material on the canvas—the actual pigment," which had dominated modern painting for a century, and his intent was to bring this to an end: "I was interested in ideas—not merely in visual products. I wanted to put painting once again at the service of the mind."[141] Duchamp declared that he wanted to react against what other painters were doing: "In French there is an old expression, *la patte,* meaning the artist's touch, his personal style, his 'paw.' I wanted to get away from *la patte* and all that retinal painting." Interestingly, the one earlier artist he exempted from his criticism was someone he recognized as a fellow conceptual innovator: "The only man in the past whom I really respected was Seurat . . . He didn't let his hand interfere with his mind."[142]

After retiring from painting Duchamp made a series of contributions that would eventually prove to be perhaps even more influential than his paintings, in what he called "readymades"—manufactured objects he purchased and signed. By presenting everyday objects such as a urinal or a snow shovel as works of art, Duchamp dramatically raised the question of what constituted art, a problem that would dominate much of modern art in the late twentieth century.[143] After a lag of several decades his work became the point of departure for Robert Rauschenberg and a host of other artists from the late 1950s

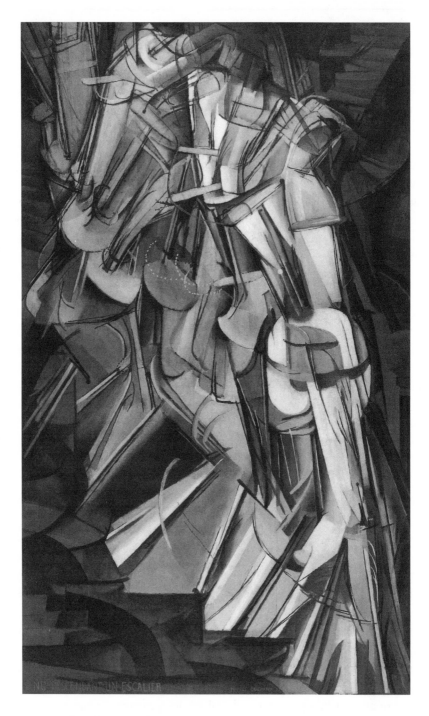

11. Marcel Duchamp, *Nude Descending a Staircase, No. 2,* 1912. Duchamp's *Nude* attacked the static images of Cubism, turning the human figure into a mechanical representation of movement diagonally across the plane of the picture. Philadelphia Museum of Art.

on. Duchamp's conceptual approach to art allowed him to make a number of radically different contributions to art, as he moved abruptly from problem to problem: "Fundamentally, I had a mania for change . . . One does something for six months, a year, and one goes on to something else."[144]

Although this chapter has only briefly surveyed the early development of modern painting in Paris, its evidence is sufficient to show that there was no simple, deterministic relationship between an artist's date of birth and his conception of the nature and goals of art. There is consequently no guarantee that the pioneers of modern painting would be experimental innovators, or that their successors would be conceptual innovators; indeed the two artists named in the title of this chapter violate this simple scheme, for Manet was a great early conceptual innovator, and Miró a great late experimentalist. Nonetheless, it is clear that there was an association between an artist's birthdate and his approach to painting, so that the great early innovators of modern painting in France were more likely to follow an experimental approach, and their successors were more likely to work conceptually.

The description of the market for ideas in the Paris art world of the late nineteenth century contained in both this and the preceding chapter provides some understanding of the intellectual environment that helped to produce this shift. The increasing intensity of the demand for innovation during the late nineteenth century produced an atmosphere of competition that created incentives for painters to produce new approaches to art. Young painters entering the art world during the 1870s and beyond became increasingly aware of these incentives, and more aware that success in that world did not have to come only after decades of study and practice. Many responded by adopting new goals, substituting the portrayal of ideas and emotions for the portrayal of nature. This change made it possible for artists to produce innovations more rapidly, and consequently earlier in their careers. As more painters perceived this, one result was the phenomenon documented earlier, as the age at which artists typically produced their most valuable—and most important—work declined sharply over time.

# 7

## New York from Marin to Minimalism

When I was a younger man, art was a lonely thing: no galleries, no collectors, no critics, no money. Yet it was a golden time, for then we had nothing to lose and a vision to gain.
    Mark Rothko, 1969[1]

I hung Baziotes' show with him at Peggy's in 1944. After it was up and we had stood in silence looking at it for a while, I noticed he had turned white . . . Suddenly, he looked at me and said, "You're the one I trust; if you tell me the show is no good, I'll take it right down and cancel it." At that moment I had no idea whether it was good or not—it seemed so far out; but I reassured him that it was—there was nothing else I *could* do . . . You see, at the opposite side of the coin of the abstract expressionists' ambition and of our not giving a damn, was also not knowing whether our pictures were even pictures, let alone whether they were any good.
    Robert Motherwell[2]

When I claim that Gorky, de Kooning, and Pollock have turned out some of the strongest art produced anywhere since 1940, it may be that I am insufficiently acquainted with the latest work done abroad. But it is with the masterpieces of Matisse, Picasso, Klee, and Miró in mind that I say that some of their work warrants a place of major importance in the art of our century.
    Clement Greenberg, 1950[3]

Today movements are just that; they have no time to stagnate before they are replaced . . . Younger critics and artists have matured in a period accustomed to rapid change.
    Lucy Lippard, 1967[4]

Some artists like to think they are working in the dark, others that they are firmly in control. The preference seems almost more a matter of generation than of individual temperament. Most of the artists whose styles were formed in the 1940s subscribed to the idea that making art meant feeling one's way through unknown territory . . . The typical art of the Sixties . . . has an air of certainty and decision. The artist, like a good executive, makes up his mind what he will do and does it, or gets it done to his specifications.
    David Sylvester, 1969[5]

T. De Duve: What if my eye told me that Stella is as reluctant an innovator as
Manet?
Greenberg: Then your eye'd be all wrong.
  DEBATE BETWEEN THIERRY DE DUVE AND CLEMENT GREENBERG, 1987[6]

We evaluate artists by how much they are able to rid themselves of convention,
to change history. Well, I don't know of anyone since Pollock who has altered the
form or the language of painting as much as he did.
  RICHARD SERRA, 1998[7]

DURING THE nineteenth and early twentieth centuries, American painting was
a provincial and largely derivative art. Paris was recognized as the center of the
art world—not only by American museums, critics, and collectors but also by
American artists. A sojourn in Paris was a standard part of the education of an
aspiring American painter. Of the American artists considered by this study,
for example, nearly all of those born between 1870 and 1890 spent time in
Paris early in their careers: John Marin, Lyonel Feininger, Marsden Hartley, Jo-
seph Stella, Patrick Henry Bruce, Arthur Dove, Edward Hopper, Charles
Demuth, Charles Sheeler, and Stanton Macdonald-Wright all made pilgrim-
ages to Paris, and some also toured Europe to see more of the work of the Old
Masters. In 1915 the writer and artist Marius de Zayas described the damaging
consequences of these trips:

> In politics, in industry, in science, in commerce, in finance, in the popular
> theatre, in architecture, in sport, in dress—from hat to shoes—the American
> has known how to get rid of European prejudices and has created his own
> laws in accordance with his own customs. But he has found himself power-
> less to do the same in art or in literature . . . American artists have always had
> before them an inner censorship formed by an exotic education.[8]

The general recognition of the provincialism of American art frustrated
these painters, many of whom were talented and imaginative artists who
wished to develop a genuinely American art. In the first instance, their own
deference to European art posed a constraint that they had to overcome before
they could make their own original contributions. A number of them suc-
ceeded in doing this. Several groups emerged as sources of distinctively Amer-
ican painting: these included the painters whose work was sponsored by the
photographer Alfred Stieglitz, among them John Marin, Marsden Hartley, Ar-
thur Dove, and Georgia O'Keeffe; the Precisionists, including Joseph Stella,

Charles Demuth, and Charles Sheeler; and the realist Ash Can artists, including George Bellows, Robert Henri, and John Sloan. Some other painters, less identified with groups, including Edward Hopper and Stuart Davis, also created distinctive new styles of American art. But the achievements of these artists were limited in influence; with few exceptions, their work was not widely shown or collected, few critics considered them the equal of the leading European painters of their time, and the assumption of American inferiority generally prevented them from becoming a formative influence on the best young American painters.

Another factor that inhibited the development of an American modern art was that although many painters studied and worked for a time in Paris, and consequently came in contact with the conceptual approaches of French painters from Neo-Impressionism and Symbolism through Fauvism and Cubism, this apprenticeship usually came after their initial training in American art schools and academies. In most cases their conception of art had therefore been formed prior to their exposure to the latest European developments, and American artists born before 1900 almost all shared a very traditional conception of painting. In view of this, it is not surprising that most expressed attitudes toward their craft that clearly identify their approach as experimental. In his mid-forties John Marin, perhaps the greatest American painter of his generation, wrote to his friend Stieglitz of his inability to plan his work:

> I have from time to time in a vague sort of way planned out work ahead. But I find this wayward temper of mine will not allow me to. So that I don't know myself, I don't know my subconscious self and this sometimes scares me and surprises me and I find things cropping up I never intentionally intended. Well, maybe this keeps me from a certain set mannerism, and this is a something I detect and what forces a dislike, an unconscious dislike, of most of the modern work I have seen.[9]

At age sixty-three, Stuart Davis expressed himself more succinctly: "My pictures are developed without preconception as to the way they will be finished."[10]

These American artists also frequently described their work as tentative and experimental. At fifty-eight, John Sloan admitted that "many pictures I make today are frankly experiments, products of my laboratory."[11] At the even more advanced age of seventy-one, Charles Burchfield complained, "My most

disturbing problem in these later years [is] that I have too many ideas . . . And even when I make up my mind to work on one definite picture, I make false moves, which have to be eliminated . . . which means that much experimenting and research must be done before I can achieve my aim."[12] Like many experimental painters, Georgia O'Keeffe worked in series; over a period of fifteen years, for example, she made twenty paintings of the patio door of her New Mexico house. Her persistence was born of dissatisfaction: "I'm always trying to paint that door—I never quite get it. It's a curse—the way I feel I must continually go on with that door." In a simile that expressed the changes in her knowledge that were involved in this process, she explained, "I have a single-track mind. I work on an idea for a long time. It's like getting acquainted with a person, and I don't get acquainted easily."[13]

These artists believed that painters could only mature slowly. At forty O'Keeffe told an interviewer that "the notion that you can make an artist overnight, that there is nothing but genius, and a dash of temperament in artistic success is a fallacy. Great artists don't just happen, any more than singers, or writers, or other creators. They have to be trained, and in the hard school of experience."[14] At forty-eight, Lyonel Feininger reflected that "the development of art is a thing of slow growth. It requires time and plenty of it. It cannot be forced. What would have become of me with insufficient time to struggle through my problems, to overcome my stumbling blocks?"[15] While teaching in 1921 at Weimar's now-famous Bauhaus art school, Feininger worried that the students were not being properly educated: "I ask myself whether our present demands for creativity on the part of complete beginners do not constitute a departure from our declared principle of avoiding at all costs the fostering of artistic pretentiousness, before students have acquired any basis through craftsmanlike discipline."[16] During the following decade, John Sloan urged his students to learn the same lesson Feininger had had in mind:

> There is no end, no goal in this job of being an artist. The longer you live the further you are from it. An artist may develop very slowly. He may be painting his best picture when he dies at seventy-five. The greatest men like Titian and Rembrandt were always growing, expanding. They didn't reach their top work and then start to repeat. They kept on maturing until they died.[17]

As these attitudes would suggest, the work of these early American modern artists typically developed gradually. Of the twelve artists in Table 2.2 born during 1870–1898 in the United States, three—including Marin—executed

their most valuable work after the age of fifty, another seven produced theirs during their forties, and only two did theirs while in their thirties. None produced his most valuable work before the age of thirty.[18]

The most urgent problem facing nearly all these early American modern artists throughout their careers was a lack of demand for their work. There were few art galleries that would show the work of living American artists, and few collectors and museums who would buy it. Occasional pioneers constituted exceptions to these rules. Most notable, perhaps, for his sustained commitment to creating an appreciation for contemporary American painting was Alfred Stieglitz, who ran a series of galleries in New York between 1908 and his death in 1934. Stieglitz's enthusiasm for the work of a small number of American painters undoubtedly contributed to the establishment of a steady demand for the work of Marin and O'Keeffe (who married Stieglitz in 1924), but even Stieglitz's zeal and dedication were not sufficient to guarantee financial success for the handful of other painters he represented. In 1937, after years of frustration, Marsden Hartley ended his association of nearly three decades with Stieglitz, complaining to a friend of Stieglitz's favoritism: "He is just hyped about O'Keeffe and Marin and he gets a racetrack quiver when he mentions these names."[19]

Not surprisingly, the Depression created severe hardships even for established American artists. In 1935, for example, at a time when his paintings were on display at both the Museum of Modern Art and the Whitney Museum, Hartley had to borrow from relatives and friends to pay an overdue bill of $184 for the storage of his paintings in New York. Unable to sell any paintings to pay for further storage, on his fifty-eighth birthday Hartley went to the storage company and destroyed more than one hundred paintings and drawings. Carl Sprinchorn, a friend and fellow artist who intervened to save some of the works, later wrote that "he did not really want to destroy any but he was full of revenge on a hard-fated life."[20] But even before the Depression, few American modern artists could support themselves from their painting alone. In 1925 John Sloan angrily told a group of businessmen that American museums were "like millionaire beggars sitting hungrily around the banquet table of European art, hoping that their millions will purchase a crumb or two." Sloan tried to shame the businessmen, telling them that "the sign of the true art patron is his attitude toward the art of his own country," but his rhetoric failed to achieve the desired goal, and for most of his career he had to support himself by teaching.[21] On the basis of his own experience, one of the first

things he would tell his classes was that "you can't make a living at art. The idea of taking up art as a calling, a trade, a profession, is a mirage."[22]

The next generation would radically change the market for the work of American modern artists, just as they would radically change the history of modern painting. A small group of painters, most born during the first two decades of the twentieth century, brought a new independence of attitude to American art. Many of them studied with older American artists, but they came to believe that their predecessors had been too timid in their approach: one of the brasher among the young painters, Jackson Pollock, declared in 1944 that "American painters have generally missed the point of modern painting from beginning to end."[23] The new generation's members realized they could learn from European painters, but they would no longer defer to European art. Several central figures—Mark Rothko, Clyfford Still, Barnett Newman, William Baziotes, Pollock, and Philip Guston—did not make the traditional early-career trip to Paris. In part this was a result of circumstances, as some of these artists entered the profession during the Depression and World War II, but in part it was a deliberate assertion of autonomy. Still recalled the moment when "I realized I would have to paint my way out of the classical European heritage," and in New York in 1944 Pollock declared simply, "I don't see why the problems of modern painting can't be solved as well here as elsewhere."[24]

The Depression and World War II both had major effects on this generation of American artists, but these were more complex, and more favorable, than might have been expected. Beginning in 1935 Arshile Gorky, Pollock, Willem de Kooning, Baziotes, Rothko, Adolph Gottlieb, and Guston were among the thousands of artists employed by the Federal Art Project of the Works Progress Administration.[25] In addition to its better-known mural division, the Project also had an easel division, for which artists submitted paintings done in any style in their own studios. The Project's stipends were modest, but they allowed artists to "live modestly and nicely," as de Kooning recalled, and they allowed him to put aside his other occupations, including carpentry and house painting, to concentrate on his art.[26] Beyond providing financial support, the Project created a sense of community among the artists involved. Barnett Newman would later claim that his decision not to join the Project had excluded him: "I paid a severe price for not being on the project with the other guys; in their eyes I wasn't a painter."[27]

World War II also brought an unexpected benefit to American art, in the

form of European painters fleeing the Nazi occupation of Paris. Marc Chagall, Fernand Léger, Piet Mondrian, and many others came to New York as refugees. But more significant for the young Americans was the arrival of the Surrealists, including their principal spokesman, the poet André Breton, and a number of Surrealist painters, among them Salvador Dali, Max Ernst, André Masson, Roberto Matta, and Yves Tanguy.[28] Direct contact between the European and American painters was limited, in part because of language barriers and in part because many of the Europeans remained somewhat aloof from their less distinguished American counterparts. There were nonetheless important points of contact and influence. One was Peggy Guggenheim's gallery, Art of This Century. When Guggenheim opened the gallery she was married to the Surrealist painter Max Ernst, and Art of This Century quickly became New York's leading showcase for modern European painting, particularly Surrealism. As Guggenheim also began to represent young Americans her gallery became a place for them to meet and see the work of the European refugees.[29] A few key relationships served to transmit European methods and ideas as well: Arshile Gorky was welcomed into the Surrealist group by André Breton, and the young Chilean Surrealist painter, Roberto Matta, introduced Robert Motherwell, William Baziotes, and Jackson Pollock to the theory of automatism.[30] In addition to giving the Americans the opportunity to see the work of the Surrealists and to learn through contact with them, the presence of the sophisticated Europeans, deeply convinced of the importance of their enterprise, provided a model for the young Americans of how successful artists worked and lived.

Perhaps most significant, the Surrealists' concept of automatism provided a key that led to stylistic breakthroughs for a number of the young Americans, and helped them create a genuinely new art. But this new use of automatism differed from that of the Europeans. André Masson and Joan Miró began their work with random markings, then finished them by articulating the figures they found to be suggested by these markings. In contrast, the Americans generally did not use automatism to create figurative works. The most celebrated adaptation was that of Jackson Pollock. After beginning a painting with random markings, Pollock would examine the pattern these had created, then develop this into a coherent but still abstract composition. Historians have observed that Pollock and his American contemporaries used the idea of automatism, rather than the manner, but that it served an important purpose,

by freeing the Americans from the pervasive and rigid influence of Cubism and allowing them to create a new, looser, and more spontaneous form of painting.[31] Robert Motherwell emphasized that automatism provided a creative principle that allowed the young Americans to produce a new art: "The theory of automatism was the first modern theory of creating that was introduced into America early enough to allow American artists to be equally adventurous or even more adventurous than their European counterparts."[32] For Motherwell, automatism was "a plastic weapon with which to invent new forms. As such it is one of the twentieth century's greatest formal inventions."[33]

The late 1940s and early 1950s became the crucial period of development for the new American art, which came to be called Abstract Expressionism. Although these artists were considered as a group—by themselves as well as by others—they actually had little in common except their dissatisfaction with existing methods of painting and their ambition to draw on the subconscious to create paintings that would communicate emotions without fixed styles or conventions. Adolph Gottlieb later recalled that "at no point was there ever any sort of doctrine or a program or anything that would make a School . . . I think it was simply a situation in which all of the painters were at that time; they were trying to break away from certain things."[34] When asked later what he had first set out to accomplish as a painter, Gottlieb replied that "I didn't have a clear idea. I was merely groping." For him and his friends "the situation was very desperate and everything seemed hopeless and we had nothing to lose . . . Nothing could have been worse than the situation in which we were, so we tried desperate things. We revolted in a way against everything—all of the standards."[35] The Abstract Expressionists had learned the skills of the modern artists who had preceded them, and had found them inadequate for their purposes. Believing—in Pollock's words—that "new needs need new techniques," they experimented with new kinds of paint, new ways of applying paint to canvas, new surface textures, new all-over compositions, and new visual images.[36] The work of each of the group's leading members came to be known for a distinctive idiom, made up of particular expressive gestures and visual effects that recurred throughout his paintings. The critic Peter Fuller later wrote that the Abstract Expressionists "sought to create visual equivalents not just for dreams, or immediate perceptions, but also for a wide range of experience including anguish, hope, alienation, physical sensations, suffer-

ing, unconscious imagery, passion and historical sentiments. They had little in common except their diverse and desperate desire to seize hold of this new subject matter."[37]

In a joint statement published in 1943, Adolph Gottlieb and Mark Rothko declared, "To us art is an adventure into an unknown world, which can be explored only by those willing to take risks."[38] This statement expressed the approach of the Abstract Expressionists not only to their enterprise in general but also to the production of individual works, for the members of the group stressed that they began each painting without specific plans or preconceptions. William Baziotes explained that "whereas certain people start with a recollection or an experience and paint that experience, to some of us the act of doing it becomes the experience; so that we are not quite clear why we are engaged on a particular work."[39] Barnett Newman declared, "I am an intuitive painter, a direct painter. I have never worked from sketches, never planned a painting, never 'thought out' a painting before."[40] Arshile Gorky's widow wrote of his work that "the aesthetic intention as seen from Gorky's point of view is practically impossible to define. In the first place G himself did not always know what he intended and was as surprised as a stranger at what the drawing became after an hour of work. It seemed to suggest itself to him constantly."[41]

Their lack of precise intentions for their works made the Abstract Expressionists feel that anticipating how and when a painting would be finished was problematic. Motherwell used a Surrealist metaphor to contrast the Abstract Expressionists' approach with that of conceptual artists: "One is a notion that a work in its beginning has its conclusion implied. The conclusion follows the original line of thought and the process is to cut out anything that is irrelevant to that line of thought. The other notion is a notion of improvising—that one begins like a blind swimmer and what one finds en route often alters the original intent."[42] Rothko explained that completion of a painting occurred in a "flash of recognition" that could not be foreseen when he began to work: "Ideas and plans that existed at the start were simply the doorway through which one left the world in which they occur." He declared that the artist's most important tool was a faith in his own ability to produce miracles: "Pictures must be miraculous . . . The picture must be . . . a revelation, an unexpected and unprecedented resolution of an eternally familiar need."[43] For the Abstract Expressionists painting was searching, and Barnett Newman believed

it had no end: "I think the idea of a 'finished' picture is a fiction. I think a man spends his whole lifetime painting one picture."[44]

The absence of preconceived outcomes became a celebrated feature of Abstract Expressionism. Pollock's signature drip method of applying paint, with the inevitable spattering and puddling of paint that could not be completely controlled by the artist, came to symbolize this lack of preconception, reinforced by his often-quoted statement, "When I am *in* my painting, I'm not aware of what I'm doing."[45] What has been less generally emphasized is that the Abstract Expressionists were motivated by visual criteria: the artists sought images that captured the emotions they felt, and their progress on each painting depended on their reactions to what they saw developing on the canvas. Motherwell recalled looking at one of his completed works, remembering how it had been painted over several times, in the course of which it had been radically changed, and "suddenly I realized that each brush stroke is a decision."[46] A revealing parallel has been drawn between Abstract Expressionism and Impressionism. This parallel first gained attention in 1955, when Clement Greenberg observed that Clyfford Still's composition followed that of Pissarro and the late Monet, in using color to unify a picture surface that lacked any single point of central interest.[47] Barnett Newman later told a friend of the powerful early influence of Impressionism on his work, for the Impressionists' abandonment of single-focus images in favor of all-over compositions. Newman explained that he found "Pissarro more of an innovator than Monet. The latter, until his transcendent last work, focused on a central theme, spotlighted a motif, while Pissarro used a more 'modern,' unemphatic distribution of paint marks across the canvas." In a seminar at Columbia University in 1959, when Meyer Schapiro asked Newman which of four traditions of modern art his work followed—Realism, Impressionism, Cubism, or Surrealism— Newman immediately chose Impressionism.[48]

An important aspect of the parallel between Impressionism and Abstract Expressionism is the fact that members of both groups used a process of trial and error in trying to achieve ambitious but imprecise visual goals.[49] The artist and critic Elaine de Kooning recognized this when she remarked in 1955 that many of the Abstract Expressionists were actually followers of the Impressionists: "As the Impressionists attempted to deal with the optical effects of nature, the followers are interested in the optical effects of spiritual states."[50] From a very different vantage point, Marcel Duchamp made a similar obser-

vation. Duchamp regretted what he called the "retinal" motivation that had dominated modern painting for over a century, in which the visual appearance of a painting took precedence over its conceptual content. In 1960 he argued that Impressionism "was the beginning of a cult devoted to the material on the canvas" that had culminated in New York: "Today abstract expressionism seems to have reached the apex of this retinal approach."[51] The experimental approach of the Abstract Expressionists generally led them to work in series, and consequently like the Impressionists they tended not to produce individual landmark paintings. Thus historian Anna Chave has observed that "the usual procedure has been to write or speak about Rothkos, Pollocks, or Newmans in generic terms, as if singling out any given painting would be an idle or irrelevant gesture. In the three most widely read books on the New York School, by Dore Ashton, Irving Sandler, and Serge Guilbaut, the authors rarely or never focus on specific works of art."[52] In a comment that recalls the practice of Monet, Motherwell remarked that "I often paint in series, a dozen or more versions of the same thing at once—of the same *theme* at once." He himself did not focus on individual pieces of his own work in retrospect: "It's the long haul that counts, and in that sense, all of these pictures to me—everybody talks about them as individuals, and they *are* in one sense—they're all sentences, or paragraphs, or slices from a continuum that has gone on my whole life, and will till the day I die."[53]

The Abstract Expressionists' working methods reveal the visual criteria they used to judge their progress in making their paintings, and the doubts that arose from the novelty of their efforts and the imprecision of their goals. In Pollock's words, "the painting has a life of its own. I try to let it come through."[54] When an interviewer asked Pollock in 1950 if he began a painting with a preconceived image in mind, he answered, "No—because it hasn't been created . . . I don't work from drawings, I don't make sketches and drawings and color sketches into a final painting. Painting, I think, today—the more immediate, the more direct—the greater the possibilities of making a direct—of making a statement."[55] Lee Krasner, Pollock's wife, described how he would frequently stop to study a work in progress. Pollock worked on large, unstretched canvases laid flat on the floor. To study one in an upright position, "he'd attach the top edge to a long piece of 2×4, and together we'd lift it up—do you know how much one of those big pictures with all that paint weighed? We'd take it to the wall, and lift it up ladders, and just nail the ends of the 2×4—which stuck out—into the studio wall." After Pollock had studied the

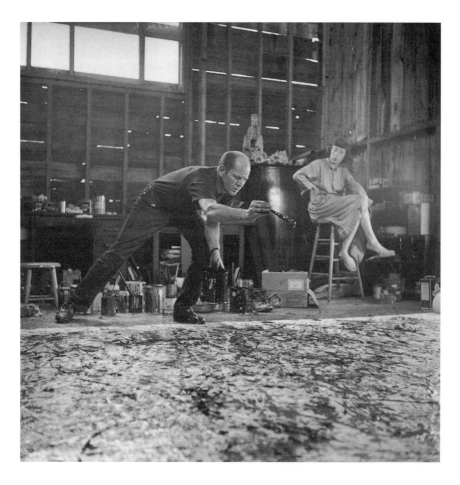

12. Jackson Pollock at work on *One: Number 31, 1950.* His wife, the painter Lee Krasner, watches as Pollock works in his trademark drip style. The setting is the barn in Long Island that he had converted into a studio.  Photograph by Hans Namuth.

painting, they would carry it down again so he could continue layering paint on the horizontal canvas. The difficulty of this laborious process for Krasner and Pollock indicates the importance Pollock attached to seeing the painting on the wall while it was in progress. Pollock worked from all four sides of a painting, and often began without determining the size or orientation of the completed work. Krasner recalled how this complicated the process of completing a painting. "Sometimes he'd ask, 'Should I cut it here? Should this be the bottom?' He'd have long sessions of cutting and editing . . . Those were

difficult sessions. His signing the canvases was even worse. I'd think every-thing was settled—tops, bottoms, margins—and then he'd have last-minute thoughts and doubts. He hated signing. There's something so final about a sig-nature."[56] Krasner also described Pollock's recurring doubts about his work. She recalled that during the early 1950s, even after he had been recognized as a leader of the Abstract Expressionists, one day "in front of a very good painting . . . he asked me, 'Is this a painting?' Not is this a good painting, or a bad one, but a *painting!* The degree of doubt was unbelievable at times."[57]

Elaine de Kooning described how her husband would repeatedly paint over his canvases: "So many absolutely terrific paintings simply vanished be-cause he changed them and painted them away."[58] In one case, de Kooning ini-tially abandoned *Woman I,* which would become one of his most famous paintings, after eighteen months of work. Photographs of the work in progress reveal that its image had gone through at least six discrete states. De Kooning returned to the painting at the urging of Meyer Schapiro, and finally accepted the work as complete a year later, two and a half years after he had started it. Even then, however, two months later de Kooning decided to reattach to the painting a vertical strip of canvas several inches wide that he had earlier cut off.[59] In pondering the question of why de Kooning wiped out so many of his pictures, his friend Thomas Hess concluded that "de Kooning by tempera-ment dislikes conclusions almost as much as he hates systems."[60] When asked how he decided to stop working on a painting, de Kooning replied: "I just stop . . . I sometimes find a terrific picture. As a matter of fact that's probably the real thing but I couldn't set out to do that. I set out keeping in mind that this thing will be a flop in all probability and, you know, it sometimes turns out very good."[61] De Kooning recalled that he considered his series of paintings of *Women*—now generally regarded as his most important contribution—a fail-ure, but that didn't faze him:

> In the end I failed. But it didn't bother me . . . For many years I was not inter-ested in making a good painting—as one might say, "Now this is really a good painting" or "a perfect work." I didn't want to pin it down at all. I was interested in that before, but I found out it was not my nature. I didn't work on it with the idea of perfection, but to see how far one could go—but not with the idea of really doing it.[62]

Like his individual works, de Kooning's art developed incrementally. Hess de-scribed the evolution of his mature style as "a continuous process—a gradual,

logical, steady development, marked by hundreds of insights, but no blinding revelation."[63]

Mark Rothko spoke of his work in visual terms: an artist who heard Rothko lecture at the California School of Fine Arts in 1949 remembered his discussion of his search for "the personal image."[64] His description of his methods attested to his experimental trial-and-error approach. In 1945 he wrote to Barnett Newman that the recent development of his work was difficult but exhilarating: "Unfortunately one can't think these things out with finality, but must endure a series of stumblings toward a clearer issue."[65] Throughout his career Rothko developed each painting by inspecting and responding to what he saw on the canvas. A friend recalled that during the 1940s, "if he saw something in one of his paintings that resembled an object, he would change the shape."[66] An assistant who worked for Rothko in the 1950s recalled that he "would sit and look for long periods, sometimes for hours, sometimes for days, considering the next color, considering expanding an area."[67] Another assistant who worked for him in the late 1960s, when Rothko was painting the large panels commissioned for a chapel built by the de Menil family in Houston, remembered that "we never really knew how a surface was going to dry, how it was going to turn out . . . It could be a perfectly magnificent black or deep wine surface, but after a few days he might decide, no, it's not right, beautiful as it is." Some of these canvases for this commission were built up with fifteen or twenty layers of paint.[68] A biographer observed that "since the late 1940s Rothko, building up his canvases with thin glazes of quickly applied paint, had spent more time considering his evolving works than he had in the physical act of producing them."[69] In words that recall Cézanne's attitude toward his failed efforts, the assistant who worked for Rothko in the last year of his life reported that the use of paper rather than canvas as a support allowed Rothko to deal summarily with unsuccessful works: "it's there or he tears it up."[70] Like other experimental artists who spent long periods pursuing a single goal, Rothko perceived his efforts as cumulative. While hanging a retrospective exhibit of his work at the Museum of Modern Art in 1961, Rothko was asked how long he had spent on a large painting. He replied, "I'm 57 years old, and it took all that time to paint this picture."[71]

Rothko first used his familiar image of stacked rectangles in 1949, and during the next two decades he made it the basis for hundreds of paintings. Yet he never ceased to experiment with the format. Anna Chave observed, "Within its parameters, the art was always changing. The scale and propor-

13. Mark Rothko, East Hampton, 1964. In a characteristic pose, Rothko studies one of his paintings, deciding whether, and how, to continue working on it. Photograph by Hans Namuth.

tions of the canvas changed; the number and scale of the rectangles changed; the palette changed; and the final effect differed accordingly, sometimes subtly and sometimes dramatically, from picture to picture."[72] Rothko defended his repeated use of the rectangles on these grounds, declaring, "If a thing is worth doing once, it is worth doing over and over again—exploring it, probing it."[73] This seriality led viewers to see Rothko's work as a whole. Thus at Rothko's 1961 show at the Museum of Modern Art, Willem de Kooning told him, "Your house has many mansions," later explaining, "knowing the way he made them, all those paintings become like one with many mansions."[74]

Although the Abstract Expressionists did not share a common style, they spent a great deal of time together arguing and discussing a wide range of subjects. In addition to meeting regularly at a series of cafeterias and bars, including the now-legendary Cedar Street Tavern, in 1948 several of the group founded and briefly operated a school called The Subjects of the Artist. When the school closed the next year, a larger group rented a loft, which they called

the Club, where the artists could meet to hear lectures and hold discussions on topics ranging from philosophy and psychology to music and painting.[75] In spite of the great differences in their styles, it is clear that during the late 1940s and early 1950s Abstract Expressionism constituted a form of collective enterprise, in which the artists both encouraged and challenged one another. Baziotes later recalled this time: "Contact with other artists has always been of great importance to me. When the artists I know best used to meet . . . the talk was mostly of ideas in painting. There was an unconscious collaboration between artists. Whether you agreed or disagreed was of no consequence. It was exciting and you were compelled to paint over your head. You had to stay on a high level or drown."[76] A biographer of Mark Rothko similarly observed that by the late 1940s "all of these artists knew each other, viewed each other's work and formed a social network . . . [I]n the absence of sales and critical recognition, this loose field of social relations, with artists attending each other's shows, engaging in conversations, spending Saturday afternoons at a gallery like Parsons' or Saturday evenings in an apartment like Ferber's—all these provided a stimulating, supportive context for innovation as well as relief from 'crushing' isolation."[77]

The effects of the Abstract Expressionists' collaboration are reflected in the outcomes of the auction market, as Table 2.2 shows that the timing of their peak values tends to cluster within short periods. Six of the group— Newman, Gorky, de Kooning, Guston, Pollock, and Tomlin—produced their most valuable work between 1945 and 1951, while another four—Reinhardt, Baziotes, Rothko, and Kline—produced theirs during 1956–1961. The Abstract Expressionists' experimental approach explains why their greatest achievements came only after extended periods of searching, and why none produced his most valuable work before the age of thirty-five: of this group of ten only two did their most valuable work before forty, five produced theirs during their forties, and three did theirs after fifty.

The Abstract Expressionists had come of age in a profession in which there was little immediate demand for their work. At the age of fifty-one, Adolph Gottlieb recalled,

When I was a boy studying art, I became aware of and accepted the difficulties of the modern artist. By the age of 18 [in 1921], I clearly understood that the artist in our society cannot expect to make a living from art; must live in the midst of a hostile environment; cannot communicate

through his art with more than a few people; and if his work is significant, cannot achieve recognition until the end of his life (if he is lucky), and more likely posthumously.

Yet by the time he spoke, in 1954, Gottlieb admitted that "in the years that have intervened some of these dismal attitudes have been modified by events. Since that time there have been vast changes in the world."[78] One of the principal causes of the changes Gottlieb had in mind was the persuasive advocacy of the critic Clement Greenberg. Greenberg had begun to write in support of some of the young American artists during the mid-1940s, and in 1948 he made the shocking and heretical declaration that contemporary American painting had surpassed that of Europe.[79] In the years that followed, in simple and direct prose Greenberg continued both to praise the quality and originality of the work of the young Americans and to scold the New York art world for what he considered its shameful failure to support them. In 1952, for example, Greenberg asserted that "if Pollock were a Frenchman . . . people would already be calling him '*maître*' and speculating in his pictures. Here in this country the museum directors, the collectors, and the newspaper critics will go on for a long time—out of fear if not out of incompetence—refusing to believe that we have at last produced the best painter of a whole generation; and they will go on believing everything but their own eyes."[80] Greenberg's promotion of the Abstract Expressionists was a powerful force not only because he took strong positions and argued them clearly in unadorned language, but also because he advanced a straightforward but powerful theory of modern art that provided a narrative history in which the Abstract Expressionists were the successors to the great French modern artists.[81] His theory was to have unexpected consequences later, but by the early 1950s Greenberg had been joined by a small but growing chorus of other critics in declaring the Abstract Expressionists the current leaders in modern painting.

As Pollock and his friends arrived at their mature styles, Abstract Expressionism quickly rose to a dominant position in the American art world. In 1955 William Seitz completed the first large-scale academic study of the movement, a Princeton University dissertation based on interviews with some of the group's most prominent members. Seitz observed that "from 1940 until 1947, Abstract Expressionism was a true advance guard, but by 1954 it had elicited the support of art journals, museums, and university art departments." In conclusion he described its influence:

Without voluminous lists of exhibitions, prizes, and artists who have been won over to the new form and content on various levels of understanding and mastery, or citations of the hundreds of young painters who turned to it early, it is impossible to fully convey the degree to which Abstract Expressionism has become a universal style. It wins the prizes in exhibitions dotted in every region of the United States. In the large national shows, its purest form heavily outweighs all other types of painting, and the other groups—socially-weighted Realism, figurative Expressionism, and Surrealism—have been so deeply marked by surface consciousness, brush, and the structure of geometric abstraction . . . that little painting remains which is both "modern" and not in some way affected by "Abstract Expressionist" characteristics.[82]

With the increasing influence and critical acclaim also came an increasing market demand for the work of the Abstract Expressionists. Peggy Guggenheim's gallery had been virtually the only showplace for their work during World War II, but when Guggenheim left New York after the war her place was taken by Charles Egan, Samuel Kootz, and Betty Parsons, who opened galleries during 1945–46.[83] Their success in turn attracted Sidney Janis, Eleanor Ward, Martha Jackson, Leo Castelli, Andre Emmerich and other new dealers during the late 1940s and early 1950s.[84] By 1955 *Fortune* magazine reported that the "art market is boiling with an activity never known before." Ranking paintings as investments, the magazine judged Old Masters to be "gilt-edged security," Impressionists and Post-Impressionists to be "blue-chip stock," and Abstract Expressionists to be "speculative or 'growth' issues." The magazine predicted that a Rothko purchased in 1955 would quadruple in value by 1960 and increase twentyfold or more by 1965.[85] Even the dour Greenberg, who in 1949 had bemoaned the fact that "it remains as difficult as ever for a young American painter or sculptor working in an advanced mode to win real attention in New York," had to admit in 1957 that "since 1952 or 1953 . . . Pollocks have been in steady demand," and in a 1958 tribute to a dealer declared that "the real issue was whether ambitious artists could live in this country by what they did ambitiously. Sidney Janis helped as much as any one to see that it was decided affirmatively."[86]

The increased demand for the Abstract Expressionists' work was undoubtedly the greatest of the changes Gottlieb had in mind in 1954. He acknowledged that "having had such a gloomy outlook at the start, any improvement in my situation was entirely unexpected. Even now when I sell a picture, I am rather surprised—that is surprised that anyone should like it

well enough to buy it."[87] But the growing market for contemporary American painting did not stop with the Abstract Expressionists. As new dealers entered the New York market during the 1950s, most found that the work of the leading Abstract Expressionists was unavailable because they already had contracts with established dealers, so these newcomers increasingly focused their efforts on the next generation of artists. When aspiring painters arrived in New York during the 1950s, they consequently found a very different situation than had Gottlieb and his contemporaries when they had started out. William Rubin later wrote, "By 1958, when [Frank] Stella came to New York, the art-buying public had become convinced that Americans could produce major painting, worthy of comparison with the best of earlier European modern art. And it was now clear that this work could be sold at prices that made an artist's profession economically feasible."[88] Instead of having to teach or find other careers to support themselves, as had many of the older painters, the younger painters increasingly entered a profession in which the strength of the market allowed them the possibility of devoting themselves exclusively to painting. The key to doing this was to attract the attention of critics, dealers, and collectors.

The leaders of the next generation of artists would attract attention by producing innovative art, and the methods they used to produce these innovations would be very different from those of the Abstract Expressionists. Ironically, this change in approach was in part an unintended consequence of the theory of modern art advanced in support of the Abstract Expressionists by Clement Greenberg. The Abstract Expressionists consistently maintained that the importance of their art lay in its subject matter. Although their work was nonrepresentational, they insisted that the purpose of their imagery was to communicate ideas and feelings. So for example in 1943 Gottlieb and Rothko bluntly declared: "There is no such thing as good painting about nothing. We assert that the subject is crucial."[89] Yet Greenberg disagreed. He dismissed the "symbolical or 'metaphysical' content" of the Abstract Expressionists' work as "half-baked."[90] In his view their contribution lay entirely in the formal properties of their paintings, in their innovative use of "line, color, and form," without reference to subject matter.[91] Greenberg's theory of modern art highlighted the importance of these formal properties, for in his view the development of modern painting had consisted of the progressively explicit recognition of the characteristics of painting that distinguished it from the other arts—the flat surface, the shape of the support, the properties of the

pigments—in a process of continuing self-criticism of their medium by paint-
ers. As summarized by Michael Fried, a younger critic and one of Greenberg's
disciples, "the history of painting from Manet through Synthetic Cubism and
Matisse may be characterized in terms of the gradual withdrawal of painting
from the task of representing reality . . . in favor of an increasing preoccupa-
tion with problems intrinsic to painting itself." A consequence of this was that
it had now become possible "to conceive of stylistic change in terms of the de-
cisions of individual artists to engage with particular formal problems thrown
up by the art of the recent past."[92]

Although many art historians and critics deplored Greenberg's single-
minded concentration on formal criteria, even his detractors acknowledged
its dominance in the New York art world in the 1950s and 1960s. One histo-
rian who regretted the influence of Greenberg's theory remarked in 1968 on
"how often recent Abstract American painting is defined and described al-
most exclusively in terms of internal problem-solving. As though the strength
of a particular artist expressed itself only in his choice to conform with a set of
existent professional needs and his inventiveness in producing the answers."
He used an industrial metaphor: "The dominant formalist critics today tend
to treat modern painting as an evolving technology wherein at any one mo-
ment specific tasks require solution . . . The artist as engineer and research
technician becomes important insofar as he comes up with solutions to the
right problems."[93]

The combined impact of formalist criticism and the expanding gallery
system produced a new regime in American modern art. In 1968 Greenberg
himself surveyed the results, and concluded that "until the middle of the last
century innovation in Western art had not had to be startling or upsetting;
since then . . . it has had to be that. And now in the 60s it is as though every-
body had finally . . . caught on not only to the necessity of innovation, but also
to the necessity—or seeming necessity—of advertising innovation by making
it startling and spectacular." Producing conspicuous innovations had become
a preoccupation: "Today everybody innovates. Deliberately, methodically.
And the innovations are deliberately and methodically made startling."[94] In
the same vein in 1969 Henry Geldzahler, a curator at New York's Metropolitan
Museum, recalled "in the late 1950s being shocked to hear painters, who be-
lieved in the primacy of de Kooning's position and who admired him, won-
dering aloud whether next year's show would repeat his success, whether he
could consolidate his lead not by painting a beautiful show but by changing in

an unexpected and unpredictable way." Geldzahler blamed this demand for novelty on galleries that catered to "an audience overeager to spot trends, rising reputations, and falls from favor," conceiving new shows "more in response to the demands of fashion than art." Yet he believed that younger artists were better prepared for this heightened demand for innovation: "The younger generation has had the example of the successful Abstract Expressionists before them and are much less vulnerable than were the artists in the fifties, the first to sit on this particular griddle."[95]

These changes in both intellectual and economic markets profoundly changed the nature of modern art. Whereas Abstract Expressionism had emerged from extended trial-and-error experimentation, the trademark touch of its practitioners was now replaced by a conceptual approach that valued new ideas above techniques and consequently could produce innovations much more rapidly. Perhaps the most successful painter of the generation that followed the Abstract Expressionists, Jasper Johns, had his first one-man show at Leo Castelli's gallery in January 1958. Thomas Hess, editor of *Artnews,* saw Johns's work at Castelli's before the show, and put one of his paintings, *Target with Four Faces,* on the front of his magazine. Johns's first show was thus announced on the cover of a leading art journal. When the show opened Alfred Barr, the first director of the Museum of Modern Art and in 1958 the museum's director of collections, bought *Target with Four Faces* and two other paintings for the museum, and persuaded the architect Philip Johnson to buy a fourth painting as a future gift to the museum. Clement Greenberg was never a great admirer of Johns's work—he later dismissed it as "minor compared with the best of Abstract Expressionism"—but he nonetheless articulated its lineage and achievement. Greenberg explained that Johns's early paintings contained an irony. A surface of uneven densities of paint, devised by de Kooning to create an illusion of depth, was used by Johns to represent inherently flat objects—numbers, targets, flags—and was thus shown to be superfluous to the goal of using the flat surface of the canvas to represent a flat image. Although Greenberg found Johns's work lacking in interest, he recognized that Johns had combined Abstract Expressionism with a form of representation.[96] When Johns's first show closed, all but two of the paintings had been sold, and at the age of twenty-seven Johns had become a new star of contemporary art. More than four decades have now passed since that first show. Today in his seventies, Johns is widely considered one of the most important painters alive, and all of his work, old and new, is eagerly sought by collectors

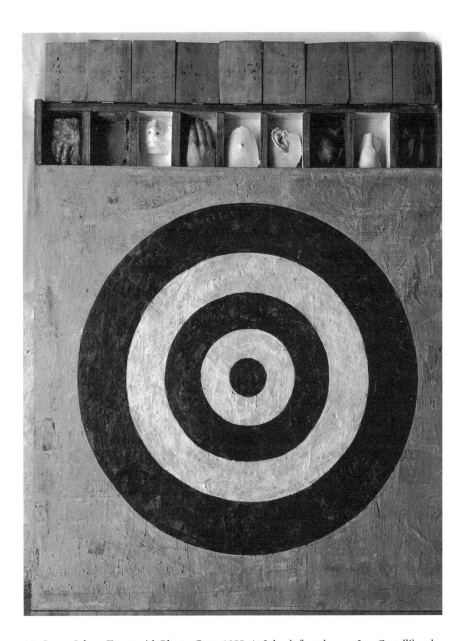

14. Jasper Johns, *Target with Plaster Casts,* 1955. At Johns's first show at Leo Castelli's gallery, Alfred Barr asked the artist if the lid of the box in *Target with Plaster Casts* that held the cast of a penis could be kept permanently closed. When Johns objected, Barr decided not to buy the painting for the Museum of Modern Art, instead substituting *Target with Four Faces.* Private collection.

and museums. But a striking fact is that his most celebrated paintings remain those he did before the age of thirty, and that the auction market considers his most valuable paintings to be those he did at age twenty-seven—the same paintings that first introduced him to the art world at Castelli's gallery in January 1958.[97]

Johns's impact on other young artists was almost immediate. Frank Stella studied art history as an undergraduate at Princeton, and was well versed in formalist criticism: Michael Fried, a college friend of Stella's, later recalled that "Greenberg was the only art critic we valued and wanted to read."[98] During his senior year in college Stella saw Johns's first show, and was struck by "the idea of stripes . . . the idea of repetition."[99] Just two years later, Stella had his own first one-man show, also at Leo Castelli's gallery. Stella's friend Fried would later characterize the paintings in this show, "in which parallel stripes of black paint, each roughly $2\frac{1}{2}$ inches wide, echo and reecho the rectangular shape of the picture support until the entire canvas is filled," as "a significant advance on the work of the Cubists or even Mondrian." The conclusion followed from formal considerations: the stripes that filled the canvas constituted "more consistent solutions to a particular formal problem," that of creating paintings that "make explicit acknowledgment of the literal character of the picture support," and therefore represented "the culmination of a tendency visible in the work of Manet if not earlier."[100] In this formalist interpretation, Manet had initiated a process in which the subject of painting would increasingly be painting itself, and after a progression of more than a century, Stella had devised the most extreme solution to date to the problem of how to eliminate everything from a painting but the recognition that it was nothing more or less than a rectangular canvas covered with paint.

Stella had no objection to formalist interpretation of his work, for he denied any symbolic intent. In a 1966 interview he declared:

> I always get into arguments with people who want to retain the old values in painting—the humanistic values they always find on the canvas. If you pin them down, they always end up asserting that there is something there besides the paint on the canvas. My painting is based on the fact that only what can be seen there *is* there.

Stella emphasized that his aim was to simplify painting:

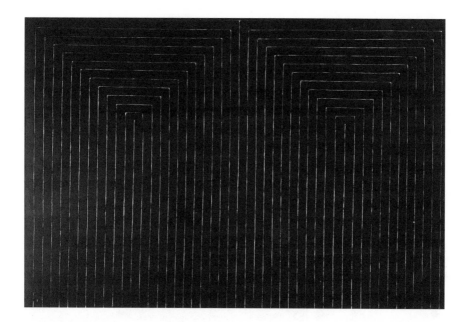

15. Frank Stella, *The Marriage of Reason and Squalor, II,* 1959. One of the Black paintings that gained Stella early critical attention, *Marriage* became the first of Stella's works to be acquired by a museum when Alfred Barr purchased it for the Museum of Modern Art in 1959. The title is an ironic comment on the situation of the young aspiring artist in New York. Museum of Modern Art, New York.

> All I want anyone to get out of my paintings, and all I ever get out of them, is the fact that you can see the whole idea without any confusion . . . What you see is what you see.

Stella specifically contrasted his attitude toward his paintings with that of his predecessors:

> We believe that we can find the end, and that a painting can be finished. The Abstract Expressionists always felt the painting's being finished was very problematical. We'd more readily say that our paintings were finished and say, well, it's either a failure or it's not, instead of saying, well, maybe it's not really finished.[101]

This difference in attitude stemmed from his conceptual approach, for Stella's images were planned precisely before he started to paint: "The painting never

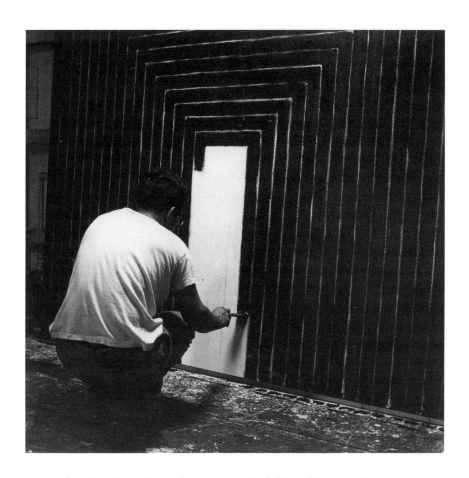

16. Frank Stella in his studio working on *Getty Tomb (Second Version)*, 1959. Stella works on a Black painting. He has previously drawn guide lines on the canvas, and is following them in applying black paint with a house painter's brush. Photograph by Hollis Frampton.

changes once I've started to paint on it. I work things out before-hand in the sketches."[102] As this would suggest, Stella valued ideas above technique: "I do think that a good pictorial idea is worth more than a lot of manual dexterity."[103]

During the 1960s both Johns and Stella became primary influences on several groups of young artists. One of these groups set out to create a more systemic art, initially called Minimalism, and later often referred to more generally as Conceptual Art. One of the group's leaders later recalled the initial

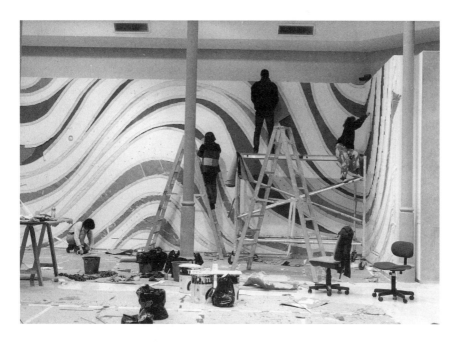

17. Installation crew for Sol LeWitt wall drawing, Caja de Madrid, 1996. As a young man, Sol LeWitt worked for the architect I. M. Pei. Like an architect, LeWitt makes plans for his wall drawings that are executed by others. LeWitt wrote that "the artist and the draftsman become collaborators in making the art." Photograph by Miguel Zavala.

discussions of "new ways of making art, trying to reinvent the process, to regain basics, to be as objective as possible." Following Johns's flags and targets and Stella's stripes, Sol LeWitt and his colleagues confronted "the problem of painting at the time: the idea of the flat surface and the integrity of the surface." These young artists were not interested in the visible gestures or emotional symbolism of Abstract Expression, nor were they interested in representation: as LeWitt recalled, "I wasn't really that interested in objects. I was interested in ideas."[104] These concerns led to LeWitt's well-known definition in 1967: "In conceptual art the idea or concept is the most important aspect of the work. When an artist uses a conceptual form of art, it means that all the planning and decisions are made beforehand and the execution is a perfunctory affair. The idea becomes a machine that makes the art." He explained that adherence to a plan would keep "arbitrary or chance decisions" to a minimum: "The artist would select the basic forms and rules that would govern the

solution of the problem. After that the fewer decisions made in the course of completing the work, the better."[105] Even more emphatically, LeWitt later wrote that "once the idea of the piece is established in the artist's mind and the final form is decided, the process is carried out blindly."[106] LeWitt stressed the preeminence of the idea by declaring that conceptual art "is usually free from the dependence on the skill of the artist as a craftsman." LeWitt himself often accomplishes this by having his work executed by others. Of his own trademark wall drawings, he wrote: "The artist conceives and plans the wall drawing. It is realized by draftsmen."[107] LeWitt did not stipulate that the artist must approve the executed drawing, and he often does not see the completed works done from his plans. In an early description of Minimalism in general, the critic Lawrence Alloway emphasized its preconception: "In all these works, the end-of-state of the painting is known prior to completion (unlike the theory of Abstract Expressionism) . . . The predictive power of the artist . . . is strongly operative, from ideas and early sketches, to the ordering of exactly scaled and shaped stretchers and help by assistants."[108]

The early work of Minimalist and Conceptual artists often relied on symmetrical organization, frequently based on a grid or other geometric device, but during the 1960s another conceptual reaction against the gestural images of Abstract Expressionism took a very different form. Pop artists also sought to eliminate the visible touch of the artist, but by using a new form of realism based on commercial images. Andy Warhol's most celebrated paintings were made by applying paint to canvas through a silk screen. The silk screens were made from photographs Warhol found in magazines or newspapers, and the screening was usually done by an assistant in Warhol's studio; the artist's role consisted of choosing the image, then deciding how large it would be and how often it would appear.[109] Warhol explained, "In my art work, hand painting would take much too long and anyway that's not the age we're living in. Mechanical means are today."[110] Working alone in his living room, Warhol produced one hundred paintings in the three months preceding his first one-man show in 1962; after the success of that show, with operations transferred to a studio Warhol called the Factory, his new assistant reported they could produce a painting in just four minutes.[111] Warhol's procedure was a direct consequence of his philosophy: "I think somebody should be able to do all my paintings for me."[112]

Other Pop artists did their own work by hand, but often with the avowed purpose of making it appear otherwise. Roy Lichtenstein told an interviewer,

"I want my painting to look as if it had been programmed. I want to hide the record of my hand."[113] The productions of the Pop artists thus introduced a novel idea, "an original art work pretending to be a copy."[114] Lichtenstein declared that "stylistically, my work is devoid of emotional content. And it's what I want." His use of enlarged cartoon images, made up of painted circles that mimicked the printed Ben Day dots that make up newspaper photographs, was intended to have a message: "I guess what it's saying is that we're living in an industrial-scientific age, and that art is heavily influenced by that. Abstract Expressionism was very human looking. My work is the opposite."[115]

The subject matter of Pop Art varied among artists, as did their methods, but their shared characteristic was the mechanical, impersonal appearance of their works that constituted a reaction against the intensely personal appearance of Abstract Expressionism. A key ingredient in producing this detached style was predetermination; their works were typically carefully planned replications of existing images, whether comic strips, billboards, or news photographs. Interestingly, although Lichtenstein's explicit Pop images might appear to have little in common with the nonrepresentational art of Frank Stella, Lichtenstein recognized a common ground between his art and Stella's, in its conceptual nature. He told a critic in 1969 that the central concern of his work was "the same kind of thing you find in Stella . . . where the image is very restricted. And I think that is what's interesting people these days: that, before you start painting the painting, you know exactly what it's going to look like."[116] Jasper Johns expressed a related attitude when a critic asked him why he had initially chosen to paint flags, targets, maps, numbers, and letters: "They seemed to me preformed, conventional, depersonalized, factual, exterior elements."[117]

Although the Pop artists' representational, often almost photographic reproduction of commercial images made their work radically different from that of the Abstract Expressionists, Pop Art did contain elements drawn from Abstract Expressionism, including the large size of many of their canvases, their all-over patterns of composition, and their repeated images. But Pop was also influenced by Jasper Johns's direct views of flat objects. In the terms of formalist criticism, the Pop artists painted representations of flat images— whether photographs, advertisements, or comic strips—on the picture plane of the canvas with no visible brushstrokes, thus eliminating any illusion of depth. Yet the central purpose of the Pop artists was not to please formalist critics, but rather to react against what these artists perceived as the exagger-

ated emotional and philosophical claims of the Abstract Expressionists for their art. Thus when asked whether he was antiexperimental, Roy Lichtenstein responded "I think so, and anti-contemplative, anti-nuance, anti-getting-away-from-the-tyranny-of-the-rectangle, anti-movement-and-light, anti-mystery, anti-paint-quality, anti-Zen, and anti all of those brilliant ideas of preceding movements which everyone understands so thoroughly."[118] A number of Pop artists remarked that they had begun painting in an Abstract Expressionist style, but had later rejected it in favor of a more conceptual approach. James Rosenquist, for example, recalled, "After some Abstract-Expressionist painting I did then, I felt I had to slice through all that, because I had a lot of residue, things I didn't want. I thought that I would be a stronger painter if I made most of my decisions before I approached the canvas; that way I hoped for a vision that would be more simple and direct."[119]

For Conceptual and Pop artists, as for Johns, Stella, and most of the other painters who became prominent in the late 1950s and 1960s, the ideas represented by their work became the work's primary significance: as one critic wrote of LeWitt, their procedures "made the initial intention more important than the execution."[120] In 1967 the critic John Perreault observed that Minimalist and Pop artists shared both a conceptual method and an aesthetic goal: "As opposed to a material or intuitive method, Minimal artists use a rational and conceptual method that is not unrelated to Pop Art approaches to the problem of composition. In many instances they perhaps share with Pop artists a desire to create instant aesthetic impact."[121] Perreault's reference to the desire for instantaneity of impact echoes comments Stella had made the previous year: "I wanted something that was direct—right to your eye . . . something you didn't have to look around—you got the whole thing right away."[122] Stella again made it clear that this goal was a reaction against earlier art:

> One could stand in front of any Abstract-Expressionist work for a long time, and walk back and forth, and inspect the depths of the pigment and the inflection and all the painterly brushwork for hours. But I wouldn't particularly want to do that and also I wouldn't ask anyone to do that in front of my paintings. To go further, I would like to prohibit them from doing that in front of my painting. That's why I make the paintings the way they are.[123]

The work of artists of this cohort posed specific artistic questions, and typically answered them to their satisfaction. An early work by one of the leaders of this generation, Robert Rauschenberg, consisted of erasing a drawing by

the Abstract Expressionist Willem de Kooning. Rauschenberg explained that "the whole idea just came from my wanting to know whether a drawing could be made out of erasing." Rauschenberg wanted "to start with something that was a hundred per cent art," so he settled on de Kooning: "He was the clearest figure around so far as quality and appreciation were concerned." He needed de Kooning's cooperation: "Bill was uncomfortable with it at first. We talked about it for quite a while . . . He said he understood the idea but he didn't like it much. But finally he agreed to cooperate." De Kooning gave Rauschenberg a drawing for the purpose. After a month of work with forty erasers, Rauschenberg decided the result was a success: "In the end it really worked. I *liked* the result. I felt it was a legitimate work of art." The result is a white sheet of paper, still owned by Rauschenberg. He framed it, and hand-lettered a label that reads: "Erased De Kooning Drawing, Robert Rauschenberg, 1953." Rauschenberg's conclusion was definite: "The problem was solved, and I didn't have to do it again."[124] Harold Rosenberg saw this effort as a turning point:

> Art-historically, the erasing could be seen as a symbolic act of liberation from the pervasive force of Abstract Expressionism, while exhibiting the drawing still clung to Abstract Expressionism for support with the public. In thus explicitly dramatizing the transition from one mode of art to another, "Erased de Kooning" (1953) is the first work with an exclusively art-historical content and produced expressly for art historians; it is this that ensured its prominence in museum shows of the next two decades. "Erased de Kooning" became the cornerstone of a new academy, devoted to replacing the arbitrary self of the artist with predefined processes and objectives—that is to say, Minimalism and Conceptualism.[125]

But Rauschenberg's conceptual assault on Abstract Expressionism did not end with this erasure. In 1957 he produced *Factum I* and *Factum II,* two paintings with collage elements, done in an Abstract Expressionist style, that appeared identical, even to the drips of paint that ran down from the smeared brushstrokes. These paintings have often been interpreted as an ironic commentary on Abstract Expressionist spontaneity and inspiration.[126] Rauschenberg does not think of his career as the pursuit of any single goal, but rather wants it to consist of separate episodes, each unrelated to those that preceded it. Now in his mid-seventies, he recently explained that he tries to clear his mind before he begins to work: "Everything I can remember, and everything I know, I have probably already done, or somebody else has." He

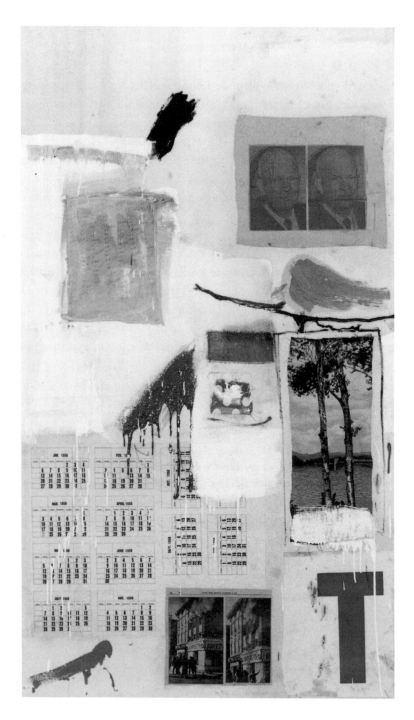

18. Robert Rauschenberg, *Factum I,* 1957. In response to the Abstract Expressionists' belief that the value of a painting was the product of the unique act of its creation, in 1957 Rauschenberg made two collages that appeared nearly identical. Their titles may underscore the challenge, for an archaic meaning of *factum* is from mathematics: "the product of two or more factors." Museum of Contemporary Art, Los Angeles.

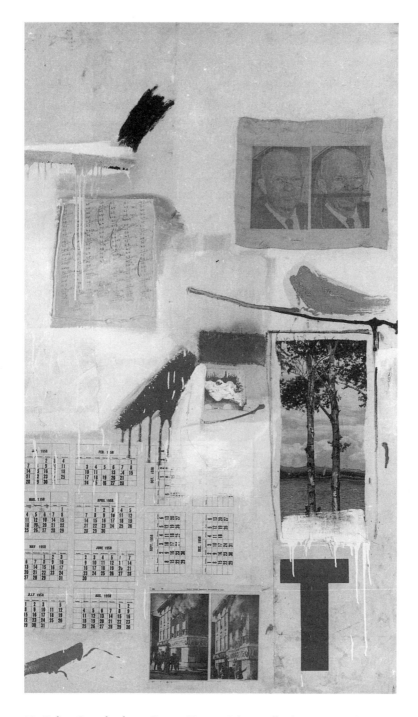

19. Robert Rauschenberg, *Factum II*, 1957. Private collection.

doesn't believe artists should want to accumulate knowledge: "I think you're born an artist or not. I couldn't have learned it, and I hope I never do because knowing more only encourages your limitations."[127]

The shift that occurred during the 1950s, from the experimental approach of the Abstract Expressionists to the conceptual approach of the next generation, produced a sharp decline in the age at which artists could produce their most important work. And the change was witnessed most dramatically in the careers of the leaders of the new movements, since their innovations were the most radical. Thus among the painters born after 1920, Table 2.2 shows that Frank Stella and Cy Twombly produced their most valuable work before the age of twenty-five, Jasper Johns and James Rosenquist did theirs before the age of thirty, and Sol LeWitt, Roy Lichtenstein, Robert Rauschenberg, and Andy Warhol all did theirs before the age of thirty-five. These central figures of the next generation thus made their major contributions at ages younger than had any of the leading Abstract Expressionists.

The changing relationship of painters to the market during the 1950s and 1960s is revealed by the ages at which the artists considered here had their first one-person gallery shows in New York. Although there are some exceptions involving artists who have earlier gained success elsewhere, whether in Europe or in regional markets in the United States, for most American artists their first New York solo exhibition is an important event in their careers, analogous to the debut of an actor or musician. Appendix C presents the ages at which all the American artists considered by this study had their first New York shows. As summarized in Table 7.1, this evidence reveals a dramatic change over time. For the cohort of artists born during 1900–1920—the group dominated by the Abstract Expressionists—debuts under the age of thirty were rare, accounting for only 11 percent of the total, and fully half of these artists had their first shows after the age of forty. For the next generation, of artists born during 1921–1940, debuts in the twenties had become common, making up nearly half the total, and all had their first shows before the age of forty.

As these figures suggest, these artists in these two generations typically had their first shows at very different stages of their careers. Among the Abstract Expressionists, only de Kooning and Newman had their first solo New York shows after the date at which they had produced the work that would become their most valuable. For Hofmann, Tomlin, Rothko, Gorky, Kline, Baziotes, Pollock, Guston, Reinhardt, and Motherwell, production of their

*Table 7.1*   Percentage distributions of ages of American artists at the time of their first one-person New York gallery exhibitions, by birth cohort

| Age at debut | Born 1870–1899 | | Born 1900–1920 | | Born 1921–1940 | |
|---|---|---|---|---|---|---|
| | *n* | % | *n* | % | *n* | % |
| 20–29 | 5 | 24 | 2 | 11 | 17 | 47 |
| 30–39 | 11 | 52 | 7 | 39 | 19 | 53 |
| 40+ | 5 | 24 | 9 | 50 | 0 | 0 |
| Total | 21 | 100 | 18 | 100 | 36 | 100 |

*Source:* Appendix C.

most valuable work came after—often long after—their formal introduction to the art world. This changed for many of the leaders of the next generation, as Francis, LeWitt, Twombly, Warhol, and Johns all executed their most valuable work before the date of their New York debuts, and Rosenquist and Stella produced their most valuable work in the same year as their first gallery shows. For the dominant painters of the generation that came of age in the 1950s and 1960s, the work that introduced them to the art world was thus typically that which would remain their most important.

When Frank Stella was given a retrospective exhibition at New York's Museum of Modern Art in 1970, at the age of just thirty-three, Harold Rosenberg, who had long been a prominent supporter of the Abstract Expressionists, was indignant. He remarked acidly, "The young master is a new phenomenon in American art . . . The indispensable qualification of the creators of American art has been longevity." Nor was this unique to American art, as Rosenberg declared that it was "inconceivable that Cézanne, Matisse, or Miró could have qualified for a retrospective in a leading museum after their first dozen years of painting; certainly Gorky, Hofmann, Pollock, and de Kooning did not." For Rosenberg, major artistic contributions necessarily involved long gestation periods: "Self-discovery has been the life principle of avant-garde art . . . and no project can, of course, be more time-consuming than self-discovery. Every step is bound to be tentative; indeed, it is hard to see how self-discovery can take less than the individual's entire lifetime." Rosenberg protested that "for a coherent body of significant paintings to spring directly out of an artist's early thoughts, a new intellectual order had to be instituted in American art."[128] Although Rosenberg deplored this situation, his analysis of it was correct. The

dramatic increase in the demand for contemporary American art during the 1950s, with the increased premium it placed on innovation, transformed the nature of painting. As the experimental methods of the early American modern artists and the Abstract Expressionists were replaced by a variety of conceptual approaches, and the expressive gestures of Pollock, de Kooning, Rothko and their contemporaries suddenly gave way to the mechanical productions of Johns, Stella, Warhol, and others of their generation, the artistic value of experience declined sharply, and the age at which successful painters produced their most important work declined precipitously.

# 8

## Intergenerational Conflict in Modern Art

I remember that, although I was full of ardor, I didn't conceive, even at forty, the deeper side of the movement we followed instinctively. It was in the air!
> CAMILLE PISSARRO, 1895[1]

We are born with the sensibility of a given period of a civilization . . . The arts have a development that comes not only from the individual, but also from the accumulated strength, the civilization that preceded us. One can't do just anything. A gifted artist cannot do just anything at all. If he used only his talents, he would not exist.
> HENRI MATISSE, 1936[2]

Even if you are against a movement, you're still part of it . . . You can't escape your own period. Whether you take sides for or against, you're always inside it.
> PABLO PICASSO, 1944[3]

Each man's lifework is also a work in a series extending beyond him in either or both directions, depending upon his position in the track he occupies. To the usual coordinates fixing the individual's position—his temperament and his training—there is also the moment of his *entrance,* this being the moment in the tradition—early, middle, or late—with which his biological opportunity coincides.
> GEORGE KUBLER, 1962[4]

The ambitious artist . . . has to assimilate the best new art of the moment, or the moments, just before his own.
> CLEMENT GREENBERG[5]

A MORE COMPLETE understanding of the history of modern art requires study of not only the careers of individual artists but also the interrelationships among artists, both within and across generations. Integrating our new understanding of individual artists' careers with a more systematic examination of artistic influence can eventually produce a richer interpretation of the history of art. A detailed exploration lies beyond the scope of this book, but central elements of the integration can be pointed out.

Most important modern artists have been influenced early in their careers by teachers who were themselves prominent artists. This could occur formally,

in schools: thus Henri Matisse studied with Gustave Moreau at the Ecole des Beaux-Arts, and Robert Rauschenberg with Josef Albers at North Carolina's Black Mountain College.[6] Often, however, these relationships have been informal. Monet's relationship with Boudin and Jongkind is an early example, as are those of Cézanne, Gauguin, and others with Pissarro, who was perhaps the most influential teacher of his time, although he never formally worked as an art instructor.[7] Jackson Pollock's early development was guided by Thomas Hart Benton; their relationship began when Pollock enrolled in Benton's class at New York's Art Students League, but later developed into a friendship.[8] Early in his New York career Mark Rothko became one of a group of young painters, which also included Adolph Gottlieb and Barnett Newman, who served informal apprenticeships with the older artist Milton Avery.[9] It is clear that the artistic excellence of these teachers was important not only for their ability to instruct but also for providing inspiration to these students who would eventually surpass their mentors' eminence. At Avery's funeral Rothko declared that "the instruction, the example, the nearness in the flesh of this marvelous man—all this was a significant fact—one which I shall never forget."[10] Cézanne's gratitude to Pissarro was no less; in his old age he liked to reminisce about the "humble and colossal" Pissarro, and past the age of sixty, decades after Pissarro had taught him the discoveries of the Impressionists, in public exhibitions of his work in Aix Cézanne scrupulously added after his name, "pupil of Pissarro."[11] Pollock credited Benton for having provided "a strong personality to react *against*," and said that Benton was a good teacher because he had taught him how not to paint like Benton.[12]

Because innovation is the source of significance in modern art, the eventual contributions of these students typically involved major departures from the teaching and practices of their mentors. But both the stature and the influence of the teachers were nonetheless important for these students. Clement Greenberg has argued that "the record shows no case of significant innovation where the innovating artist didn't possess and grasp the convention or conventions he changed or abandoned," and apprenticeship with an important painter of an older generation is perhaps the surest route to this understanding.[13] Even in extreme cases in which the teacher ultimately repudiated the work of the student, the teacher could have provided the student with the knowledge of the most advanced current practice, which could then serve as the point of departure for the student's own innovation. Although Gauguin must have been hurt by the denunciation of his mature Symbolist

work by his old teacher Pissarro, he nonetheless reaffirmed the value of what Pissarro had given him. As late as 1902, long after he had rejected the methods and goals of the Impressionists, Gauguin paid tribute to Pissarro, avowing, "He was one of my masters and I do not disown him."[14]

Although some important modern artists did not have teachers who were prominent artists—Picasso is an obvious example—the same is not true of early collaborators. Almost without exception successful modern artists have developed their art at an early stage in the company of other like-minded young and talented artists. The crucial role of collaboration in the development of Impressionism, Cubism, and Abstract Expressionism has long been a commonplace of art history, as the young Monet worked with Bazille, Pissarro, Renoir, and Sisley, the young Picasso with Braque, and the young Pollock with Motherwell, Baziotes, and others of their group. Only slightly less celebrated are the collaborations of Seurat with Paul Signac and his other Neo-Impressionist followers, of Gauguin with Emile Bernard and the many other Symbolists in Pont-Aven, and of Matisse with André Derain and others to produce Fauvism.

Picasso and Braque began to work together in 1909, and for the next five years they were nearly always in close contact. Picasso later recalled that "almost every evening, either I went to Braque's studio or Braque came to mine. Each of us *had* to see what the other had done during the day. We criticized each other's work. A canvas wasn't finished unless both of us felt it was."[15] In looking back at this period, both artists recognized the importance of the joint effort in solving the problems that constituted their invention of Cubism. Picasso specifically compared their collaboration to the practice of scientists: "So you see how closely we worked together. At that time our work was a kind of laboratory research from which every pretension or individual vanity was excluded."[16] Braque similarly stressed that the effort to make new discoveries had taken precedence over that of creating individual styles: "In the early days of Cubism, Pablo Picasso and I were engaged in what we felt was a search for the anonymous personality. We were inclined to efface our personalities in order to find originality. Thus it often happened that amateurs mistook Picasso's painting for mine and mine for Picasso's. This was a matter of indifference to us because we were primarily interested in our work and the new problem it presented."[17]

As an aspiring young artist in New York, Robert Motherwell befriended the young Chilean painter Roberto Matta. Motherwell was searching for an

approach to art, and Matta inspired him: "He was the most energetic, enthusiastic, poetic, charming, brilliant young artist that I've ever met." Motherwell recalled that "in the three months of that summer of 1941, Matta gave me a ten-year education in surrealism." Motherwell later described Matta as a catalyst who enabled the American to develop the insights he had gained from Surrealism into a distinctively new art in collaboration with other young artists in New York: "Matta in turn introduced me to a young American, William Baziotes, who in turn introduced me to young Jackson Pollock, Willem de Kooning, and the older Hans Hofmann. Such artists became my real graduate education."[18]

Jasper Johns and Robert Rauschenberg became partners in designing department-store window displays in New York in 1954, and lived together for most of the next seven years. This became the key formative period for the art of both, in which they made the major innovations that would inspire most of the advanced American painting of the 1960s. Rauschenberg recalled, "He and I were each other's first serious critics . . . Jasper and I literally traded ideas."[19] Similarly, Johns later told an interviewer that "I learned more about painting from Bob than I learned from any other artist or teacher, and working as closely as we did and more or less in isolation we developed a strong feeling of kinship."[20] And in a comment that echoes many other advanced artists' attitudes toward their early alliances, Rauschenberg told a friend that at a time when he and Johns were developing their art with little encouragement from the art world at large, the support they afforded each other gave them "permission to do what we wanted."[21]

## Art Schools:
## Group Work in Modern Painting

Whereas every serious artist throughout history has had to solve the problems of his medium, it has always been personal, a problem of talent. It was not until the Impressionists that a group of artists set themselves a communal task—the exploration of a technical problem together.

BARNETT NEWMAN, 1944[22]

The artists who have formed this school believe that receiving instruction in regularly scheduled courses from a single teacher is not necessarily the best spirit in which to advance creative work. Those who are in a learning stage benefit most by associating with working artists and developing with them variations on the artistic process (through actually drawing, painting, and sculpting) . . . Those

attending the classes will not be treated as "students" in the conventional man-
ner, but as collaborators with the artists in the investigation of the artistic pro-
cess, its modern conditions, possibilities, and extreme nature, through discus-
sions and practice.

FROM THE CATALOG OF THE SUBJECTS OF THE ARTIST SCHOOL, BY WILLIAM
BAZIOTES, DAVID HARE, ROBERT MOTHERWELL, AND MARK ROTHKO, 1948[23]

Most truly original new art is the result of group activity. It appears that the con-
junction of several exceptional talents results in something that is greater than
the parts.

ALAN BOWNESS, 1989[24]

Artistic production is stimulated and sustained by an art world—a working
community of artists and others—not isolation in some garret. Such stimulation
and support are emotional and communicative as much as they are material.

HARRISON WHITE, 1993[25]

The relationship between Picasso and Braque during the time of early and high
Cubism . . . was a relationship in which two young artists who were at once men
of genius and great virtuosi and who had totally contrasting temperaments were
joined in the creation of a revolutionary style, inspiring each other, guiding each
other through a journey in the dark, goading each other with their intense ri-
valry, loving each other, often disliking and distrusting each other.

DAVID SYLVESTER, 1997[26]

Even a cursory review indicates that collaborations of young artists have
played a central role in the early development of most, if not all, of the major
innovators in modern art. Even when artists' primary contributions have not
appeared until well after the period of their collaboration, those innovations
can often be understood as consequences of new methods or approaches that
originated during the association. The existence and importance of the collab-
orations described above, and many others, have been generally accepted by
art historians, who typically organize their narratives of the development of
modern art around them. Yet what has received less attention is the common
structure of these collaborations. For these have not simply been fortuitous
occurrences, or accidents of circumstance, as is sometimes implied by ac-
counts of individual episodes. Rather, collaborations have been the rule for
important modern painters; collaboration appears to have been almost a nec-
essary condition for the production of significant contributions to modern
art. Just as modern scientists have generally recognized that team efforts are
more likely than individual initiatives to allow them to solve major problems,

so modern artists, from Monet on, appear to have recognized that group efforts are more likely to produce significant innovations. In most cases, early in their careers important modern artists have devoted substantial investments of time and effort to forming and sustaining groups of their peers, to make common cause in the attempt to produce new forms of modern art.

Artists' groups have functioned in a variety of different ways. There have been few attempts to examine in detail how artists have worked within these groups, and in consequence it is difficult to describe precisely how the activity of a group has influenced the production of specific innovations. Yet the available descriptions of these groups, often based on the reminiscences of group members, make it clear that they could provide a variety of benefits.[27]

As discussed in Chapter 6, Monet emphasized the educational benefits of group work. In part, these benefits are a consequence of the differing initial skills of the artists in the group, which create the opportunity for members to learn from one another. When Bazille first worked in the countryside with Monet, for example, he reported to his parents that Monet was "quite good at landscape, he gave me advice that helped me very much."[28] Differences in abilities that could not be fully exchanged among group members could also be of help in achieving new solutions to problems, for each member might make a contribution that others couldn't, allowing the group to produce an innovation that no individual member could have made alone.

Some of the benefits of artistic research groups have been psychological. In virtually every case, the groups of advanced artists considered here produced innovations to which most of the art world was initially hostile. From the Impressionists on, the groups served as an important source of encouragement to their members, reassuring them that their goals and accomplishments were valuable in spite of the fact that not only the general public but also most other artists were antagonistic to their activities. The groups also often served to motivate and inspire their members. Collaborations among young, ambitious, and talented artists created constructive rivalries, challenging each member to increase his efforts in order to gain the lead in the professional competitions the groups created.

Artistic research groups have generally been short-lived; few major artists have remained closely associated with one for more than a decade. This is because group work obviously also imposes costs on the members, and groups dissolve when these grow larger than the benefits. In addition to the expenditure of time required to participate in the group, members bear the risk that

they may not receive full credit for their contributions. Thus it may be difficult for outsiders to determine accurately who should receive credit for a given innovation. If group members come to believe that a group's leader or most prominent members are receiving disproportionate credit for collective achievements, they may leave the group.

Artistic research groups have typically involved artists who are young. Young artists are more willing to invest their time and effort in learning skills from others, and are often more willing to make the compromises that are necessary for collaboration. Over time, the interests of group members have tended to diverge; once the central problem that gave rise to the collaboration is solved, a number of different implications may appear. Disagreements over which of these to pursue have generally resulted in dissolution of the group.

## Old Masters versus Young Geniuses

All my friends say [my] exhibition is very beautiful. Degas told me that no matter what the "great masters" of the youth, who treat us as dolts, say, we still have the upper hand . . . The yap of *La Revue Blanche* seems hostile to me, it is the organ of the new generation.

CAMILLE PISSARRO TO HIS SON LUCIEN, 1896[29]

I think the young painters are much more intelligent than the others, the old ones see in me only a disastrous rival.

PAUL CÉZANNE, 1906[30]

These young artists are out to murder us.

MARK ROTHKO[31]

I heard a story about Willem de Kooning. He was annoyed with my dealer Leo Castelli, for some reason, and said something like, "That son of a bitch, you could give him two beer cans and he could sell them." I heard this and thought, "What a sculpture—two beer cans." It seemed to me to fit in perfectly with what I was doing, so I did them—and Leo sold them.

JASPER JOHNS, 1964[32]

There are unsuccessful Abstract Expressionists who accuse me of killing them; they blame me for their funerals. But they were dead already. I just helped remove the bodies.

LEO CASTELLI[33]

In 1962 the art historian Leo Steinberg stated what he called a "general rule": that "whenever there appears an art that is truly new and original, the men

who denounce it first and loudest are artists. Obviously, because they are most engaged." Steinberg noted that it was not only academic painters who had opposed novel approaches: "The leaders of a revolutionary movement in art may get just as mad over a new departure, because there are few things as maddening as insubordination or betrayal in a revolutionary cause." Steinberg observed that these denunciations had become common because of the history of innovation in modern painting: "Every moment during the past hundred years has had an outrageous art of its own, so that every generation, from Courbet down, has had a crack at the discomfort to be had from modern art." Steinberg illustrated his "rule" with two examples, Paul Signac's denunciation of Henri Matisse in 1906 on the occasion of Matisse's defection from Neo-Impressionism, and Matisse's denunciation of Picasso a year later after Matisse's first sight of *Les Demoiselles d'Avignon*.[34]

Steinberg's general rule was actually a restatement of a phenomenon familiar to scholars in many other disciplines. In 1860 Charles Darwin wrote in the *Origin of Species*, "Although I am fully convinced of the truth of the views given in this volume . . . I by no means expect to convince experienced naturalists whose minds are stoked with a multitude of facts all viewed, during a long course of years, from a point of view directly opposite to mine." Darwin believed that the principal influence of his work would consequently be on later generations: "I look with confidence to the future, to young and rising naturalists, who will be able to view both sides of the question with impartiality."[35] Max Planck, the creator of quantum physics, would later declare that "a new scientific truth does not triumph by convincing its opponents and making them see the light, but rather because its opponents eventually die, and a new generation grows up that is familiar with it."[36] This generalization, commonly known as Planck's principle, has been extended to scholarly disciplines outside the sciences. One quantitative study, for example, tested it in a field of history, finding that during the 1970s the acceptance of cliometrics—a new approach that applies economic theory and econometrics to the study of history—was strongly related to age, as a thirty-five-year-old economic historian was almost three times more likely to practice cliometrics than a colleague thirty years older.[37]

Examples abound of scholars who have turned from youthful revolutionaries into aging reactionaries. This can result not only from a selfish desire to prevent the devaluation of the scholar's own accumulated knowledge and skills, but also from habits of thought that produce an inability to see the mer-

its of a new approach. As Sigmund Freud wrote late in his life in *Civilization and Its Discontents,* "The conceptions I have summarized here I first put forward only tentatively, but in the course of time they have won such a hold over me that I can no longer think in any other way."[38]

Intergenerational conflict has been a distinctive feature of modern art. In both periods considered here, in Paris in the 1880s and New York in the 1950s, an older generation of painters vigorously resisted the changes introduced by the leaders of the younger one. But for reasons revealed by the analysis of career patterns carried out in earlier chapters, these cases of intergenerational conflict appear to have run deeper than the more common conflicts Leo Steinberg had in mind. For in both cases studied here, the older artists felt the threat not only that the particular style they practiced would be replaced, but that the successful replacement of their underlying experimental approach in favor of a conceptual one would result in nothing less than a changed conception of the purposes of art, producing a change in artistic values that they believed would nullify their own accomplishments. Thus to the Impressionists in the 1880s or the Abstract Expressionists in the 1950s, the fear was not only that their own reputations and incomes would be undermined by critical or public enthusiasm for new styles, but that the artistic tradition they revered, and had made such great sacrifices to carry on, would be destroyed by young artists whose lack of artistic values caused them to have no appreciation for the achievements of their predecessors. In both cases the objection carried a strong moral element, as the older artists believed that the opportunism of the young would lead them casually to destroy these hard-won achievements.

The struggles that expressed these conflicts were often hidden from view, but glimpses sometimes appear in private documents. A notable incident of the conflict of the 1880s, Camille Pissarro's anger toward Paul Gauguin, is revealed in Pissarro's letters to his son Lucien. Pissarro's resentment at what he perceived as Gauguin's opportunistic rejection of Impressionism in pursuit of a more facile and commercial art was probably compounded by a sense of personal betrayal, for Pissarro had tutored Gauguin in Impressionist techniques when the latter had first decided to become a painter in the late 1870s, and had largely been responsible for Gauguin's initial inclusion in the Impressionist group exhibitions in 1879.[39] But Pissarro was the most fair-minded of men, and did not let his personal feelings color his artistic judgment. A dramatic illustration of this is provided by a later episode, in 1898, when Degas broke with the Jewish Pissarro during the Dreyfus affair. Pissarro wrote an-

grily to Lucien that his old friend was a "ferocious anti-Semite," then just two days later wrote, "what a real master Degas is; his drawings are more beautiful than Ingres.'"[40] Thus Pissarro did not let Degas' bigotry, or his betrayal of a friendship of more than two decades, interfere with his appreciation of Degas' art. The honesty of Pissarro's evaluation of Gauguin's work should consequently not appear in serious doubt.

Although Gauguin was obviously a gifted student, from early on Pissarro had misgivings not only about Gauguin's excessive eagerness for commercial success but about his lack of artistic judgment and his inability to separate the facile from the real accomplishment.[41] Pissarro's worst fears were no doubt confirmed in 1886, when Gauguin decided to make a radical change in his art: rather than remaining a follower of Impressionism, he would become a leader of Symbolism. Hearing reports of Gauguin's influence on a group of Symbolist painters in Brittany, with bitter irony Pissarro told his son that "this summer at the sea shore he laid down the law to a group of young disciples, who hung on the words of the master. At any rate it must be admitted that he has finally acquired great influence. This comes from years of hard and meritorious work—as a sectarian!"[42] Soon thereafter Pissarro told Lucien he was not surprised at Gauguin's behavior, for "at bottom his character is anti-artistic, he is a maker of odds and ends."[43]

In 1891, however, the critic Albert Aurier anointed Gauguin as the chief of Symbolist art, and singled out for praise his painting *The Vision after the Sermon*.[44] In that work, Gauguin used a dramatic diagonal division of the canvas—a device borrowed from the Japanese artist Hokusai—to separate a triangular space representing a group of Breton peasant women from another triangular field that contained their imagined vision of Jacob wrestling with the angel. The real and illusory figures are further separated by distortions of scale, perspective, and color. Gauguin considered the painting a genuinely religious work, and offered it—unsuccessfully—as a gift to a Breton chapel.[45] But Pissarro could see the painting only as insincere and opportunistic, as he condemned Gauguin both for misappropriating the work of another culture and for pandering to the prejudices of his desired audience:

> The Japanese practiced this art as did the Chinese, and their symbols are wonderfully natural, but then they were not Catholics, and Gauguin is a Catholic.—I do not criticize Gauguin for having painted a rose background

nor do I object to the two struggling fighters and the Breton peasants in the foreground, what I dislike is that he copied those elements from the Japanese, the Byzantine painters and others. I criticize him for not applying his synthesis to our modern philosophy which is absolutely social, anti-authoritarian and anti-mystical. There is where the problem becomes serious. This is a step backwards; Gauguin is not a seer, he is a schemer who has sensed that the bourgeoisie are moving to the right, recoiling before the great idea of solidarity which sprouts among the people.[46]

Thus Pissarro believed that Gauguin had cynically betrayed his commitment to a truthful, realistic art—Impressionism—to produce insincere and plagiarized works in pursuit of commercial success. Pissarro's dedication to an experimental art based on extended observation and incremental change was so strong that he was unable to credit the younger conceptual artist with any genuine accomplishment. In retrospect, however, Gauguin's accomplishment was considerable. Today, as shown in Table 5.2, *The Vision after the Sermon* is among the half dozen most celebrated modern French paintings of the nineteenth century. George Heard Hamilton explains why the painting was a breakthrough work: "The inability of the . . . Impressionists to represent experiences which cannot be explained by sense perceptions was surmounted by Gauguin in his first completely Symbolist painting, *The Vision After the Sermon*."[47] Pissarro could not accept the painting's significance, because he regarded this goal as illegitimate. A few months later another article praising Gauguin caused Pissarro to return to the same theme: "When one does not lack talent and is young into the bargain how wrong it is to give oneself over to impostures! How empty of conviction are this representation, this décor, this painting!"[48]

Paul Durand-Ruel presented an exhibit of Gauguin's paintings when the artist returned from his first stay in Tahiti in 1893. Pissarro again saw in the work only dishonesty, and told his former pupil as much:

I saw Gauguin; he told me his theories about art and assured me that the young would find salvation by replenishing themselves at remote and savage sources. I told him that this art did not belong to him, that he was a civilized man and hence it was his function to show us harmonious things. We parted, each unconvinced. Gauguin is certainly not without talent, but how difficult it is for him to find his own way! He is always poaching on someone's ground; now he is pillaging the savages of Oceania.[49]

Pissarro noted that his friends, including Monet and Renoir, felt the same: "Everyone to whom I talked about Gauguin's exhibition was furious."[50]

Gauguin's remarks to Pissarro at the gallery were prophetic, for his work would in fact influence many of the leading painters of the next generation. Notable among these was Pablo Picasso. One of Picasso's most highly prized possessions was a copy of *Noa Noa*, Gauguin's book about his first stay in Tahiti, which Picasso covered with his own drawings. After seeing a show of Gauguin's Tahitian work at Vollard's gallery in 1901, Picasso made a number of drawings after them, including one that he signed "Paul Picasso" in tribute to the older artist.[51] Picasso's biographer John Richardson has argued that a retrospective exhibition of Gauguin's work in the fall of 1906 had a considerable impact on the young artist in the final months before he produced the *Demoiselles d'Avignon*, for Gauguin's demonstration that a wide variety of types of art, not least those considered primitive, could be combined in a novel and powerful synthesis.[52] But as Gauguin appears to have recognized, the gap that Pissarro documented was generational; whereas the young conceptual artists of the generations after Gauguin could find inspiration in the originality of his Symbolism and his imaginative use of primitive art, Pissarro and his Impressionist friends, whose careers—and lives—were dedicated to a visual art, could see in his work only insincerity, opportunism, and plagiarism.[53]

In New York in the fall of 1962 a leading dealer, Sidney Janis, presented a group show titled "The New Realism." It included paintings by Andy Warhol, Jim Dine, Tom Wesselman, Wayne Thiebaud, and other Pop artists. In his preface to the show Janis declared that these artists "belong to a new generation (age average about 30) whose reaction to Abstract Expressionism is still another manifestation in the evolution of art. As the Abstract Expressionist became the world recognized painter of the 50s, the new Factual artist . . . may already have proved to be the pacemaker of the 60s."[54]

The show had a powerful impact: not only did it draw large crowds, but four Abstract Expressionists—William Baziotes, Adolph Gottlieb, Robert Motherwell, and Mark Rothko—resigned from the Janis Gallery in protest. Janis was both startled and disappointed at what he considered the older artists' hypocrisy: "It took me completely by surprise. Here we had been showing Pollock cheek-by-jowl with Léger, and de Kooning with Mondrian, and Kline with Klee, but when we took up the next generation our artists were furious."[55]

Yet as the critic Calvin Tomkins explained, the Abstract Expressionists' anger was not really so surprising: "They had struggled for many years in total obscurity, their achievements recognized only by one another . . . The recognition that they had so recently and so arduously won was now being usurped, or so they believed, by a new generation of brash youngsters who had become 'artists overnight,' who had not earned anything the hard way, and whose most apparent common bond seemed to be mockery and rejection of all serious art, especially Abstract Expressionism. Pollock and de Kooning and Rothko and Newman had not repudiated Picasso, Mondrian, and Léger. They had worshiped the European masters, while striving heroically to go beyond them. Now, suddenly, heroism and high art were out of style."[56]

Comments by Robert Motherwell at the time of the Janis show confirm Tomkins's claim that the Abstract Expressionists could not see the Pop artists as their heirs or successors. Motherwell declared that Pop was "the 'folk art' of industrial civilization, and thus different from preceding art: i.e., the reference will not be to high art, but to certain effects of industrial society. The Pop artists couldn't care less about Picasso or Rembrandt"—or, in what might seem an obvious unspoken addition, about Rothko or Motherwell.[57] And it wasn't just the Pop artists about whom the Abstract Expressionists took this position, but most of the leading younger conceptual painters of the 1950s and 1960s. When Motherwell first saw Frank Stella's early paintings of black stripes, he remarked, "It's very interesting, but it's not painting."[58] After visiting Jasper Johns's first one-man show in 1958, Mark Rothko commented, "We worked for years to get rid of all that."[59] During the 1960s Rothko's own work was selling for ever higher prices, but he was "depressed because he felt that what was happening in the world of art had passed him by." A friend explained, "The problem was not just being replaced, but *what* was replacing him."[60]

An explicit moral indictment of the younger generation of artists was given by Jon Schueler, a second-generation Abstract Expressionist who had been a student of Clyfford Still. In a letter to the collector Ben Heller in 1961, Schueler wrote:

Perhaps we should consider Jasper Johns. A nice lad, and I'm all for him. . . . Those who have purchased his work have proved themselves willing to foster a symbol of decadence. Paintings are moral statements. They mirror and make mankind. The green-tinted plaster genitals, and their targets [the refer-

ence is to Johns' *Target with Plaster Casts*], are meant to underline and con-
tribute to the degeneracy of an already-sick society. Curiously, the final, bit-
ter, Dada joke is the purchase of objects resulting from this distorted,
amusing, talented, antimoral activity.

Comparing his own work with that of Johns, Schueler asked Heller: "Shall I
charge less for good than one charges for evil?"[61] Although Johns often ex-
pressed his admiration for the Abstract Expressionists, he was not above
mocking the macho image they projected. In 1960 he produced *Painting with
Two Balls*, and admitted that it was an ironic reference to the remarks the Ab-
stract Expressionists often made about "ballsy painting."[62] But the Abstract
Expressionists' moral objections went beyond the homosexuality of Johns,
Rauschenberg, and Warhol to what they perceived as the younger generation's
lack of commitment to making high art, and their consequent belief that the
younger artists were cynically producing a facile art for commercial reasons.

Leo Steinberg describes the source of Matisse's anger at Picasso in 1907 as
the belief that the *Demoiselles d'Avignon* was "an attempt to ridicule the whole
modern movement."[63] Yet Matisse later realized that it wasn't. Matisse's own
art was subsequently influenced by Picasso's Cubism, and the two painters
long maintained a cordial and respectful relationship in mutual recognition of
their rivalry.[64] In sharp contrast, Monet and Pissarro would not be influenced
by Gauguin, nor would they ever recognize him as a worthy rival. Similarly,
Motherwell and Rothko would not be influenced by Johns or Warhol, nor
would they ever in any way treat them as equals.[65] Unlike Matisse and Picasso,
who recognized that the differences between them were matters of style, the
Impressionists and the Abstract Expressionists were separated from many of
their chronological successors by differences in their very conception of art. In
both periods, the inability of these dedicated older experimentalists to respect
the conceptual art of the younger painters who followed them meant that they
could not regard them as worthy successors, because they could not accept
their art as valid. These episodes are therefore marked by conflicts that ran
deeper than those typically covered by Planck's principle or Steinberg's "gen-
eral rule," for they stand as cases in which there was not only the replacement
of an existing method by a newer one, but the replacement of one conception
of a discipline by a different one, which rested on a sharply contrasting
definition of the values of that discipline.

# The Changing Careers of Modern Artists

Degas' career offers strong proof of the fact that a painter must live long to live forever. There are few exceptions . . . [M]ost great figures in the history of art developed the manner we know them by late in life . . . Given talent, an original point of view, vitality, it would seem that time is the fourth essential to the attainment of immortality.

HAROLD VAN DOREN, 1928[1]

How much I admire artists like Bonnard and Maillol. These two will continue to struggle until their last breath. Each year of their old age marks a new birth. The great ones develop and grow as they get older.

JOAN MIRÓ, 1936[2]

Seurat, van Gogh, Lautrec: three glorious names in the art of the dying nineteenth century, three industrious lives broken at the height of their élan . . . Despite their youth all three achieved what Cézanne called *realization*, giving their full measure at an age when others are still seeking.

JOHN REWALD, 1943[3]

There are lives of artists which are short. Raphael, Van Gogh, Gauguin, Seurat, for example. But these people expressed themselves completely. They died represented.

HENRI MATISSE, 1952[4]

Seurat's art is an astonishing achievement for so young a painter. At thirty-one— Seurat's age when he died in 1891—Degas and Cézanne had not shown their measure. But Seurat was a complete artist at twenty-five when he painted the *Grande Jatte*.

MEYER SCHAPIRO, 1963[5]

IN BOTH PARIS in the late nineteenth century and New York in the decades following World War II, the careers of modern painters changed dramatically. This is reflected in the statistics presented in Tables 9.1 and 9.2. For the painters in each of the two periods considered here, these tables show the changes over time in the proportions of artists who executed their most highly valued work before they reached the age of forty. For the French painters, this proportion was just one-tenth for those born prior to 1840, but rose sharply thereafter, to three-fifths for those born from 1840 through the 1870s, and to

*Table 9.1*    Percentage of French painters whose most valuable work was executed before age forty, by birth cohort

|  | Born 1799–1839 | Born 1840–1879 | Born 1880–1900 |
|---|---|---|---|
| Percentage | 9% | 59% | 79% |
| Total artists in cohort | 11 | 17 | 14 |

*Source:* Table 2.1.

four-fifths for those born after 1880. For the Americans, this proportion was one-fourth for painters born during 1870–1899 and just one-eighth for those born during 1900–1920, but jumped up to three-fifths for those born in the 1920s and 1930s.[6]

The importance of these shifts for art history was established by the demonstration of Chapter 3 that modern artists' most valuable work has generally also been that which art scholars consider their most important. Since the importance of an artist in the modern era has been a function of innovativeness, Tables 9.1 and 9.2 imply that in both Paris and New York there was a sudden decline in the age at which important artists typically produced their major innovations.

This study has shown that in both of these periods there was a generational shift in the prevalent attitude of the leading modern painters toward their enterprise. In both cases, the important artists early in the period placed a premium on the development of technique and craftsmanship that would allow them to portray visual sensations, whereas their successors instead emphasized the primary importance of a conceptual approach that would communicate ideas or emotions. The early artists in both eras typically followed a time-consuming development of their art through an experimental process of trial and error, but their successors saw no need for this lengthy process, because they generally believed their thoughts and feelings could successfully be translated quickly, even immediately, into images. The two approaches consequently tended to produce very different career paths: the extended searching of the experimental artists usually meant that the significance of their work continued to develop well into their old age, as they gained in skill, knowledge, and experience, whereas the conceptual artists typically produced their most important work very early in their careers, for they tended to generate their most novel ideas before they had become so accustomed to existing conventions that they could no longer conceive of radically different alternatives. For

*Table 9.2*    Percentage of American painters whose most valuable work was executed before age forty, by birth cohort

|                         | Born 1870–1899 | Born 1900–1920 | Born 1921–1940 |
|-------------------------|:--------------:|:--------------:|:--------------:|
| Percentage              | 25%            | 13%            | 62%            |
| Total artists in cohort | 16             | 15             | 26             |

*Source:* Table 2.2.

the experimentalists, innovations usually came slowly and gradually, appearing incrementally in large bodies of work, whereas for the conceptualists, innovations could come quickly and abruptly, often appearing in celebrated individual breakthrough works.

It is important to emphasize that there has been no simple and invariant relationship between an innovative artist's approach and the age at which he produced his greatest contribution: important conceptual innovations are not exclusively made by the young, nor are experimental innovations made only by the old. It is true, however, that important conceptual innovators usually make their most important contributions early, and that important experimental innovators usually make theirs late. Examination of cases that depart from these norms can usually point to unusual circumstances that resulted in deviations from these typical relationships. As discussed earlier, for example, several apparent anomalies result from a difference between an artist's chronological and professional ages: both Gauguin and van Gogh made major conceptual innovations at relatively old ages, but their delayed entry into art meant that these innovations came early in their careers as painters. In an opposite case, in which an experimental innovator made a great contribution at an early age, Monet's leadership in the breakthroughs of Impressionism appears to have been a consequence of his ability to build on the extended studies of older artists: his relationship with Boudin and Jongkind may have been equivalent to joining a research project already in progress, and may have allowed him to formulate the goals and develop the techniques of Impressionism much sooner than if he had had to begin without the benefit of their lessons.[7]

The association of conceptual innovation with youth, and that of experimental innovation with age, are therefore not laws, but tendencies. In spite of occasional exceptions, however, these tendencies are sufficiently strong to account for the variations observed in the career patterns of most important

modern painters. And the evidence of Tables 9.1 and 9.2 reflects another important fact, for it indicates that whole generations of modern artists have generally been dominated by just one of these two types of innovators. Again the association is not perfect: Manet, for example, was a major conceptual innovator in a cohort dominated by experimentalists. But in general the leading painters of a generation have shared a conception of painting, and have consequently shared an approach to it. Thus Cézanne, Degas, Monet, and Renoir (born 1834–1841) were experimental innovators, whereas in the next generation Gauguin, van Gogh, Seurat, and Toulouse-Lautrec (born 1848–1864) were conceptual innovators, as were Duchamp, Léger, Matisse, and Picasso (born 1869–1881) in the generation that followed. Similarly, Feininger, Marin, O'Keeffe, and Sloan (born 1870–1887) shared an experimental approach, as did de Kooning, Motherwell, Pollock, and Rothko (born 1903–1915) in the next generation, but in the generation that followed them, Johns, Rauschenberg, Stella, and Warhol (born 1925–1936) were all conceptual innovators.

This clustering of artists within generations by approach was in part simply a consequence of their exposure as students and young artists to the same basic practices and ideas, those that prevailed at the time when they first entered their profession. Yet as discussed in Chapter 8, the clustering often had a more specific source, since at formative stages in their careers many of the leading modern artists were members of movements committed to particular conceptions of art. In these cases their shared commitment to a particular approach to innovation was not simply a consequence of when they entered their profession, but was more specifically a consequence of a deliberate choice to collaborate in pursuit of a common goal.

In each generation, a number of innovative schools or groups have contended for dominance within the world of modern art. Which of these groups succeed in achieving central positions generally becomes apparent most clearly in retrospect, for the most important criterion of success—not only for scholars or other outside observers of art history, but for most, if not all, of the artists themselves—is perceived most clearly in the long run, in the form of influence on other artists.

The greatest influence of major innovators is typically on subsequent generations. The transition across generations can, but need not, involve a change in the predominant type of innovator, in the form of a shift from experimentalists to conceptualists or vice versa. Notable examples of all possi-

ble types of transition appear in the periods studied here. In France, the conceptual innovations of Manet influenced the experimental discoveries of the Impressionists, which in turn helped to produce both the experimental innovations of Cézanne and the conceptual breakthroughs of Seurat, Gauguin, and van Gogh. Both the experimentalist Cézanne and the conceptual innovators Seurat, Gauguin, and van Gogh helped to inspire the conceptual innovations of the Fauves and the Cubists. Cubism, and the reaction to it, then led to a variety of new approaches, including the conceptual innovations of Duchamp and the experimental innovations of Miró, Masson, and others in their branch of Surrealism. In the United States, the experimental approach of the Abstract Expressionists was followed by the conceptual innovations of Johns, Rauschenberg, and Stella, and the lead of these younger conceptual artists was then followed by a number of later movements of conceptual innovators, including prominently Pop Art, Minimal Art, Conceptual Art, and a host of others in the 1960s and beyond.

As the variety of these transitions would suggest, modern artists' careers have not changed in any predictable way over time: there is no need for experimental or conceptual approaches to alternate in any fixed or deterministic way across generations. And this is true not only at the group level, but also for individuals. Thus it might be thought that experimental painters could best learn from other experimentalists; certainly Cézanne's enthusiastic response to Pissarro's teaching suggests the advantage of a shared commitment to an experimental approach. Yet as seen earlier, Gauguin could also learn key fundamental techniques in his apprenticeship with Pissarro, then depart from them to make conceptual innovations that were anathema to his teacher. The nature of influence is too diverse, and possibilities for innovation too varied, to reduce the relationships among artists and among movements to any deterministic formula.

It appears clear, however, that some external conditions can favor one approach over another, and foster shifts in the prevailing conception of art. The periods examined in this study demonstrate that an increased demand for innovation, experienced by artists in the form of intellectual and financial pressures in a central location of the art world, can strongly encourage conceptual innovation, because of the greater speed with which conceptual breakthroughs can be made. Thus the intense debates among artists and critics in Paris in the 1880s, and both the intellectual debates and the growing financial rewards for advanced art in New York in the 1950s, produced a heightened de-

mand for innovation and led to generations dominated by conceptual innovation: Seurat and Gauguin became leaders of young advanced artists in the earlier period, and Johns and Rauschenberg became leaders in the later one. Nor would it appear to be an accident that the major French experimental innovator of the decades after 1880, Cézanne, left Paris quite early and remained in relative seclusion in the distant provincial town of Aix, where he developed his art at a slower pace, away from the pressures of the art world's center.[8]

## Quantifying Art History

If ever there was a study which, needing as it does the cooperation of so many sciences, would benefit by sharing the life of the University, it is surely that of Art-history . . . [W]e have such a crying need for systematic study in which scientific methods will be followed wherever possible, where at all events the scientific attitude may be fostered and the sentimental attitude discouraged.
ROGER FRY, 1933[9]

The value of any rapprochement between the history of art and the history of science is to display the common traits of invention, change, and obsolescence that the material works of artists and scientists both share in time.
GEORGE KUBLER, 1962[10]

Why do people think artists are special? It's just another job.
ANDY WARHOL, 1975[11]

In "The Value of Modern Art," a lecture first given in 1948, Meyer Schapiro described the features that set modern painting apart from earlier art and discussed the specific goals that led modern painters to practices that had been so widely condemned. He observed that the modern artist, unlike his predecessors, "is committed to the idea of endless invention and growth . . . He has an ideal of permanent revolution in art." This goal had been understood by sophisticated critics in Paris as early as the late nineteenth century, and would later be broadly accepted by art historians. Yet Schapiro then proceeded to a striking parallel:

The artist must be ceaselessly open to new possibilities and suggestions and is impelled by a ruthlessness and conception of integrity to search for means of developing and surmounting his actual style. In that respect he is like the most advanced natural scientists and mathematicians, who feel that there are always latent in problems unforeseen relationships that, if disclosed, would

at once require a complete reopening of the whole field and a change in their habits of thought.[12]

Schapiro's identification of the commonality of the enterprises of the artist and the scholar has not been fully appreciated by art historians, perhaps because it conflicts with the romanticized view of the artist's enterprise that serves as the implicit foundation for much of art history.[13] Yet it suggests a number of interesting implications, several of which were discussed in Chapter 8. Thus the frequency with which important modern painters have had teachers who were themselves important artists of the preceding generation has a strong parallel in academic disciplines, in the high probability that a prominent scholar will have had an older prominent scholar as a teacher.[14] And the general rule that early in their careers important modern painters have worked closely with other major artists of their own generation is similarly matched by the high frequency with which distinguished scholars learn their trades early in their careers in close contact with talented peers.

The core of this study has established the significance of another important parallel between artists and academics that has not previously received systematic attention. It has demonstrated that modern artists, like scholars in many academic disciplines, can be divided into two groups: those who work experimentally and those who work conceptually. For both artists and scholars, the career patterns of these groups differ sharply, as conceptualists usually make their most important theoretical contributions early in their careers, whereas experimentalists usually produce their most important empirical innovations later in theirs.

This book has been able to draw on an outstanding strength of existing scholarship on the history of modern art, namely the great attention it has devoted to careful qualitative study of important painters. Art historians have thoroughly documented the careers, described the procedures, and analyzed the accomplishments of all major, and many minor, contributors to modern art. Historians have also studied the activities of groups of artists, with detailed analysis of the movements modern painters have created. Yet the present study has also exposed a significant deficiency in art historical scholarship. For what has been neglected is systematic generalization about modern artists.

This is not a new observation. When the distinguished critic Roger Fry was elected Slade Professor of Fine Art at Cambridge University in 1933, he

took the occasion of his inaugural lecture to decry the absence of "systematic study," employing "scientific methods," from his discipline. Interestingly, in that same lecture Fry raised an issue that has been a central concern here. He observed that "the mere length of time that an artist has lived has then inevitably an influence on the work of art." Pointing out that some artists produce their best work late, and others early, he touched briefly on their contrasting characteristics:

> When we look at the late works of Titian or Rembrandt we cannot help feeling the pressure of a massive and rich experience which leaks out, as it were, through the ostensible image presented to us, whatever it may be. There are artists, and perhaps Titian and Rembrandt are good examples, who seem to require a very long period of activity before this unconscious element finds its way completely through into the work of art. In other cases, particularly in artists whose gift lies in a lyrical direction, the exaltation and passion of youth transmits itself directly into everything they touch, and then sometimes, when this flame dies down, their work becomes relatively cold and uninspired.

Fry acknowledged the casual nature of his comments, conceding apologetically, "I fear that a great deal of this must appear to you to be rather wildly speculative and hazardous."[15] He raised this issue, however, because for him understanding these effects of age on an artist's achievement was central to interpreting works of art.

Although many decades have passed since Fry spoke, art historians have not taken up the challenges of his lecture. It is striking how pertinent his general methodological criticism, of art historians' neglect of "systematic study in which scientific methods will be followed wherever possible," remains today. Nor have art historians followed up his speculations on the issue of age and artistic achievement, for artists from any period. The present study has shown the value of doing this. The discovery of the common career patterns within birth cohorts, and of the contrasting patterns across cohorts, deepens our understanding not only of why individual modern painters have matured artistically at such dramatically different rates, but also of how, and why, modern painting has changed in the ways it has at particular times.

Systematic comparisons of artists' careers can most readily be done through quantification. As demonstrated here, the quantification involved need not be complex. Measuring the relationship between the auction values

of paintings and the age of the artist when he executed them is straightforward; so is tabulating the numbers of paintings in a retrospective exhibition according to the artist's age when they were made, or doing the same for the paintings of a given artist reproduced in a collection of art history textbooks. But as has been shown, these simple quantitative measures can be powerful tools in separating painters according to their approach to their work and to their conception of the goals of their art.

## Seekers and Finders

> I seek in painting.
> PAUL CÉZANNE[16]

> I don't seek, I find.
> PABLO PICASSO[17]

There have been two very different life cycles among great modern artists. Some, like Cézanne, have developed their art slowly, and arrived at their greatest contributions only after long years of work. Others, like Picasso, have matured rapidly, and made their greatest contributions very early in their careers. Study of the methods of these artists further reveals that each career path has been associated with a distinct set of artistic practices. Cézanne and the other seekers have generally worked by trial and error, experimenting by continually making marginal changes in their techniques; carefully inspecting their work in progress, they change their images accordingly and arrive incrementally at new contributions. Picasso and the other finders have typically made discrete leaps in their work, suddenly producing innovations through the use of new ideas; after thinking their work out in advance, they execute it according to carefully preconceived plans.

Study of the ideas of these artists reveals that these two different life cycles, and sets of practices, have been associated with very different conceptions of the nature of modern art. The seekers have based their work on perception. Their goal has been to present visual sensations, and they have thought of their careers as an extended process of searching for the elusive best means of accomplishing this. In contrast, the finders have based their work on conception. Their goal has been to communicate their ideas or emotions, and they have considered their careers as consisting of a series of statements—often unrelated—in which these ideas appear.

Through systematic study of large numbers of painters, this book has sought to add another dimension to our understanding of the history of modern art. Recognition of the sharp contrast between experimental and conceptual innovators in methods and goals illuminates a number of features of that history that had previously been neglected, or that were only poorly understood. These range widely: from the puzzle raised in Chapter 1, of why some important painters could make great contributions so young while others toiled into old age before making theirs; through a problem seen in Chapter 5, of why some of the most famous individual paintings have been produced by relatively minor artists, while many of the most important painters have not produced famous individual works; to a question considered in Chapter 8, of why some artistic battles across the generations have been so violent, and why some of these conflicts could not be reconciled. And these examples could be multiplied considerably, both with questions that have been considered here and with others that remain to be studied in future. For this book has exposed a deep fault line in the history of modern art, by revealing the dramatic and systematic differences between experimental and conceptual approaches to artistic innovation that have separated seekers and finders over the course of time.

APPENDIXES

NOTES

BIBLIOGRAPHY

CREDITS

INDEX

## Appendix A

## THE CRITICAL EVALUATION OF THE CAREERS OF FRENCH ARTISTS

How closely does the auction market's assessment of the most important time in a painter's career agree with the judgments of art historians? This appendix provides a systematic comparison of the results obtained from the econometric analysis of auction market outcomes with those implied by the evidence of textbook illustrations for the modern French painters considered by this study. Although some of the textbooks used here survey the history of art in general, many are devoted exclusively to the history of modern art. Art historians' judgments of when modern art began differ somewhat, but the earliest painters included in nearly all of the books are those born during the 1830s. The analysis presented here will consequently be restricted to painters born from 1830 on.

As discussed in Chapter 3, the present analysis of textbook illustrations is done in the spirit of a citation study: the painting or paintings by a given artist that a historian selects for reproduction are assumed to be those the historian considers to be that painter's most important work, or to represent that painter's most important contribution. The procedure here is to examine the dates at which the paintings reproduced in each text were executed in order to determine which period each author judges to be an artist's most important. Pooling this evidence on dates from as large a collection of books as possible then provides a systematic survey of the opinions of art historians regarding when an artist produced his most important work.

This study found a total of thirty-three books that had been published in English since 1968 and that provided illustrated surveys of at least the full history of modern painting.[1] The analysis of these books began by listing the date of execution of every painting reproduced in these books by the forty-one painters included in Table 1.1 who were born after 1830. For each artist, Table A.1 presents the distribution of these reproduced paintings according to the artist's age at the time of their production. To smooth fluctuations across indi-

*Table A.1*  Distribution, by artist's age, of paintings illustrated in textbooks, French artists (mean paintings per year)

| Artist | 15–19 | 20–24 | 25–29 | 30–34 | 35–39 | 40–44 | 45–49 | 50–54 | 55–59 | 60–64 | 65–69 | 70–74 | 75–79 | 80–84 | 85–89 |
|---|---|---|---|---|---|---|---|---|---|---|---|---|---|---|---|
| Arp | 0 | 0 | 0.2 | 3.0 | 1.0 | 0.4 | 0.2 | 0.2 | 0 | 0 | 0.2 | 0 | 0 | 0 | |
| Bissière | 0 | 0 | 0 | 0 | 0 | 0 | 0 | 0 | 0 | 0 | 0.6 | 0 | 0 | | |
| Bonnard | 0 | 0.2 | 0.6 | 1.0 | 0 | 0.2 | 1.0 | 0 | 0.2 | 0.4 | 1.6 | 0.4 | 0.2 | 0 | |
| Braque | 0 | 0.4 | 12.6 | 3.4 | 2.0 | 1.0 | 1.6 | 0 | 1.2 | 0 | 0.8 | 0.2 | 0 | 0 | |
| Caillebotte | 0 | 0 | 0.8 | 0.2 | 0 | 0 | 0 | | | | | | | | |
| Cassatt | 0 | 0 | 0 | 0.4 | 1.0 | 0.2 | 2.2 | 0 | 0 | 0 | 0 | 0 | 0 | 0 | |
| Cézanne | 0 | 0.2 | 0.4 | 3.0 | 1.2 | 1.8 | 4.2 | 2.6 | 4.0 | 2.2 | 12.7 | | | | |
| Chagall | 0 | 2.0 | 2.2 | 1.4 | 0.4 | 0 | 0 | 0.2 | 0.4 | 0.2 | 0 | 0 | 0 | 0 | 0.2 |
| Degas | 0 | 0.2 | 0.8 | 1.2 | 2.2 | 6.0 | 1.8 | 2.6 | 0.8 | 0.4 | 0.2 | 0 | 0 | 0 | |
| Delaunay | 0 | 0.4 | 5.4 | 0 | 0 | 0 | 0 | 0 | 0 | | | | | | |
| Derain | 0 | 0 | 4.6 | 0.2 | 0 | 0.2 | 0 | 0 | 0.4 | 0 | 0 | 0 | | | |
| Duchamp | 0 | 0.8 | 7.2 | 3.2 | 3.2 | 0 | 0 | 0 | 0 | 0 | 0 | 0 | 0 | 0 | |
| Dufy | 0 | 0 | 0.6 | 0 | 0 | 0 | 0 | 0.6 | 0 | 0 | 0 | 0.2 | 0 | | |
| Gauguin | 0 | 0 | 0 | 0 | 0.4 | 13.2 | 5.0 | 0.8 | 0 | | | | | | |
| Gris | 0 | 0.2 | 2.8 | 0.4 | 0.4 | 0 | | | | | | | | | |
| Guillaumin | 0 | 0 | 0.2 | 0 | 0 | 0 | 0 | 0 | 0 | 0 | 0 | 0 | 0 | 0 | 0 |
| Herbin | 0 | 0 | 0 | 0 | 0 | 0 | 0 | 0 | 0.2 | 0.2 | 0.2 | 0 | 0 | | |
| Léger | 0 | 0 | 0.4 | 1.8 | 3.0 | 2.4 | 0.2 | 0.2 | 1.8 | 0.4 | 0 | 0 | | | |
| Manet | 0 | 0 | 1.4 | 10.4 | 5.6 | 3.0 | 1.2 | 10.5 | | | | | | | |
| Masson | 0 | 0 | 0.2 | 1.2 | 0 | 0.2 | 0.8 | 0 | 0 | 0 | 0 | 0 | 0 | 0 | 0 |
| Matisse | 0 | 0 | 0.6 | 1.0 | 13.0 | 7.4 | 3.4 | 2.4 | 1.2 | 0.8 | 0.6 | 0.4 | 0.8 | 2.2 | 2.2 |
| Miró | 0 | 0.4 | 1.0 | 4.4 | 1.0 | 3.2 | 1.6 | 0 | 0.2 | 0.2 | 0.6 | 0.2 | 0 | 0 | 0 |

| | | | | | | | | | | | | | | | |
|---|---|---|---|---|---|---|---|---|---|---|---|---|---|---|---|
| Modigliani | 0 | 0 | 0.2 | 1.8 | 0 | 0.6 | 0.6 | 5.0 | 0.2 | 0.6 | 0.6 | 0 | 0.8 | 2.0 | 0.6 |
| Monet | 0 | 0 | 5.6 | 5.6 | 2.8 | 0.6 | 0.6 | 0 | 0 | 0 | | | | | |
| Morisot | 0 | 0 | 0.2 | 1.6 | 0.8 | 0.2 | 0.6 | 0 | 0 | 0 | | | | | |
| Picabia | 0 | 0 | 0 | 0.6 | 2.0 | 1.0 | 0.4 | 0 | 0 | 0 | 0 | 0 | | 0 | |
| Picasso | 0.4 | 7.4 | 18.4 | 14.8 | 2.0 | 9.6 | 3.2 | 3.0 | 6.4 | 0.6 | 0.4 | 0.4 | 0.2 | 0 | 0 |
| Pissarro | 0 | 0 | 0 | 0 | 1.0 | 2.2 | 1.0 | 0.2 | 1.6 | 0 | 1.2 | 0.4 | 0.2 | | |
| Redon | 0 | 0 | 0 | 0 | 0.2 | 0.6 | 1.0 | 0 | 0.2 | 1.2 | 0.6 | 0.6 | 0.4 | | |
| Renoir | 0 | 0 | 2.4 | 1.6 | 4.0 | 3.2 | 1.6 | 0.6 | 0.4 | 0 | 0.2 | 0.4 | 0 | | |
| Rouault | 0 | 0.2 | 0 | 0.8 | 1.6 | 0.2 | 0.4 | 0.2 | 0.4 | 0.4 | 1.8 | 0.2 | | | |
| Rousseau | 0 | 0 | 0 | 0 | 0 | 0.2 | 0.8 | 2.0 | 0 | 0.8 | 2.0 | | | | |
| Seurat | 0.2 | 0.4 | 9.4 | 3.3 | | 0 | 0 | 0.2 | 0 | | | | | | |
| Sisley | 0 | 0 | 0 | 0.6 | 0.6 | 0 | 0 | | | | | | | | |
| Soutine | 0 | 0 | 1.2 | 1.2 | 0.2 | 0 | 0 | | | | | | | | |
| Tanguy | 0 | 0 | 1.0 | 0 | 0.6 | 0.6 | 0 | 0.4 | | | | | | | |
| Toulouse-Lautrec | 0 | 0.8 | 5.4 | 1.8 | 0 | | | | | | | | | | |
| van Gogh | 0 | 0 | 0.4 | 5.6 | 28.7 | 0 | 0 | 0 | 0.2 | 0 | 0.2 | 0 | 0 | | |
| Vlaminck | 0 | 0.2 | 0.6 | 1.8 | 0 | 0 | 0 | 0 | 0 | 0 | 0 | | | | |
| Vuillard | 0 | 0.6 | 1.4 | 1.0 | 0.2 | 0.4 | 0 | 0 | 0 | 0 | 0 | | | | |
| Whistler | 0 | 0 | 1.0 | 0.4 | 1.6 | 2.6 | 0.2 | 0 | | | | | | | |

*Source*: This table and Table A.2 are based on the textbooks listed in note 1. See the text for the procedure. In the final interval of each painter's life, illustrations per year were calculated only for the portion of the interval for which he survived.

vidual years, the distributions are presented as five-year averages. Each entry in Table A.1 therefore represents the mean number of an artist's paintings executed in each year of a given five-year period of his life that are reproduced in the thirty-three books considered here. For example, the table shows that an average of three paintings per year by Jean Arp are reproduced in the texts from the five years when he was 30–34; the thirty-three books thus contain a total of fifteen illustrations of paintings he executed during those five years. The table also shows that that age interval was the most heavily represented for Arp in the textbooks, as no other five-year period in Arp's career had an average of more than one illustration per year.

To facilitate the comparison of the evidence based on prices with that drawn from the textbooks, for all of the French artists for whom ages at peak value could be estimated from the auction data, Table A.2 presents these peak ages, together with the five-year interval of the artist's career that was most often illustrated in the textbooks. A total of thirty-six artists are listed in Table A.2. For seventeen of these—including Braque, Cézanne, Gauguin, Manet, Monet, Picasso, Renoir, Seurat, Toulouse-Lautrec, and van Gogh—their age at peak value falls within the same span of their careers (usually a five-year period) that is most heavily represented by textbook illustrations. For another thirteen—including Arp, Degas, Derain, Léger, Modigliani, Pissarro, and Vlaminck—their age at peak value falls within five years of the period most heavily illustrated by the textbooks. Thus for thirty of the thirty-six artists— more than four-fifths—the age at peak value is no more than five years from the period of the artist's career that is most heavily illustrated in textbooks.

Of the remaining six cases, for three—Bonnard, Guillaumin, and Tanguy —the age at peak value is less than ten years from the age interval of the artist's career with the most illustrations. Thus for 92 percent of the cases considered, the evidence of the auction market and that of the textbooks agree on the most important decade of the artist's career. This suggests that the two sources effectively agree on what constituted the artist's most important contribution more than 90 percent of the time.

For only three artists—Matisse, Miró, and Rouault—does the age at peak value lie more than ten years from the most heavily illustrated interval of the artist's career. For Matisse the auction market valuations clearly disagree with the critical consensus. In the cases of Miró and Rouault, however, the disagreement is less pronounced. Table A.1 shows that no single short period dominates the historians' assessments of their work; for both painters the text-

book illustrations are spread more evenly over longer portions of their careers. For Miró, the peak age interval for textbook illustrations is 30–34, with an average of 4.4 illustrations per year. Yet ages 40–44 are not far below this, with 3.2 illustrations per year, and Miró's age at peak value closely follows this interval, at 46. The disagreement in this case between the auction market and the textbooks is thus not extreme. In Rouault's case, the textbooks fail to identify any period of his career as far more important than others; the books do not contain a total of as many as ten paintings from any five-year span. The textbook evidence consequently suggests that no single period of Rouault's career was of special importance. The disagreement for Rouault between the auction market and the textbooks consequently seems relatively unimportant.

Table A.2 also reports the single year of each artist's career that is most heavily represented in the textbook illustrations, for those artists who had at least one year represented by at least five illustrations. In twenty-two of twenty-eight cases—79 percent—this single year is within six years of the artist's age at peak value. This again underlines the high degree of agreement between collectors and scholars in identifying most artists' greatest contributions.

The strength of the textbook evidence on any specific artist depends on the importance of the artist, for the greater the number of textbook illustrations of an artist's work, the more clearly the consensus of historians on the relative importance of the stages of his career can be identified. It is consequently of considerable interest that for nine of the ten artists whose work is most often reproduced in the textbooks, the auction market's age at peak value agrees with the consensus of the art historians.[2] Thus for eight of these—Picasso, Cézanne, Manet, Monet, Braque, van Gogh, Gauguin, and Renoir (in descending order of total illustrations)—the age at peak value falls within the five-year span most represented in the textbooks, while for Degas the age at peak value of 46 lies just outside that range of 40–44. Only for Matisse is there a significant disagreement between the two measures; the reasons for this, which may involve the unusual nature of his contributions and his career, are discussed in Chapter 6.

No judgment of the most important period of an artist's career, whether that of art historians or of collectors, should be accepted automatically and uncritically. Investigating the sources of any differences of opinion on this issue, whether they arise between market valuations and scholarly judgments, or simply among scholars, can add to our understanding of the artist's career.

*Table A.2*   Ages at peak value and ages with most illustrations, French artists

| Artist | Age at peak value | Age interval with most illustrations | Age in single year with most illustrations |
|---|---|---|---|
| Arp | 35 | 30–34 | 31 |
| Bissière | 70 | 65–69 | |
| Bonnard | 77 | 65–69 | 46 |
| Braque | 28 | 25–29 | 29 |
| Cassatt | 40 | 45–49 | 46 |
| Cézanne | 67 | 65–67 | 67 |
| Chagall | 29 | 25–29 | 24 |
| Degas | 46 | 40–44 | 42 |
| Derain | 24 | 25–29 | 25 |
| Dufy | 59 | 25–29, 50–54 | |
| Gauguin | 44 | 40–44 | 41 |
| Gris | 28 | 25–29 | 28 |
| Guillaumin | 35 | 25–29 | |
| Herbin | 73 | 55–69 | |
| Léger | 33 | 35–39 | 38 |
| Manet | 50 | 50–51 | 31 |
| Masson | 34 | 30–34 | 31 |
| Matisse | 66 | 35–39 | 36 |
| Miró | 46 | 30–34 | 32 |
| Modigliani | 35 | 30–34 | 33 |
| Monet | 29 | 25–34 | 54 |
| Morisot | 33 | 30–34 | 31 |
| Picabia | 39 | 35–39 | 38 |
| Picasso | 26 | 25–29 | 26 |
| Pissarro | 45 | 40–44 | 43 |
| Redon | 59 | 60–64 | 63 |
| Renoir | 35 | 35–39 | 35 |

*Table A.2   (continued)*

| Artist | Age at peak value | Age interval with most illustrations | Age in single year with most illustrations |
|---|---|---|---|
| Rouault | 81 | 65–69 | 65 |
| Seurat | 29 | 25–29 | 27 |
| Sisley | 35 | 30–39 | |
| Soutine | 37 | 25–34 | |
| Tanguy | 35 | 25–29 | |
| Toulouse-Lautrec | 26 | 25–29 | 28 |
| van Gogh | 36 | 35–37 | 35 |
| Vlaminck | 29 | 30–34 | 30 |
| Vuillard | 26 | 25–29 | |

*Note:* Age at peak value is taken from Table 2.1.

Age interval with most illustrations is taken from Table A.1. This is a single five-year period except in the case of ties, in which case it includes two or three five-year periods. The interval is shorter than five years only in cases in which the artist died before the end of a standard interval.

Age in single year with most illustrations is not reported for artists who did not have at least five illustrations in any single year.

Yet when the opinions of collectors agree with those of art historians, this increases our confidence that we have accurately observed the results of a broad consensus on the timing of an artist's most important contribution. It is consequently of considerable interest to learn what the analysis of this appendix reveals, that for the overwhelming majority of artists, collectors and art historians agree on the timing of the most important work of the French artists considered by this study.

## Appendix B

## THE CRITICAL EVALUATION OF THE CAREERS OF AMERICAN ARTISTS

How closely does the auction market's assessment of the most important period of an artist's career agree with the judgments of art historians? This appendix compares the estimated ages at peak value obtained from auctions with the evidence of retrospective exhibitions for the American painters considered by this study. As noted in Chapter 3, this analysis is based on the premise that museum curators who arrange retrospective exhibitions implicitly reveal their judgments of the relative importance of an artist's work at different ages through their decisions on how many paintings to include from each phase of the artist's career.

Retrospective exhibitions have gained considerable public attention in recent years. Retrospectives of modern painters—including Jackson Pollock, Mark Rothko, Jasper Johns, and Robert Rauschenberg—have been prominent among the large traveling exhibitions that have come to dominate the attention, and the revenues, of leading museums.[1] Nor are these exhibitions merely an economic phenomenon, for retrospectives can serve as the occasion for critical reassessments of an artist's work; the catalogues of these exhibitions, for example, often include substantial essays by scholars. It is perhaps surprising, in view of its apparent importance, that the retrospective exhibition as an art world institution has largely been ignored by art historians.[2] In the absence of such attention, the precise purpose of retrospectives remains unclear. Curators rarely state directly the purpose of their exhibitions. Yet the size and composition of particular exhibitions can be suggestive. Some retrospectives appear to be intended as comprehensive surveys that document artists' entire careers. These shows can be very large, and include work from all stages of their subjects' lives. Other retrospectives appear to have more restricted critical goals, in representing the development of a particular contribution of the artist considered. These exhibits may ignore some aspects of the artist's career, quickly passing over or even omitting entirely work from periods deemed ir-

relevant to the contribution of interest. Although such differences of purpose are of interest in understanding the role of retrospectives in general, for present purposes they may not be crucial. For regardless of whether curators choose to include some work from what they consider relatively unimportant phases of an artist's career, or to ignore them entirely, the periods from which they present the largest numbers of paintings should normally be those they consider the most important.

The first step in the present analysis was to attempt to locate catalogues from exhibitions, specifically intended as full career retrospectives, for all of the American painters considered by this study. At least one such catalogue was found for all but six of the seventy-five painters listed in Table 2.2. When an artist had had more than one retrospective, the most recent was chosen for this analysis.

For the sixty-nine painters covered by these catalogues, Table B.1 presents the distribution of paintings included in each retrospective according to the artist's age at the date of their execution. The distributions are presented as five-year averages, so each entry in Table B.1 indicates the mean number of paintings produced in each year of a specified five-year period of an artist's life that were included in his retrospective exhibit. For example, the table shows that an average of 5.2 paintings per year from the five years when he was 50–54 were included in Josef Albers's 1988 Guggenheim Museum retrospective; thus the exhibition contained a total of 26 paintings that Albers made in those five years. The table also shows that this age interval was the one most heavily represented in the exhibition, as no other five-year period in Albers's career had an average of more than 3.2 paintings per year.

To facilitate the comparison of the evidence based on prices with that drawn from the retrospectives, for each American artist for whom both an age at peak value could be estimated from the auction data and a retrospective catalogue could be found, Table B.2 presents both the age at peak value and the five-year interval of the artist's career that was most heavily represented in the retrospective. A total of fifty-three artists are listed in Table B.2.

Four of the artists in Table B.2—Dine, Estes, Motherwell, and Pearl-stein—must immediately be eliminated from this analysis. For these four, their most recent retrospective exhibition was held before the date at which their work reached its estimated peak value. It would consequently be impossible for the two sources to agree on the timing of their most important work.

This leaves forty-nine artists to be considered. For nineteen of these—

including Francis, Frankenthaler, Gorky, Johns, Kline, Louis, Pollock, Sloan, and Warhol—the estimated age at peak value falls within the same five-year span that was most heavily represented in their retrospective exhibitions. For another sixteen—including de Kooning, Feininger, Hofmann, Lichtenstein, Newman, Noland, O'Keeffe, Rauschenberg, and Frank Stella—the age at peak value falls within five years of the period most emphasized by the retrospectives. And for another four—Dove, LeWitt, Olitski, and Twombly— their age at peak value falls within ten years of the period most emphasized by the retrospective. Thus for thirty-nine of forty-nine painters—80 percent— the estimated age at peak value is within a decade of the five-year period most heavily represented in retrospective exhibitions. In virtually every one of these cases, this means that the auction market outcomes agree with the judgment of museum curators on the artist's most important style or contribution.

This leaves eleven artists for whom there is a difference of more than ten years between their age at peak value and the primary period identified by their retrospective exhibition. Yet not all of these disagreements are as pronounced as this difference might suggest. For example, Mark Rothko's age at peak value was 54, whereas the major period of his retrospective was the last, ages 65–67. Yet the annual average of 3.8 paintings per year in the exhibit from ages 50–54 was less than 30 percent below the average of 5.3 from his final three years, as was the 3.8 per year from ages 55–59, and the average of 4.4 from ages 45–49 was less than 20 percent below the mean for his last period. In contrast, the exhibition's emphasis on all of these late periods is far greater than that for earlier periods of his career; the retrospective contained no paintings that Rothko made before the age of 30, and annual averages of only 1 and 2 paintings per year from the first and second half of his thirties, respectively. Thus although the retrospective gave its greatest emphasis to Rothko's final three years, it also paid considerable attention to his late forties and fifties, and did not judge these years to be far below his last few in importance. Five other artists—Anuszkiewicz, Kelly, Marin, Rosenquist, and Tobey—are similar to Rothko in this respect, as the retrospective for each contained more than half as many paintings from the period that included their estimated age at peak value as from the interval most heavily represented in the retrospective. For these artists it might consequently be said that although there is a considerable disagreement in time between the two sources on the date of an artist's best work, the intensity of the disagreement is not great.

There then remain four painters for whom the retrospectives give strong

Table B.1  Distribution by artist's age of paintings included in retrospective exhibitions, American artists (mean paintings per year)

| Artist | 15–19 | 20–24 | 25–29 | 30–34 | 35–39 | 40–44 | 45–49 | 50–54 | 55–59 | 60–64 | 65–69 | 70–74 | 75–79 | 80–84 | 85–89 |
|---|---|---|---|---|---|---|---|---|---|---|---|---|---|---|---|
| Albers | 0 | 0 | 0.6 | 0 | 1.4 | 3.2 | 3.0 | 5.2 | 2.2 | 3.2 | 0.8 | 1.2 | 3.2 | 3.2 | 0.3 |
| Anuszkiewicz | 0 | 0.6 | 2.4 | 1.0 | 2.4 | 2.2 | 1.4 | 2.2 | 1.8 | 1.6 | 1.0 | | | | |
| Baziotes | 0 | 0 | 0 | 0.6 | 2.8 | 2.8 | 2.0 | 2.0 | | | | | | | |
| Bruce | 0 | 0 | 0 | 0.8 | 2.0 | 2.6 | 1.4 | 1.0 | | | | | | | |
| Burchfield | 0 | 5.4 | 5.4 | 0.8 | 3.4 | 2.6 | 2.4 | 2.4 | 2.0 | 1.4 | 2.2 | 2.0 | | | |
| Close | 0 | 0 | 1.6 | 3.8 | 4.6 | 1.6 | 3.2 | 2.6 | 3.7 | | | | | | |
| Davis | 0 | 3.8 | 3.8 | 4.4 | 6.8 | 2.2 | 3.2 | 1.2 | 2.2 | 3.2 | 2.2 | 2.3 | | | |
| de Kooning | 0 | 0 | 0 | 0.2 | 0.6 | 2.2 | 3.4 | 2.8 | 1.2 | 1.2 | 1.2 | 2.0 | 1.2 | 0.8 | |
| Demuth | 0 | 0 | 0 | 6.8 | 7.2 | 4.6 | 4.0 | 1.0 | | | | | | | |
| Diebenkorn | 0 | 0 | 2.2 | 4.2 | 5.0 | 6.8 | 3.0 | 3.6 | 4.4 | 3.0 | 1.4 | 4.0 | | | |
| Dine | 0 | 1.4 | 15.2 | 8.4 | | | | | | | | | | | |
| Dove | 0 | 0 | 0.2 | 2.6 | 0.4 | 2.6 | 4.0 | 1.6 | 2.8 | 3.8 | 0.5 | | | | |
| Estes | 0 | 0 | 0.2 | 1.4 | 2.2 | 1.3 | | | | | | | | | |
| Feininger | 0 | 0 | 0 | 0 | 3.2 | 3.2 | 7.4 | 1.8 | 3.2 | 3.4 | 2.4 | 4.6 | 2.2 | 2.6 | |
| Flack | 0.2 | 1.6 | 1.2 | 2.0 | 0.6 | 2.0 | 1.4 | 1.2 | | | | | | | |
| Francis | 0 | 0.2 | 1.4 | 4.6 | 3.8 | 1.6 | 0.6 | 1.8 | 1.2 | 0.8 | 1.2 | | | | |
| Frankenthaler | 0 | 0.2 | 0.4 | 1.6 | 1.6 | 0.8 | 1.6 | 1.0 | 0.6 | 1.0 | | | | | |
| Gorky | 0 | 2.2 | 5.6 | 9.8 | 8.6 | 19.8 | | | | | | | | | |
| Gottlieb | 0 | 1.0 | 1.0 | 1.6 | 4.0 | 3.0 | 3.0 | 2.6 | 2.2 | 1.4 | 3.8 | 3.0 | | | |
| Guston | 0.4 | 0.2 | 0.6 | 1.2 | 1.8 | 1.6 | 1.6 | 1.6 | 2.2 | 5.4 | 7.5 | | | | |
| Hartley | 0 | 0 | 0 | 2.2 | 7.2 | 1.8 | 1.2 | 1.4 | 2.4 | 4.6 | 5.0 | | | | |

|  | | | | | | | | | | | | | | | | |
|---|---|---|---|---|---|---|---|---|---|---|---|---|---|---|---|---|
| Hockney | 0.4 | 2.2 | 6.2 | 3.0 | 2.4 | 3.2 | 5.6 | 1.6 | 2.0 | 1.8 | 1.8 | 1.0 | 1.0 | 3.0 | 3.4 | 7.0 |
| Hofmann | 1.0 | 0.6 | 0 | 1.0 | 0.4 | 0.2 | 1.2 | 6.2 | 10.0 | 7.2 | 3.0 | 2.8 | 2.8 | 1.8 | 2.5 | |
| Hopper | 5.4 | 6.6 | 10.4 | 3.4 | 5.4 | 8.2 | 13.2 | 2.2 | 0.8 | 0.8 | 0.4 | 2.0 | 2.0 | 1.0 | | |
| Indiana | 0 | 0 | 0 | 3.2 | 4.0 | 1.6 | 0.4 | 1.4 | 3.2 | 3.0 | 1.0 | 1.0 | | | | |
| Jensen | 0 | 0 | 0 | 0 | 0 | 0 | 0 | | | | 1.0 | | | | | |
| Johns | 0 | 0.4 | 6.6 | 6.2 | 1.4 | 1.2 | 1.4 | 3.6 | 3.4 | 1.6 | | | | | | |
| Kelly | 0 | 0.2 | 6.4 | 4.0 | 3.8 | 2.4 | 3.4 | 2.2 | | | | 3.0 | | | | |
| Kitaj | 0 | 0 | 1.2 | 2.4 | 1.4 | 4.0 | 13.8 | | | | | | | | | |
| Kline | 0 | 0 | 0.8 | 2.2 | 4.2 | 3.8 | 3.4 | 10.0 | | | | | | | | |
| LeWitt | 0 | 0 | 0 | 8.6 | 7.6 | 21.6 | 15.0 | 8.2 | 4.4 | | | | | | | |
| Lichtenstein | 0 | 0 | 0.4 | 0 | 6.8 | 8.4 | 3.8 | 3.8 | 1.8 | 1.8 | 4.0 | | | | | |
| Louis | 0 | 0 | 0.2 | 0 | 0.8 | 2.6 | 5.2 | 10.0 | | | | | | | | |
| Macdonald-Wright | 0 | 1.0 | 3.2 | 1.0 | 1.6 | 0.8 | 0.2 | 1.0 | 0.8 | 1.6 | 4.0 | 2.8 | 1.4 | | | |
| Marin | 0.2 | 0.2 | 0.4 | 1.2 | 2.0 | 3.8 | 3.2 | 2.6 | 2.2 | 3.4 | 2.2 | 3.2 | 3.6 | 4.0 | | |
| Martin | 0 | 0 | 0 | 0 | 0 | 0 | 3.6 | 7.8 | 0.6 | 0.4 | 2.8 | 1.2 | 1.0 | 2.0 | | |
| Mitchell | 0.2 | 0.2 | 1.6 | 2.4 | 1.4 | 3.2 | 4.8 | 4.2 | 4.2 | 2.5 | | | | | | |
| Moskowitz | 0 | 0.4 | 2.4 | 1.2 | 2.0 | 2.4 | 3.4 | 1.4 | | | | | | | | |
| Motherwell | 0 | 0 | 1.2 | 2.2 | 1.4 | 2.0 | 1.8 | 1.8 | 4.2 | 2.2 | 2.3 | | | | | |
| Murray | 0 | 0 | 0 | 0 | 1.8 | 6.6 | 1.5 | | | | | | | | | |
| Neel | 0 | 0 | 0 | 0.2 | 0 | 0 | 0 | 0.2 | 0.4 | 0.8 | 1.2 | 1.4 | 1.4 | 2.3 | | |

*Table B.1* *(continued)*

| Artist | 15–19 | 20–24 | 25–29 | 30–34 | 35–39 | 40–44 | 45–49 | 50–54 | 55–59 | 60–64 | 65–69 | 70–74 | 75–79 | 80–84 | 85–89 |
|---|---|---|---|---|---|---|---|---|---|---|---|---|---|---|---|
| Newman | 0 | 0 | 0 | 0 | 0 | 4.6 | 5.0 | 0.8 | 3.2 | 4.0 | 5.0 | | | | |
| Noland | 0 | 0 | 0 | 1.2 | 5.4 | 10.8 | 5.8 | 1.7 | | | | | | | |
| O'Keeffe | 0 | 0 | 2.8 | 4.6 | 3.4 | 5.4 | 1.2 | 2.2 | 2.2 | 0 | 0.2 | 1.2 | 1.0 | | |
| Olitski | 0 | 0 | 0 | 0 | 1.0 | 6.0 | 2.6 | 12.0 | | | | | | | |
| Pearlstein | 0.2 | 0 | 0.8 | 1.2 | 4.0 | 4.4 | 4.2 | 5.4 | 3.3 | | | | | | |
| Pollock | 0 | 0.6 | 7.2 | 10.2 | 16.0 | 3.0 | | | | | | | | | |
| Porter | 0 | 0.2 | 0 | 0.2 | 0.2 | 1.0 | 1.8 | 4.6 | 5.4 | 5.4 | 11.8 | | | | |
| Rauschenberg | 0 | 0.6 | 14.6 | 8.6 | 14.4 | 4.6 | 7.8 | 5.2 | 5.6 | 4.4 | 6.8 | 4.4 | | | |
| Reinhardt | 0 | 0 | 1.4 | 1.2 | 8.6 | 4.6 | 1.8 | 1.5 | 2.0 | | | | | | |
| Rivers | 0 | 0 | 0 | 2.4 | 5.0 | 2.6 | 1.6 | 2.6 | 2.0 | | | | | | |
| Rosenquist | 0 | 0 | 3.2 | 3.6 | 1.4 | 1.4 | 1.2 | 1.4 | 5.0 | | | | | | |
| Rothko | 0 | 0 | 0 | 1.0 | 2.0 | 3.6 | 4.4 | 3.8 | 3.8 | 1.4 | 5.3 | | | | |
| Ryman | 0 | 0 | 2.6 | 3.4 | 2.4 | 2.4 | 1.2 | 1.4 | 2.2 | 1.0 | | | | | |
| Shahn | 0 | 0 | 0 | 3.0 | 3.2 | 2.0 | 4.0 | 1.6 | 3.0 | 3.2 | 4.4 | 5.0 | | | |
| Sheeler | 0 | 0 | 0.6 | 1.2 | 2.8 | 2.2 | 2.8 | 1.2 | 2.2 | 0.4 | 1.4 | 2.2 | 1.0 | | |
| Sloan | 0.2 | 2.2 | 0.8 | 5.4 | 5.6 | 7.0 | 3.6 | 3.6 | 2.6 | 1.4 | 0.2 | 0.2 | 1.8 | 3.0 | |
| Stella, F. | 0 | 1.8 | 3.4 | 2.4 | | | | | | | | | | | |
| Stella, J. | 0 | 1.2 | 0.8 | 5.6 | 4.0 | 8.6 | 7.2 | 5.6 | 1.0 | 2.8 | 1.3 | | | | |
| Still | 0 | 0 | 0 | 0 | 0.6 | 1.2 | 3.6 | 3.4 | 1.6 | 0.6 | 2.4 | 2.4 | | | |
| Thiebaud | 0 | 0 | 0 | 0 | 0 | 2.8 | 3.0 | 2.2 | 3.0 | 6.8 | 2.2 | 2.0 | 3.0 | 3.0 | |
| Tobey | 0 | 0 | 0 | 0 | 0 | 0 | 0.2 | 1.4 | 1.4 | 2.0 | 2.2 | 2.0 | 3.0 | 3.0 | |

| | | | | | | | | | | | |
|---|---|---|---|---|---|---|---|---|---|---|---|
| Tomlin | 0 | 0 | 0.2 | 0.6 | 0.4 | 1.2 | 1.8 | 4.4 | | | |
| Twombly | 0 | 0.6 | 4.2 | 5.8 | 0.6 | 2.6 | 0.6 | 1.0 | 3.6 | 1.6 | 0.8 |
| Warhol | 0 | 0.4 | 9.8 | 26.0 | 18.8 | 1.8 | 3.6 | 6.4 | 11.2 | | |
| Weber | 0 | 0 | 2.2 | 1.8 | 1.6 | 1.2 | 1.4 | 0.2 | 1.6 | 2.0 | 1.0 |
| Wesselman | 0 | 0 | 1.8 | 4.6 | 1.4 | 1.8 | 1.8 | 2.8 | 2.8 | 4.3 | 1.6 |
| Wood | 0 | 0 | 0.6 | 1.6 | 3.0 | 4.4 | 6.0 | 6.0 | | | |
| Youngerman | 0 | 0 | 0 | 1.4 | 3.2 | 1.6 | 0.4 | 1.8 | 3.4 | | |

*Source:* Waldman, Josef Albers; Buchsteiner and Mossinger, Anuszkiewicz Op Art; Alloway, William Baziotes; Agee and Rose, Patrick Henry Bruce; Maciejunes and Hall, The Paintings of Charles Burchfield; Storr, Chuck Close; Sims, Stuart Davis; Prather, Willem de Kooning; Haskell, Charles Demuth; Livingston, The Art of Richard Diebenkorn; Gordon, Jim Dine; Balken, Arthur Dove; Arthur, Richard Estes; Demetrion, Lyonel Feininger; Gouma-Peterson, Breaking the Rules; Agee, Sam Francis; Carmean, Helen Frankenthaler; Waldman, Arshile Gorky; Alloway and MacNaughton, Adolph Gottlieb; Hopkins, Philip Guston; Haskell, Marsden Hartley; Tuchman and Barron, David Hockney; Goodman, Hans Hofmann; Levin, Edward Hopper; Gallant, Love and the American Dream; Messer, Alfred Jensen; Varnedoe, Jasper Johns; Waldman, Ellsworth Kelly; Shannon, R. B. Kitaj; Gordon, Franz Kline; Singer, Sol LeWitt Drawings; Waldman, Roy Lichtenstein; Fried, Morris Louis; Scott, The Art of Stanton Macdonald-Wright; Curry, John Marin; Haskell, Agnes Martin; Bernstock, Joan Mitchell; Rifkin, Robert Moskowitz; Buck, Robert Motherwell; Graze and Halbreich, Elizabeth Murray; Harris, Alice Neel; Hess, Barnett Newman (1971); Waldman, Kenneth Noland; Cowart and Hamilton, Georgia O'Keeffe; Moffett, Jules Olitski; Bowman, Philip Pearlstein; Varnedoe, Jackson Pollock; Moffett, Fairfield Porter; Hopps and Davidson, Robert Rauschenberg; Bois, Ad Reinhardt; Haenlien, Larry Rivers; Alborch, James Rosenquist; Weiss, Mark Rothko; Storr, Robert Ryman; Sloshberg, Ben Shahn; Scott, Charles Sheeler; Scott, John Sloan; McLean, Frank Stella; Haskell, Joseph Stella; O'Neill, Clyfford Still; Tsujimoto, Wayne Thiebaud; Breeskin, Tribute to Mark Tobey; Baur, Bradley Walker Tomlin; Varnedoe, Cy Twombly; McShine, Andy Warhol; Story, Max Weber; Buchsteiner and Letze, Tom Wesselman; Corn, Grant Wood; Waldman, Jack Youngerman.

*Note:* Unless indicated otherwise, this table includes all works in the retrospectives indicated. Exceptions are as follows. Albers: architecture, assembly, drawings, furniture, photographs, and prints are excluded; Flack: sculptures are excluded; Gottlieb: graphics and postcards are excluded; Hockney: etchings, lithographs, photographs, and photo collages are excluded; Hopper: drawings and prints are excluded; Jensen: sketchbooks are excluded; Johns: drawings, prints, and sculptures are excluded; Kelly: photographs are excluded; Lichtenstein: lithographs, murals, sculptures, and screenprints are excluded; Newman: architecture, sculpture, and works on paper are excluded; Pollock: prints are excluded; Rauschenberg: choreography, collaborations, and performance are excluded; F. Stella: drawings are excluded; Twombly: sculptures are excluded; Weber: lithographs are excluded.

Table B.2   Ages at peak value and ages with most paintings in retrospective exhibitions, American artists

| Artist | Age at peak value | Age interval(s) with most paintings | Artist | Age at peak value | Age interval(s) with most paintings | Artist | Age at peak value | Age interval(s) with most paintings |
|---|---|---|---|---|---|---|---|---|
| Anuszkiewicz | 57 | 25–29, 35–39 | Kelly | 47 | 25–29 | Rivers | 38 | 35–39 |
| Baziotes | 44 | 35–39, 40–44 | Kline | 51 | 50–54 | Rosenquist | 29 | 55–59 |
| Davis | 68 | 35–39 | LeWitt | 32 | 40–44 | Rothko | 54 | 65–69 |
| de Kooning | 43 | 45–49 | Lichtenstein | 35 | 40–44 | Shahn | 41 | 70–74 |
| Demuth | 41 | 35–39 | Louis | 50 | 50–54 | Sheeler | 45 | 35–39, 45–49 |
| Dine | 42 | 25–29 | Macdonald-Wright | 43 | 65–69 | Sloan | 42 | 40–44 |
| Dove | 36 | 45–49 | Marin | 54 | 80–84 | Stella, F. | 24 | 25–29 |
| Estes | 54 | 35–39 | Martin | 52 | 50–54 | Stella, J. | 41 | 40–44 |
| Feininger | 40 | 45–49 | Moskowitz | 48 | 45–49 | Thiebaud | 66 | 60–64 |
| Francis | 31 | 30–34 | Motherwell | 71 | 55–59 | Tobey | 61 | 75–79, 80–84 |
| Frankenthaler | 33 | 30–34, 35–39, 45–49 | Newman | 40 | 45–49, 65–69 | Tomlin | 52 | 50–54 |
| Gorky | 41 | 40–44 | Noland | 35 | 40–44 | Twombly | 24 | 30–34 |
| Guston | 36 | 65–69 | O'Keeffe | 48 | 40–44 | Warhol | 33 | 30–34 |
| Hartley | 32 | 35–39 | Olitski | 41 | 50–54 | Weber | 27 | 25–29 |
| Hockney | 30 | 25–29 | Pearlstein | 69 | 50–54 | Wesselman | 28 | 30–34 |
| Hofmann | 84 | 85–89 | Pollock | 38 | 35–39 | | | |
| Indiana | 42 | 35–39 | Porter | 68 | 65–69 | | | |
| Jensen | 58 | 55–59 | Rauschenberg | 31 | 25–29 | | | |
| Johns | 27 | 25–29 | Reinhardt | 43 | 35–39 | | | |

Source: Tables 2.2 and B.1.

preference to a period of the artist's career far from the estimated age at peak value: Davis, Guston, Macdonald-Wright, and Shahn. Stuart Davis is probably the most important of these artists. Although obviously less influential overall in modern art than Matisse, Davis's case may be similar to that of Matisse, discussed in Chapter 6, in that he made notable contributions at a number of points during a long and productive career, with none clearly more significant than the others. Davis developed a distinctive early style that blended Synthetic Cubism with American symbols and images, and his style continued to evolve from the 1920s through the 1960s. Although his rejection of Abstract Expressionism led to the general neglect of his work during the 1950s, his paintings would later interest younger artists: Roy Lichtenstein singled Davis out as an influence on Pop Art, and in 1962 the young sculptor Donald Judd, who would become a leading figure in the development of Minimalism, began a review of a show of Davis's new work by declaring, "There should be applause. Davis, at sixty-seven, is still a hot shot."[3] Davis's 1991 retrospective gave its greatest emphasis to the artist's late thirties, a period that included his formative first visit to Paris and its immediate aftermath, and which "established . . . Davis as a leading exponent of American modernism"; the auction market gives highest value to the work of his last years, in which he produced relatively few works, "marked by a greater size, scale, and monumentality," that would inspire Judd and other young artists of the 1960s.[4] Thus although Davis was an important American modern artist, as in the case of Matisse the apparent absence of a single dominant contribution may explain the differing views of the timing of his best work that come from the auction market and his latest retrospective.

Among the other painters for whom the two sources disagree, it might be worth noting that Philip Guston's case exemplifies an effect also present in others, in which a retrospective exhibition for a living artist gives considerably greater emphasis to the artist's most recent work than does the auction market. There are at least two possible causes of this, both related to the fact that the cooperation of a living artist is crucial to the organization of a retrospective. In some cases the artist's ability to provide recent work can give a curator a desirable opportunity to display paintings that have not previously been publicly exhibited. Alternatively, a curator's willingness to emphasize the artist's recent work may be necessary to gain the artist's cooperation. Nor are these two motives necessarily entirely mutually exclusive. In Guston's case, the 1980 retrospective at San Francisco's Museum of Modern Art came at a time

when the art world was just beginning to accept the representational paintings he had produced throughout the 1970s; the artist took considerable satisfaction from what he considered this vindication, and was actively involved in the selection of paintings for the retrospective.[5] Thus Guston's involvement may have reinforced an already existing interest of the museum in presenting a large-scale showing of the artist's late work.

In sum, for the great majority of the painters considered here, analysis of the composition of retrospective exhibitions indicates that art scholars agree with collectors on when the artists produced their best work. In a smaller number of cases the two sources disagree, but only in a very small number is the disagreement emphatic. The consistency of the evidence of the two sources strengthens our confidence in both. Quantitative analysis of both auction market outcomes and retrospective exhibitions thus appears to be useful in identifying the periods in which modern painters made their most important contributions.

# Appendix C

## AGES OF AMERICAN ARTISTS AT THE TIME OF THEIR FIRST ONE-PERSON NEW YORK GALLERY EXHIBITIONS

| Artist | Year of birth | Age at first show | Artist | Year of birth | Age at first show |
|---|---|---|---|---|---|
| Marin | 1870 | 39 | Neel | 1900 | 38 |
| Feininger | 1871 | 65 | Gottlieb | 1903 | 27 |
| Sloan | 1871 | 46 | Jensen | 1903 | 52 |
| Hartley | 1877 | 32 | Rothko | 1903 | 30 |
| J. Stella | 1877 | 36 | Gorky | 1904 | 34 |
| Bruce | 1880 | 36 | de Kooning | 1904 | 44 |
| Dove | 1880 | 32 | Still | 1904 | 42 |
| Hofmann | 1880 | 64 | Newman | 1905 | 45 |
| Weber | 1881 | 30 | Porter | 1907 | 45 |
| Hopper | 1882 | 38 | Kline | 1910 | 40 |
| Demuth | 1883 | 31 | Baziotes | 1912 | 32 |
| Sheeler | 1883 | 37 | Louis | 1912 | 45 |
| O'Keeffe | 1887 | 30 | Martin | 1912 | 46 |
| Albers | 1888 | 48 | Pollock | 1912 | 31 |
| Macdonald-Wright | 1890 | 24 | Guston | 1913 | 32 |
| Tobey | 1890 | 27 | Reinhardt | 1913 | 31 |
| Wood | 1892 | 44 | Motherwell | 1915 | 29 |
| Burchfield | 1893 | 24 | Thiebaud | 1920 | 42 |
| Davis | 1894 | 23 | Diebenkorn | 1922 | 34 |
| Shahn | 1898 | 32 | Olitski | 1922 | 36 |
| Tomlin | 1899 | 24 | Francis | 1923 | 33 |

*(continued)*

| Artist | Year of birth | Age at first show | Artist | Year of birth | Age at first show |
|---|---|---|---|---|---|
| Kelly | 1923 | 33 | Morley | 1931 | 26 |
| Lichtenstein | 1923 | 28 | Wesselman | 1931 | 30 |
| Rivers | 1923 | 28 | Kitaj | 1932 | 33 |
| Noland | 1924 | 33 | Rosenquist | 1933 | 29 |
| Pearlstein | 1924 | 31 | Rockburne | 1934 | 36 |
| Rauschenberg | 1925 | 26 | Dine | 1935 | 25 |
| Mitchell | 1926 | 26 | Moskowitz | 1935 | 27 |
| Youngerman | 1926 | 32 | Estes | 1936 | 32 |
| Frankenthaler | 1928 | 23 | F. Stella | 1936 | 24 |
| Indiana | 1928 | 34 | Hockney | 1937 | 27 |
| LeWitt | 1928 | 37 | Mangold | 1937 | 27 |
| Twombly | 1928 | 27 | Poons | 1937 | 26 |
| Warhol | 1928 | 34 | Ruscha | 1937 | 35 |
| Anuszkiewicz | 1930 | 30 | Marden | 1938 | 28 |
| Johns | 1930 | 28 | Close | 1940 | 30 |
| Ryman | 1930 | 37 | Murray | 1940 | 36 |
| Flack | 1931 | 28 | | | |

*Sources:* General—Sandler, *The Triumph of American Painting,* pp. 277–280; Sandler, *The New York School,* pp. 322–325; Geldzahler, *New York Painting and Sculpture,* pp. 429–450; Turner, *The Dictionary of Art,* 19:878, 20:486, 26:483; Politi, *Dictionary of International Contemporary Artists,* pp. 83, 219, 282; Hillstrom and Hillstrom, *Contemporary Women Artists,* pp. 480, 483; Marks, *World Artists,* pp. 398, 903; Davidson, *Early American Modernist Painting,* p. 13.

Individual artists—Buchsteiner and Mossinger, *Anuszkiewicz Op Art,* p. 110; Agee and Rose, *Patrick Henry Bruce,* p. 145; Baur, *Charles Burchfield,* p. 6; Arnason, *Stuart Davis Memorial Exhibition,* p. 85; Haskell, *Charles Demuth,* p. 49; Balken, *Arthur Dove,* p. 176; Arthur, *Richard Estes,* p. 54; Demetrion, *Lyonel Feininger;* Gouma-Peterson, *Breaking the Rules,* p. 149; Haskell, *Marsden Hartley,* p. 187; Clothier, *David Hockney,* p. 119; Levin, *Edward Hopper,* p. 301; Jensen, *Alfred Jensen,* p. 92; Shannon, *R. B. Kitaj,* p. 51; Weitman, *Sol LeWitt;* de Wilde, *Robert Mangold;* Kertess, *Brice Marden;* Rifkin, *Robert Moskowitz,* p. 200; Goodrich and Bry, *Georgia O'Keeffe,* p. 186; Storr, *Robert Ryman,* p. 216; Sloshberg, *Ben Shahn;* Scott, *Charles Sheeler,* p. 101; Scott, *John Sloan,* p. 49; Haskell, *Joseph Stella,* p. 225; Tsujimoto, *Wayne Thiebaud,* p. 171; Bastian, *Cy Twombly,* 1:280; Story, *Max Weber,* p. 10; Buchsteiner and Letze, *Tom Wesselman,* p. 33; Corn, *Grant Wood,* p. 148.

# NOTES

## Preface

1. Menard, "From Servants to Slaves"; Galenson, *White Servitude in Colonial America,* chaps. 8–9.

2. Fogel and Engerman, *Time on the Cross,* chap. 3.

3. For example, Thernstrom, *Poverty and Progress.*

4. Kaestle and Vinovskis, *Education and Social Change in Nineteenth-Century Massachusetts;* Galenson, "Neighborhood Effects."

5. A notable early exception is the use of quantitative analysis by White and White, *Canvases and Careers.* Although other isolated examples could also be given, these do not constitute a sustained effort within art history.

6. The misconception involved in debating whether to prefer a quantitative or a qualitative approach to art history was neatly described by the economic historian T. S. Ashton in commenting on an analogous disagreement: "The whole discussion as to whether deduction or induction is the proper method to use in the social sciences is, of course, juvenile: it is as though we were to debate whether it was better to hop on the right foot or on the left. Sensible men endowed with two feet know that they are likely to make better progress if they walk on both"; "Relation of Economic History to Economic Theory," p. 177.

## 1. The Problem

1. Cézanne, *Paul Cézanne, Letters,* pp. 293–294.

2. Ibid., pp. 329–330.

3. Quoted in Barr, *Picasso,* pp. 270–271.

4. Bell, "The Debt to Cézanne," p. 75; Greenberg, *Collected Essays and Criticism,* 3:83.

5. Reff, "Painting and Theory in the Final Decade," p. 13; Schapiro, *Paul Cézanne,* p. 27; Hamilton, *Painting and Sculpture in Europe,* p. 42.

6. Rewald, *Paintings of Paul Cézanne,* pp. 509–511. The last of the three *Great Bathers* is illustrated in more textbooks than any other painting by Cézanne; for discussion of this criterion of importance, see Galenson, "Quantifying Artistic Success," and Chapter 5.

7. Cousins and Seckel, "Chronology of *Les Demoiselles d'Avignon,*" pp. 148–154.

8. Russell, *Meanings of Modern Art,* p. 97; see also Golding, *Visions of the Modern,* pp. 101–118.

9. Golding, *Cubism*, p. xiii.

10. Rewald, *Paintings of Paul Cézanne*, p. 509; Cousins and Seckel, "Chronology of *Les Demoiselles d'Avignon*, p. 148.

11. The contrast between the two artists' careers is sometimes poignant. Near the end of her 1980 biography of Picasso, Mary Mathews Gedo describes the ceramic sculptures he produced at a pottery in Vallauris during the late 1940s. Working with skilled potters, Picasso made molds that were used to cast small ceramic sculptures; he enjoyed experimenting with colors and glazes that produced complex surface patterns. Gedo then critically assesses the work: "Certainly, no matter how appealing Picasso's ceramics may be, they represent a regression from his highest level of creativity . . . The artist who had convulsed the world with the *Demoiselles d'Avignon* and *Guernica* had become a mere decorator of pots fashioned by other hands" (Gedo, *Picasso*, pp. 211–212). Gedo's devastating judgment was too much for an anonymous sympathetic reader at the University of Chicago, who defended Picasso in the margin of the library's copy of the book: "Give the man a break—he's over 60 years old!" Yet it was after he had passed the age of sixty that Cézanne reached the peak of his creative powers, and produced the work that would be not only a primary inspiration for the young Picasso's innovation of Cubism but a central source of the most important art of the twentieth century. (For other judgments of Picasso's late ceramics, see Hamilton, *Painting and Sculpture in Europe*, p. 461; O'Brian, *Picasso*, p. 391; Cabanne, *Pablo Picasso*, p. 513; Gilot and Lake, *Life with Picasso*, pp. 187, 218; Richardson, *Sorcerer's Apprentice*, p. 182.)

12. Quoted in Rewald, *Impressionism*, p. 458.

13. Quoted in Zinnes, *Ezra Pound and the Visual Arts*, p. 4.

14. Flam, *Matisse on Art*, p. 119.

15. Greenberg, *Collected Essays and Criticism*, 2:193.

16. Wittkower and Wittkower, *Born under Saturn*, p. 294.

17. The selection of both groups of artists began by listing all painters who had at least one work reproduced in three or more of the following six art history textbooks: Hamilton, *Nineteenth and Twentieth Century Art;* Russell, *Meanings of Modern Art;* Arnason, *History of Modern Art;* Hughes, *Shock of the New;* Hunter and Jacobus, *History of Modern Art;* and Wheeler, *Art since Mid-Century.* All artists on the resulting list who had been born in France from 1819 (the birth year of Courbet) through 1900 were placed in the sample for Table 1.1, as were artists born elsewhere in the same period who had spent significant portions of their lives in France. Two groups of artists were then added to Table 1.1, to enlarge the sample in specific areas. One was made up of important painters from the generation immediately preceding the Impressionists; these artists— Boudin, Corot, Daubigny, Daumier, Delacroix, Jongkind, Millet, and T. Rousseau— were born during 1796–1825. The second added group consisted of five artists— Caillebotte, Cassatt, Guillaumin, Morisot, Sisley—who each participated in at least four of the eight group shows held by the Impressionists.

The artists listed in Table 1.2 are all the artists born from 1870 through 1940 who had at least one work illustrated in at least three of the six texts listed above who were either born in the United States or spent significant portions of their careers there.

Painters born after 1940 were not included in the study because of the relatively short spans of their careers that would currently be available for analysis.

18. The procedure used to define the sample of artists was motivated by the goal of studying those artists who are generally considered the most important painters in the two periods to be analyzed here. Relying on popular textbooks and surveys allowed this definition to be based on the judgments of prominent art historians and critics. On the use of illustrations to measure artists' importance, see Chapter 3 and Galenson, "Quantifying Artistic Success."

## 2. Artists, Ages, and Prices

1. Gauguin, *Writings of a Savage*, p. 267.

2. Whistler, *Gentle Art of Making Enemies*, p. 5.

3. Quoted in House, "Camille Pissarro's Idea of Unity," p. 16.

4. Van Gogh, *Complete Letters of Vincent van Gogh*, 3:295.

5. Gauguin, *Writings of a Savage*, p. 212.

6. Flam, *Matisse on Art*, p. 37.

7. Quoted in Ness, *Lyonel Feininger*, p. 49.

8. Stein, *Autobiography of Alice B. Toklas*, p. 210.

9. Brassaï, *Conversations with Picasso*, p. 133.

10. For the econometric analysis, each painting sold constituted a single observation. Separate regression equations were estimated for each artist. The dependent variable was the natural logarithm of the sale price in (constant 1983) dollars. To test for the best form for the age-price relationship, five regressions were estimated for each artist, beginning with a linear specification, then adding successively higher-order terms in age, up to a fifth-degree polynomial. The variant selected for each artist was that which produced the best fit, as measured by the adjusted $R^2$. A binary independent variable indicated whether the work was done on paper or canvas. The size of the work was controlled, using the natural logarithm of the surface area in square inches. Substantial fluctuations occurred in the art market during the sample period, and independent variables were consequently included to allow for the effect of the date at which the work was auctioned.

It might be noted that the econometric analysis done here is an application of hedonic regression analysis of prices. For discussion of this approach and additional references, see Griliches, *Price Indexes and Quality Change*. For expositions of the technique of multiple regression analysis of varying degrees of detail and complexity, see, for example, Rao and Miller, *Applied Econometrics;* Kmenta, *Elements of Econometrics,* chap. 10; and Maddala, *Econometrics,* chap. 8.

The question might be raised of why this analysis uses market valuations from a period after—often long after—the production of the work, rather than contemporaneous market valuations. This is a consequence of this study's concern not with temporary importance, but with the importance of artists in the long run. As will be discussed

in Chapter 4, genuine importance is a function of influence on other artists. This requires time, and perception of this influence usually requires additional time. The period 1970–1997 was consequently chosen as the latest available for this study that allows analysis of a sufficiently large number of transactions to produce strong econometric results.

11. All values in Figures 2.1 and 2.2 were calculated for works on canvas, 24″ × 24″, sold in 1990–1994, in constant (1983) dollars. The description of the values in the figures as hypothetical simply refers to this standardization. The estimated regressions from which Figures 2.1 and 2.2 were drawn, as well as those for all the other artists listed in Table 1.1, are reported in Galenson, "The Lives of the Painters of Modern Life," app.

It might be noted here that the choice of the base period of 1990–1994 for evaluation of prices affects the estimated level of the price of an artist's work, but not the estimated age at peak value. The ages at peak value shown in Figures 2.1 and 2.2 derive from analysis of auction data from the entire period 1970–1997, and would not change if any other base period within that span were chosen to calculate the level of prices. (Similarly, it might be noted that the peak ages presented in Tables 2.1 and 2.2 are based on analysis of auction data from the entire period 1970–1997.)

12. Daniel-Henry Kahnweiler reported that in 1955 Picasso told him, "I bought the L'Estaque picture by Cézanne, although I don't like it as much as my other paintings by him . . . And I know it will always fetch the highest price"; McCully, *A Picasso Anthology*, p. 253. The painting appears to be no. 395 in Rewald, *Paintings of Paul Cézanne*, p. 264. It has variously been dated as completed from 1879 to 1886, or when Cézanne was forty through forty-seven. Inspection of Figure 2.1 suggests that Picasso's statement may demonstrate his understanding of the strong positive correlation between the value of Cézanne's paintings and his age at the time of their execution.

13. The changes in value for both artists' work over the course of their careers are considerable. Figure 2.1 shows that a painting executed by Cézanne in 1864, with the characteristics specified in note 11 above, would be expected to sell for $275,000, while a painting with the same characteristics executed in 1904 would sell for an expected $2.05 million. Similarly, Figure 2.2 shows that a painting made by Picasso in 1906 would sell for an expected $1.55 million, compared with $505,000 for a painting alike in other respects that he executed in 1946. Thus Cézanne's work from age sixty-five was more than seven times as valuable as that from age twenty-five, whereas Picasso's work from age twenty-five was three times as valuable as that from age sixty-five.

It is interesting to note that a study of auction prices that uses a somewhat different sampling period (1962–1991) and a different regression specification produces similar results for Picasso. That study identifies his most expensive period as 1902–1906, and his cheapest period as 1954 and after; de la Barre, Docclo, and Ginsburgh, "Returns of Impressionist, Modern, and Contemporary European Paintings," p. 161, table 5.

14. Age was judged to have a statistically significant effect on price if a *t*-test or *F*-test rejected the null hypothesis that all the age coefficients were simultaneously equal to zero at the .10 level. The absence of a statistically significant impact of age on price indicates that at least one of two conditions is present: that the artist's age at execution of a work genuinely had little or no impact on the value of the work, or that there was inadequate evidence with which to measure the relationship. The two causes can interact, for in general larger amounts of evidence will be needed to detect weaker age-price relation-

ships than stronger ones. In some cases, an artist's work so rarely comes to auction that the relationship obviously cannot be measured with confidence: the sample analyzed here, for example, contained only ten works by Marcel Duchamp, fifteen by Barnett Newman, twelve by Clyfford Still, and seven by Chuck Close. For the French artists, age was found to have a statistically insignificant effect on price for only three artists with more than one hundred paintings in the sample; similarly for the Americans, there was no significant age effect for only three artists with more than one hundred works sold.

15. One other study has estimated periods of peak value for seven of the French artists included in Table 2.1. Using somewhat different evidence and methods, that investigation produces similar results. For Picasso, see note 13 above; for Braque, Chagall, Leger, Matisse, Monet, and Renoir, the year of peak value shown in Table 2.1 always lies within the most expensive period identified by de la Barre, Docclo, and Ginsburgh, "Returns of Impressionist, Modern, and Contemporary European Paintings," p. 161, table 5.

16. The decline over time in the age at peak value was confirmed for both groups of artists by a different statistical approach. In this alternative approach, only one multiple regression equation was estimated for all the French artists, and only one for all the Americans. The same auction data were used. In each equation the natural logarithm of the sale price of a painting was again specified as a linear function of a (fourth-degree) polynomial in the artist's age at the date of its execution, the size and support of the work, and its sale date. Fixed effects for individual artists were also included as independent variables. And finally, the artist's age at execution was interacted with binary variables that identified birth cohorts. This specification therefore produced estimated age-price profiles for each birth cohort of artists, instead of for each individual artist. This allowed the calculation of the average age at which artists born in a particular period produced their most valuable work.

For the French artists, the estimated age at peak value fell from 46.6 years for artists born during 1820–1839 to 37.0 years for those born during 1840–1859, 28.8 for those born during 1860–1879, and 27.0 for those born during 1880–1890. The decline from the first to each of the later cohorts was highly significant statistically.

For the American artists, the estimated age at peak value fell from 50.6 years for artists born during 1900–1920 to 28.8 years for those born during 1921–1940. The difference is again highly significant statistically.

This more aggregated approach thus strongly confirms the decline over time in the typical age at peak value for both the French and the American artists studied here. For additional discussion and documentation of this alternative approach, see Galenson and Weinberg, "Creating Modern Art," and Galenson and Weinberg, "Age and the Quality of Work."

17. For both groups of artists, the difference in the proportions is statistically significant at the .01 level.

18. The difference in the proportions is significant for the French artists at the .01 level, and that for the Americans is significant at the .02 level.

19. For a discussion of these and other influences on the prices of paintings, see Keen, *Money and Art,* chap. 2.

20. The question might also be raised of how the profiles of Figures 2.1 and 2.2 are affected by the absence from the auction market of many of the greatest works of Cézanne and

Picasso, because they were acquired by museums before 1970. Although museums sometimes sell paintings, in general they are believed to be less likely to sell than are private collectors. This question involves sample selection bias: the profiles of Figures 2.1 and 2.2 may not be based on a random sample of Cézanne's and Picasso's paintings, and may consequently not give an unbiased indication of the relative value of their work at each stage of their careers.

The most likely effect of the bias resulting from museum acquisitions is to cause the relative valuations by age of Figures 2.1 and 2.2 to be understated: the true relative value of the late work of Cézanne and the early work of Picasso should probably be even greater than the figures suggest. Art historians overwhelmingly agree that Cézanne's late works are his most important, and that Picasso's early, Cubist works are his most important (for evidence of this, see Chapters 3 and 6). Paintings from these periods are consequently those most prized by museums. And it is of course the best works of these periods that are most eagerly sought by museums. The effect of this process of selection by museums over time has consequently been disproportionately to remove the best late Cézannes and the best Cubist Picassos from the market. The late Cézannes and early Picassos that remain in private collections, and are more likely to come to auction, consequently tend to be lower in quality relative to the artists' entire output from those periods than is the case for the early Cézannes and late Picassos that come to auction. It can therefore be seen that if no Cézannes and Picassos were held by museums, and the paintings that came to auction were randomly selected from all periods of their careers, the likely effect would be to increase the relative value of Cézanne's late works compared with the data presented in Figure 2.1, and increase the relative value of Picasso's early works compared with the data presented in Figure 2.2.

As will be shown below, in Chapter 3 and Appendixes A and B, it is generally true that art historians' judgments of artists' careers agree quite closely with the relative valuations of the auction market. As a result, this discussion for Cézanne and Picasso can in most cases be generalized: because an artist's most important works are usually his most valuable, the effect of museum acquisitions is generally to make the auction market understate the true value of the artist's most valuable period relative to that of the rest of his career. This effect consequently typically strengthens the usefulness of using auction data to date the timing of an artist's best work.

21. On proxy variables in general, see Rao and Miller, *Applied Econometrics*, pp. 82–88.

22. On the evolution of Cézanne's style, see, for example, Fry, *Cézanne;* Rubin, *Cézanne*.

23. This general point was made by a journalist who studied the art market: "It helps if a painting or drawing dates from a 'good' period in an artist's career; in other words, a period in which he is generally considered to have produced his greatest works. In the case of Rembrandt or Turner, for instance, this means their later years, when both in their different ways developed their greatest power and originality. Applied to Monet and Renoir, it means the late 1860s and 1870s, the years when the Impressionist movement was born and flowered; their later works are generally less highly regarded" (Keen, *Money and Art,* p. 40).

24. For discussion see Galenson, "The Careers of Modern Artists."

25. Kennedy, *A Guide to Econometrics,* p. 57.

26. Herbert, "Method and Meaning in Monet," p. 92.

27. Apart from a footnote explaining that ease of access and the condition of the works dictated the selection of the paintings he studied, Herbert offers no justification for his choice of these paintings, or any explanation of how the six paintings he studied are representative of Monet's work in general; "Method and Meaning in Monet," p. 107. It might be noted that the six paintings represent a tiny proportion of the total of 2,050 works listed in Monet's catalogue raisonné; Wildenstein, *Monet*, p. 7.

28. Herbert, "Method and Meaning in Monet," p. 92.

29. Harrison, "On the Surface of Painting," pp. 325–326.

30. Ibid., pp. 327–329.

31. Ibid., p. 329.

## 3. Market Values and Critical Evaluation

1. Barr, *Defining Modern Art*, p. 73.

2. Greenberg, *Collected Essays and Criticism*, 4:118.

3. Kubler, *Shape of Time*, p. 83.

4. Keen, *Money and Art*, p. 40.

5. Hauser, *Sociology of Art*, p. 516.

6. Rosenberg, *Art on the Edge*, p. 80.

7. Hughes, *Nothing If Not Critical*, p. 237.

8. Frey and Pommerehne, *Muses and Markets*, p. 93.

9. Quoted in Duff, "In Payscales, Life Sometimes Imitates Art," p. B1.

10. Kozloff, "'Pop' Culture, Metaphysical Disgust, and the New Vulgarians," p. 32; see also Naifeh, *Culture Making*, pp. 28–32.

11. Stokstad, *Art History*, p. 6.

12. For further discussion and evidence, see Galenson, "Quantifying Artistic Success."

13. I thank Britt Salvesen of the Art Institute for this information.

14. Art scholars might object to the use made here of textbook illustrations as an indication of the judgments of art historians on the relative importance of different paintings, on several grounds. One objection might be that reproductions drawn from textbooks of the 1970s and 1980s define a traditional canon that has increasingly been rejected by art historians in recent years. Yet this does not appear to be the case. One recent text (published in 1993) is a multivolume series written for the British Open University by a group of art historians, described by its authors as presenting "a range of approaches and methods characteristic of current art-historical debates" (Frascina et al., *Modernity and Modernism*, p. 1; Harrison, Frascina, and Perry, *Primitivism, Cubism, Abstraction*, p. 1; and Wood et al., *Modernism in Dispute*, p. 1). These books together reproduce twelve of the twenty-one individual paintings by the French painters considered in this study that appear most often in the thirty-three textbooks analyzed here (for the full list of these twenty-one paintings, see Galenson, "Quantifying Artistic Success," table 3). This is three more of those twenty-one paintings than are reproduced, for example, in

one of the oldest textbooks analyzed here, George Heard Hamilton's *Nineteenth and Twentieth Century Art*. A more recent Open University text reproduces ten of the twenty-one canonical works; Wood, *Challenge of the Avant-Garde*. Or consider another recent textbook, Richard Brettell's *Modern Art, 1851–1929*, published in 1999 after data collection for this study was completed. The book's jacket copy describes it as an "innovative account" that provides a "fresh approach" to its subject, and a fellow academic's blurb there describes it as "very refreshing and original," with a "visual range" that "wrenches our tired assumptions about pictorial modernism into vivid new perspectives." The author himself states that "the book's aim is to provide a critical introduction to the recent debates and issues surrounding modern art" (p. 7). Yet this book includes illustrations of nine of the twenty-one French paintings most often reproduced by the thirty-three older textbooks analyzed by this study—the same number as Hamilton's book, published three decades earlier. (In fact, Brettell's book actually reproduces a higher proportion of those twenty-one paintings that were eligible for his study than does Hamilton's, because *Guernica* was painted in 1937, after the closing date of his book.) The point here is not to deny the innovativeness of the Open University or Brettell texts. Yet what they demonstrate is that the core of the canon of modern art has not changed, and that the same images that were central to that canon in the 1970s and 1980s remained central to it in the 1990s.

A different objection to the analysis of textbooks might be that they reproduce basic images for beginning students, but that the works illustrated in the books, like the books themselves, are of little interest to sophisticated scholars of art history. This objection also appears to be false. One clear contradiction is afforded by a book published in 1996, to which thirteen art historians, including such well-known scholars as Richard Shiff, Carol Armstrong, Albert Boime, David Carrier, and John House, contributed essays about a single painting that ranks high among the French paintings most often reproduced by the textbooks analyzed here; see Collins, *12 Views of Manet's Bar*. In choosing a subject that would give unity to essays intended to demonstrate the diversity of current methodological approaches in art history, the book's editor states that he chose Manet's *A Bar at the Folies-Bergère*—ranked sixth in Table 5.2—"not only because it was a painting that had long interested me but because I knew that it could bear up well under such concentrated scrutiny" (p. xx). One of the book's essays observes that the painting has "become a sort of epicenter for variations on the practice of the social history of art"; another notes that "modernist and postmodernist critics have enshrined [the painting] as one of their heroic and exalted monuments" (pp. 25, 47). Another painting by Manet listed in Table 5.2 has also been the subject of essays by Carol Armstrong, John House, and others, in another recent book; see Tucker, *Manet's Le Déjeuner sur l'herbe*. Examples like these could be multiplied, but this seems unnecessary. The fact is that there is continuing scholarly interest in most—perhaps all—of the paintings most often illustrated in the textbooks.

The tastes of individual scholars can differ, and the images presented in particular books consequently differ to some extent. Yet it is nonetheless clear that the textbooks analyzed here do define a basic canon of modern art history that is respected and used by a broad consensus of scholars and that has remained quite consistent over an extended period.

15. It might be objected that the percentages given in the text do not take into account the differing lengths of the two artists' careers. This can be done readily.

Cézanne's earliest known surviving paintings date from 1860, when he was twenty-one years old; see Rewald, *Paintings of Paul Cézanne*, p. 66. His career ended with his death at sixty-seven, and therefore spanned forty-seven years. The twenty-eight years from ages forty to sixty-seven thus constitute 60 percent of his career, and account for a disproportionate 82 percent of his total illustrations in Table 3.1; the final eight years of his life, from ages sixty to sixty-seven, constitute just 17 percent of his career, but account for 36 percent of his illustrations.

The imbalances are even greater for Picasso. Dating the start of his career is more difficult, because he was a child prodigy. Some of his juvenilia has survived. If we date his first mature works at age twenty, his adult career spanned seventy-three years, through his death at ninety-two. The twenty years from ages twenty to thirty-nine then constitute 27 percent of his career, but account for a disproportionate 64 percent of his total illustrations in Table 3.1; the decade of his twenties, just 14 percent of his career, accounts for 38 percent of his illustrations.

Thus it is clear that the textbook illustrations place a disproportionate emphasis on Cézanne's late work, particularly that of his sixties, and that they similarly place a disproportionate emphasis on Picasso's early work, particularly that of his twenties.

16. See Galenson, "Quantifying Artistic Success."

17. Some indication of the magnitude of the efforts involved in arranging retrospectives can be gained from catalogues of the shows. So for example Walter Hopps and Susan Davidson, the curators of the Robert Rauschenberg retrospective of 1997–1999, mention by name more than three hundred individuals in their acknowledgments; Hopps and Davidson, *Robert Rauschenberg*, pp. 17–19.

18. For major painters, their place in the canon of art history becomes increasingly clear as time passes. In consequence, the textbook coverage of their work tends to become more extensive, while at the same time their paintings tend to play a more important role in attracting visitors to museums. The latter effect makes museums more reluctant to lend their work for temporary exhibitions elsewhere. The analysis of textbook illustrations for the French artists, and of the composition of retrospective exhibitions for the Americans, is therefore a response to the relative abundance of the two types of evidence for the two groups of artists, since recent full retrospective exhibitions are relatively rare for the French painters, and textbook coverage is less extensive for the Americans.

19. The stability of the critical assessment of Pollock's career witnessed by the similarity of the distributions of paintings by age in the two retrospective exhibitions held thirty years apart points to the response to another common concern about the analysis of auction prices. It is well known that the art world's evaluation of an artist's importance can change considerably over time, and that in consequence the price of his work can also change dramatically. Yet this poses less of a problem for the analysis of this study than might initially be supposed. For although changes can occur in the assessments of art scholars and collectors of the importance of an artist's contribution, it is much rarer that their assessment of the nature of the contribution—and consequently of its timing—changes. Thus if a painter's reputation rises, all of his work will typically become more highly valued, by both scholars and collectors, without necessarily changing the relative prices of his work from different ages.

The econometric analysis of this study allows for changes over time in the level of the price of a painter's work, by including binary independent variables for the dates at which paintings were auctioned. So for example the estimated coefficients of these variables indicate that the real price of a Pollock of the same size, support, and date of execution was nearly five times as high in 1997 as in 1970. But the same regression suggests that the relative value of Pollock's work by age changed little in this period. Thus the coefficients of the age variables in the equation for Pollock that yielded the highest $R^2$ were estimated quite precisely: the $F$-statistic for the age variables in the cubic specification was significant at the .0018 level. If the value of Pollock's work by age had fluctuated considerably over time, the precision of the estimated age-price relationship would be expected to have been poorer.

The stability of this relationship is not surprising, for the timing of Pollock's greatest contribution was defined critically very early, and has not significantly changed since. Thus already in 1955 Clement Greenberg argued that Pollock's work had declined from its peak: "His most recent show, in 1954, was the first to contain pictures that were forced, pumped, dressed up . . . His 1951 exhibition, on the other hand, included four or five huge canvases of monumental perfection and remains the peak of his achievement so far"; *Collected Essays and Criticism,* 3:226. In 1959, the poet and critic Frank O'Hara observed that Pollock "had incited in himself, and won, a revolution in three years (1947–50)"; *Jackson Pollock,* p. 30. And in 1998, in an essay accompanying the latest Pollock retrospective, the curator Kirk Varnedoe provided a recent overview: "It's been suggested by a journalist that Pollock's life is basically a drama in three acts: 1930–47, he searches for himself; 1947–50, he finds himself; 1950–56, he loses himself. Brutal . . . but not untrue"; *Jackson Pollock,* p. 62. For other similar judgments see Karmel, *Jackson Pollock,* pp. 84, 97, 165, 266. The auction market's strong indication that Pollock's work reached its peak value in 1950 is thus consistent with a long-standing critical consensus.

20. Schapiro, *Modern Art,* p. 224.

21. Schjeldahl, *The "7 Days" Art Columns,* p. 93.

22. Veblen, *Theory of the Leisure Class,* p. 75.

23. Caves, *Creative Industries,* pp. 331–333.

24. For example, see Frey and Pommerehne, *Muses and Markets,* chap. 7.

25. Veblen, *Theory of the Leisure Class,* p. 129.

26. Quoted in Duff, "In Payscales, Life Sometimes Imitates Art," p. B1.

27. The question might be raised here of the direction of causation: do the experts' opinions cause the auction market outcomes, or vice versa? This would be a difficult question to answer, in part because the two mechanisms are not mutually exclusive. Yet resolving this issue of causation is unnecessary for present purposes. What matters here is simply that the evaluations of scholars (as measured in the ways indicated) and auction market outcomes usually produce the same judgment of when an artist produced his best work. This means that the period of an artist's career most highly valued by the auction market will generally be the most important period of his career for art history. Whatever the causal relationship between the two sources, the question of interest for this study will be why this period is judged the artist's most important.

## 4. Importance in Modern Art

1. Mallarmé, "Impressionists and Edouard Manet," p. 32.

2. Quoted in Courthion and Cailler, *Portrait of Manet*, pp. 160–66.

3. Whistler, *Gentle Art of Making Enemies*, p. 30.

4. Cézanne, *Paul Cézanne, Letters*, p. 313.

5. Brassaï, *Conversations With Picasso*, p. 107.

6. Quoted in Sandler, *Triumph of American Painting*, p. 47.

7. Lewis, *Creatures of Habit and Creatures of Change*, pp. 290–91.

8. Quoted in Los Angeles County Museum of Art, *New York School*, p. 25.

9. Terenzio, *Collected Writings of Robert Motherwell*, p. 35.

10. Quoted in Tuchman, *Validating Modern Art*, p. 9.

11. Quoted in Brown, *After Mountains and Sea*, pp. 30–31.

12. Schapiro, *Modern Art*, p. 153.

13. Greenberg, *Collected Essays and Criticism*, 4:300.

14. Bowness, *Modern European Art*, p. 172.

15. Moulin, *French Art Market*, p. 30.

16. Steinberg, *Other Criteria*, pp. 6, 15.

17. Fried, *Art and Objecthood*, pp. 17, 218.

18. Bourdieu, *Rules of Art*, p. 244.

19. Rosenberg, *Tradition of the New*, p. 37.

20. Several aspects of this argument are perhaps worth emphasizing. Innovation is used here simply to refer to influential changes in art. Innovations in art constitute progress in the sense that painters can make use of discoveries made by their predecessors without having to make them again. Yet since we have no metric with which to measure quality in art absolutely, we cannot assume that any innovator is a better artist than his predecessors. On art and progress, see Koestler, *Act of Creation*, chap. 23. A related point is that identification and assessment of particular innovations is not determined by judgments of quality on my part. My intent is rather to rely on the judgments of artists, art critics, and art historians concerning the nature and significance of particular innovations. The argument here is that within the existing canon of modern art, as recognized by a broad consensus of artists, critics, and scholars, innovation has been the central criterion for artistic success.

21. Van Gogh, *Complete Letters of Vincent van Gogh*, 3:543.

22. Pissarro, *Letters to His Son Lucien*, p. 277.

23. Vollard, *Recollections of a Picture Dealer*, p. 220.

24. Kahnweiler, *My Galleries and Painters*, pp. 39–40.

25. This argument has been made about the arts in general by Martindale, *Clockwork Muse*, pp. 10–11.

26. Jensen, *Marketing Modernism in Fin-de-Siècle Europe,* pp. 24, 35. In 1961, Reitlinger observed that "in terms of real values, it is certain that no painter has ever seen his work fetch as much in his own lifetime as Meissonier"; *Economics of Taste,* 1:383.

27. On the early recognition of talented artists by other artists, see Bowness, *Conditions of Success,* p. 16. In this lecture, Bowness argued that the success of modern artists is not arbitrary, but is rather the predictable result of a clear and regular progression. In Bowness's scheme, the first step is recognition of an artist by his peers, the second recognition by critics, the third patronage by dealers and collectors, and the fourth public acclaim. Bowness further estimates that the time required for a truly original artist to be accepted is twenty-five years. Bowness' hypothesis has not yet received systematic testing and evaluation. Some evidence consistent with it comes from a study of the careers of etchers; Lang and Lang, *Etched in Memory,* chap. 9. Some suggestive evidence on the quantitative importance of artists as an audience for advanced art in a more recent period is given by Haacke, *Framing and Being Framed,* pp. 17, 42.

28. See Chapter 8.

29. Quoted in Weitzenhoffer, *Havemeyers,* p. 212.

30. Kahnweiler, *My Galleries and Painters,* p. 60.

31. Baudelaire, *Painter of Modern Life and Other Essays;* Blake and Frascina, "Modern Practices of Art and Modernity," pp. 50–140; Richardson, *A Life of Picasso,* vol. 2, chap. 1.

32. Mayne, "Editor's Introduction," in Baudelaire, *Painter of Modern Life and Other Essays,* pp. xiv, xvi. No work by Guys is illustrated in any of the textbooks consulted in selecting artists for this study; see Chapter 1.

33. For example, see Ashton, *New York School,* pp. 157–161; Reise, "Greenberg and the Group: A Retrospective View," pp. 252–263; Carrier, *Artwriting,* chap. 1; Rubenfeld, *Clement Greenberg,* pp. 100–114.

34. For example, Greenberg, *Collected Essays and Criticism,* 4:95, 99–100, 133, 149–153, 281–282, 306, 308. It should be emphasized that I am not claiming that Greenberg did not contribute to the success of the Abstract Expressionists: quite the contrary, there is evidence that his prose not only helped them gain commercial success by persuading galleries to show their work, and collectors to buy it, but also helped them gain the attention of younger artists (for example, see Chapter 7). The point here is that critical support cannot make an artist's work important in the long run in the absence of influence on other artists. The decline in the reputations of Noland and Olitski since the early 1960s appears to be a result of the loss of interest of painters of recent generations in formalist criticism and gestural abstraction, and of the consequent realization that Noland and Olitski did not have a great influence on younger painters; for example, see Collings, *It Hurts,* pp. 96–107.

35. Jensen, *Marketing Modernism in Fin-de-Siècle Europe,* chap. 3.

36. Pissarro, *Letters to His Son Lucien,* p. 23.

37. Weld, *Peggy: The Wayward Guggenheim,* chap. 44.

38. Quoted in Tomkins, *Post—to Neo—,* pp. 25, 37.

39. Rosenberg, *Discovering the Present,* p. 112. On museums, also see the comments of Walker, *Self-Portrait with Donors,* p. xviii.

40. Rosenberg, *Discovering the Present,* p. 118.

41. Quoted in O'Neill, *Barnett Newman,* p. 67.

42. White and White, *Canvases and Careers,* pp. 119–21.

43. Danto, *Embodied Meanings,* p. 85.

44. Brassaï, *Conversations with Picasso,* p. 69.

45. Baudelaire, *Painter of Modern Life and Other Essays,* p. 3.

46. Ibid., pp. 4, 13.

47. Quoted in Hamilton, *Manet and His Critics,* pp. 95–96.

48. Ibid., p. 146.

49. Duranty, "New Painting," pp. 41–42.

50. Mallarmé, "Impressionists and Edouard Manet," pp. 29, 33.

51. Huysmans, "'L'Exposition des Independents' in 1880," pp. 45–48.

52. Quoted in Broude, *Seurat in Perspective,* p. 40.

53. Quoted in Rewald, *Post-Impressionism,* p. 481.

54. Pissarro, *Letters to His Son Lucien,* pp. 99–100.

55. Quoted in Broude, *Seurat in Perspective,* p. 105.

56. Quoted in Rewald, *Post-Impressionism,* pp. 368, 372.

57. Van Gogh, *Complete Letters of Vincent van Gogh,* 3:251.

58. Ibid., 3:252.

59. Pissarro, *Letters to His Son Lucien,* p. 276.

60. Gauguin, *Writings of a Savage,* p. 219.

61. White and White, *Canvases and Careers,* pp. 94–99, 128, 150–152. For examples of art historians' evaluations of *Canvases and Careers,* see House, *Monet,* p. 234; Ward, *Pissarro, Neo-Impressionism, and the Spaces of the Avant-Garde,* p. 4.

62. Jensen, *Marketing Modernism in Fin-de-Siècle Europe,* chap. 2.

63. White and White, *Canvases and Careers,* p. 150; Pissarro, *Letters to His Son Lucien,* p. 174.

64. Pissarro, *Letters to His Son Lucien,* p. 163.

65. Van Gogh, *Complete Letters of Vincent van Gogh,* 2:515. Four of the artists van Gogh mentioned by name were dead; the fifth, Dupré, was seventy-six years old.

66. Quoted in Rewald, *History of Impressionism,* p. 560.

67. Jensen, *Marketing Modernism in Fin-de-Siècle Europe,* pp. 49–54, 63–67; Cottington, *Cubism in the Shadow of War,* pp. 43–44.

68. Jensen, *Marketing Modernism in Fin-de-Siècle Europe,* p. 134.

69. Fitzgerald, *Making Modernism.*

70. Brassaï, *Conversations With Picasso,* p. 180.

71. Fitzgerald, *Making Modernism,* pp. 10, 30.

72. Ibid., pp. 34–44.

73. Baudelaire, *Painter of Modern Life and Other Essays*, p. 46.

74. Quoted in Hamilton, *Manet and His Critics*, p. 91.

75. Van Gogh, *Complete Letters of Vincent van Gogh*, Volume 3, p. 398.

76. Gauguin, *Writings of a Savage*, p. 130.

77. Quoted in Barr, *Picasso*, p. 270.

78. Flam, *Matisse on Art*, pp. 149–150.

79. Kahnweiler, *My Galleries and Painters*, pp. 57–58.

80. Quoted in Friedman, *Jackson Pollock*, p. 176.

81. Quoted in Rose, *Frankenthaler*, p. 29.

82. Zola, "Edouard Manet," p. 31.

## 5.  Experimental and Conceptual Innovators

1. Quoted in House, *Monet*, p. 165.

2. Pissarro, *Letters to His Son Lucien*, p. 277.

3. Quoted in Hamilton, *Painting and Sculpture in Europe*, p. 373.

4. Miró, *Selected Writings*, p. 209.

5. Quoted in Shapiro and Shapiro, *Abstract Expressionism*, p. 397.

6. Quoted in Madoff, *Pop Art*, p. 104.

7. LeWitt, "Paragraphs on Conceptual Art," p. 78.

8. For clarity and economy of expression these two methods will be described qualitatively, and as distinctly separate. Artists' actual practices may of course contain elements of both methods. The distinction remains useful, however, because artists' approaches are either predominantly experimental or predominantly conceptual. The distinction presented here is thus useful in the same way as that used in economics between theoretical and empirical research: although in practice much research combines elements of both, the proportions vary so much and the principal contribution of any given scholar, and of any given study, is so rarely evenly divided between the two, that the distinction contains much relevant information.

9. Cézanne, *Paul Cézanne, Letters*, p. 302.

10. Quoted in Richardson, *A Life of Picasso*, 1:52.

11. Quoted in Golding, *Cubism*, p. 60.

12. Cézanne, *Paul Cézanne, Letters*, pp. 327–330.

13. It is perhaps worth emphasizing that Cézanne's persistent self-doubt and dissatisfaction were not mere eccentricities, but are in fact common characteristics of experimental innovators. It is not surprising that frustration is common among painters who combine ambitious goals with strong skepticism about the possibility of genuine resolution of artistic problems. This frustration may be even more prevalent among more important experimental painters, for it may often provide the motivation that pushes them to

pursue their goals more intensely and over longer periods, allowing them to achieve greater results.

14. Fry, *Cézanne*, p. 3.

15. Schapiro, *Paul Cézanne*, p. 10.

16. Bowness, *Modern European Art*, p. 37.

17. Quoted in Bois, *Painting as Model*, pp. 49, 276.

18. Shiff, *Cézanne and the End of Impressionism*, pp. 130, 181; Brion-Guerry, "Elusive Goal," p. 74.

19. Fry, *Cézanne*, p. 33.

20. Rewald, *History of Impressionism*, pp. 292–294; Fry, *Cézanne*, pp. 31–35.

21. Rewald, *Paul Cézanne*, p. 95.

22. Shiff, *Cézanne and the End of Impressionism*, p. 136.

23. Cézanne, *Paul Cézanne, Letters*, p. 299.

24. Ibid., p. 306.

25. Ibid., p. 315.

26. Ibid., p. 313.

27. Vollard, *Cézanne*, chap. 8.

28. Rewald, *Paintings of Paul Cézanne*, p. 146.

29. Vollard, *Cézanne*, pp. 48, 63, 77; Vollard, *Recollections of a Picture Dealer*, p. 182.

30. Shiff, *Cézanne and the End of Impressionism*, p. 162. Signed paintings by Cézanne are in fact not as rare as is sometimes claimed. Of the total of 954 works listed in Rewald's catalogue raisonné of Cézanne's paintings, 64, or 7 percent, are signed. Rewald notes that Cézanne may have signed works only if they were intended for a friend, an exhibition, or a collector; *Paintings of Paul Cézanne*, p. 88. Thus it may be the case that Cézanne generally felt no need to certify that his paintings were finished, whether because he did not consider them to be, or because his own knowledge of his paintings was sufficient to him, and he felt no need to provide a detailed guide for posterity. In either case, his attitude and practice contrast markedly with those of Picasso, described below.

31. Bell, "Debt to Cézanne," p. 77.

32. Quoted in Reff, "Painting and Theory in the Final Decade," p. 37.

33. Cézanne, *Paul Cézanne, Letters*, p. 303.

34. Vollard, *Cézanne*, p. 105.

35. Quoted in Barr, *Picasso*, pp. 270–71.

36. McCully, *A Picasso Anthology*, p. 145.

37. Elgar, *Picasso*, p. 171; Gedo, *Picasso*, p. 253; O'Brian, *Pablo Ruiz Picasso*, p. 236; Penrose, *Picasso*, p. 244; Berger, *Success and Failure of Picasso*, pp. 35–6. For a similar judgment, that Picasso made frequent changes of style, that was arrived at by a very different method, see Martindale, *Clockwork Muse*, pp. 304–308.

38. Cabanne, *Pablo Picasso*, p. 272.

39. McCully, *A Picasso Anthology*, p. 228.

40. Venturi, *Painting and Painters*, p. 207.

41. Quoted in Barr, *Picasso*, p. 272.

42. Quoted in Cabanne, *Pablo Picasso*, p. 253.

43. Gilot and Lake, *Life with Picasso*, p. 314. Picasso unsuccessfully attempted to prevent publication of Gilot's book, and his attempts were publicly supported by a number of his friends and admirers. Many scholars consequently rejected Gilot's book as unreliable; for example, see Penrose, *Picasso*, pp. 455–456. Yet for a critical assessment by the author of the most detailed biography of Picasso, see Richardson, *A Life of Picasso*, 1:478; Richardson, *Sorcerer's Apprentice*, p. 290.

44. Quoted in Cabanne, *Pablo Picasso*, p. 511.

45. O'Brian, *Pablo Ruiz Picasso*, p. 179; Brassaï, *Conversations with Picasso*, pp. 183–84.

46. O'Brian, *Pablo Ruiz Picasso*, p. 288. During the early phase of Cubism, Picasso, like Braque, rarely signed his paintings on the front. By 1914, however, Picasso began to reintroduce his signature in a variety of forms, including trompe l'oeil nameplates; Kahnweiler et al., *Picasso in Retrospect*, pp. 66–74, 256. Apart from this episode, Picasso's signature was almost always prominently placed on his thousands of paintings and drawings, as well as on thousands of his etchings and lithographs. And contrary to some accounts, Picasso insisted that even the early Cubist works were always signed, even if only on the back: "In one way or another, I always marked my pictures." He was so consistent in this practice that when a collector brought him an early work of his to be signed, he refused, saying it was unnecessary: "If you don't see my signature and the date, madam, it's because the frame is hiding it"; Brassai, *Conversations with Picasso*, p. 93.

47. Cabanne, *Pablo Picasso*, pp. 246, 500.

48. Quoted in Gilot and Lake, *Life with Picasso*, p. 123.

49. Quoted in Gilot and Lake, *Life with Picasso*, pp. 220–222.

50. Steinberg, "Le Bordel philosophique," p. 322.

51. Rubin, "Genesis of *Les Demoiselles d'Avignon*," pp. 14, 119.

52. Golding, *Visions of the Modern*, p. 101; Hamilton, *Painting and Sculpture in Europe*, pp. 458–459.

53. Chipp, *Picasso's Guernica*, p. 78.

54. Rewald, *Paul Cézanne*, p. 203.

55. McCully, *A Picasso Anthology*, p. 88.

56. Golding, *Cubism*, p. 60.

57. Ibid., p. 15.

58. Quoted in Valéry, *Degas, Manet, Morisot*, p. 51.

59. Terenzio, *Collected Writings of Robert Motherwell*, p. 78.

60. Rosenberg, *Act and the Actor*, p. 9.

61. Bowness, *Modern European Art,* p. 73.

62. Quoted in Zevi, *Sol LeWitt,* p. 106.

63. Wollheim, "Minimal Art," p. 396.

64. Lehman, *Age and Achievement,* pp. 330–331.

65. Bowness, *Modern European Art,* p. 122.

66. Simonton, *Scientific Genius,* p. 72.

67. In other terms, the argument begins by positing that an artist's creativity depends in part on his stock of human capital, where that stock has been determined by both his formal training in art and his experience as a painter. The proposition advanced here is that this relationship differs for the two types of practitioners: whereas the experimental artist's creativity is a positive function of his stock of human capital over a large range of the latter, the conceptual artist's creativity quickly becomes inversely related to his stock of human capital. Thus experience generally increases the likelihood of innovation for an experimental artist, but reduces that likelihood for a conceptual artist. The prediction follows that age and creativity will typically be directly correlated for experimental artists, and inversely correlated for conceptual artists.

68. Lehman, *Age and Achievement,* pp. 324–325; Simonton, *Scientific Genius,* p. 67; Simonton, *Greatness,* pp. 185–188.

69. Simonton, *Scientific Genius,* pp. 68–75; Simonton, *Greatness,* pp. 205–208.

70. Simonton, *Greatness,* pp. 187–189.

71. Quoted in Gersh-Nesic, *Early Criticism of André Salmon,* p. 40.

72. Many of the texts used to collect these data treated only modern art. Sample members born before 1830 were consequently not included in this tabulation.

73. The dates of these views of Mont Sainte-Victoire range from 1885 to 1906. If the novelty of the motif were the source of these paintings' importance, the earliest should be the most often reproduced. This is not the case, as the 1885 painting from the Barnes Collection is reproduced only once. Because of Cézanne's incremental process of innovation, it is one of the latest in the series—the 1904 painting from the Philadelphia Museum of Art—that is most often reproduced.

74. Rewald, *Paintings of Paul Cézanne.*

75. Quoted in House, *Monet,* p. 195.

76. Kendall, *Monet by Himself,* p. 189.

77. For example, see Hamilton, *Painting and Sculpture in Europe,* pp. 50–52.

78. For example, see ibid., pp. 261–263, 375–376.

79. Gauguin, *Writings of a Savage,* p. 24.

80. Ward, "Rhetoric of Independence and Innovation," in Moffett, *New Painting,* pp. 429–430, 444.

81. Sweetman, *Paul Gauguin,* pp. 130, 201.

82. Hamilton, *Painting and Sculpture in Europe,* p. 84; Sweetman, *Paul Gauguin,* p. 201.

## 6. Paris from Manet to Miró

1. Pissarro, *Letters to His Son Lucien*, p. 36.

2. Van Gogh, *Complete Letters of Vincent van Gogh*, 2:515.

3. Schapiro, *Modern Art*, p. 191.

4. Greenberg, *Collected Essays and Criticism*, 4:305.

5. Bourdieu, *Field of Cultural Production*, pp. 243–244.

6. White and White, *Canvases and Careers*, p. 17; Boime, *Academy and French Painting in the Nineteenth Century*.

7. Delacroix, *Journal of Eugène Delacroix*, pp. 543–544.

8. Fer, "Introduction," pp. 21–30; Hamilton, *Manet and His Critics*, pp. 42–51, 67–80; Greenberg, *Art and Culture*, p. 154; Tucker, *Manet's Le Déjeuner sur l'herbe*.

9. For example, see Richardson, *Manet*, pp. 26–27.

10. Herbert, "Privilege and the Illusion of the Real," p. 215.

11. Flam, "Looking into the Abyss," p. 168.

12. Duret, *Manet and the French Impressionists*, p. 57.

13. Ibid., p. 90. See also de Leiris, *Drawings of Edouard Manet*, pp. 29–35; Reff, *Manet: Olympia*, pp. 72–79; Tucker, *Manet's Le Déjeuner sur l'herbe*, p. 24.

14. Duret, *Manet and the French Impressionists*, p. 6.

15. Quoted in Hanson, *Manet and the Modern Tradition*, p. 44.

16. Hamilton, *Manet and His Critics*, p. 241; Duret, *Manet and the French Impressionists*, pp. 106–108.

17. Pissarro, *Letters to His Son Lucien*, p. 50.

18. Fried, *Manet's Modernism*, pp. 1–2; Hamilton, *Manet and His Critics*, p. 18.

19. Duret, *Manet and the French Impressionists*, p. 72.

20. White and White, *Canvases and Careers*, pp. 116–117; Adams, *The Barbizon School and the Origins of Impressionism*, p. 98.

21. Quoted in Hess, *Barnett Newman* (1971), p. 40.

22. Quoted in Rewald, *History of Impressionism*, p. 111.

23. Quoted in Nochlin, *Impressionism and Post-Impressionism*, p. 42.

24. House, *Monet*, chaps. 7–8.

25. Duret, *Manet and the French Impressionists*, pp. 71–72. Interestingly, painting in the open air had only become practical around 1850, with the first commercial appearance of paint in metal tubes; Bomford, *Art in the Making*, pp. 339–340. Renoir later remarked that "paints in tubes, being easy to carry, allowed us to work from nature, and nature alone. Without paints in tubes, there would have been no Cézanne, no Monet, no Sisley, or Pissarro, nothing of what the journalists were later to call Impressionism"; Renoir, *Renoir*, p. 77.

26. Kendall, *Monet by Himself*, p. 20.

27. Ibid., pp. 26, 112.

28. Ibid., p. 126.

29. Ibid., p. 172.

30. Ibid., p. 178.

31. Ibid., p. 245.

32. Quoted in White, *Renoir*, p. 115.

33. White, *Renoir*, p. 166.

34. Vollard, *Renoir*, p. 191.

35. Pissarro, *Letters to His Son Lucien*, p. 30.

36. Ibid., p. 47.

37. Ibid., p. 32.

38. Ibid., p. 53.

39. Ibid., p. 234.

40. Quoted in Rewald, *History of Impressionism*, p. 458.

41. Quoted in Nochlin, *Impressionism and Post-Impressionism*, p. 42.

42. Clark, *Landscape into Art*, pp. 170–176; see also Herbert, *Impressionism*, pp. 210–219.

43. The Impressionists' brighter palette was enriched by new technology, for many of the wide range of colors they used were new synthetic pigments that had been invented by chemists in the expanding French and German metallurgical industries of the nineteenth century. See Bomford, *Art in the Making*, pp. 51–75.

44. House, *Monet*, chaps. 3, 5, 6.

45. Here again the Impressionists benefited from new technology. Metal ferrules, which had first been added to painters' brushes earlier in the nineteenth century, made it possible to produce flat brushes, in addition to the round brushes that artists had used for centuries. The new brushes readily produced the flat broad strokes that became a distinctive feature of early Impressionist painting. See Bomford, *Art in the Making*, pp. 92–93.

46. Mallarmé, "Impressionists and Edouard Manet," p. 32.

47. Bazille would probably have been included in this core group, but he was killed in 1870 in the Franco-Prussian War.

48. Schapiro, *Impressionism*, pp. 264–65.

49. Quoted in Rewald, *History of Impressionism*, p. 38.

50. Quoted in Broude, *Impressionism*, p. 42.

51. Tucker, "The First Impressionist Exhibition in Context;" Berson, *The New Painting*, pp. 3–13.

52. Rewald, *History of Impressionism*, p. 591.

53. Jensen, *Marketing Modernism in Fin-de-Siècle Europe*, chap. 3.

54. Quoted in Rewald, *History of Impressionism*, p. 177.

55. Quoted in Vollard, *Degas*, p. 96.

56. Valéry, *Degas, Manet, Morisot,* p. 70.

57. Guérin, *Lettres de Degas,* p. 107.

58. Vollard, *Degas,* p. 102.

59. Valéry, *Degas, Manet, Morisot,* p. 39.

60. Ibid., p. 50.

61. Ibid., p. 92. More generally, Rouart observed that "the urge to revise an unfinished work to his taste never left him, and many were the canvases he kept at home with a view to retouching them, since he did not consider them worthy to leave his studio in their actual condition" (ibid., pp. 92–93). An instance of this involved a prominent American collector. In the spring of 1891, Mary Cassatt and her friend Louisine Havemeyer visited Degas' studio, where Mrs. Havemeyer bought a small oil painting. Degas asked to keep the work for a while, to "add a few touches." As time passed, Degas refused to part with the painting; in October 1894, Cassatt reported that she had been unable to persuade him to let it go. When Degas subsequently demanded a higher price for the now improved painting, Harry Havemeyer was annoyed, but agreed to pay. Mrs. Havemeyer wrote, "It was no use! Degas was quite stubborn about it, and the idea was so fixed in his mind that he was entitled to the increase in value that at last Mr. Havemeyer yielded. We felt that we were perhaps fortunate to get the picture back unspoiled, for Degas had a dangerous habit of retouching which sometimes spoiled a picture"; Weitzenhoffer, *Havemeyers,* p. 81.

62. Moore, *Impressions and Opinions,* p. 229.

63. Broude, *Seurat in Perspective,* p. 31; Halperin, *Félix Fénéon and the Language of Art Criticism,* chap. 3.

64. Quoted in Broude, *Seurat in Perspective,* p. 148.

65. Quoted in Hamilton, *Painting and Sculpture in Europe,* p. 49.

66. Homer, *Seurat and the Science of Painting,* chap. 2.

67. Ibid., pp. 36–43.

68. Herbert, *Georges Seurat,* p. 170.

69. Smith, *Seurat and Avant-Garde,* p. 21; Herbert, *Georges Seurat,* p. 172.

70. Rewald, *Georges Seurat,* p. 26. Seurat's belief that the value of his work lay in the application of scientific theory, rather than in his own talent or inspiration, led him to resist showing his work in public, for fear that other artists would copy his methods and reduce the value of his work; Pissarro, *Letters to His Son Lucien,* pp. 99–100; Rewald, *Post-Impressionism,* p. 114.

71. Rewald, *Post-Impressionism,* p. 86.

72. Pissarro, *Letters to His Son Lucien,* p. 64.

73. Ibid., p. 64.

74. Ibid., pp. 73–74.

75. Ibid., p. 93.

76. Ibid., p. 30.

77. Ibid., pp. 132, 158; Rewald, *Post-Impressionism,* p. 130.

78. Rewald, *Georges Seurat*, p. 68.

79. Pissarro, *Letters to His Son Lucien*, pp. 273–274.

80. Ibid., p. 135.

81. Quoted in Homer, *Seurat and the Science of Painting*, p. 181.

82. Rewald, *Post-Impressionism*, pp. 99–101; Homer, *Seurat and the Science of Painting*, chap. 4; Roskill, *Van Gogh, Gauguin, and the Impressionist Circle*, p. 90.

83. Flam, *Matisse on Art*, p. 120.

84. Fry, *Transformations*, p. 250.

85. Pissarro, *Letters to His Son Lucien*, p. 44.

86. Gauguin, *Writings of a Savage*, pp. 5, 22.

87. Ibid., p. 204.

88. Rewald, *Post-Impressionism*, p. 481.

89. Gauguin, *Writings of a Savage*, p. 145.

90. Ibid., p. 109.

91. Rewald, *Post-Impressionism*, p. 189.

92. Gauguin, *Writings of a Savage*, pp. 159–160. Sweetman argues that the painting's execution actually took longer than Gauguin claimed, but nonetheless believes the work was made according to a preconceived plan; *Paul Gauguin*, pp. 452–459.

93. Van Gogh, *Complete Letters of Vincent van Gogh*, 2:525.

94. Ibid., 3:6.

95. Ibid., 3:28–31.

96. Ibid., 3:58.

97. Ibid., 2:606–607.

98. Fry, *Transformations*, p. 240.

99. Dorn, "Arles Period," p. 136.

100. Van Gogh, *Complete Letters of Vincent van Gogh*, 2:606.

101. Ibid., 3:399–400.

102. Ibid., 2:605.

103. Ibid., 2:619.

104. Quoted in Gilot and Lake, *Life with Picasso*, pp. 74–75.

105. Quoted in Barr, *Matisse*, p. 63.

106. Giry, *Fauvism*, p. 250.

107. Flam, *Matisse on Art*, pp. 37–40.

108. Ibid., p. 120.

109. Ibid., p. 145.

110. Spurling, *Unknown Matisse*, p. 293; Flam, *Matisse on Art*, pp. 130–131.

111. O'Brian, *Ruthless Hedonism*, chap. 6.

112. Another recent study argues that Rothko's 1954 *Homage* was influenced by a Matisse stained-glass window executed in 1952 and presented to the Museum of Modern Art the next year; Gage, "Rothko: Color as Subject," p. 253.

113. O'Brian, *Ruthless Hedonism*, pp. 165–169.

114. Ibid., pp. 169–170.

115. Shiff, *Cézanne and the End of Impressionism*, pp. 55–56.

116. Greenberg, *Collected Essays and Criticism*, 3:173.

117. Carrier, *Artwriting*, p. 43.

118. Stein, *Autobiography of Alice B. Toklas*, p. 79.

119. Richardson, *Life of Picasso*, 1:411–419.

120. Ibid., 2:83.

121. Hamilton, *Painting and Sculpture in Europe*, p. 238.

122. Cooper, *The Cubist Epoch*, p. 42. The phase is Braque's description of their relationship.

123. Richardson, *Life of Picasso*, 2:105.

124. Cooper, *Cubist Epoch*, pp. 57–58; Kahnweiler, *Rise of Cubism*, p. 12; Golding, *Cubism*, chaps. 2–3.

125. Cooper, *Cubist Epoch*, p. 60; Golding, *Cubism*, pp. 27, 96–99; Richardson, *Life of Picasso*, 2:176; Kahnweiler, *Juan Gris*, pp. 30–31.

126. Kahnweiler, *Juan Gris*, pp. 165–166.

127. Quoted in Kahnweiler, *My Galleries and Painters*, p. 46.

128. Cooper, *Cubist Epoch*, p. 11.

129. On the diffusion of Cubism, see ibid., chaps. 2–3.

130. Quoted in Rubin and Lanchner, *André Masson*, p. 13.

131. Rubin and Lanchner, *André Masson*, p. 21.

132. Miró, *Selected Writings and Interviews*, pp. 62–63.

133. Ibid., p. 98.

134. Ibid., p. 209.

135. Ibid., p. 217.

136. Ibid., p. 51.

137. Ibid., p. 55.

138. Robert Motherwell considered automatism so important to the creation of Abstract Expressionism that in 1965 he described Miró as "the godfather of modern American painting"; Terenzio, *Collected Writings of Robert Motherwell*, p. 144.

139. Both of these paintings rank among the ten individual works by the French modern artists considered in this study that are most often reproduced in textbooks; see Table 5.2.

140. Quoted in Kuh, *Artist's Voice*, pp. 89–90.

141. Ibid., p. 89; Sanouillet and Peterson, *Writings of Marcel Duchamp*, p. 125.

142. Quoted in Tomkins, *Bride and the Bachelors,* p. 24.

143. De Duve, *Kant after Duchamp;* Brandon, *Surreal Lives,* chap. 2.

144. Cabanne, Dialogues with Marcel Duchamp, p. 37.

## 7.  New York from Marin to Minimalism

1. Quoted in Breslin, *Mark Rothko,* p. 539.

2. Terenzio, *Collected Writings of Robert Motherwell,* p. 3.

3. Greenberg, *Collected Essays and Criticism,* 3:61.

4. Lippard, *Changing,* pp. 27–31.

5. Sylvester, *About Modern Art,* pp. 229–30.

6. De Duve, *Clement Greenberg between the Lines,* p. 127.

7. Quoted in Kimmelman, *Portraits,* pp. 52–54.

8. De Zayas, *How, When, and Why Modern Art Came to New York,* p. 86.

9. Norman, *Selected Writings of John Marin,* p. 17.

10. Quoted in Kelder, *Stuart Davis,* p. 147.

11. Sloan, *Gist of Art,* p. 192.

12. Townsend, *Charles Burchfield's Journals,* p. 546.

13. Quoted in Kuh, *The Artist's Voice,* pp. 190–91.

14. Quoted in Lynes, *O'Keeffe, Stieglitz, and the Critics,* p. 288.

15. Quoted in Ness, *Lyonel Feininger,* p. 110.

16. Ibid., p. 55.

17. Sloan, *Gist of Art,* p. 190.

18. Italian-born Joseph Stella produced his most valuable work in 1904, at age forty-one, after arriving in the States at age nineteen; Davidson, *Early American Modernist Painting,* p. 101. Russian-born Max Weber produced his most valuable work in 1908, at age twenty-seven, while studying with Matisse in Paris (ibid., p. 29). German-born Hans Hofmann, who became a teacher of the Abstract Expressionists, did not produce his most valuable work until 1964, at age eighty-four.

19. Quoted in Luddington, *Marsden Hartley,* p. 259.

20. Ibid., pp. 238–240.

21. Loughery, *John Sloan,* p. 280.

22. Sloan, *Gist of Art,* p. 26.

23. Quoted in Carmean and Rathbone, *American Art at Mid-Century,* p. 15.

24. Quoted in O'Neill, *Clyfford Still,* p. 178; quoted in Karmel, *Jackson Pollock,* p. 15.

25. Ashton, *New York School,* pp. 44–51; Sandler, *Triumph of American Painting,* pp. 5–7.

26. Quoted in Hess, *Willem de Kooning,* p. 147.

27. Quoted in Hess, *Barnett Newman* (1969), p. 42.

28. Sawin, *Surrealism in Exile.*

29. Terenzio, *The Collected Writings of Robert Motherwell,* p. 146.

30. De Kooning, *The Spirit of Abstract Expressionism,* p. 92; Terenzio, *Collected Writings of Robert Motherwell,* pp. 155–167.

31. Carmean and Rathbone, *American Art at Mid-Century,* pp. 16–23.

32. Terenzio, *Collected Writings of Robert Motherwell,* p. 165.

33. Ibid., p. 34.

34. Quoted in Shapiro and Shapiro, *Abstract Expressionism,* p. 265.

35. Ibid., pp. 266–267.

36. Quoted in Friedman, *Jackson Pollock,* p. 176.

37. Quoted in Shapiro and Shapiro, *Abstract Expressionism,* p. 171.

38. Quoted in Ashton, *New York School,* p. 128.

39. Quoted in Alloway, *William Baziotes,* p. 40.

40. Quoted in Bois, *Painting as Model,* p. 190.

41. Quoted in Spender, *From a High Place,* p. 275.

42. Quoted in Seitz, "Abstract-Expressionist Painting in America," pp. 253–254.

43. Quoted in Shapiro and Shapiro, *Abstract Expressionism,* pp. 397–398.

44. Quoted in Goodnough, "Artists' Sessions at Studio 35," p. 321.

45. Quoted in Carmean and Rathbone, *American Art at Mid-Century,* p. 128.

46. Terenzio, *Collected Writings of Robert Motherwell,* p. 227.

47. Greenberg, *Collected Essays and Criticism,* 3:228–230.

48. Hess, *Barnett Newman* (1969), pp. 53–54.

49. The historian William Seitz expressed this point in general terms: "Post–World War II painting was a synthesis of structure with improvisation and, on the level of content, of *conception* with *expression.* The rediscovery of Impressionism in 1956 advanced *perception* as an escape from this dualism"; *Art in the Age of Aquarius,* pp. 13–14.

50. De Kooning, *The Spirit of Abstract Expressionism,* p. 149.

51. Quoted in Kuh, *The Artist's Voice,* p. 89.

52. Chave, *Mark Rothko,* pp. 11–12.

53. Terenzio, *Collected Writings of Robert Motherwell,* pp. 141, 228.

54. Quoted in Friedman, *Jackson Pollock,* p. 100.

55. Quoted in Stiles and Selz, *Theories and Documents of Contemporary Art,* p. 24.

56. Quoted in Carmean and Rathbone, *American Art at Mid-Century,* pp. 133–139; see also Goodnough, "Pollock Paints a Picture."

57. Quoted in Friedman, *Jackson Pollock,* p. 183.

58. De Kooning, *The Spirit of Abstract Expressionism,* p. 226.

59. Carmean and Rathbone, *American Art at Mid-Century,* p. 158.

60. Hess, *Willem de Kooning,* p. 25.

61. Quoted in Shapiro and Shapiro, *Abstract Expressionism,* p. 228.

62. Quoted in Hess, *Willem de Kooning,* p. 149.

63. Hess, *Willem de Kooning,* p. 46.

64. Breslin, *Mark Rothko,* p. 607.

65. Quoted in ibid., p. 232.

66. Ibid., p. 237.

67. Ibid., p. 317.

68. Ibid., p. 468.

69. Breslin, *Mark Rothko,* p. 469.

70. Quoted in ibid., pp. 495–496.

71. Ibid., p. 326.

72. Chave, *Mark Rothko,* p. 12.

73. Quoted in Breslin, *Mark Rothko,* p. 526.

74. Quoted in Ashton, *About Rothko,* p. 5.

75. Shapiro and Shapiro, *Abstract Expressionism,* pp. 48–58.

76. Quoted in Alloway, *William Baziotes,* p. 41.

77. Breslin, *Mark Rothko,* pp. 257–258.

78. Gottlieb, "Artist and the Public," p. 267.

79. Greenberg, *Collected Essays and Criticism,* 2:215; Rubenfeld, *Clement Greenberg,* chap. 6; Guilbaut, *How New York Stole the Idea of Modern Art,* pp. 168–172.

80. Greenberg, *Collected Essays and Criticism,* 3:105–106.

81. On the importance of Greenberg's criticism, see Ashton, *New York School,* pp. 157–161; Reise, "Greenberg and the Group." pp. 252–263; Wood et al., *Modernism in Dispute,* pp. 42–65; Rubenfeld, *Clement Greenberg,* pp. 100–114; Carrier, *Artwriting,* pp. 35–41.

82. Seitz, "Abstract-Expressionist Painting in America," pp. iii, 442–443.

83. Ashton, *New York School,* pp. 132, 168; Geldzahler, *Making It New,* pp. 114–16; Robson, *Prestige, Profit, and Pleasure,* pp. 80–128.

84. Sandler, *New York School,* pp. 36–38; Watson, *From Manet to Manhattan,* pp. 285–290; Robson, *Prestige, Profit, and Pleasure,* pp. 80–128.

85. Shapiro and Shapiro, *Abstract Expressionism,* p. 175; Breslin, *Mark Rothko,* pp. 340–341.

86. Greenberg, *Collected Essays and Criticism,* 2:321, 4:46, 53. See also Guggenheim, *Out of This Century,* pp. 362–363.

87. Gottlieb, "Artist and the Public," p. 267.

88. Rubin, *Frank Stella,* p. 41.

89. Quoted in Ashton, *New York School,* p. 128.

90. Greenberg, *Collected Essays and Criticism,* 2:189.

91. Shapiro and Shapiro, *Abstract Expressionism,* p. 178.

92. Greenberg, *Collected Essays and Criticism*, 2:221–225, 3:113–119; Fried, *Three American Painters*, pp. 5–8.

93. Steinberg, *Other Criteria*, pp. 77–78.

94. Greenberg, *Collected Essays and Criticism*, 4:300..

95. Geldzahler, *Making It New*, p. 112.

96. Greenberg, *Collected Essays and Criticism*, 4:126–127, 302.

97. On Kirk Varnedoe's judgment of Johns's best work, see Table 3.2. For the judgments of some other art historians, see Galenson, "Careers of Modern Artists," table 3, p. 93. This shows that six surveys of modern American art, published from 1969 through 1994, contain a total of seventeen illustrations of paintings by Johns, and that fifteen of the seventeen are of paintings he produced between the ages of twenty-five and thirty.

98. Fried, *Art and Objecthood*, p. 3.

99. Rubin, *Frank Stella*, p. 12.

100. Fried, *Art and Objecthood*, pp. 24, 251–252.

101. Battcock, *Minimal Art*, pp. 157–161.

102. Quoted in Jones, *Machine in the Studio*, p. 90.

103. Quoted in Rubin, *Frank Stella*, p. 32.

104. Quoted in Zevi, *Sol LeWitt*, p. 123.

105. LeWitt, "Paragraphs on Conceptual Art," pp. 78–79.

106. LeWitt, "Sentences on Conceptual Art," p. 90.

107. LeWitt, "Paragraphs on Conceptual Art," p. 78; LeWitt, "Doing Wall Drawings," p. 95.

108. Alloway, "Systemic Painting," p. 58.

109. Madoff, *Pop Art*, p. 291.

110. Quoted in Jones, *Machine in the Studio*, pp. 197–198.

111. Bockris, *Warhol*, pp. 153, 170.

112. Quoted in Madoff, *Pop Art*, p. 104.

113. Ibid., p. 198.

114. Rose, *The Drawings of Roy Lichtenstein*, p. 20.

115. Quoted in Gruen, *The Artist Observed*, p. 225.

116. Quoted in Sylvester, *About Modern Art*, p. 230.

117. Johns, *Writings, Sketchbook Notes, Interviews*, p. 113.

118. Quoted in Madoff, *Pop Art*, pp. 107–8.

119. Ibid., p. 115.

120. Zevi, *Sol LeWitt*, p. 293. The critic Lawrence Alloway made a similar observation in 1969, when he noted that Pop Art had in common with other recent art what he called "process abbreviation." Thus Pop artists either went through fewer stages in the production of their work than earlier painters, or made it appear that they had; see Madoff, *Pop Art*, pp. 172–173.

121. Perreault, "Minimal Abstracts," p. 257.

122. Quoted in Rubin, *Frank Stella*, p. 30.

123. Quoted in Battcock, *Minimal Art*, p. 159.

124. Quoted in Tomkins, *Off the Wall*, p. 97.

125. Rosenberg, *Art and Other Serious Matters*, p. 245.

126. Sandler, *New York School*, p. 180; Tomkins, *Off the Wall*, p. 156.

127. Quoted in Kimmelman, "The Irrepressible Ragman of Art," p. 26.

128. Rosenberg, *The De-definition of Art*, pp. 130–131.

## 8.  Intergenerational Conflict in Modern Art

1. Pissarro, *Letters to His Son Lucien*, p. 265.

2. Flam, *Matisse on Art*, p. 123.

3. Quoted in Gilot and Lake, *Life with Picasso*, p. 76.

4. Kubler, *The Shape of Time*, p. 6.

5. Greenberg, *Homemade Esthetics*, p. 117.

6. Flam, *Matisse on Art*, p. 79; Tomkins, *Off the Wall*, pp. 30–32.

7. Sylvester, *About Modern Art*, p. 440; Rewald, *History of Impressionism*, pp. 456–58; Brettell, *Pissarro and Pontoise*, p. 204.

8. Friedman, *Jackson Pollock*, pp. 18–36.

9. Breslin, *Mark Rothko*, pp. 91–96.

10. Quoted in ibid., p. 93.

11. Rewald, *History of Impressionism*, pp. 578–579.

12. Quoted in Friedman, *Jackson Pollock*, pp. 117, 162.

13. Greenberg, *Homemade Esthetics*, p. 53.

14. Gauguin, *Writings of a Savage*, p. 218.

15. Quoted in Gilot and Lake, *Life with Picasso*, p. 76.

16. Ibid., p. 77.

17. McCully, *A Picasso Anthology*, p. 64.

18. Terenzio, *The Collected Writings of Robert Motherwell*, pp. 158–159, 280.

19. Quoted in Tomkins, *Off the Wall*, p. 118.

20. Johns, *Writings, Sketchbook Notes, Interviews*, pp. 280–281.

21. Quoted in Tomkins, *Off the Wall*, p. 118.

22. Quoted in Hess, *Barnett Newman* (1971), p. 40.

23. Terenzio, *The Collected Writings of Robert Motherwell*, p. 294.

24. Bowness, *The Conditions of Success*, p. 51.

25. White, *Careers and Creativity*, p. xiii.

26. Sylvester, *About Modern Art*, p. 445.

27. The discussion of the remainder of this section draws on Galenson and Weinberg, "Art Schools."

28. Bazille, *Correspondance*, p. 51.

29. Pissarro, *Letters to His Son Lucien*, pp. 286–287.

30. Cézanne, *Paul Cézanne, Letters*, p. 337.

31. Quoted in Breslin, *Mark Rothko*, p. 425.

32. Johns, *Writings, Sketchbook Notes, Interviews*, p. 94.

33. Obituary of Leo Castelli, *New York Times*, August 23, 1999, p. A16.

34. Steinberg, *Other Criteria*, pp. 3–6.

35. Darwin, *On the Origin of Species*, pp. 481–482.

36. Planck, *Scientific Autobiography*, pp. 33–34.

37. Diamond, "Age and the Acceptance of Cliometrics," pp. 838–841; Simonton, *Greatness*, p. 202.

38. Freud, *Civilization and Its Discontents*, pp. 98–99.

39. Sweetman, *Paul Gauguin*, p. 90; Pickvance, "Contemporary Popularity and Posthumous Neglect," p. 248.

40. Pissarro, *Letters to His Son Lucien*, pp. 319–320; Shikes and Harper, *Pissarro*, p. 308.

41. Pissarro, *Letters to His Son Lucien*, p. 57.

42. Ibid., pp. 96–97.

43. Ibid., p. 97.

44. Rewald, *Post-Impressionism*, pp. 478–482.

45. Gaugin, *Writings of a Savage*, pp. 23–24; Sweetman, *Paul Gauguin*, pp. 200–201.

46. Pissarro, *Letters to His Son Lucien*, p. 164.

47. Hamilton, *Painting and Sculpture in Europe*, p. 84.

48. Pissarro, *Letters to His Son Lucien*, p. 174.

49. Ibid., p. 221.

50. Ibid., p. 222.

51. Richardson, *A Life of Picasso*, 1:263–264; Blunt and Pool, *Picasso*, ills. 120–127.

52. Richardson, *A Life of Picasso*, 1:461, 475.

53. See also Stuckey, *Monet*, p. 248.

54. Quoted in Madoff, *Pop Art*, p. 39.

55. Quoted in Tomkins, *Off the Wall*, p. 185.

56. Tomkins, *Off the Wall*, p. 185. Harold Rosenberg similarly pointed to the psychological distance between the two generations: "In the creations of the pioneer Abstract Expressionists, a principle was manifest—the avant-garde principle of transforming the self and society. The 'objectivity' of Pop was a deliberate abandonment of this principle,

and it had the effect of a betrayal. If Pop succeeded, the epoch of art's rebelliousness and secession from society would have come to an end"; *Art on the Edge,* p. 237.

57. Terenzio, *Collected Writings of Robert Motherwell,* p. 137.

58. De Duve, *Kant after Duchamp,* p. 216.

59. Quoted in Breslin, *Mark Rothko,* p. 427.

60. Ibid., p. 433.

61. Schueler, *The Sound of Sleat,* p. 107.

62. Johns, *Writings, Sketchbook Notes, Interviews,* pp. 156–157.

63. Steinberg, *Other Criteria,* p. 4.

64. Barr, *Matisse,* pp. 168–174; Gilot and Lake, *Life with Picasso,* pp. 261–272; Bois, *Matisse and Picasso.* Matisse and Picasso both bought a number of paintings by the other, and on at least two occasions, in a gesture of mutual respect they exchanged paintings; Brassaï, *Conversations with Picasso,* p. 333.

65. See, for example, Breslin, *Mark Rothko,* p. 426.

## 9. The Changing Careers of Modern Artists

1. Quoted in Vollard, *Degas,* p. 13.

2. Miró, *Selected Writings and Interviews,* p. 150.

3. Rewald, *Georges Seurat,* p. xvii.

4. Flam, *Matisse on Art,* p. 212.

5. Schapiro, *Modern Art,* p. 104.

6. The samples in Tables 9.1 and 9.2 are not large, but the changes they show over time are nonetheless highly significant statistically. The $t$-statistic for the increase in the proportion of peak ages under forty in Table 9.1 from the first to the second period, from 9 percent to 59 percent, is 2.65; the $t$-statistic for the increase in that proportion from the second to the third period in Table 9.2 from 13 percent to 62 percent, is 3.04. Both differences are significant at the .05 level.

7. The stronger statement might be made that without the lessons of Boudin and Jongkind, Monet might never have formulated the goals that led to the innovations that constituted Impressionism. Monet's own remarks suggest this. In 1920, for example, he told the critic Gustave Geffroy, "I've said it before and can only repeat that I owe everything to Boudin and I attribute my success to him. I came to be fascinated by his studies, the products of what I call instantaneity"; Kendall, *Monet by Himself,* p. 255.

8. Cézanne himself indicated his frustration at his inability to produce results in his art that would give rise to polished theoretical statements about it comparable to those that were made about new conceptual innovations in Paris in the 1880s. Thus he wrote to the organizer of a Belgian exhibition in 1889 that "as the many studies to which I have dedicated myself have given me only negative results, and as I am afraid of only too justified criticism, I had resolved to work in silence until the day when I should feel myself able to defend theoretically the result of my attempts"; *Paul Cézanne, Letters,* p. 231.

9. Fry, *Last Lectures*, p. 3.

10. Kubler, *Shape of Time*, p. 10.

11. Warhol, *Philosophy of Andy Warhol*, p. 178.

12. Schapiro, *Worldview in Painting*, pp. 142–143.

13. See, for example, the comments of Bourdieu, *Field of Cultural Production*, pp. 29–30.

14. Studies of scientists have found that studying with a past Nobel laureate increases a scientist's chances of winning a Nobel Prize; Simonton, *Scientific Genius*, pp. 113–114; Simonton, *Greatness*, p. 382.

15. Fry, *Last Lectures*, pp. 3, 14–15.

16. Quoted in Shiff, *Cézanne and the End of Impressionism*, p. 222.

17. McCully, *A Picasso Anthology*, p. 252.

## Appendix A

1. The books surveyed are the following; they are listed chronologically. (In each of two cases indicated, two books that were included in a series were treated as one book.)

    Arnason, *History of Modern Art*; Hamilton, *Nineteenth and Twentieth Century Art*; (two books treated as one) Novotny, *Painting and Sculpture in Europe, 1780 to 1880*, and Hamilton, *Painting and Sculpture in Europe, 1880–1940*; Lucie-Smith, *A Concise History of French Painting*; Bowness, *Modern European Art*; Cleaver, *Art: An Introduction*; Ruskin, *History in Art*; de la Croix and Tansey, *Gardner's Art through the Ages*; Spencer, *The Image Maker*; Janson, *History of Art*; Lynton, *The Story of Modern Art*; Canaday, *Mainstreams of Modern Art*; Russell, *The Meanings of Modern Art*; Hughes, *The Shock of the New*; Honour and Fleming, *A World History of Art*; Cornell, *Art: A History of Changing Style*; Britsch and Britsch, *The Arts in Western Culture*; Gombrich, *The Story of Art*; Hartt, *Art*, vol. 2; Wood, Cole, and Gealt, *Art of the Western World*; Wheeler, *Art since Mid-Century*; Hunter and Jacobus, *Modern Art*; Strickland and Boswell, *The Annotated Mona Lisa*; (two books treated as one) Frascina, Blake, Fer, Garb, and Harrison, *Modernity and Modernism*, and Harrison, Frascina, and Perry, *Primitivism, Cubism, Abstraction*; Silver, *Art in History*; Adams, *A History of Western Art*; Stokstad and Grayson, *Art History*; Dawtrey, Jackson, Masterson, Meecham, and Wood, *Investigating Modern Art*; Gallup, Gruitrooy, and Weisberg, *Great Paintings of the Western World*; Harrison, *Modernism*; Wilkins, Schultz, and Linduff, *Art Past, Art Present*; Freeman, *Art: A Crash Course*; Gebhardt, *The History of Art*.

2. For the rankings of the fifteen leading French artists by total illustrations, see Table 5.1; for rankings of all the modern French artists considered by this study, see Galenson, "Quantifying Artistic Success," table 2.

## Appendix B

1. Feldstein, *The Economics of Art Museums*, pp. 29, 69; Heilbrun and Gray, *The Economics of Art and Culture*, pp. 185–187.

2. Robert Jensen has provided an interesting analysis of the nineteenth-century origins of the retrospective, but no comparable study has traced its subsequent development and evolution in the twentieth century; Jensen, *Marketing Modernism in Fin-de-Siècle Europe,* chap. 4.

3. Madoff, *Pop Art,* pp. 109, 201; Sims, *Stuart Davis,* p. 302.

4. Sims, *Stuart Davis,* pp. 52, 83; Goossen, "Two Exhibitions," p. 168.

5. Mayer, *Night Studio,* pp. 180, 211.

# BIBLIOGRAPHY

Adams, Laurie Schneider. *A History of Western Art.* New York: Abrams, 1995.

Adams, Steven. *The Barbizon School and the Origins of Impressionism.* London: Phaidon, 1994.

Agee, William C. *Sam Francis: Paintings, 1947–1990.* Los Angeles: Museum of Contemporary Art, 1999.

Agee, William C., and Barbara Rose. *Patrick Henry Bruce.* New York: Museum of Modern Art, 1979.

Alborch, Carmen. *James Rosenquist.* Valencia: Institut Valencia d'Art Modern, 1991.

Alloway, Lawrence. *William Baziotes: A Memorial Exhibition.* New York: Solomon R. Guggenheim Foundation, 1965.

———— "Systemic Painting." In Battcock, *Minimal Art,* pp. 37–60.

———— *American Pop Art.* New York: Collier Books, 1974.

Alloway, Lawrence, and Mary Davis MacNaughton. *Adolph Gottlieb: A Retrospective.* New York: Arts Publisher, 1981.

Arnason, H. H. *Stuart Davis Memorial Exhibition, 1894–1964.* Washington, D.C.: Smithsonian Institution, 1965.

———— *History of Modern Art.* 3d ed. New York: Abrams, 1986.

Arthur, John. *Richard Estes.* Boston: Museum of Fine Arts, 1978.

Ashton, Dore. *The New York School: A Cultural Reckoning.* Berkeley: University of California Press, 1973.

———— *About Rothko.* New York: Da Capo Press, 1996.

Ashton, T. S. "The Relation of Economic History to Economic Theory." In N. B. Harte, ed., *The Study of Economic History.* London: Frank Cass, 1971.

Balken, Debra Bricker. *Arthur Dove: A Retrospective.* Cambridge: MIT Press, 1997.

Barr, Jr., Alfred H. *Picasso: Fifty Years of His Art.* New York: Museum of Modern Art, 1946.

———— *Matisse: His Art and His Public.* New York: Museum of Modern Art, 1951.

———— *Defining Modern Art.* New York: Harry N. Abrams, 1986.

Bastian, Heiner, ed. *Cy Twombly: Catalogue Raisonné of the Paintings.* Berlin: Schirmer, Mosel, 1992.

Battcock, Gregory, ed. *Minimal Art: A Critical Anthology.* Berkeley: University of California Press, 1968.

Baudelaire, Charles. *The Painter of Modern Life and Other Essays.* New York: Da Capo Press, 1964.

Baur, John I. H. *Charles Burchfield*. New York: Macmillan, 1956.

——— *Bradley Walker Tomlin*. New York: Macmillan, 1957.

Bazille, Frédéric. *Correspondance*. Montpellier: Les Presses du Languedoc, 1992.

Bell, Clive. "The Debt to Cézanne." In Frascina and Harrison, *Modern Art and Modernism,* pp. 75–78.

Berger, John. *The Success and Failure of Picasso*. New York: Vintage Books, 1989.

Bernstock, Judith E. *Joan Mitchell*. New York: Hudson Hills Press, 1988.

Berson, Ruth. *The New Painting: Impressionism, 1874–1886*. Vol. 2: *Documentation*. San Francisco: Fine Arts Museum of San Francisco, 1996.

Blake, Nigel, and Francis Frascina. "Modern Practices of Art and Modernity." In Frascina et al., *Modernity and Modernism,* pp. 50–140.

Blunt, Anthony, and Phoebe Pool. *Picasso: The Formative Years*. London: Studio Books, 1962.

Bockris, Victor. *Warhol*. New York: Da Capo Press, 1997.

Boime, Albert. *The Academy and French Painting in the Nineteenth Century*. New Haven: Yale University Press, 1971.

Bois, Yve-Alain. *Painting as Model*. Cambridge: MIT Press, 1990.

——— *Ad Reinhardt*. New York: Rizzoli, 1991.

——— *Matisse and Picasso*. Paris: Flammarion, 1998.

Bomford, David, et al. *Art in the Making: Impressionism*. London: National Gallery Publications, 1990.

Bourdieu, Pierre. *The Field of Cultural Production*. New York: Columbia University Press, 1993.

——— *The Rules of Art: Genesis and Structure of the Literary Field*. Stanford: Stanford University Press, 1996.

Bowman, Russell. *Philip Pearlstein: A Retrospective*. Milwaukee: Milwaukee Art Museum, 1983.

Bowness, Alan. *Modern European Art*. London: Thames and Hudson, 1972.

——— *The Conditions of Success: How the Modern Artist Rises to Fame*. New York: Thames and Hudson, 1989.

Brandon, Ruth. *Surreal Lives: The Surrealists, 1917–1945*. New York: Grove Press, 1999.

Brassaï. *Conversations with Picasso*. Chicago: University of Chicago Press, 1999.

Breeskin, Adelyn D. *Tribute to Mark Tobey*. Washington, D.C.: Smithsonian Institution Press, 1974.

Breslin, James E. B. *Mark Rothko: A Biography*. Chicago: University of Chicago Press, 1993.

Brettell, Richard R. *Pissarro and Pontoise: The Painter in a Landscape*. New Haven: Yale University Press, 1990.

——— *Modern Art, 1851–1929: Capitalism and Representation*. Oxford: Oxford University Press, 1999.

Brion-Guerry, Liliane. "The Elusive Goal." In Rubin, *Cézanne,* pp. 73–82.

Britsch, Ralph A., and Todd A. Britsch. *The Arts in Western Culture.* Englewood Cliffs, N.J.: Prentice-Hall, 1984.

Broude, Norma. *Impressionism: A Feminist Reading.* New York: Rizzoli, 1991.

Broude, Norma, ed. *Seurat in Perspective.* Englewood Cliffs, N.J.: Prentice-Hall, 1978.

Brown, Julia. *After Mountains and Sea: Frankenthaler, 1956–1959.* New York: Guggenheim Museum, 1998.

Buchsteiner, Thomas, and Otto Letze. *Tom Wesselman.* Tubingen: Cantz Verlag, 1996.

Buchsteiner, Thomas, and Ingrid Mossinger. *Anuszkiewicz Op Art.* Tubingen: Institut fur Kulturaustasch, 1997.

Buck, Robert T. *Robert Motherwell.* New York: Abbeville Press, 1983.

Cabanne, Pierre. *Pablo Picasso.* New York: William Morrow, 1977.

——— *Dialogues with Marcel Duchamp.* New York: Da Capo Press, 1987.

Canaday, John. *Mainstreams of Modern Art.* 2d ed. Ft. Worth: Harcourt Brace Jovanovich, 1981.

Carmean, Jr., E. A. *Helen Frankenthaler: A Paintings Retrospective.* New York: Harry N. Abrams, 1989.

Carmean, Jr., E. A., and Eliza E. Rathbone. *American Art at Mid-Century: The Subjects of the Artist.* Washington, D.C.: National Gallery of Art, 1978.

Carrier, David. *Artwriting.* Amherst: University of Massachusetts Press, 1987.

Caves, Richard E. *Creative Industries: Contracts between Art and Commerce.* Cambridge, Mass.: Harvard University Press, 2000.

Cézanne, Paul. *Paul Cézanne, Letters.* Edited by John Rewald. New York: Da Capo Press, 1995.

Chave, Anna C. *Mark Rothko.* New Haven: Yale University Press, 1989.

Chipp, Herschel B. *Picasso's Guernica: History, Transformations, Meanings.* Berkeley: University of California Press, 1988.

Clark, Kenneth. *Landscape into Art.* 2d ed. New York: Harper and Row, 1976.

Clark, T. J. *The Painting of Modern Life: Paris in the Art of Manet and His Followers.* Princeton: Princeton University Press, 1984.

Cleaver, Dale G. *Art: An Introduction.* 2d ed. New York: Harcourt Brace Jovanovich, 1972.

Clothier, Peter. *David Hockney.* New York: Abbeville Press, 1995.

Collings, Matthew. *It Hurts: New York Art from Warhol to Now.* London: 21 Publishing, 1998.

Collins, Bradford R., ed. *12 Views of Manet's Bar.* Princeton: Princeton University Press, 1996.

Cooper, Douglas. *The Cubist Epoch.* London: Phaidon, 1970.

Corn, Wanda M. *Grant Wood.* New Haven: Yale University Press, 1983.

Cornell, Sara. *Art: A History of Changing Style.* Englewood Cliffs, N.J.: Prentice-Hall, 1983.

Cottington, David. *Cubism in the Shadow of War: The Avant-Garde and Politics in Paris, 1905–1914.* New Haven: Yale University Press, 1998.

Courthion, Pierre, and Pierre Cailler. *Portrait of Manet.* New York: Roy Publishers, 1960.

Cousins, Judith, and Hélène Seckel. "Chronology of *Les Demoiselles d'Avignon,* 1907 to 1939." In Rubin, Seckel, and Cousins, *Les Demoiselles d'Avignon,* pp. 145–205.

Cowart, Jack, and Juan Hamilton. *Georgia O'Keeffe.* Washington, D.C.: National Gallery of Art, 1987.

Crane, Diana. *The Transformation of the Avant-Garde: The New York Art World, 1940–1985.* Chicago: University of Chicago Press, 1987.

Curry, Larry. *John Marin, 1870–1953.* Los Angeles: Los Angeles County Museum of Art, 1970.

Danto, Arthur C. *Embodied Meanings.* New York: Farrar, Straus and Giroux, 1994.

Darwin, Charles. *On the Origin of Species.* London: John Murray, 1859.

Davidson, Abraham A. *Early American Modernist Painting, 1910–1935.* New York: Da Capo Press, 1994.

Dawtrey, Liz, Toby Jackson, Mary Masterson, Pam Meecham, and Paul Wood. *Investigating Modern Art.* New Haven: Yale University Press, 1996.

de Duve, Thierry. *Kant after Duchamp.* Cambridge: MIT Press, 1996.

––––––– *Clement Greenberg between the Lines.* Paris: Editions Dis Voir, 1996.

de Kooning, Elaine. *The Spirit of Abstract Expressionism.* New York: George Braziller, 1994.

de la Barre, Madeleine, Sophie Docclo, and Victor Ginsburgh. "Returns of Impressionist, Modern, and Contemporary European Paintings, 1962–1991." *Annales d'Economie et de Statistique,* no. 35 (1994): 143–181.

de la Croix, Horst, and Richard G. Tansey. *Gardner's Art through the Ages.* 6th ed. New York: Harcourt Brace Jovanovich, 1975.

de Leiris, Alain. *The Drawings of Edouard Manet.* Berkeley: University of California Press, 1969.

de Wilde, Edy. *Robert Mangold.* Amsterdam: Stedelijk Museum, 1982.

de Zayas, Marius. *How, When, and Why Modern Art Came to New York.* Cambridge: MIT Press, 1996.

Delacroix, Eugène. *The Journal of Eugène Delacroix.* New York: Crown Publishers, 1948.

Demetrion, James. *Lyonel Feininger.* Pasadena: Pasadena Art Museum, 1966.

Diamond, Arthur M. "Age and the Acceptance of Cliometrics." *Journal of Economic History,* 40, no. 4 (December 1980): 838–841.

Dorn, Roland. "The Arles Period: Symbolic Means, Decorative Ends." In Dorn et al., *Van Gogh Face to Face,* pp. 134–71.

Dorn, Roland, et al. *Van Gogh Face to Face.* Detroit: Detroit Institute of Arts, 2000.

Duff, Christina. "In Payscales, Life Sometimes Imitates Art." *Wall Street Journal,* May 22, 1998.

Duranty, Louis Emile Edmond. "The New Painting." In Moffett, *The New Painting,* pp. 37–50.

Duret, Théodore. *Manet and the French Impressionists.* Philadelphia: J. B. Lippincott, 1910.

Elgar, Frank. *Picasso.* New York: Tudor Publishing Company, 1956.

Feldstein, Martin, ed. *The Economics of Art Museums.* Chicago: University of Chicago Press, 1991.

Fer, Briony. "Introduction." In Frascina et al., *Modernity and Modernism,* pp. 3–49.

Fitzgerald, Michael C. *Making Modernism: Picasso and the Creation of the Market for Twentieth-Century Art.* Berkeley: University of California Press, 1995.

Flam, Jack. *Matisse on Art.* Berkeley: University of California Press, 1995.

———— "Looking into the Abyss: The Poetics of Manet's *A Bar at the Folies Bergère.*" In Collins, *12 Views of Manet's Bar,* pp. 164–188.

Fogel, Robert W., and Stanley L. Engerman. *Time on the Cross: The Economics of American Negro Slavery.* Boston: Little, Brown, 1974.

Frascina, Francis, and Charles Harrison, eds. *Modern Art and Modernism.* New York: Harper and Row, 1982.

Frascina, Francis, Nigel Blake, Briony Fer, Tamar Garb, and Charles Harrison. *Modernity and Modernism: French Painting in the Nineteenth Century.* New Haven: Yale University Press, 1993.

Freeman, Julian. *Art: A Crash Course.* New York: Watson-Guptill Publications, 1998.

Freud, Sigmund. *Civilization and Its Discontents.* London: Hogarth Press, 1949.

Frey, Bruno S., and Werner W. Pommerehne. *Muses and Markets: Explorations in the Economics of the Arts.* Oxford: Basil Blackwell, 1989.

Fried, Michael. *Three American Painters.* Cambridge, Mass.: Fogg Art Museum, 1965.

———— *Morris Louis, 1912–1962.* Boston: Museum of Fine Arts, 1967.

———— *Manet's Modernism.* Chicago: University of Chicago Press, 1996.

———— *Art and Objecthood.* Chicago: University of Chicago Press, 1998.

Friedman, B. H. *Jackson Pollock.* New York: Da Capo Press, 1995.

Fry, Roger. *Transformations.* Garden City, N.Y.: Doubleday Anchor Books, 1956.

———— *Last Lectures.* Boston: Beacon Press, 1962.

———— *Vision and Design.* London: Oxford University Press, 1981.

———— *Cézanne.* Chicago: University of Chicago Press, 1989.

Gage, John. "Rothko: Color as Subject." In Weiss, *Mark Rothko,* pp. 246–263.

Galenson, David W. *White Servitude in Colonial America: An Economic Analysis.* Cambridge: Cambridge University Press, 1981.

———— "Neighborhood Effects on the School Attendance of Irish Immigrants' Sons in Boston and Chicago in 1860." *American Journal of Education,* 105 (May 1997): 261–293.

———— "The Lives of the Painters of Modern Life: The Careers of Artists in France from Impressionism to Cubism." NBER Working Paper 6888 (January 1999).

———— "Quantifying Artistic Success: Ranking French Painters—and Paintings—from Impressionism to Cubism." *Historical Methods,* forthcoming.

——— "The Careers of Modern Artists: Evidence from Auctions of Contemporary Art." *Journal of Cultural Economics,* 24, no. 2 (May 2000): 87–112.

Galenson, David W., and Bruce A. Weinberg. "Art Schools: Group Work and the Careers of the Impressionists and Cubists." Unpublished paper, University of Chicago, 2000.

——— "Age and the Quality of Work: The Case of Modern American Painters." *Journal of Political Economy,* 108, no. 4 (August 2000): 761–777.

——— "Creating Modern Art: The Changing Careers of Painters in France from Impressionism to Cubism." *American Economic Review,* forthcoming.

Gallant, Aprile. *Love and the American Dream: The Art of Robert Indiana.* Portland, Maine: Portland Museum of Art, 1999.

Gallup, Alison, Gerhard Gruitrooy, and Elizabeth M. Weisberg. *Great Paintings of the Western World.* New York: Hugh Lauter Levin Associates, 1997.

Gauguin, Paul. *The Writings of a Savage.* Edited by Daniel Guérin. New York: Da Capo Press, 1996.

Gebhardt, Volker. *The History of Art.* Hauppage, N.Y.: Barron's Educational Series, 1998.

Gedo, Mary Mathews. *Picasso: Art as Autobiography.* Chicago: University of Chicago Press, 1980.

Geldzahler, Henry. *New York Painting and Sculpture: 1940–1970.* New York: E. P. Dutton, 1969.

——— *Making It New.* San Diego: Harcourt Brace and Company, 1996.

Gersh-Nesic, Beth. *The Early Criticism of André Salmon.* New York: Garland, 1991.

Gibson, Ann Eden. *Issues in Abstract Expressionism: The Artist-Run Periodicals.* Ann Arbor: UMI Research Press, 1990.

Gilot, Francoise, and Carlton Lake. *Life with Picasso.* New York: Anchor Books, 1989.

Giry, Marcel. *Fauvism: Origins and Development.* New York: Alpine Fine Arts, 1982.

Golding, John. *Cubism: A History and Analysis, 1907–1914.* London: Faber and Faber, 1959.

——— *Visions of the Modern.* Berkeley: University of California Press, 1994.

Gombrich, E. A. *The Story of Art.* 14th ed. Englewood Cliffs, N.J.: Prentice-Hall, 1985.

Goodman, Cynthia. *Hans Hofmann.* Munich: Prostel-Verlag, 1990.

Goodnough, Robert. "Pollock Paints a Picture." In Karmel, *Jackson Pollock,* pp. 74–78.

Goodnough, Robert, ed. "Artists' Sessions at Studio 35 (1950)." In Gibson, *Issues in Abstract Expressionism,* pp. 314–344.

Goodrich, Lloyd, and Doris Bry. *Georgia O'Keeffe.* New York: Whitney Museum of American Art, 1970.

Goossen, E. C. "Two Exhibitions." In Battcock, *Minimal Art,* pp. 165–174.

Gordon, John. *Franz Kline, 1910–1962.* New York: Whitney Museum, 1968.

——— *Jim Dine.* New York: Praeger Publishers, 1970.

Gottlieb, Adolf. "The Artist and the Public." *Art in America,* 42, no. 4 (December 1954): 267–271.

Gouma-Peterson, Thalia. *Breaking the Rules: Audrey Flack, a Retrospective.* New York: Harry N. Abrams, 1992.

Graze, Sue, and Kathy Halbreich. *Elizabeth Murray.* New York: Harry N. Abrams, 1987.

Greenberg, Clement. *Art and Culture.* Boston: Beacon Press, 1961.

———— *The Collected Essays and Criticism.* Vol. 2. Chicago: University of Chicago Press, 1986.

———— *The Collected Essays and Criticism.* Vol. 3. Chicago: University of Chicago Press, 1993.

———— *The Collected Essays and Criticism.* Vol. 4. Chicago: University of Chicago Press, 1993.

———— *Homemade Esthetics: Observations on Art and Taste.* New York: Oxford University Press, 1999.

Griliches, Zvi, ed. *Price Indexes and Quality Change: Studies in New Methods of Measurement.* Cambridge, Mass.: Harvard University Press, 1971.

Gruen, John. *The Artist Observed: 28 Interviews with Contemporary Artists.* Chicago: A Cappella Books, 1991.

Guérin, Marcel, ed. *Lettres de Degas.* Paris: Bernard Grasset, 1931.

Guggenheim, Peggy. *Out of This Century: Confessions of an Art Addict.* New York: Universe Books, 1987.

*Le Guide Mayer.* Lausanne: Sylvio Acatos, annual.

Guilbaut, Serge. *How New York Stole the Idea of Modern Art.* Chicago: University of Chicago Press, 1983.

Haacke, Hans. *Framing and Being Framed: 7 Works, 1970–75.* Halifax: Press of Nova Scotia College of Art and Design, 1975.

Haenlien, Carl. *Larry Rivers: Retrospektive.* Hannover: Kestner-Gesellschaft, 1980.

Halperin, Joan. *Félix Fénéon and the Language of Art Criticism.* Ann Arbor: UMI Research Press, 1980.

Hamilton, George Heard. *Manet and His Critics.* New Haven: Yale University Press, 1954.

———— *Nineteenth and Twentieth Century Art.* New York: Abrams, 1970.

———— *Painting and Sculpture in Europe, 1880–1940.* Harmondsworth: Penguin, 1972.

Hanson, Anne Coffin. *Manet and the Modern Tradition.* New Haven: Yale University Press, 1977.

Harris, Ann Sutherland. *Alice Neel: Paintings, 1933–1982.* Los Angeles: Loyola Marymount University, 1983.

Harrison, Charles. "On the Surface of Painting." *Critical Inquiry,* 15, no. 2 (Winter 1989): 292–336.

———— *Modernism.* Cambridge: Cambridge University Press, 1997.

Harrison, Charles, Francis Frascina, and Gill Perry. *Primitivism, Cubism, Abstraction: The Early Twentieth Century.* New Haven: Yale University Press, 1993.

Hartt, Frederick. *Art.* Vol. 2. 3d ed. Englewood Cliffs, N.J.: Prentice-Hall, 1989.

Haskell, Barbara. *Marsden Hartley.* New York: New York University Press, 1980.

——— *Charles Demuth.* New York: Whitney Museum of American Art, 1988.

——— *Agnes Martin.* New York: Whitney Museum of American Art, 1992.

——— *Joseph Stella.* New York: Whitney Museum of American Art, 1994.

Hauser, Arnold. *The Sociology of Art.* Chicago: University of Chicago Press, 1982.

Heilbrun, James, and Charles M. Gray. *The Economics of Art and Culture: An American Perspective.* Cambridge: Cambridge University Press, 1993.

Herbert, James D. "Privilege and the Illusion of the Real." In Collins, *12 Views of Manet's Bar,* pp. 214–232.

Herbert, Robert L. "Method and Meaning in Monet." *Art in America* (September 1979): 90–108.

——— *Impressionism: Art, Leisure, and Parisian Society.* New Haven: Yale University Press, 1988.

——— *Georges Seurat, 1859–1891.* New York: Metropolitan Museum of Art, 1991.

Hess, Thomas B. *Willem de Kooning.* New York: Museum of Modern Art, 1968.

——— *Barnett Newman.* New York: Walker and Company, 1969.

——— *Barnett Newman.* New York: Museum of Modern Art, 1971.

Hillstrom, Laurie Collier, and Kevin Hillstrom. *Contemporary Women Artists.* Detroit: St. James Press, 1999.

Homer, William Innes. *Seurat and the Science of Painting.* Cambridge: MIT Press, 1964.

Honour, Hugh, and John Fleming. *A World History of Art.* London: Macmillan, 1982.

Hopkins, Henry T. *Philip Guston.* New York: George Braziller, 1980.

Hopps, Walter, and Susan Davidson. *Robert Rauschenberg: A Retrospective.* New York: Guggenheim Museum, 1997.

House, John. *Monet: Nature into Art.* New Haven: Yale University Press, 1986.

——— "Camille Pissarro's Idea of Unity." In Christopher Lloyd, ed., *Studies on Camille Pissarro,* pp. 15–34. London: Routledge and Kegan Paul, 1986.

Hughes, Robert. *The Shock of the New.* New York: Knopf, 1982.

——— *Nothing If Not Critical.* New York: Penguin Books, 1990.

Hunter, Sam, and John Jacobus. *Modern Art: Painting, Sculpture, Architecture.* 3d ed. Englewood Cliffs, N.J.: Prentice-Hall, 1992.

Huysmans, J. K. "'L'Exposition des Independents' in 1880." In Frascina and Harrison, *Modern Art and Modernism,* pp. 45–50.

Janson, H. W. *History of Art.* 2d ed. Englewood Cliffs, N.J.: Prentice-Hall, 1977.

Jensen, Alfred. *Alfred Jensen: Paintings and Diagrams from the Years 1957–1977.* Buffalo: Albright-Knox Gallery, 1978.

Jensen, Robert. *Marketing Modernism in Fin-de-Siècle Europe.* Princeton: Princeton University Press, 1994.

Johns, Jasper. *Writings, Sketchbook Notes, Interviews.* Edited by Kirk Varnedoe. New York: Museum of Modern Art, 1996.

Jones, Caroline A. *Machine in the Studio.* Chicago: University of Chicago Press, 1996.

Kaestle, Carl F., and Maris A. Vinovskis. *Education and Social Change in Nineteenth-Century Massachusetts.* Cambridge: Cambridge University Press, 1980.

Kahnweiler, Daniel-Henry. *The Rise of Cubism.* New York: Wittenborn, Schultz, 1949.

———— *Juan Gris.* Rev. ed. New York: Henry Abrams, 1968.

———— *My Galleries and Painters.* New York: Viking Press, 1971.

Kahnweiler, Daniel-Henry, et al. *Picasso in Retrospect.* New York: Praeger Publishers, 1973.

Karmel, Pepe, ed. *Jackson Pollock: Interviews, Articles, and Reviews.* New York: Museum of Modern Art, 1999.

Keen, Geraldine. *Money and Art: A Study Based on the Times-Sotheby Index.* New York: G. P. Putman's Sons, 1971.

Kelder, Diane, ed. *Stuart Davis.* New York: Praeger Publishers, 1971.

Kendall, Richard, ed. *Monet by Himself.* New York: Knickerbocker Press, 1999.

Kennedy, Peter. *A Guide to Econometrics.* Cambridge: MIT Press, 1979.

Kertess, Klaus. *Brice Marden.* New York: Abrams, 1992.

Kimmelman, Michael. *Portraits.* New York: Modern Library, 1998.

———— "The Irrepressible Ragman of Art." *New York Times,* August 27, 2000, sect. 2, pp. 1, 26.

Kmenta, Jan. *Elements of Econometrics.* New York: Macmillan, 1971.

Koestler, Arthur. *The Act of Creation.* New York: Macmillan, 1964.

Kozloff, Max. " 'Pop' Culture, Metaphysical Disgust, and the New Vulgarians." In Madoff, *Pop Art,* pp. 29–32.

Kubler, George. *The Shape of Time.* New Haven: Yale University Press, 1962.

Kuh, Katharine. *The Artist's Voice.* New York: Harper and Row, 1962.

Lang, Gladys Engel, and Kurt Lang. *Etched in Memory: The Building and Survival of Artistic Reputation.* Chapel Hill: University of North Carolina Press, 1990.

Lehman, Harvey C. *Age and Achievement.* Princeton: Princeton University Press, 1953.

Levin, Gail. *Edward Hopper.* New York: W. W. Norton, 1980.

Lewis, Wyndham. *Creatures of Habit and Creatures of Change.* Santa Rosa, Calif.: Black Sparrow Press, 1989.

LeWitt, Sol. "Paragraphs on Conceptual Art." In Zevi, *Sol LeWitt,* pp. 78–82.

———— "Sentences on Conceptual Art." In Zevi, *Sol LeWitt,* pp. 88–90.

———— "Doing Wall Drawings." In Zevi, *Sol LeWitt,* pp. 95–96.

Lippard, Lucy R. *Changing: Essays in Art Criticism.* New York: E. P. Dutton, 1971.

Livingston, Jane. *The Art of Richard Diebenkorn*. New York: Whitney Museum of American Art, 1997.

Los Angeles County Museum of Art. *New York School*. Los Angeles: County Museum of Art, 1965.

Loughery, John. *John Sloan*. New York: Henry Holt, 1995.

Lucie-Smith, Edward. *A Concise History of French Painting*. New York: Praeger, 1971.

Luddington, Townsend. *Marsden Hartley*. Ithaca, N.Y.: Cornell University Press, 1998.

Lynes, Barbara Buhler. *O'Keeffe, Stieglitz, and the Critics, 1916–1929*. Ann Arbor: UMI Research Press, 1989.

Lynton, Norbert. *The Story of Modern Art*. Ithaca, N.Y.: Cornell University Press, 1980.

Maciejunes, Nannette V., and Michael D. Hall. *The Paintings of Charles Burchfield: North by Midwest*. New York: Harry N. Abrams, 1997.

Maddala, G. S. *Econometrics*. Tokyo: McGraw-Hill Kogakusha, 1977.

Madoff, Steven Henry, ed. *Pop Art: A Critical History*. Berkeley: University of California Press, 1997.

Mallarmé, Stéphane. "The Impressionists and Edouard Manet." In Moffett, *The New Painting*, pp. 27–36.

Marks, Claude. *World Artists, 1950–1980*. New York: H. W. Wilson Company, 1984.

Martindale, Colin. *The Clockwork Muse: The Predictability of Artistic Change*. New York: Basic Books, 1990.

Mayer, Musa. *Night Studio: A Memoir of Philip Guston*. New York: Da Capo Press, 1997.

Mayne, Jonathan. "Editor's Introduction." In Baudelaire, *The Painter of Modern Life and Other Essays*, pp. ix–xvii.

McCully, Marilyn, ed. *A Picasso Anthology*. Princeton: Princeton University Press, 1982.

McLean, John. *Frank Stella*. London: Arts Council of Great Britain, 1970.

McShine, Kynaston. *Andy Warhol: A Retrospective*. New York: Museum of Modern Art, 1989.

Menard, Russell. "From Servants to Slaves: The Transformation of the Southern Labor System." *Southern Studies*, 16, no. 4 (Winter 1977): 355–390.

Messer, Thomas M. *Alfred Jensen: Paintings and Works on Paper*. New York: Solomon R. Guggenheim Museum, 1985.

Miró, Joan. *Selected Writings and Interviews*. Edited by Margit Rowell. New York: Da Capo Press, 1992.

Moffett, Charles, ed. *The New Painting: Impressionism, 1874–1886*. San Francisco: Fine Arts Museum of San Francisco, 1986.

Moffett, Kenworth. *Jules Olitski*. Boston: Museum of Fine Arts, 1973.

——— *Fairfield Porter (1907–1975)*. Boston: Museum of Fine Arts, 1982.

Moore, George. *Impressions and Opinions*. New York: Brentano, 1913.

Morgan, Ann Lee, ed. *Dear Stieglitz, Dear Dove*. Newark: University of Delaware Press, 1988.

Moulin, Raymonde. *The French Art Market: A Sociological View.* New Brunswick: Rutgers University Press, 1987.

Naifeh, Steven W. *Culture Making: Money, Success, and the New York Art World.* Princeton, N.J.: History Department of Princeton University, 1976.

Ness, June L. *Lyonel Feininger.* New York: Praeger Publishers, 1974.

*New York Times.* Obituary of Leo Castelli, August 23, 1999.

Nochlin, Linda. *Impressionism and Post-Impressionism, 1874–1904.* Englewood Cliffs, N.J.: Prentice-Hall, 1966.

Norman, Dorothy, ed. *The Selected Writings of John Marin.* New York: Pellegrini and Cudahy, 1949.

Novotny, Fritz. *Painting and Sculpture in Europe, 1780 to 1880.* 2d ed. Harmondsworth: Penguin, 1970.

O'Brian, John. *Ruthless Hedonism: The American Reception of Matisse.* Chicago: University of Chicago Press, 1999.

O'Brian, Patrick. *Pablo Ruiz Picasso: A Biography.* New York: W. W. Norton, 1994.

O'Connor, Francis V. *Jackson Pollock.* New York: Museum of Modern Art, 1967.

O'Hara, Frank. *Jackson Pollock.* New York: George Braziller, 1959.

O'Neill, John P. *Clyfford Still.* New York: Metropolitan Museum of Art, 1979.

O'Neill, John P., ed. *Barnett Newman: Selected Writings and Interviews.* New York: Alfred A. Knopf, 1990.

Penrose, Roland. *Picasso: His Life and Work.* 3d ed. Berkeley: University of California Press, 1981.

Perreault, John. "Minimal Abstracts." In Battcock, *Minimal Art,* pp. 256–262.

Pickvance, Ronald. "Contemporary Popularity and Posthumous Neglect." In Moffett, *The New Painting,* pp. 243–265.

Pissarro, Camille. *Letters to His Son Lucien.* Edited by John Rewald. New York: Da Capo Press, 1995.

Planck, Max. *Scientific Autobiography and Other Papers.* New York: Greenwood Press, 1968.

Politi, Giancarlo. *Dictionary of International Contemporary Artists.* Milan: Flash Art Books, 1995.

Prather, Marla. *Willem de Kooning.* New Haven: Yale University Press, 1994.

Rao, Potluri, and Miller, Roger LeRoy. *Applied Econometrics.* Belmont, Calif.: Wadsworth Publishing Company, 1971.

Reff, Theodore. "Painting and Theory in the Final Decade." In Rubin, *Cézanne,* pp. 13–54.

——— *Manet: Olympia.* New York: Viking Press, 1977.

Reise, Barbara M. "Greenberg and the Group: A Retrospective View." In Francis Frascina and Jonathan Harris, eds., *Art in Modern Culture,* pp. 252–263. London: Phaidon, 1992.

Reitlinger, Gerald. *The Economics of Taste.* Vol. 1. London: Barrie and Rockliff, 1961.

Renoir, Jean. *Renoir, My Father.* Boston: Little, Brown, 1958.

Rewald, John. *Georges Seurat.* New York: Wittenborn, 1943.

———— *Paul Cézanne: A Biography.* New York: Simon and Schuster, 1948.

———— *Post-Impressionism: From Van Gogh to Gauguin.* New York: Museum of Modern Art, 1956.

———— *The History of Impressionism.* Rev. ed. New York: Museum of Modern Art, 1961.

———— *The Paintings of Paul Cézanne: A Catalogue Raisonné.* Vol. 1. New York: Harry N. Abrams, 1996.

Richardson, John. *Manet.* London: Phaidon, 1967.

———— *A Life of Picasso.* Vol. 1: *The Early Years, 1881–1906.* New York: Random House, 1991.

———— *A Life of Picasso.* Vol. 2: *1907–1917, The Painter of Modern Life.* New York: Random House, 1996.

———— *The Sorcerer's Apprentice: Picasso, Provence, and Douglas Cooper.* New York: Alfred A. Knopf, 1999.

Rifkin, Ned. *Robert Moskowitz.* Washington, D.C.: Smithsonian Institution, 1989.

Robinson, Roxana. *Georgia O'Keeffe.* Hanover: University Press of New England, 1989.

Robson, A. Deirdre. *Prestige, Profit, and Pleasure: The Market for Modern Art in New York in the 1940s and 1950s.* New York: Garland Publishing, 1995.

Rose, Barbara. *Frankenthaler.* New York: Harry N. Abrams, 1971.

Rose, Bernice. *The Drawings of Roy Lichtenstein.* New York: Museum of Modern Art, 1987.

Rosenberg, Harold. *The Anxious Object.* Chicago: University of Chicago Press, 1966.

———— *Discovering the Present: Three Decades in Art, Culture, and Politics.* Chicago: University of Chicago Press, 1973.

———— *Act and the Actor: Making the Self.* Chicago: University of Chicago Press, 1983.

———— *Art on the Edge.* Chicago: University of Chicago Press, 1983.

———— *The De-definition of Art.* Chicago: University of Chicago Press, 1983.

———— *Art and Other Serious Matters.* Chicago: University of Chicago Press, 1985.

———— *The Case of the Baffled Radical.* Chicago: University of Chicago Press, 1985.

———— *The Tradition of the New.* New York: Da Capo Press, 1994.

Roskill, Mark. *Van Gogh, Gauguin, and the Impressionist Circle.* Greenwich, Conn.: New York Graphic Society, 1970.

Rowell, Margit, ed. *Joan Miró.* New York: Da Capo Press, 1992.

Rubenfeld, Florence. *Clement Greenberg.* New York: Scribner, 1997.

Rubin, William S. *Frank Stella.* New York: Museum of Modern Art, 1970.

———— "The Genesis of *Les Demoiselles d'Avignon.*" In Rubin, Seckel, and Cousins, *Les Demoiselles d'Avignon,* pp. 13–144.

Rubin, William, ed. *Cézanne: The Late Work.* New York: Museum of Modern Art, 1977.

Rubin, William, and Carolyn Lanchner. *André Masson*. New York: Museum of Modern Art, 1976.

Rubin, William, Hélène Seckel, and Judith Cousins. *Les Demoiselles d'Avignon*. New York: Museum of Modern Art, 1994.

Ruskin, Ariane. *History in Art*. New York: Franklin Watts, 1974.

Russell, John. *The Meanings of Modern Art*. New York: Museum of Modern Art, 1981.

Sandler, Irving. *The Triumph of American Painting: A History of Abstract Expressionism*. New York: Praeger, 1970.

———— *The New York School: The Painters and Sculptors of the Fifties*. New York: Harper and Row, 1978.

Sanouillet, Michel, and Elmer Peterson. *The Writings of Marcel Duchamp*. New York: Da Capo Press, 1989.

Sawin, Martica. *Surrealism in Exile and the Beginning of the New York School*. Cambridge: MIT Press, 1995.

Schapiro, Meyer. *Paul Cézanne*. New York: Abrams, 1952.

———— *Modern Art: Nineteenth and Twentieth Centuries*. New York: George Braziller, 1968.

———— *Impressionism: Reflections and Perceptions*. New York: George Braziller, 1997.

———— *Worldview in Painting: Art and Society*. New York: George Braziller, 1999.

Schjeldahl, Peter. *The "7 Days" Art Columns, 1988–1990*. Great Barrington, Mass.: The Figures, 1990.

Schueler, Jon. *The Sound of Sleat*. Edited by Magda Salvesen and Diane Cousineau. New York: Picador, 1999.

Scott, David W. *The Art of Stanton Macdonald-Wright*. Washington, D.C.: National Collection of Fine Arts, 1967.

———— *Charles Sheeler*. Washington, D.C.: Smithsonian Institution, 1968.

———— *John Sloan, 1871–1951*. Washington, D.C.: National Gallery of Art, 1971.

Seckel, Hélène, ed. *Les Demoiselles d'Avignon*. 2 vols. Paris: Musée Picasso, 1988.

Seitz, William C. "Abstract-Expressionist Painting in America." Ph.D. dissertation, Princeton University, 1955.

———— *Art in the Age of Aquarius, 1955–1970*. Washington, D.C.: Smithsonian Institution Press, 1992.

Shannon, Joe. *R. B. Kitaj*. Washington, D.C.: Smithsonian Institution Press, 1981.

Shapiro, David, and Cecile Shapiro, eds. *Abstract Expressionism: A Critical Record*. Cambridge: Cambridge University Press, 1990.

Shiff, Richard. *Cézanne and the End of Impressionism*. Chicago: University of Chicago Press, 1984.

Shikes, Ralph, and Paula Harper. *Pissarro: His Life and Work*. New York: Horizon Press, 1980.

Silver, Larry. *Art in History.* New York: Abbeville Press, 1993.

Simonton, Dean Keith. *Scientific Genius.* Cambridge: Cambridge University Press, 1988.

———— *Greatness: Who Makes History and Why.* New York: Guilford Press, 1994.

Sims, Lowery Stokes. *Stuart Davis: American Painter.* New York: Metropolitan Museum of Art, 1991.

Singer, Susanna. *Sol LeWitt Drawings, 1958–1992.* The Hague: Haags Gemeentemuseum, 1992.

Sloan, John. *Gist of Art.* New York: American Artists Group, 1939.

Sloshberg, Leah. *Ben Shahn.* Trenton: New Jersey State Museum, 1969.

Smith, Paul. *Seurat and the Avant-Garde.* New Haven: Yale University Press, 1997.

Spencer, Harold. *The Image Maker: Man and His Art.* New York: Charles Scribner's Sons, 1975.

Spender, Matthew. *From a High Place: A Life of Arshile Gorky.* New York: Alfred A. Knopf, 1999.

Spurling, Hilary. *The Unknown Matisse: A Life of Henri Matisse: The Early Years, 1869–1908.* New York: Alfred A. Knopf, 1998.

Stein, Gertrude. *The Autobiography of Alice B. Toklas.* New York: Harcourt, Brace, 1933.

Steinberg, Leo. *Other Criteria.* London: Oxford University Press, 1972.

———— "Le Bordel philosophique." In Seckel, *Les Demoiselles d'Avignon,* 2: 319–366.

Stiles, Kristine, and Peter Selz, eds. *Theories and Documents of Contemporary Art.* Berkeley: University of California Press, 1996.

Stokstad, Marilyn, and Marion Spears Grayson. *Art History.* New York: Abrams, 1995.

Storr, Robert. *Robert Ryman.* London: Tate Gallery, 1993.

———— *Chuck Close.* New York: Museum of Modern Art, 1998.

Story, Ala. *Max Weber.* Santa Barbara: University of California, 1968.

Strickland, Carol, and John Boswell. *The Annotated Mona Lisa.* Kansas City: Andrews and McMeel, 1992.

Stuckey, Charles F., ed. *Monet: A Retrospective.* New York: Park Lane, 1986.

Sweetman, David. *Paul Gauguin.* New York: Simon and Schuster, 1995.

Sylvester, David. *About Modern Art: Critical Essays, 1948–1997.* New York: Henry Holt, 1997.

Terenzio, Stephanie, ed. *The Collected Writings of Robert Motherwell.* New York: Oxford University Press, 1992.

Thernstrom, Stephan. *Poverty and Progress: Social Mobility in a Nineteenth-Century City.* Cambridge, Mass.: Harvard University Press, 1964.

Tomkins, Calvin. *The Bride and the Bachelors: The Heretical Courtship in Modern Art.* New York: Viking Press, 1965.

———— *Off the Wall: Robert Rauschenberg and the Art World of Our Time.* Garden City, N.Y.: Doubleday, 1980.

———— *Post—to Neo—: The Art World of the 1980s.* New York: Penguin, 1988.

Townsend, J. Benjamin, ed. *Charles Burchfield's Journals.* Albany: State University of New York Press, 1993.

Tsujimoto, Karen. *Wayne Thiebaud.* Seattle: University of Washington Press, 1985.

Tuchman, Maurice. *Validating Modern Art.* Los Angeles: County Museum of Art, 1975.

Tuchman, Maurice, and Stephanie Barron. *David Hockney: A Retrospective.* Los Angeles: Los Angeles County Museum of Art, 1988.

Tucker, Paul. "The First Impressionist Exhibition in Context." In Moffett, *The New Painting,* pp. 93–144.

Tucker, Paul Hayes, ed. *Manet's Le Déjeuner sur l'herbe.* Cambridge: Cambridge University Press, 1998.

Turner, Jane, ed. *The Dictionary of Art.* London: Macmillan, 1996.

Valéry, Paul. *Degas, Manet, Morisot.* Princeton: Princeton University Press, 1989.

van Gogh, Vincent. *The Complete Letters of Vincent van Gogh.* 3 vols. London: Thames and Hudson, 1958.

Varnedoe, Kirk. *Cy Twombly: A Retrospective.* New York: Museum of Modern Art, 1994.

———— *Jasper Johns: A Retrospective.* New York: Museum of Modern Art, 1996.

———— *Jackson Pollock.* New York: Museum of Modern Art, 1998.

Veblen, Thorstein. *The Theory of the Leisure Class.* New York: Penguin Books, 1994.

Venturi, Lionello. *Painting and Painters.* New York: Charles Scribner's Sons, 1945.

Vollard, Ambroise. *Renoir: An Intimate Record.* New York: Alfred A. Knopf, 1925.

———— *Degas.* London: George Allen and Unwin, 1928.

———— *Recollections of a Picture Dealer.* Boston: Little, Brown, 1936.

———— *Cézanne.* New York: Dover, 1984.

Waldman, Diane. *Kenneth Noland: A Retrospective.* New York: Solomon R. Guggenheim Foundation, 1977.

———— *Arshile Gorky, 1904–1948: A Retrospective.* New York: Harry N. Abrams, 1981.

———— *Jack Youngerman.* New York: Solomon R. Guggenheim Museum, 1986.

———— *Josef Albers: A Retrospective.* New York: Solomon R. Guggenheim Museum, 1988.

———— *Roy Lichtenstein.* New York: Guggenheim Museum, 1993.

———— *Ellsworth Kelly: A Retrospective.* New York: Guggenheim Museum, 1996.

Walker, John. *Self-Portrait with Donors: Confessions of an Art Collector.* Boston: Little, Brown, 1974.

Ward, Martha. "The Rhetoric of Independence and Innovation." In Moffett, *The New Painting,* pp. 421–442.

———— *Pissarro, Neo-Impressionism, and the Spaces of the Avant-Garde.* Chicago: University of Chicago Press, 1996.

Warhol, Andy. *The Philosophy of Andy Warhol.* New York: Harcourt Brace Jovanovich, 1975.

Watson, Peter. *From Manet to Manhattan: The Rise of the Modern Art Market*. New York: Random House, 1992.

Weiss, Jeffrey. *Mark Rothko*. Washington, D.C.: National Gallery of Art, 1998.

Weitman, Wendy. *Sol LeWitt: Prints, 1970–1995*. New York: Museum of Modern Art, 1996.

Weitzenhoffer, Frances. *The Havemeyers: Impressionism Comes to America*. New York: Harry N. Abrams, 1986.

Weld, Jacqueline Bograd. *Peggy: The Wayward Guggenheim*. New York: E. P. Dutton, 1986.

Wheeler, Daniel. *Art since Mid-Century*. Englewood Cliffs, N.J.: Prentice-Hall, 1991.

Whistler, James Albert McNeill. *The Gentle Art of Making Enemies*. New York: G. P. Putnam's Sons, 1922.

White, Barbara Ehrlich. *Renoir: His Life, Art, and Letters*. New York: Harry N. Abrams, 1984.

White, Harrison C. *Careers and Creativity: Social Forces in the Arts*. Boulder: Westview Press, 1993.

White, Harrison C., and Cynthia A. White. *Canvases and Careers: Institutional Change in the French Painting World*. Chicago: University of Chicago Press, 1993.

Wildenstein, Daniel. *Monet: Or the Triumph of Impressionism*. Cologne: Taschen, 1996.

Wilkins, David, Bernard Schultz, and Katheryn Linduff. *Art Past, Art Present*. New York: Abrams, 1997.

Wittkower, Rudolf, and Margot Wittkower. *Born under Saturn*. New York: Random House, 1963.

Wollheim, Richard. "Minimal Art." In Battcock, *Minimal Art,* pp. 387–399.

Wood, Michael, Bruce Cole, and Adelheid Gealt. *Art of the Western World*. New York: Simon and Schuster, 1989.

Wood, Paul, Francis Frascina, Jonathan Harris, and Charles Harrison. *Modernism in Dispute: Art since the Forties*. New Haven: Yale University Press, 1993.

Wood, Paul, ed. *The Challenge of the Avant-Garde*. New Haven: Yale University Press, 1999.

Zevi, Adachiara. *Sol LeWitt: Critical Texts*. Rome: Editrice Inonia, 1994.

Zinnes, Harriet, ed. *Ezra Pound and the Visual Arts*. New York: New Directions Books, 1980.

Zola, Emile "Edouard Manet." In Frascina and Harrison, *Modern Art and Modernism,* pp. 29–38.

# CREDITS

1. Paul Cézanne, *Self-Portrait with a Beret*, about 1898–99. Oil on canvas, 25 × 21″. Museum of Fine Arts, Boston; Charles H. Bayley Picture and Painting Fund and partial gift of Elizabeth Paine Metcalf. Reproduced with permission. © Museum of Fine Arts, Boston. All rights reserved.

2. Pablo Picasso, *Self-Portrait with Palette*, 1906. Oil on canvas, 37 × 28″. Philadelphia Museum of Art; A. E. Gallatin Collection. © 2001 Estate of Pablo Picasso/Artists Rights Society (ARS), New York.

3. Paul Cézanne, *Mont Sainte-Victoire*, 1904. Oil on canvas, 28 × 35″. Philadelphia Museum of Art; George W. Elkins Collection.

4. Pablo Picasso, *Les Demoiselles d'Avignon*, 1907. Oil on canvas, 96 × 92″. Museum of Modern Art, New York; acquired through Lillie P. Bliss Bequest. © 2001 Estate of Pablo Picasso/Artists Rights Society (ARS), New York. Photo © 2000 Museum of Modern Art, New York.

5. Paul Gauguin, *The Vision after the Sermon*, 1888. Oil on canvas, 29 × 36″. National Gallery of Scotland, Edinburgh.

6. Edouard Manet, *Le Déjeuner sur l'herbe*, 1863. Oil on canvas, 84 × 106″. Musée d'Orsay, Paris. Giraudon/Art Resource, New York.

7. Edouard Manet, *Bar at the Folies-Bergère*, 1882. Oil on canvas, 38 × 50″. Courtauld Institute of Art, University of London.

8. Claude Monet, *La Grenouillère*, 1869. Oil on canvas, 29 × 39″. Metropolitan Museum of Art, New York; H. O. Havemeyer Collection. All rights reserved.

9. Pierre-Auguste Renoir, *La Grenouillère*, 1869. Oil on canvas, 26 × 32″. Nationalmuseum med Prins Eugens Waldemarsudde, Stockholm.

10. Georges Seurat, *A Sunday on la Grande Jatte—1884*, 1884–1886. Oil on canvas, 82 × 121″. Art Institute of Chicago; Helen Birch Bartlett Memorial Collection. Photograph © 2001, Art Institute of Chicago.

11. Marcel Duchamp, *Nude Descending a Staircase, No. 2*, 1912. Oil on canvas, 58 × 35″. Philadelphia Museum of Art; Louise and Walter Arensberg Collection. © Artists Rights Society (ARS), New York/ADAGP, Paris/Estate of Marcel Duchamp.

12. Jackson Pollock at work on *One: Number 31, 1950*. Photograph by Hans Namuth. © Hans Namuth Estate. Collection Center for Creative Photography, University of Arizona.

13. Mark Rothko, East Hampton, 1964. Photograph by Hans Namuth. © Hans Namuth Estate. Collection Center for Creative Photography, University of Arizona.

14. Jasper Johns, *Target with Plaster Casts*, 1955. Encaustic and collage on canvas with

objects, 51 × 44 × 3½". Private collection. © Jasper Johns/licensed by VAGA, New York, New York. Photograph by Rudolph Burckhardt, courtesy Jasper Johns.

15. Frank Stella, *The Marriage of Reason and Squalor, II*, 1959. Enamel on canvas, 91 × 133". Museum of Modern Art, New York; Larry Aldrich Foundation Fund. © Frank Stella/Artists Rights Society (ARS), New York. Photograph © Museum of Modern Art, New York.

16. Frank Stella in his studio working on *Getty Tomb (Second Version)*, 1959. Hollis Frampton photograph, courtesy Frampton Estate.

17. Installation: "Sol LeWitt: Dibujos Murales, Wall Drawings," 1996. Sala de las Alhajas, Caja de Madrid, Spain. Photograph Miguel Zavala, courtesy Susanna Singer.

18. Robert Rauschenberg, *Factum I*, 1957. Combine painting, 62 × 36". Museum of Contemporary Art, Los Angeles; Panza Collection. © Robert Rauschenberg/licensed by VAGA, New York, New York. Photograph Paula Goldman.

19. Robert Rauschenberg, *Factum II*, 1957. Combine painting, 62 × 36". Private collection. © Robert Rauschenberg/licensed by VAGA, New York, New York. Photograph by Rudolph Burckhardt, courtesy estate of Rudy Burckhardt.

# INDEX

*Page numbers in italics refer to illustrations or tables.*